A VICTIM'S SHOE, A BROKEN WATCH, AND MARBLES

A VICTIM'S SHOE, A BROKEN WATCH, AND MARBLES

DESIRE OBJECTS AND HUMAN RIGHTS

LEA DAVID

Columbia University Press *New York*

Columbia University Press
Publishers Since 1893
New York Chichester, West Sussex

Copyright © 2025 Lea David
All rights reserved

Library of Congress Cataloging-in-Publication Data
Names: David, Lea, 1976– author.
Title: A victim's shoe, a broken watch, and marbles : desire objects and human rights / Lea David.
Description: New York : Columbia University Press, [2025] | Includes bibliographical references and index.
Identifiers: LCCN 2024022288 | ISBN 9780231217736 (hardback) | ISBN 9780231217743 (trade paperback) | ISBN 9780231561884 (ebook)
Subjects: LCSH: Human rights—Exhibitions—Social aspects. | Atrocities. | Collective memory. | Memorialization. | Museum exhibits—Social aspects.
Classification: LCC JC585 .D337 2025 | DDC 323/.044—dc23/eng/20241007

Cover design: Elliott S. Cairns
Cover image: Vladimir Miladinović, *Free Objects*, Foundobjects/Photography, 2024

To those who have lost someone, something, or themselves along the way.

CONTENTS

Prologue ix

Introduction: Desire Objects and Human Rights 1

I THE CONCEPTUAL FRAMEWORK

1 Desire Objects 25
2 A Theoretical Model: Desire Objects and Moral Labor 46
3 Ideological Coatings: Human Rights and Nationalism 59

II THE MOVEMENT AND BIOGRAPHIES OF DESIRE OBJECTS

4 The First Circuit: The Survival of Personal Objects After an Atrocity 89
5 The Second Circuit: Desire Objects in Private Homes 109
6 The Third Circuit: Public Display, Moral Labor, and the Discursive Value of Desire Objects 132

III MORAL LABOR, POLITICAL ACTION, AND HUMAN RIGHTS

7 Other Shoes Paved the Way: On the Circulation of Knowledge 157

8 Desire Objects, Political Action, and Ideology 193

9 Concluding Remarks: Desire Objects, Moral Labor, Ideologies, and Tacit Memory 222

Notes 239

Bibliography 291

Index 325

PROLOGUE

Grief is love with no place to go.

MY JOURNEY

Two unrelated events were the impetus for my research into personal items found where atrocities have taken place. The first had to do with my first book, *The Past Can't Heal Us: The Dangers of Mandating Memory in the Name of Human Rights*, published in 2020.[1] In that book, I argued that the human rights memorialization agenda, referred to as "moral remembrance," is constructed and adopted as a result of experiences of historically grounded events that, once transformed into policy-oriented memorialization efforts, become an oppressive force. In *The Past Can't Heal Us* and in this volume, I assert that it is necessary to understand human rights as an ideology. Doing so gives us a clear understanding, on three levels, of how human rights are promoted worldwide. According to Sinisa Malešević's extensive research on nationalism, the ideological outlook of human rights should be assessed based on three criteria: its organizational power (i.e., the institutions and organizations in place to promote a certain ideological worldview); its ideological or dogmatic power (i.e., the content, norms, and values being promoted); and micro-solidarity

(i.e., how "ordinary" people understand and adopt or reject an ideological worldview). Hence, *The Past Can't Heal Us* took a top-down approach, following the emergence of the human rights memorialization agenda and its standardization at the level of the global polity. Although the book was well received, two issues were raised by readers: (1) that the implementation of human rights from the bottom up is much more diverse than described in the book (true) and (2) that the outcomes of human rights projects are more impactful than suggested in the book (not true). Since then, I have continued to wonder whether my results would be different were I to write a new book "upside down." Were I to take a bottom-up perspective, would I discover a more optimistic future for human rights? Would I find that human rights are capable of proliferating from the bottom to the top of social structures, from ordinary people to political action?

While struggling to find the best way to investigate the issues I wanted to explore, an event in my personal life gave me just the impetus I needed. At the time, I was living in Dublin with my husband and our two daughters, but many of our possessions were elsewhere and had to be shipped to Ireland. However, the COVID-19 pandemic had just begun, making travel impossible. Thus, we needed to ask our families to help out. We spent one long afternoon on Skype, looking through the screen at what was in the boxes we had stored several years ago to decide what we needed and what could be given away. Pots and pans, forks, cups, printed articles, books, old bags, arts and crafts, paintings and drawings, objects that we even didn't recognize or remember, and many, many other things that we had collected over the years, neatly stored in the attic. "Keep it, throw it away, keep it . . . wait . . . let me see . . . oh . . . it doesn't matter . . . no need to open that box . . . wait, just some old curtains, ok, did you open that bag? . . . ," etc. As you can imagine, it was a draining process that brought up feelings of guilt at imposing such a burden on our families, so we were all keen to finish it as quickly as possible. Several weeks later, our things were sent on their way. It was an emotional moment for us;

not only did it mean that we had moved to a new country for good, but going through all the things with our daughters when the boxes arrived was quite moving: seeing my colorful, funky clothes, my high-heeled pink shoes, going through my youth pictures, my diaries, all of that, gave then a glimpse of who I was before they appeared.

But then I realized that the most important bag was not there, the one that I had years ago labeled "nostalgia" and contained my most precious . . . clothes! Throughout the many moves in my life, I had one bag in which I kept all of my most loved pieces of clothing, including two dresses I had gotten from my mother that I had worn as a two-year-old, my mother's hippie wedding skirt, my grandmother's handmade nightwear, some dresses from my teenage years, and some carefully selected pieces from my daughters' childhoods. Gone. Apparently put out with the rubbish.

For weeks, I tried to rationalize that it was just stuff, that what was important was that we were all well. And yet I was overwhelmed with emotion. I was grieving, I was angry, I was anxious, and I was going around in circles. And I didn't know why. Psychological explanations of grief and loss felt extremely insufficient and shallow. I wondered, What are the mechanisms that shape human–object relations? Why was one small, faded dress different from all others?

At the time, I was preparing the module I would soon be teaching on genocide and human rights and suddenly found myself thinking about all those personal items found in places where human rights atrocities had taken place and wondering how survivors might feel when they see them. And then it hit me: The objects are not the end of the story. They are just the beginning. And that is how this research came about.

This book was written in solitude. I just started writing it one day, and apart from intervals of teaching and administrative duties, I was fully invested in the research and writing for months. Siniša Malešević, my former supervisor, as well as a colleague and friend, was the only person I felt comfortable sharing early drafts with,

given that I was on new academic terrain. He provided me with valuable feedback and, more importantly, the motivation to endure and the conviction that I was doing something original and important. The significant turning point of my work was an invitation to give a lecture at the Vienna Wiesenthal Institute for Holocaust Studies, where for the first time I presented some of the findings from my new research. The feedback I got from the audience, a conversation I had with the institute's director, Éva Kovács, and the reviews I later received of an article I had written on the topic were crucial in helping me understand the blind spots and inconsistencies in the research. Many other people also helped me find relevant material and shape my key arguments, and several provided support that helped me keep going: my sister, Mia David, Sarah Gensburger, Carol Kidron, Bojan Toncic, and members of the McLonac group, just to mention a few.

This book was also written in a frenzy. Once I got into it, I was not able to let it go. My biggest fans and supporters were my family—my husband, Nery, our twin daughters, Aya and Zoe, and our dog, Sushi. Over months and months, Nery not only had to listen to a stream of seemingly random thoughts and ideas but also to try to make sense of them all. Zoe and Aya helped me tremendously in streamlining my research ideas, relentlessly asking why, what, and how, forcing me to be clear and precise. Aya even sketched a comic for me to simplify the logic of the project that was brilliant, perceptive, and inspiring. Sushi was a cuddling pillow, pure love in a fur coat.

I wish to dedicate this book to people who are grieving, who have grieved, or who will grieve. It is therefore for each and every one of us, as no one is immune to grief and loss. If grief is love with no place to go, then this book is my attempt to find places where love *can* go.

A VICTIM'S SHOE, A BROKEN WATCH, AND MARBLES

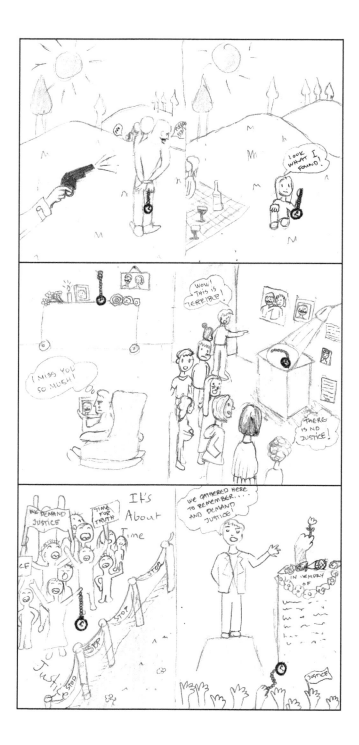

INTRODUCTION
Desire Objects and Human Rights

Arber was only seven and half years old. During the Kosovo war, he and his family found refuge with the Bogujevci family in Podujevo, north of Kosovo. Four days after the NATO bombardment in 1999, the members of the Bogujevci household were forcefully taken from their home by paramilitary forces aligned with the Serbian government. Just outside the house, the Serbian forces, led by a notorious paramilitary group called the Scorpions, killed fourteen people, including Arber, his mother; his brother, Albion; and his two sisters, Mimoza and Dafina. Three children from the Bogujevci family were also killed that day. In Arber's pocket on the day of his murder were marbles he played with with his friends. The marbles were a gift from his father, Enver Duriqi, who found them in the garden several months after his entire family was brutally slaughtered by Serbian forces on March 28, 1999. When he appeared in court in 2003 to testify about the atrocity, the room fell silent. In a trembling hand he held Arber's bag of marbles while looking directly at the face of Saša Cvjetan, the accused. The marbles are his most prized possession. "In the courtroom, he took a small white bundle from his pocket, carefully unwrapped it, and showed the marbles to the judges," the Humanitarian Law Center states.[1] The marbles, Duriqi's most prized possession, eventually became part of an exhibition entitled *Once Upon a Time and Never Again* at

the Humanitarian Law Center Kosovo, where visitors could learn about the story behind them.

This book is about desire objects: personal items found where atrocities have taken place. These objects belonging to the missing or killed are often understood as the last tangible link with those who are absent, and seeing them can generate emotions far beyond what is associated with their mundane function. A personal item that survives war, genocide, or any other mass atrocity is considered a powerful "material witness," harboring evidence of preconflict life, violence, and subsequent travels.[2] I call such objects "desire objects"—not as in the context of commodities, in which the desire to acquire an object is set against one's ability to purchase it, but in terms of the emotional responses to these objects that reflect people's various desires regarding how the world should look. These include the desires for the killed or missing to come back, to prolong the memory of the killed or missing, to remember death or loss in a particular way, to ensure that the unjust loss of a particular person or group is acknowledged, to make some sense of a tragic event and help people find peace, and to promote a particular vision of the future. In this book, I argue that all the desires embedded in desire objects do not arise independently but instead reflect ideological moral orders of what the world should look like.

Before I delve into the subject, I want to acknowledge that, for many, this is a sensitive and often painful topic. The items found in places where atrocities have occurred, such as mass graves, detention or concentration camps, and sites of terrorist attacks and mass shootings, are personal and directly linked to the very concrete crimes committed. They are not abstract or imagined but painfully real and leave emotional and psychological scars for not only those immediately affected but also subsequent generations. If it is distressing to lose memorabilia of someone we love, the pain of being left only a random personal item that belonged to a loved one who was brutally killed must be excruciating. Yet naming those rare personal items that are so tightly connected to an atrocity "desire objects" is meant as no

disrespect. On the contrary, although desire objects at first glance represent a link with death and violence, in this book I trace the multiplicity of desires embedded in them to find meaning and ideas of "the world as it should be." In the afterlife of desire objects, their meaning transcends individual and community grief, and they may become integral to and encourage the development of a desired moral order and various forms of hope and solidarity.

Why do personal items found at the sites of atrocities matter? How do they shape human–object relations? How do desire objects contribute to the vocabulary of political action, and to what end? How are different ideological worldviews shaped by desire objects, and how do they shape them in turn? While I try to answer these questions to a certain extent, the main aim of my research is to understand how desire objects affect and are affected by the ideological worldview of human rights. Although one may rightly ask where the assumption that desire objects are linked to human rights comes from, I show throughout the book that with each movement from one societal circuit—arena of different social arrangement and interaction—to another, desire objects become ideologically grounded and potent with the capacity to influence desired moral orders.

Desire objects are found in the depths of death pits, muddy forests, idyllic hillsides, and murky rivers, as well as in abandoned prisons, schools, churches, factories, shelters, and ruins; they are found in both out-of-the-way and remarkably central places, carrying secrets of torture, agony, suffering, execution, and death. Most often, they vanish with their owners into an irreversible decay. But sometimes, just every so often, as with hidden precious gems, they survive. They appear suddenly, and they are discovered and kept. From there, their second life begins with an uncertain trajectory: some will end up well preserved in storage rooms where they will be used to establish their owners' identities; some less fortunate, in a state of putridity, will be discarded as useless and destroyed. But some will be reunited with the family members of the deceased, with those who will recognize them

immediately, those who will cry tears of hope and despair. For many desire objects, their journey will end here. But some will reach the public sphere, where they will be put on display, available for a wide audience to see them.

Hence, this is a story of a victim's shoe, a broken watch, marbles, and many other personal items found after incidents of extreme violence. These objects are not particularly unique, yet they are. Left alone, they don't tell us a story, as is often suggested. The presumption that "things and objects can 'speak' to the beholder and may contain the spirit of the past" is often taken for granted and has almost become axiomatic in the way we treat objects.[3] In this book, I ask you to question the belief, so common in both research and public discourse, that personal items found at sites of atrocities "tell us a story." Objects don't tell a story; *we* tell a story. And the story we tell is not uniquely our own but one that is fabricated ideologically. My research shows how desire objects become permeated with ideology and why this has become a blind spot for us. However, it is the people around these objects, those with an immediate connection to them, as well as those distant to them, who imbue them with feelings and ascribe meanings to them. Desire objects represent both hope and despair, the ghostly leftovers of lives not fully lived. They are scarce and irreplaceable, and their survival makes them powerful far beyond their usual function. They are silent, yet under the right conditions they mend moral orders. However, the emotions and meanings attached to desire objects do not, as we often think, originate from the objects but rather are deeply grounded in ideological worldviews.

THE SOCIOLOGICAL REASONING BEHIND DESIRE OBJECTS

This is a detective story with striking political implications. It is a detective story because it tracks and follows the trajectories of

personal items found where atrocities have occurred. But instead of tracing the murderers, this story traces how the objects inspire new desired moral orders. I focus not on a particular object but desire objects as a category. I show that there are certain almost predestined patterns when it comes to the movement of desire objects, patterns shaped by ideological infrastructures, namely those of human rights. Yet as is demonstrated throughout the book, the ideologization of desire objects is at times interrupted by a competing, nationalistic ideological worldview. I show that though chance often plays a role in whether objects are discovered or destroyed, clear patterns of movement can gift desire objects a second life. Inquiries into the biographies of desire objects demonstrate the circumstances under which they are granted agency, illustrating why only a few be used in political actions.

I use desire objects here as a case study; this book is not about the objects per se but about how ideologies shape human interactions with them to promote certain moral orders. This book is a historical-sociological analysis of an under-researched and largely neglected matter: the transformation of the perceived value and emotional energy of desire objects that occurs when, over the course of time, they move from one societal circuit to another and how that transformation is both influenced by and influences human rights. Taking a historical-sociological approach means understanding human rights as an ideology that develops gradually and gains its ideological and organizational power through a development of societal structures shaped historically, politically, and culturally by complex social processes. It also means recognizing that the patterns of the movement of desire objects are shaped by accumulative processes over time. For example, whereas the victims' shoes found during the liberation of the concentration camps at the end of World War II had a narrow purpose as desire objects (mostly to attest to the volume and gravity of the atrocity committed), the shoes of atrocity victims today have many functions and trajectories (from serving identification

and evidentiary purposes to becoming symbols of personal grief, elements of educational displays, and motivators of political action). The patterns of movement of desire objects are embedded in *longue durée* historical-sociological processes and closely linked with the expansion of human rights infrastructures, values, and reasoning. The emergence of humanitarian forensics in the 1980s, the growth of transitional justice mechanisms since the end of the Cold War, the rise of memorial museums in the twenty-first century, and the popular culture that captured and emulated the trends arising during the development of human rights have been key to shaping the patterned trajectories and biographies of desire objects.[4] It is these generative processes that infuse desire objects with meanings and emotions beyond their initial connotations.

The journeys of desire objects and the patterns they create point us to the mechanisms by which human rights operate and promote a particular moral order. Although the items found at sites of atrocities are largely regarded as objects that tell the truth about a given atrocity, their trajectories demonstrate the much wider range of their purpose. These trajectories not only show us how the norms and values of human rights are disseminated, understood, and embedded but also point to the limited capacity of human rights to penetrate shared meanings across moral communities.

In addition to describing the purpose of this book, it is equally important to say straight away what this book is *not* about. I do not compare desire objects in terms of their contexts, the magnitude of their associated atrocities, or their varied geopolitical meanings and implications. Similarly, when describing displays of desire objects at memorial museums and other sites of "dark tourism" around the world, I do not account for the vast differences in displays. Doing so would simply be impossible and is not crucial to my arguments. I am not interested in one particular desire object or another but desire objects as a category. I am not interested in one particular museum or another; my interest in them pertains to how they are used to

highlight emerging patterns in human–object relations and how they are influenced by and influence ideological thinking. Further, I am not normatively assessing nationalism or human rights as either inherently good or bad. Focusing on the concept of ideology does not imply normative assumptions; rather, I use ideology merely as a theoretical concept to help us understand how different moral worldviews expand or clash. Generalization as a methodological choice is a necessity here, though it naturally comes with certain shortcomings. No serious research is ever about "all," "always," or "everywhere." Yet generalization can help us recognize patterns whose meanings have been overlooked or simply not researched.

Finally, my research does not delegitimize other approaches to assessing the expansion and embedding of human rights; instead, it offers a unique approach that goes beyond human rights indexes and measurements, surveys, and self-reporting on human rights norms and values to assess the pathways by which people internalize, adapt, or reject the moral orders of human rights. While human rights scholars and practitioners have put considerable effort into developing a variety of measures and indicators to describe advances and setbacks in the promotion and protection of human rights in order to explain their overall global variation and expansion and to find ways to guarantee their improved protection in the future, sociological mechanisms are rarely addressed. The persistent difference between "rights in principle" and "rights in practice" has given rise to numerous forms of measurements, such as the coding of country participation in regional and international human rights regimes, the coding of national constitutions according to their rights provisions, quantitative and qualitative summaries of human rights violations, survey data and opinion polls on perceptions of rights conditions, abstract scales and indexes of human rights, and individual and aggregate measures that map the outcomes of government policies that have consequences for the enjoyment of rights.[5] A guide for measuring human rights published by the UN in 2012 introduces the structure–process–outcome

model, designed to measure the extent to which human rights are respected and protected and to "promote human rights standards in any given environment."[6] Cross-cultural studies have addressed the effectiveness of human rights in implementing values and norms in the long run. We see, for example, that both very rich economies (e.g., Saudi Arabia, Kuwait, Equatorial Guinea) and very poor ones (e.g., Nigeria, Democratic Republic of the Congo, Myanmar) score poorly on human rights, yet such data tell us next to nothing about why human rights activist engagement is strong in some countries, both rich and poor, but not others.[7] These studies provide important comparative data; shed light on tendencies, correlations, predicted behaviors, networks, and statistical data; and illustrate the "principle–application gap."[8] However, such studies are rarely sociologically grounded. In this book, I take a road less traveled by investigating the logic of how human–object relations have become immersed in ideological thinking.

A BRIEF NOTE ON METHODOLOGY

Methodologically speaking, my research is based on a wide range of sources, including newspapers, museum websites and archives, blogs, Tripadvisor reviews of museum exhibitions, the Getty Images database of shoe protests, and literature on the subject. I reviewed hundreds of newspaper articles, images, and museum artifact databases to be able to recognize emerging patterns in the movement of desire objects. Because of the restrictions of the COVID-19 pandemic but primarily as a methodological choice, I did not conduct interviews with survivors of atrocities. Not only could such interviews be traumatizing for participants, but it was also clear to me that conducting interviews would not be beneficial for my research for two reasons. First, because I intended to cover vast geographical areas and contexts (though I focus largely on evidence from the Balkans because of

my language abilities and the availability of data), it would have been impossible to include survivors from multiple post-atrocity settings. I didn't want to limit myself geographically to any particular atrocity because the main focus of my work is on the emergence of a global phenomenon. There are methodological difficulties in generating theoretical concepts that are applicable globally when basing one's research on only a single set of geopolitical circumstances. Interviewing just a handful of individuals would have narrowed the spotlight to one situational setting, and I wanted to avoid this. Additionally, research of this kind involves numerous time and budget constraints.

Second, I wanted to protect the neutrality of the research because I was aware that conducting interviews with survivors would not have left me indifferent. On the contrary, I would have become emotionally involved, which could have obscured, rather than revealed, what happens in human–object encounters. As my research focuses on the concept of emotional energy, I didn't want to be emotionally drawn into the lived experiences of the interlocutors. Instead, I chose to rely on survivors' statements as they appeared in various newspapers, blogs, and testimonies collected for memorial museum activities (e.g., oral projects, exhibitions).

In chapter 7, I make extensive use of comments from Tripadvisor. Though this is an unorthodox approach, many researchers have used Tripadvisor responses as means of estimating visitors' responses to museum exhibitions.[9] Visitors' comments are important sources of information about their encounters with desire objects in memorial museums. They not only provide an ample amount of data but also convey the emotions and meanings that visitors have attached to desire objects. In addition, I gathered hundreds of images of desire objects from mass graves and other sites of atrocities, as well as memorial museums and protests.

Importantly, this book offers new ways to methodologically link material culture with the development of norms and beliefs. Describing collective patterns of the movement of desire objects, not just as

individual biographies but as a reflection of social structures that change over time, brings fresh and exciting opportunities to research and thus better understand the intersection between material culture and ideological and organizational development, both locally and globally.

THE CONCEPTUAL FRAMEWORK

This book is about the personal items of the missing or killed found at sites of mass atrocities and their peculiar trajectories. As I will elaborate, these objects move through various societal circuits with various outcomes—as simple grieving objects, tools of identification or court evidence, or encapsulations of ideological moral claims that call for political action. While their biographies (or journeys, as I call them), as patterns of their movement, both vary and overlap, desire objects often transcend their mundane function to mirror a variety of desires embedded in grief and in a perception of unjust, premature death.

The logic of how and why desire objects are kept privately or donated and then preserved, collected, and displayed or destroyed or left to decay—or transformed into political symbols—is often obscured or taken for granted. In this book, I present the varied and peculiar yet patterned, biographical trajectories of desire objects that are best understood through their movement in three societal circuits in which they are ascribed different meanings. In the first circuit, where desire objects are discovered, stored, and used as tools of identification or evidence in court, their main purpose is evidentiary. They are used forensically to identify bodies or as evidence of an atrocity to bring the culprits to justice. Here, the human–object relationship is reflected in an attempt to establish facts of identity and the nature of the atrocities. The second circuit marks the movement of desire objects to private homes when objects are returned to the families of the killed. Their main purpose in this context is to help those close to the deceased in their bereavement and in coming to terms with

the loss of their loved ones. Here, the human–object relationship is reflected in the intense emotions that emerge following a victim's identification. The third circuit describes the movement of desire objects from the private domain to the public sphere, most commonly to museums and exhibitions, where they are exposed to the wider public. And while the trajectories of desire objects are predetermined from the moment of discovery by existing ideological infrastructures, once they are on public display, they become repackaged and aligned to certain ideological meanings. Hence, the human–object relationship in this context is reflected in ascribing certain moral orders. That said, not all desire objects move linearly from one circuit to another. In addition to there being a limited number of possible trajectories for desire objects, many are destroyed along the way or become permanently stored in private homes or public institutions, never again to see the light of day. However, in this book, I expand the notion—both methodologically and theoretically—of the biographies of desire objects to account for possible future trajectories, not only past ones.

My main argument is that the movement of desire objects follows certain patterns largely predetermined by the human rights infrastructures and circulating narratives in place in a given context. They move from one circuit to another, and, by affecting the emotional energy of the people who encounter them, they experience a change in the value ascribed to them. Under certain circumstances, ascribing agency to desire objects can lead to various political actions. Emotional energy is the main driving force in social life.[10] Randall Collins defines *emotional energy* as the amount of emotional power that flows through one's actions; it does not refer to one specific emotion. Central to Collins's interaction ritual theory, upon which this book builds, is the notion that people in face-to-face encounters perform mutual rituals that are sustained by an emotional energy that results in a feeling of membership and a desire for action considered a morally "proper" path.[11] I expand Collins's concept of "interaction ritual chains" to human–object relations, showing that encounters between

people and desire objects, influenced by ideological meanings, shape and synchronize the emotional energy among people. I argue that in some instances, it is not that the emotional energy among people creates "sacred objects"; instead, it is the other way around.

Emotional energy is key to motivating people to pursue moral labor. However, moral labor differs from emotional labor according to Arlie Hochschild in her groundbreaking works, which focus on how people in service jobs are pressured to commit themselves to emotional labor.[12] Emotional labor is found primarily, but not exclusively, in the service economy. Simply put, emotional labor is what employees perform (often against their will and beliefs) when they are required to feel, or at least project, certain emotions as they engage in job-relevant interactions. This significant, often unacknowledged component of a service worker's job requires "skilled, effort-intensive, and productive labor."[13] Moral labor, on the other hand, involves an intense emotional energy charge coupled with particular ideological staging in which desire objects are the focus of interaction ritual chains. Not only is moral labor largely voluntary, but people most often pay to engage in it. Manipulated spaces, such as memorial museums and other sites of dark tourism that enhance the authenticity of desire objects to provoke an emotional charge and encourage moral labor, are designed to elicit emotional energy and thus define the value of a given object. As more emotional energy is created, the value of a desire object increases.

Importantly, desire objects create the most emotional energy when they are housed privately and viewed by people with intimate knowledge of the dead or missing; in public spaces, where objects are viewed by people without such intimate knowledge, less emotional energy is generated on an individual level. However, what matters here is the *accumulation* of emotional energy as more and more people encounter a desire object. In this context, the value of the object is directly connected with the plurality and synchronization of emotional energy created through the moral labor of visitors. Although desire objects

create less emotional energy individually in the public sphere, a collective emotional energy not possible in the private sphere emerges and increases as more visitors engage with the objects. Consequently, the perceived value of desire objects is directly related to the amount of collective emotional energy they generate. Although an emotional energy charge is necessary to ascribe agency to a desire object, this alone is not sufficient. Desire objects become attributed with agency only when the emotional labor encouraged by them is connected with ideological thinking. Only then, when people who interact with desire objects are pushed to conduct moral labor, are the objects granted a voice: the voice of ideological underpinning. Simply put, moral labor is emotional labor that is heavily embedded in ideological meaning-making processes.

When put on display, desire objects, whether a broken watch, a crumpled ID, a bloody garment, or a bag of marbles, require a staged environment to trigger interaction ritual chains through which people can focus their emotional attention on the objects. The environmental context matters greatly since it dictates not only the intensity of the emotional energy charge but also the ideological understanding of the past event associated with the objects. And for most desire objects, a public display will be their final destination. They will stay there, reproducing and reinforcing interactional rituals as an integral part of a series of feedback loops in which changing audiences are encouraged over and over again to pursue moral labor. Continued exhibition is a highly generative process in which the meanings of desire objects become coded and reinforced with each new wave of visitors.

While desire objects come in various shapes, forms, and textures of materiality, moral labor embeds the emotions generated by the objects with moral meanings. Only a small number of objects—not specific objects but objects as a category—will be incorporated into a widely recognizable vocabulary of political action. Desire objects are often used in political action: action designed to achieve a goal through the

use of political power or activity in political channels. Objects used in protests serve as elevated props; they amplify and homogenize the core idea of the discontent. In this context, the potential of desire objects to serve political agendas can hypothetically be reactivated because protests are most effective when they are highly imaginatively theatrical and carnivalized. Although many recognizable symbols of protest have emerged over time, such as the key as a symbol of hope among Palestinians; the keffiyehs, the black-and-white head scarf, a symbol of freedom and resistance for Palestinians; and the white head scarf, a symbol of unity in the context of Argentina's Dirty War, the emotional energy they generate across temporal and spatial dimensions is limited by their scope and meaning.[14] And although we have extensive literature on the use of official political symbols (such as flags, anthems, and other ideological imagery such as the hammer and sickle, the fist, and the rainbow), we know almost nothing about how symbols emerge from the biographies of specific objects or how desire objects shape the moral claims used to promote political agendas and actions.

Of all desire objects, victims' shoes likely constitute the most diverse trope in political action. However, it would be incorrect to assume that shoes are used like any other type of desire object in protests. Rather, the staging of victims' shoes in protests as a main focus of interaction ritual chains is possible only because of the generative meanings of the past trajectories of *all* desire objects. The trope of victims' shoes acts as an overarching symbol of death, loss, and destruction. Without these genealogical meanings, shoes have no place in political action.[15] It is in the use of the trope of victims' shoes that we see how desire objects become both disassociated and reassociated with the moral orders of human rights. Hence, the use of victims' shoes as the pinnacle of all desire objects in political action shows us how ideological meanings travel—and how these meanings get intercepted and appropriated by nationalist infrastructures already in place.

MAJOR CLAIMS

In this book, I propose new ways of exploring how human rights ground themselves in social structures. I use desire objects as a case study to gain access to the meaning-making processes of people in their encounters with desire objects to demonstrate that the objects' movements are ideologically framed. This framing in turn shapes the meanings people ascribe to desire objects, as well as the desired moral orders to which people strive. The book follows a complex web of spatial and temporal intersections in which desire objects simultaneously exist. Hence, the linearity presented here is only for operational sake. The book navigates through a number of topics, but all are presented to shed light on the mechanisms through which desire objects become ideologically embedded.

In this book, I have three general theses. First, desire objects are a novel phenomenon. The market for desire objects was created by clashes between the development of human rights and nationalistic worldviews. Research points to the historical-sociological process of the ideological development of human rights since the end of World War I. Rather than narrating this period of historical development chronologically, I describe how the branching of human rights infrastructures, practices, and narratives affects the meanings ascribed to desire objects in different societal circuits. The widening of the scope of human rights via the development of humanitarian forensics, transitional justice mechanisms, and memorial museums as an emerging genre have all contributed to the alteration of the meaning—and desires—assigned to desire objects. Their value, though changing via their movement among societal circuits, is tightly linked with the ideological infrastructures in place. Their movement is predetermined by the logic and morality of human rights, but occasionally also those of nationalism. Thus, my first argument is that desire objects embody the ideological clashes that determine their biographical trajectories.

Second, moral labor is inherently ideologically driven. Whereas emotional energy creates interaction ritual chains, the embedding of ideology in desire objects is how moral labor homogenizes people's emotions and sentiment. Though the ideological subtext can be subtle or explicit, moral labor both unifies and censors the meanings of desire objects. Through moral labor, people come to tell stories they adopt as authentically their own. Yet the stories they tell about the events represented by desire objects are particular and ideologically driven. This means that the meaning-making process is influenced by wider ideological infrastructures often taken for granted. I show how, in staged environments such as memorial museums designed to promote social change and human rights, emotional energy ignites moral labor. However, this is not to say that people engage in moral labor only in staged environments. Nor is it to say that people cannot acquire ideological meaning without engaging in moral labor. Although moral labor is an important channel through which ideologization takes place, it has rarely been acknowledged as such. Finally, moral labor is not a phenomenon restricted to human rights alone but is relevant and applicable to all other ideological worldviews.

Third, political actions in which desire objects are the focus of interaction chain rituals often diverge significantly from human rights moral orders. I first describe the circumstances under which desire objects gain agency to inspire political action. I then demonstrate how the use and contextualization of desire objects changes significantly once the objects move beyond the staged environments of their journey through societal circuits preestablished as meaningful crossroads for the ideological expansion of human rights. In the context of political actions, desire objects function as skeuomorph objects, derivative objects that retain attributes from structures necessary in the original. For example, though victims' shoes always represent death, loss, and destruction, the positioning of who is dead, who lost what, and what was destroyed points us to certain desired moral orders. Further, political actions that use the logic of desire objects

operate on various temporal scales: at certain times, political action is directed toward settling historical injustices, whereas at others, it is grounded in narrow, pragmatic, presentist demands and concerns about future loss and destruction. Different temporalities also mean different desired moral orders, which speaks to both the expansiveness of the moral worldviews and the obstacles and limitations of human rights.

THE LAYOUT OF THE BOOK

The book consists of three parts, each consisting of three chapters. The first part offers a theoretical perspective that serves as a conceptual framework and provides guidelines for the research. The second part deals with the movement of desire objects among three societal circuits—rediscovery, private homes, and public display—to establish the patterns of their movement. The final part narrows the category of desire objects to victims' shoes and addresses the importance of moral labor, political action, and ideological divergence in human–object relations.

Part I: The Conceptual Framework

In the first chapter of the book, I introduce desire objects: personal items found in places where mass atrocities have occurred. Despite a growing interest in the material culture approach, personal objects are still marginal to the histories of war, genocide, and displacement.[16] My reason for selecting this category of objects is because personal items recovered from the sites of political violence, especially in the absence of bodies, become potent embodiments of feeling and loci of emotional investment and of mourning and memory.[17] It is their placement, their associative link with a given atrocity, and the

emotional energy charge they produce that makes this a unique category of objects. I propose that for an object to be a *desire* object, four conditions must be met:

1) The event of dying that took place where the object was found is not regarded as part of a natural life cycle. This means that the event cannot be categorized as having happened because of natural causes, such as an earthquake or fire. The event must involve a responsible party, an intention to commit a violent and harmful act, a violent act, and a deep feeling that an injustice has been done.

2) The objects found at sites of mass atrocity provide a direct link to the event of the atrocity. The event must be a part of living memory. The people immediately affected by the event are themselves direct carriers of the memory of the event. Desire objects accumulate more emotional energy when the event is temporally closer to the survivors. As the event becomes more temporally distant and its memory is narrated by subsequent generations, the emotional energy of desire objects is attenuated.

3) Found objects are scarce and unique, and their "survival" ignites an instant link between the killed and the act of killing. The fewer desire objects available, the more emotional energy they will accumulate. However, the scarcity of the objects is always determined on the temporal axis: while objects present at the event of an atrocity have the most emotional potential, as time passes, other objects and personal items that belonged to the killed become more scarce and thus gain value.

4) Objects found at the sites of atrocities can be traced to their owners or closely associated with the killed or missing. This connection is highly significant because the link between the owner of an object and the atrocity almost instantly becomes understood as an object's innate attribute of violence and bridges a person's life and death. Thus, desire objects are associated with intense emotions.

In chapter 1, I position desire objects between their biographical journeys and their activation by the bodies and minds of those who encounter them.

In chapter 2, I describe the theoretical model used to understand the patterns of the trajectories by which desire objects move from one circuit to another and how they might end up as part of a recognizable vocabulary in a wide range of political actions. The theoretical model works on two axes and aims to differentiate (1) between the biographies of objects and their potential agency and (2) between emotional labor and moral labor. In the first part of the chapter, I explain the differences between the biographies of desire objects and their potential to acquire agency. In the second part, I discuss the difference between emotional labor and moral labor, the role moral labor plays in synchronizing a collective emotional energy charge, and how moral labor defines the value of desire objects.

In chapter 3, I position the movements of desire objects, the variation in their value, and the emotional energy charge they attract within ideological infrastructures. I claim that without understanding the ideological setting in which a desire object travels, it is impossible to understand the pattern of its trajectory. All three societal circuits—rediscovery, private homes, and public display—in which desire objects circulate are embedded in ideological worldviews, either directly or indirectly. These background ideologies matter because they shape and influence the meanings that people allocate in their encounters with desire objects. From the moment of their (re)discovery to their placement in storage for forensic or legal work, to their possible transition to the private homes of the families of the killed or missing, to their public display in museums or sites of dark tourism, desire objects are incorporated and used to serve particular ideological worldviews. Desire objects are equally important for two competing forms of remembrance: one in service of nationalism and one in service of human rights.

Part II: The Movement and Biographies of Desire Objects

In chapter 4, I elaborate on the intentional and unintentional discoveries of desire objects. Regardless of where they are found, whether in a mass grave or an untouched field, their rediscovery and salvation from further decomposition marks the beginning of their life in movement. The value that will be ascribed to them varies significantly and is a function of their current material condition, the demand for such items, and pure luck. However, already in the first societal circuit, desire objects are set on a similar trajectory: to be stored and then to be used as a tool for identification or as forensic evidence in court.

In chapter 5, I describe the paths, some more likely than others, by which desire objects start circulating among various social realms. Each transition involves at least two levels of social interaction. With each transition, the intensity of the emotional energy generated by an object and the object's perceived value change. Here, we see what happens once objects are reunited with the family of the killed or missing and how, in some cases, unintentional national bonds are created that influence the meaning-making process of what desire objects stand for.

In chapter 6, I elaborate on why and to what end desire objects often end up being donated to memorial museums. Desire objects reach such public spaces after already having acquired an initial value as objects authentically associated with violence, death, and destruction, potent with emotional energy and perceived through the lens of particular biographies. With the assistance of numerous curatorial, artistic, and technological devices, desire objects play a vital role in the structured sequences of the emotional and cognitive narration of past atrocities. Desire objects play a crucial role in moral labor, and, in return, moral labor plays a crucial role in how wider audiences talk and think about them. Tightly linked to this idea is the process of emotional mining: the process by which people without a direct link

to the remembered event connect to it by encountering a desire object face to face; it is in this way that desire objects reach their peak of emotional energy. While emotional energy homogenizes the sentiments arising from encounters with desire objects, emotional mining enables a shortcut to the more guarded emotions that we conceal on a day-to-day basis, which can be reached only in the face of the extraordinary.

Part III: Victims' Shoes, Political Actions, and Human Rights

In chapter 7, I focus on the trope of victims' shoes. I demonstrate how other desire objects have historically and sociologically become subsumed into this trope and explain why victims' shoes generate more emotional energy than other desire objects. I show that the contrasting meanings of victims' shoes—as mundane objects connected to people's livelihoods and as a potent symbol of death, loss, and destruction—and the wide circulation of images of victims' shoes are necessary preconditions to elevating these objects from the mundane to the revered. Yet, this process cannot be fully understood without an understanding of how emotional energy feeds into moral labor. It is moral labor that provides the networks of meanings that set the stage for political action.

In chapter 8, I discuss what happens when the victims' shoes trope is used in political actions. I provide an overview of political protest and of the rich and surprising ways in which the trope is made the focus of interaction ritual chains. I also elaborate on how the ideological worldview of human rights becomes interrupted by nationalist sentiments in a wide range of protests in which shoes are positioned at the heart of a desire to achieve a certain moral order.

Finally, in chapter 9, I discuss the significance and implications of desire objects for moral labor, ideological worldviews, and memory

construction. I claim that desire objects are used to reveal hidden or explicit desires and to link those desires with particular moral orders. Although all desire objects originate in mass human abuses linked to the coercive capacities of the nation-state, when used in political actions, the objects come to represent many ideological alignments that are often distinctively detached from their historical origins. I then show that the category of desire objects represents a societal layer shaped by the rise of both human rights and nationalism, as well as by collisions and overlaps between these two ideologies. In that sense, desire objects should be seen as both material and symbolic representations of this ideological intersection, which is directly linked to how the schemas of memory are created. They are sediments engraved with the ideological clash between human rights and nationalism, and it is the generative power of tacit memory, embedded in the human–object relations of desire objects, that defines the conditions under which they will be used to promote certain moral orders. I conclude by asserting that the influence of human rights grows through tacitly engraved memory schemata that, without our ever noticing, bear meanings that support the expansion of human rights.

I

THE CONCEPTUAL FRAMEWORK

1

DESIRE OBJECTS

Huso Halilović, a Bosniak survivor of the 1995 Srebrenica massacre, recognized his father's watch and comb in a mass grave in Kamenica, near Zvornik: "When I see these items, I'm flooded with tears; I remember how his watch was always on his hand and he was combing his hair every morning. Those are the only mementos I have."[1]

Mass atrocities are marked by destruction. Concentration camps; factories and schools that became sites of torture and death; buildings full of people targeted in terrorist attacks; open fields, forests, and rivers where bodies were left after mass atrocities—all are sites of devastation. All leave blasted landscapes of death and despair. In addition to the debris, blood, and scattered reminders of life, what is left are pain and a profound feeling of injustice.

This book is about the personal items of the missing or killed found where mass atrocities have taken place—referred to here as "desire objects"—and their unique trajectories. As I will elaborate, these objects move through several societal circuits and have various outcomes, including as objects of grief and bereavement, tools of identification and court evidence, and symbols encapsulating ideological moral claims that call for political action. While their biographies, as patterns of their movement, vary and overlap, all desire objects manage to transcend their mundane function to mirror *desires*

embedded in grief and in a perception of unjust, premature death. As mentioned in the introduction, I call such objects "desire objects" not as in the context of their purchasing availability, but in terms of the emotional responses to these objects that reflect people's various desires regarding how the world should look. For the families and friends of the dead or missing, desire objects reflect a desire for loved ones to return, a desire to prolong the memory of those lost, a desire to make sense of an unjust death or loss, a desire to find peace. Desire objects represent the wishes and hopes of the people to whom those objects are significant. However, desire objects can also become significant to much wider communities. Those with no personal connection to the killed or missing who engage with a desire object will reflect onto it different kinds of desires: a desire to shape the memory of a violent event (rather than the individual victims), a desire to make sense of the event, a desire to prevent future mass atrocities or to plot revenge, a desire to call for political action.

The logic of how and why desire objects are kept privately or donated and then preserved, collected, and displayed or destroyed or left to decay—or transformed into political symbols—is often obscured or taken for granted. To better understand the various meanings of these objects, it is important to understand how desire objects become invested with meaning: which economic, cultural, social, and psychological processes are involved, and how are they substantiated in things? To what extent does the trajectory of things—their movement among human beings—determine the meaning of these things?[2] As Arjun Appadurai has said, it is only "things-in-motion," the trajectory of things among human beings, that enables us to understand their meaning.[3] The possession of an object is not in itself significant because the object possesses meaning only in the context of its performance.

In this book, I present the varied and peculiar yet patterned, biographical trajectories of desire objects that are best understood through their movement in three societal circuits in which they

are ascribed different meanings. In the first circuit, their main purpose is evidentiary. They are used forensically to identify bodies or as evidence of an atrocity to bring the perpetrators to justice. Here, the human–object relationship is reflected in an attempt to establish personal identity of the victims and to establish the nature of the atrocities. The second circuit marks the movement of desire objects to private homes if and when objects are returned to the families of the killed. Their main purpose in the second circuit is to help those close to the deceased in their bereavement and in coming to terms with the loss of their loved ones. Desire objects here to help those close to the deceased in their bereavement process and in coming to terms with the inevitability of their missing loved ones' destiny. The human–object relationship is reflected in the intense emotions that emerge following a victim's identification. The third circuit describes the movement of desire objects from the private domain to the public sphere, most commonly to museums and exhibitions, where they are displayed for the wider public. And yet, while the trajectories of desire objects are predetermined from the moment of discovery by existing ideological infrastructures, once they are on public display, they become repackaged and aligned to certain ideological meanings— either of nationalism or human rights. Hence, the human–object relationship is reflected in ascribing certain moral orders. That said, it is important to stress that not all desire objects move linearly from one circuit to another. In addition to there being a limited number of possible trajectories for desire objects, many are destroyed along the way or become permanently stored in private homes or public institutions, never again to see the light of day.

Occasionally, desire objects acquire meanings far beyond what is associated with their mundane function. In fact, at times and under certain conditions, desire objects can instigate political action. I contend that their transition from one social circuit to another, how they accumulate emotional energy, and how they are ascribed value result in various moral claims and political action. I use the term *political*

action, defined as "action designed to attain a purpose by the use of political power or by activity in political channels,"[4] to demonstrate how the biographical trajectories of desire objects, dictated by preexisting ideological infrastructures, influence a broad spectrum of political involvement.

Desire objects are sought by various parties, and they often change hands many times as they move among societal circuits. My main argument in this book is that desire objects matter not only because of their personal or evidentiary value *but also because they can tell us how communities try to restore particular moral orders*. They serve not only as historical "witnesses" but, more importantly, also as tools crucial to establishing normative worldviews and morals. However, we cannot understand how desire objects operate without understanding the concepts of emotional energy and of the biographies and agency of objects.

A CONCEPTUAL GUIDE TO DESIRE OBJECTS

An Emotional Energy Charge

My main argument is that the movement of desire objects follows certain patterns largely predetermined by the human rights infrastructures and circulating narratives in place in a given context. They move from one circuit to another, and, by affecting the emotional energy of the people who encounter them, they experience a change in the value ascribed to them. Under certain circumstances, ascribing agency to desire objects can lead to various political actions. Emotional energy is the main driving force in social life.[5] Randall Collins defines *emotional energy* as the amount of emotional power that flows through one's actions; it does not refer to one specific emotion. According to Collins's model of interaction ritual chains, emotional energy is carried across situations by symbols that have been changed

by emotional situations.[6] People focus attention on the same thing, become aware of one another's focus, and get caught up in one another's emotions. Thus, emotional energy is the emotional charge that people take away with them from an interaction.

Collins asserts that emotional attachments play an indispensable role in human actions. He argues that emotional energy is the main motivating force in social life and that the emotional, symbolic, and value-oriented behavior of any group participant is determined by chains of previous encounters, which he calls "interaction rituals." Human interactions demonstrate a tendency for people who establish a common focus of attention to become mutually entrained in a common rhythm of speech and bodily movements and the intensification of a shared emotional mood—what Collins calls an "interaction ritual chain." Collins developed a theory of situations, arguing that interconnections among local situations and their embedding in larger structures across time and space, along with the extent of their spillover, constitute a micro-pattern. Central to Collins's interaction ritual theory is the notion that people in face-to-face encounters perform mutual rituals that are sustained by an emotional energy that results in a feeling of membership and a desire for action considered a morally "proper" path. Collins parts from Erving Goffman's interaction ritual analysis in which sacred objects are already structured, arguing that an "intense ritual experience creates new symbolic objects and generates energies that fuel major social change."[7] People are much more motivated to participate in the shared action when their concerns are personal and involve people they know and care about. Interaction rituals generate a variable level of emotional energy in each person over time. Emotional energy operates as the common denominator in terms of the choice made among alternative courses of action. Individuals apportion their investment in work and in ritual participation with a view to maximizing their overall flow of emotional energy.

According to Collins, *emotional energy* refers to a dynamic created by interhuman relations that mobilizes and generates feelings that

become aggregated over time.[8] Although Collins and many others have applied his theory to vast situational contexts, including protests and movements, class experiences, workplaces, and family settings, I intend to show that desire objects are primarily a focus for an emotional energy charge.[9] According to Collins, even the most ordinary things can become sacred, and the process by which people develop mutual focus and synchronize their micro-rhythms and emotions lies at the center of an interaction ritual.[10] He argues that symbols become imbued with positive emotional energy and significance, and when these symbols become the focus of group attention, they become sacred objects.

I find that it is rather the encounter between people and desire objects that shapes and synchronizes the emotional energy among people. I argue that in some instances, it is not that the emotional energy among people creates "sacred objects" but the other way around. The encounter with a desire object shapes the emotional energy charge. Emotions are part of the "stuff" connecting human beings to one another and to the world around them, acting as a lens that colors all our thoughts, actions, perceptions, and judgments.[11] Emotional states become amplified in settings characterized by high physical density, clearly bounded relations, and mutual focus.[12] Emotions are understood here as culturally or socially constructed. This means that my research places emotions at the junction of social rules for expressing feelings, the management of emotions by oneself and others, and the social evaluation of emotions.[13] A wide spectrum of emotions exists, including primary emotions, like fear, anger, sadness, and happiness, and secondary elaborations of primary emotions, like pride, shame, love, and embarrassment. And while David Boyns and Sarah Luery suggest that a distinction should be made between "positive" emotional energies (like happiness, joy, and excitement) and "negative" ones (like hate, vengeance, and humiliation),[14] I show here that, although different people experience different emotions in their encounters with a desire object, the most frequently experienced

secondary feeling is moral outrage. Of all the emotions, injustice is most closely associated with "the righteous anger that puts fire in the belly and iron in the soul."[15] As illustrated in Collins's interaction ritual theory, it is really the excitement caused by mutual presence that adds an emotional weight to the experience of a ritual. This emotional weight is then slowly reinforced as the group begins to develop a mutual rhythm in a coordinated and synchronized manner by following repertoires of action regulated by a set of explicit and implicit prescriptions. These prescriptions are crucial for setting the tone of both the action and the emotion. The emotional energy increases and transports ritual participants to a different world, one away from daily routines that transmits to them the sensation of being in contact with something "sacred" that they themselves are creating.[16] This synchronization happens because emotional engagement is associated with reactions to one's peers, meaning that in a structured environments such as a museum, the emotional energy that comes from an encounter with a desire object becomes, to a certain extent, homogenized.[17] Finally, as I will demonstrate, emotional energy in the form of moral outrage can at times be translated into a powerful motivation for protest when there is someone to blame for an injustice.[18]

The Biographies and Agency of Objects

Material culture is inseparable from our day-to-day life. We build and purchase houses; we buy, exchange, and dispose of objects; we collect memorabilia. Things have no meaning apart from those endowed to them by human transactions, attributions, and motivations. Hence, their meanings are always inscribed in their forms, their uses, and their trajectories. Things bear historical witness to the affective relationship of people with the material world, ideas, and feelings. For historians, the significance of objects comes in many forms such as receipts, letters, old photos, newspaper cuttings, and the simple mementos we keep to

remind us of key life events. Leora Auslander argues for the utility and importance of material culture for historical research and that historiography should go "beyond the words," or take what is known in the field of historical research as a "material turn."[19] Much of the research that relies on material culture sees objects as tangible markers of past experience and, by association, as evidence and carriers of memory.

However, different disciplines focus on different things. For archaeology—the study of human activity through the recovery and analysis of material culture—objects have always been central to its endeavors, but interest in objects has often been defined according to their function, dating, and, to a lesser extent, style. But objects do not just provide a stage setting for human action; they are integral to it. Chris Gosden has rightly stressed the need to create a framework that acknowledges objects as a creative part of our social life, one that focuses on the effects of objects in creating or subverting the values attached to human relations, as well as the means by which human aspirations and values are carried by objects, seen as prosthetic extensions of ourselves.[20] Although the research on material culture and human–object relations has advanced significantly in recent years—in particular with the emergence of new paradigms such as "symmetric archaeology," new materialisms, and post-Anthropocene studies— what Carl Kopytoff claimed is still relevant: the universe of people and the universe of objects are culturally axiomatic of nineteenth- and twentieth-century Western thought.[21]

Two major and interconnected approaches have been developed in recent years to bridge this division in human–object relations. One is to conceptualize and overcome this largely artificial dichotomy is by ascribing agency to objects. The idea is to encourage serious and detailed analyses of the formal qualities of objects, paying attention to how those formal qualities affect and are affected by human social relationships.[22] Wiebe Bijker argues that an object must be seen simply as a node in a wider network and that the agency of an object is contingent upon the nature of its interconnections with other nodes in the

network.[23] This notion implies that agency is widely distributed and inherent in the relationships among the various entities that constitute a field of action.[24] Bruno Latour argues for a shift from "subject oriented" to "object oriented," using "Back to Things!" as the motto of his work.[25] Working with the actor network theory, Latour and others have argued against the privileged ascription of agency to human beings, arguing that, as "actants" of sorts, "nonhuman entities," too, may be interpreted as effecting "agency."[26] Knappett similarly suggests understanding agency as distributed across a far-flung network of people and artifacts and as a social network that may remain after the biological death of an individual. This movement of objects within the social networks depends largely upon which stage an artifact is at in its life cycle. In a similar fashion, historians of artifacts point to the limitations of using language as the principal generator of cultural meaning and argue that things and objects possess agency, are markers of continuity and change, and can initiate dialogue between the past and present.[27]

The second major approach to bridging the division in human–object relations, one asserting that "objects have social lives" (a notion that became axiomatic of the field), is the biographical approach to objects.[28] This approach seeks to understand how objects become invested with meaning through the social interactions they are involved in and posits that meanings change and are renegotiated throughout the life of an object. The cultural biography perspective, formulated by Kopytoff, states that as things move through various hands, contexts, and uses, they accumulate a specific biography or set of biographies. Chris Gosden and Yvonne Marshall point out the distinction between objects that accumulate their own biographies (i.e., inherent meanings) and those that contribute to the biography of a ceremony or body of knowledge.[29] Yet at the heart of the notion of biography are questions about the links between people and things, about how meanings and values are accumulated and transformed.

A slightly different approach to biography is found in the work of Janet Hoskins, who has looked at how individuals' biographies are

tied up in objects.³⁰ She shifts the focus from the biographies that objects may accumulate to how objects are used to create and sustain the meaning of people's lives. When asking people about their life stories in eastern Indonesia, Hoskins found that they elicited little response, but when she asked about significant objects, her interlocutors offered detailed descriptions of their biographies.³¹ Historians are also increasingly paying attention to collective emotions, biographies, and the formation of communities around objects. However, despite a growing interest in the material culture approach, personal objects are still marginal to the histories of war, genocide, and displacement.³² Historians typically use objects rescued from wars to validate battlefield experiences, making the objects' biographical journeys from battlefield to archive to history book appear natural and maintaining much of the focus of historical research on state practices, and, in particular, the economic and political ramifications of wars.

In much anthropological and sociological writing, objects have been considered primarily in two ways: as commodities or gifts. Correspondingly, the relationships of people to things and to other people seem to fall into two broad categories often regarded as mutually exclusive: impersonal, economic, or market relationships with strangers and personal relationships involving the sharing of gifts with friends or family.³³ Appadurai discusses Jacques Maquet's four classifications of aesthetic productions: (1) commodities by destination, that is, objects intended by their producers to be principally for exchange; (2) commodities by metamorphosis, that is, things intended for other uses that are placed into a commodity state; (3) commodities by diversion, a particular case of commodities by metamorphosis in which objects are placed into a commodity state despite originally having been protected from it; and (4) ex-commodities, that is, things retrieved either temporarily or permanently from a commodity state and placed into some other state.³⁴ Commodities as valuables are at the heart of economic anthropology, and, as with the medium of gifting, they are at the heart of exchange theory and social anthropology

generally. Objects as commodities, following the Marxist notion of the "fetishism of commodities," focus our attention on the social life of any "thing," defined as the situation in which its exchangeability (in the past, present, or future) for some other thing is its socially relevant feature.[35] Hence, commoditization of objects lies at the complex intersection of temporal, cultural, and social factors.

Despite the use of different conceptual tools, social exchange theory in anthropology and sociology is based on the notion that people's relationships are driven by the trade of goods and services that produce not only economic but also social and symbolic gains.[36] Probably the most famous example of this is that of the Kula valuables exchanged among Trobriand Islanders, explored by one of the most influential early anthropologists, Bronislaw Malinowski a century ago.[37] The Kula is a complex regional system for the circulation of particular kinds of valuables, usually between men, in the Massim group of islands off the eastern part of New Guinea. The main objects exchanged are of two types: ornate shell and bead necklaces (which circulate in one direction) and shell armbands (which circulate in the other). These valuables acquire specific biographies, and consequently acquire value, as they move from place to place and hand to hand, just as the men who exchange them gain and lose reputation as they acquire, hold, and part with these valuables. The path taken by these objects, and their interdependent biographies, is thus both reflective and constitutive of social partnerships and struggles linked to the politics of reputation.

In that context, the book *The Social Life of Things*, edited by Arjun Appadurai, has had a major impact on the emergent interdisciplinary field of material culture studies, which has brought together anthropologists, archaeologists, historians, psychologists, and sociologists.[38] For Appadurai, context is everything; rather than making blanket distinctions between objects, we must look at the political and social circumstances surrounding exchanges, as well as the conditions under which objects acquire worth and circulate in various regimes of

value in space and time. According to Appadurai, objects circulate in specific cultural and historical milieus, and it is desire and demand, reciprocal sacrifice and power interactions, that create economic value in specific social situations. Consequently, there are different paths, diversions, and strategies, both individual and institutional, that make establishing the value of an object a politically mediated process. It is the diversions that are linked to short- and long-term patterns in commodity circulation, which in turn makes consumption a subject of social control and political redefinition bound by desire and demand. Finally, to define the trajectories of objects and how they acquire worth, one must understand that the political value of objects is inherent and rests upon the relationship between knowledge and commodities.[39]

The agency and divergent biographies of objects are not consistent in their significance but rather change while circulating among regimes of values. Possessions swap hands and are voluntarily or forcefully relinquished, exchanged for food and shelter, hidden away, entrusted to friends and neighbors for safekeeping, or forced into exile. Objects find their way to mass graves in pockets, on fingers and wrists, and in bodily orifices.[40] Personal items become treasured, even sacred objects of memory, stored for safekeeping or displayed on a mantelpiece, dresser, or bedside table in the home, traditionally places of personal memory. Personal items and objects belonging to those brutally killed somewhat paradoxically often secure value through theft and dispossession, a phenomenon that occurs randomly after atrocities. For example, in the Spanish Civil War, objects were stolen during the fighting, from bodies in graves, and from surviving relatives as part of the systematic repression of the Republicans by the Francoists that occurred during and immediately following the war.[41] The thefts of the *Arbeit Macht Frei* signs from the gates of Auschwitz in 2009 and Dachau in 2014 are hardly isolated examples of the unique allure of items from notorious sites of violence and death.[42] The personal items of the killed or missing victims of atrocities, such as jewelry, clothing, and furniture, acquire value while also becoming

loci of both desire and discomfort, simultaneously valued for their economic worth and perceived as haunted by the previous owners.

In justifying and condemning misappropriation, responses to repossessed property yield new symbolic, moral, and tangible economies in which other people's belongings structure communities and forge both individual and collective identities.[43] Sacred objects, via gifting, theft, and commerce, also experience various patterns of movement but in a larger context of ecclesiastical control, local competition, and community rivalry. Missing, stolen, destroyed, or irreversibly lost things function as powerful mnemonic objects: they become sites of emotional and imaginative investment, taking center stage in post-conflict narratives and memory performances.[44] The value of an object does not have an absolute worth as a result of the demand for it, but demand and desire, as the basis of a real or imagined exchange, endow the object with value. It is the exchangeability of things, broadly speaking, that sets the parameters of utility and scarcity.[45] For Georg Simmel, value, which is neither wholly subjective nor wholly objective, is never an inherent property of objects but a judgment made about them by subjects.[46] Simmel believed that people create value by making objects, then separating themselves from those objects, and then trying to overcome that distance. He found that objects that were too close to people, as well as those that were too far away for people to obtain, were not considered valuable. Yet the key to the comprehension of value, according to Simmel, is that objects acquire values because "we call those objects valuable that resist our desire to possess them." But how do rescued, looted, misappropriated, abandoned, found, and recovered things live on in the aftermath of mass violence? And what desires do they reveal?

Desire Objects: A Definition

A growing body of scholarship on personal belongings (including photographs, letters, postcards, and other keepsakes) rescued by genocide survivors, experts, and ordinary people shows how things

can activate oral performances and offer a window into a transgenerational and transnational memory of an event.[47] The personal items of those who have (voluntarily or involuntarily) participated in wars or survived atrocities (often both) have been collected (often selectively), cherished, and preserved by loved ones, public institutions, and many other types of interested parties. Soldiers' diaries and letters, badges of honor, and personal items such as pencils, tobacco boxes, and watches, together with war memorabilia such as guns have traditionally been a focus of both private and public collectors, though often to very different ends. Objects matter because the living memory of the dead is itself mortal since those who remember the dead will eventually die themselves. Meaningful objects belonging to those who have been killed testify to the discontinuity of memory within individuals, between individuals, and across generations. At times, such items are discovered through personal inquiries. For example, Santanu Das has explained how a search through his extended family in Kolkata helped him recover the war mementos of her late relative, Colonel Dr. Manindranath Das, an Indian soldier who fought in World War I: his uniform, whistle, razor, brandy bottle, tiffin box, and photo album, as well as the Military Cross he was awarded for tending to his men under perilous circumstances.[48] There is an abundance of stories of Holocaust survivors and their descendants who discovered precious objects that belonged to their deceased family members. Finding an object that belonged to someone close who has been the victim of an atrocity is always accompanied by intense feelings of grief and loss. Relatives fortunate enough to rescue the personal effects of loved ones seldom refashion them into mementos or reminders of the violence they experienced.

Desire objects differ significantly from personal belongings in general. Personal belongings are a much wider category, and, although they may be found at sites of atrocities, the term does not refer exclusively to personal items embedded in unjust violence. An antique lamp sitting on a shelf is a personal belonging, but it is not a desire

object. A knife used to stab someone in a fight might be a personal belonging, but despite being connected to a violent experience, it is not a desire object. A jewelry box is a personal belonging but not a desire object. But a necklace found on a skeleton in a mass grave *is* a desire object. Hence, to understand what desire objects are—and what they are not—we must define the term properly. Determining whether an object belongs to this category is typically a pretty straightforward process but not always.

Simply put, desire objects are personal items found at sites of mass atrocities. One question must be asked before we move on: What is so special about the objects found at sites of atrocities and large-scale human rights abuses? What makes them desire objects, as no other items can be? What imbues them with an emotional energy that can give them a life of their own, enable them to travel great distances, transform them beyond their mundane function into meaningful symbols, and eventually become codified by and embedded in various ideological worldviews? Through their discovery at sites of mass atrocities and their trajectories among societal circuits, desire objects are ideally suited to gaining meaning elevated beyond their initial function. For an object to be called a desire object, four conditions must be met:

1) Event: The event of dying in a mass atrocity is not regarded as part of the natural cycle of life. This means that the event cannot be categorized as having occurred because of natural causes, such as a natural disaster. The event must involve (1) a responsible party, (2) an intention to commit a violent act, (3) a violent act, and (4) a feeling that an injustice has been done. When these requirements are met, personal items found where any type of mass violence has taken place, whether a school shooting or large-scale ethnic cleansing, become desire objects. What matters here is that there are two unequal sides. The event is not a battlefield situation in which both sides are armed but rather an unbalanced situation in which one side is intentionally

committing an atrocity on a community that is harmless or at least helpless at the time of the atrocity.

2) Link: The objects found at the location of a mass atrocity provide a direct link to the event of the atrocity, and the event must be a part of living memory. Those immediately affected by the event are themselves direct carriers of the memory of the event. Desire objects accumulate the most emotional energy when the event is temporally close to the survivors. As the event recedes into the past and its memory becomes narrated by subsequent generations, the emotional energy attenuates. The objects found where atrocities have taken place are also versatile, including both personal items and weaponry. In the case of secondary mass graves or terrorist attacks, bodies and personal items are immersed in debris. And although all of the objects present possess a clear link to the given atrocity, only personal items, via their embedded emotional meaning to the killed or missing, link specific people to the event.

3) Scarcity: Objects found at sites of atrocities are scarce and unique, and their "survival" ignites an instant link between the killed and the act of killing. The fewer desire objects available, the more emotional energy they will accumulate. However, scarcity is always determined on a temporal axis: while the objects present at the event initially have the most emotional potential, as time passes, other personal items of the killed or missing gain scarcity and value. When there are no more desire objects to be found at the site of an atrocity, "secondary" personal objects are sought, items that belonged to the deceased but not to the event of their passing.

4) Traceability: Objects found at sites of atrocity can be traced to their owners or closely associated with those killed in the event. This connection is highly significant because the link between the owner and the violent event almost instantly becomes understood as an object's innate attribute of violence, one that bridges the life and death of a person. Thus, desire objects are associated with intense emotions. It is one thing to find a desire object but completely another

to trace it back to the family of a person killed in mass atrocity. The link between the desire object and the deceased is a powerful tool that increases the object's emotional energy charge.

Finally, it is important to understand when the notion of desire objects is ambiguous and what is excluded from this taxonomy. On one hand, I have purposely omitted from this discussion both body parts and what Zuzanna Dziuban calls "atopic objects," such as gold teeth and prosthetics, for two reasons.[49] First, it is arguable whether we can categorize such objects as personal items; second, and more importantly, attitudes toward the human body are both culturally and religiously contested. Hence, although piles of human hair and teeth are still displayed in Holocaust museums, they are met with great ambivalence and provoke diverse cultural responses. In that sense, they cannot teach us much about the agency ascribed to desire objects and their potential to provoke political action. On the other hand, some categories of objects are included in one context but not in another. Suitcases, for example, are not regarded as desire objects when found at the locations of mass executions because the people executed would usually not have been carrying suitcases. But when found in concentration camps, suitcases count as desire objects. Desire objects are always a function of their situational context.

An object that survives war, genocide, or forced migration is a powerful "material witness," harboring evidence of pre-conflict life, violence, and subsequent travels.[50] Whether we understand them as material witnesses or "surviving objects," scholars across disciplines agree that such objects constitute powerful narrative devices because they provide direction regarding how to structure the story of an atrocity.[51] Desire objects provide a way to define who we are to ourselves and to others.[52] They are emergent "sites of feeling," capable of triggering bodily reactions and emotional responses. They convey symbolic meanings, referring to both the nature and the actual or desired status of the relationship between human beings. The power

of these artifacts in general lies in the fact that their uniqueness and their immediate associability with their owners can generate meanings to oblige reciprocity through their symbolic value. Objects are "tie signs": signs of social bonds.[53] Desire objects, in particular, are activated through bodies and minds, just as stories cannot be reanimated without places, events, and the imagination. Personal items recovered from the sites of political violence, especially in the absence of a body, become potent embodiments of feeling and loci of emotional investment, mourning, and memory.[54]

Neither a Gift nor a Commodity: How to Understand Desire Objects

Contemplate for a second a tragic event such as a car accident in which a man is killed by a drunk driver, leaving his wife, children, and extended family in a state of shock and grief. The emotional energy will likely be strongest among the immediate members of the grieving family. The first and immediate cycle of object circulation includes the man's close family and carries the most intense feelings, as the event has significantly affected their immediate life course. The second cycle, involving slightly less intense emotions, includes the man's relatives and close friends, whose lives will change to varying degrees depending on how close they were to the him. The third cycle, involving less intense emotions than in the second cycle, includes the man's colleagues, neighbors, and acquaintances, who will be affected by the loss but soon recover. In the fourth cycle, the wider community receives the news as yet another terrible but fairly common event. The dilution of emotional energy in such a situation works similarly to an earthquake: the closer to the epicenter, the stronger the emotional response. Any death causes an emotional reaction, but death from natural causes such as disease or old age, whether anticipated or sudden, is ultimately regarded as "nature taking its course," and the

emotions associated with the death will be less intense than those associated with an unnatural death, such as from a car accident or mass atrocity.

Although this anecdote helps explain the dilution of emotional energy, to fully understand the steep erosion of emotions following a death, we must also factor in the social placement of the deceased and how the death came about. Some lives may be considered more valuable than others when they have the potential to rock the foundations of a society. The passing of a beloved leader, such as Josip Broz Tito, Queen Elizabeth II, or Nelson Mandela, creates a great emotional response that goes far beyond the person's family, friends, and associates.[55] The emotional impact tends to be even more intense when the death is perceived as shocking, sudden, and, most importantly, unjust. Hence, the assassination of a major political figure, such as that of Yitzhak Rabin, Zoran Djindjic, Anwar Sadat, or John F. Kennedy, has the potential to have a highly intense and "contagious" emotional impact on society and "ordinary" people. This is because the death, which is associated with violence and injustice, is perceived as being out of place and unnatural. But what happens to the emotional impact of violent and unjust death when it is not a single person but an entire community, or a significant part of it, that is erased? Even if we speak of ordinary people uninvolved in the foundation of societal structures, the sheer number of people forcefully killed significantly increases the intensity of the emotional response. Hence, in all of the cases discussed here, the gap between what is perceived as a normal versus an abnormal part of the life course is one of emotional intensity.

The degree to which desire objects become the focus of emotional attention has to do with (1) their scarcity in terms of how many are left behind; (2) their proximity to the event; and (3) the previous value (whether emotional or other) attached to the object. According to these criteria, we can relatively easily form a hierarchy of desire objects that reflects their initial value—not their economic value but their emotional value at the moment of an unjust death. If we go back

to the example of the man who died in a car crash, we notice that all of the objects that belong to the sphere of the dead man are immediately "upgraded" to the status of "special" objects following his death. Even seemingly random objects will now generate substantial emotional energy because they represent the last palpable link between his life and his death—the note he left for his wife on the fridge the day of the crash, the umbrella he forgot to take despite his wife telling him to. However, when it comes to his personal possessions, some will soon start generating additional layers of emotions. His precious violin, for example, will most likely gather more attention than his clothes. Moreover, personal items recovered from the scene of the accident—his broken glasses or the watch he inherited from his late father—those items with a personal story, because of their uniqueness and scarcity and their inscribed character as bearing witness to an abrupt life ending, are likely to generate the most intense emotions. Because of the structured logic of the emotional "engraving" of very particular objects, many of the man's personal items will go away. Some will never transcend their mundane, functional purpose and are likely to be disposed of or donated, such as shoes, clothes, and impersonal items such as office supplies. Some objects will be disposed of with indifference, some with deep sadness, some with disgust. For example, we see that objects need a certain symbolic "purity" for the sake of social propriety because "dirt is essentially disorder."[56] Hence, if more "desirable" objects are available, items such as socks, underpants, or a toothbrush are likely to be thrown away and not publicly displayed. Items that adhere to the logic of desire objects and are capable of generating emotional energy provoke a wide range of emotions from desperation, sadness, and nostalgia to fear, repulsion, and disgust to happiness, exaltation, and pride.

In terms of desire objects, this logic is applied on a much larger scale. There are many casualties, a party who intentionally initiated a violent act (as opposed to a natural disaster or the actions of a drunk driver), and a significant impact on the fabric of the affected community.

Objects found in such environments are capable of embodying the essence of the emotional energy charge of the event—a crucial factor in how people allocate meanings and agency to objects in order to restore a particular moral order. Thus, for example, once a wallet is found in a mass grave, it is instantly understood as a direct link to death and destruction. In places where the atrocity is still part of living memory, this knowledge immediately sparks a connection between the desire objects and the crime scene, whereby those immediately affected are themselves direct carriers of the memory of the event.

How those bonds between people and objects are forged and how the sudden significance of desire objects is shaped beyond the audience of those directly affected by the atrocity is the main focus of this book. However, although this is a story of a victim's shoe, a broken watch, and marbles, it is not a story about any particular object but desire objects as a category. I follow the trajectories of various desire objects to establish their shared patterns of movement because those patterns point to the changing nature of human–object relations. This is a crucial point because with each movement, desire objects gain new meanings that may lead to various political actions. Hence, the model presented here does not account for any specific object but aims to sketch possible trajectories that explain how desire objects that start from similar categorical venture points—sites of mass atrocities—can end up producing a wide variety of political actions. I propose a conceptual model to explain how and why desire objects, when moving from one social circuit to another, are shaped by ideological outlooks—most importantly that of human rights— that change their value and shape human–object relations in some extraordinary ways. Such a model is critical for two reasons. First, the transformation of the meanings of desire objects tells us something profound about the junction between the ideological formation of memory patterns and the impact of these memory patterns on political action. Second the model reveals the entanglement of desire objects in various attempts to restore particular moral orders.

2

A THEORETICAL MODEL
Desire Objects and Moral Labor

To understand the patterns of trajectories by which desire objects move from one circuit to another, and how they might end up as a recognizable vocabulary in a wide range of political actions, I sketch here a theoretical model to navigate this process. The model works on two axes and aims to differentiate (1) between the biographies of desire objects and the potential agency of desire objects, and (2) between emotional labor and moral labor. The chapter proceeds in two parts based on these axes. In the first part, I explain the differences between desire objects' biographies and their potential to acquire agency. In the second part, I discuss the difference between emotional and moral labor, the role moral labor plays in synchronizing a collective emotional energy charge, and how moral labor defines the value of desire objects.

DESIRE OBJECTS: THEIR BIOGRAPHIES VERSUS THEIR POTENTIAL AGENCY

The model suggests that the biography of a desire object differs significantly from the potential agency the object may acquire. The biography of any object is defined by the object's trajectory from its inception to its final destination. The biography marks the journey

of the object and includes its physical, functional, and value transformations. This means that every object has a unique biography and that no two objects travel the identical route. Yet those routes are patterned, meaning that despite the variety in the movement of desire objects, only a limited number of trajectories are possible, as trajectories are predetermined by ideological underpinnings. The predictability of this movement is even more striking for desire objects as they outlive their owners and move from one circuit to another. A broken watch found in a mass grave in Bucha will have a different route from that of a watch found in a mass grave near Srebrenica or in the debris of the September 11 attacks. The value of desire objects is established throughout their trajectories, yet when objects belong to the same broad category of objects (e.g., clocks and watches), that category bestows a particular significance to all such objects.

Contrary to this type of automatically applied significance, the agency of desire objects is not a given; rather, it is acquired under a number of circumstances. Whereas some desire objects—those that end up on display in public spaces—will generate emotional energy in their encounters with observers, only a small number of desire objects generate agency. Agency is determined by the frequency of the object's physical, visual, or narrative circulation in the public sphere. The more an object and its image travel, the more agency the object will gain. As I will show throughout this book, once desire objects enter the public sphere, their physical form is often decoupled from their representation in imagery. In other words, while an object might come to rest in a museum display, its image—and its story—might start traveling the world via museum catalogs, the internet, or documentaries, for example, thus imbuing the object with new life and meaning. In that sense, a desire object's agency is closely connected with the circulation of its image and its ability to function as a catalyst for political action.

However, desire objects are like no other objects. They are personal items that link people to their unjust and sudden deaths. Importantly,

they are *personal*, and they can convey both the literal and figurative DNA of the deceased. Hence, desire objects bridge the gap between individual and collective grievances because they can explain what happened in an atrocity. But their value and the emotional energy they generate in their encounters with observers vary significantly as objects change hands. Both Randall Collins's "interaction ritual chain theory" and the data collected for my research suggest that a desire object's emotional energy charge is at its highest once it is returned to the family of the deceased. This is because they are personal items and thus immediately recognizable to loved ones ("He wore those shoes to work," "Her grandmother gave her this watch, "She bought those earrings to wear at her graduation"). Each item tells a story; for those closest to the deceased, the story is a living memory of them. The object brings back happy memories of a life spent together but also acts as a reminder of death and loss. Just seeing it, smelling it, or touching it is enough to generate a burst of emotional energy. In terms of value, a desire object is priceless to those left to mourn the dead but worthless (at this stage) to all those outside the person's circle of family and friends.

While all desire objects have similar (but unique) biographical trajectories, their agency varies significantly. To grasp this point, we must look to the distinct existing "pre-knowledge" of each object within its given category. Regardless of the atrocity with which an object is associated, what knowledge about it is being circulated?

The biographies and agency of desire objects operate on both spatial and temporal axes. Whereas the linear movement (its movement from circuit to circuit) of a desire object defines its biography, its agency is determined by the frequency of its circulation. For example, a broken watch discovered in a forest where people were executed may travel from a storage facility to a courtroom and then to a family member's home or a museum. There is a certain linearity to this movement—not fully predictable but traceable. Agency works differently because it is not linked to one particular object but to a category

of objects: it is no longer about the trajectory of one victim's shoe but about the entire *category* of victims' shoes. For a desire object to have agency, it must become culturally, politically, and socially encoded as meaningful beyond its particular biography. But how do certain categories of objects become meaningful? Why do some objects become culturally, politically, and socially resonant while many others lose their emotional energy shortly after they are found? In the coming chapters, I will delve into these questions.

As mentioned, a desire object's agency is directly linked to the circulation of both it and its imagery. This circulation is a process that happens over time, and it is not linear but circular and wave-like. It does not follow the chain-like pattern of objects' journeys as they move from one circuit to another. Though the physical object may travel from one museum to another, one city to another, or one country to another, this travel is fairly limited. In contrast, the circulation of a desire object's imagery, which takes place simultaneously, is much wider. This wide circulation explains how memories travel both spatially and temporally and how a desire object manages to transcend its bare materiality to become encoded with particular meanings. The documentaries that replicate images of an object, news articles, novels that narrate emotional engagement with the object, history textbooks, academic publications, museum catalogs, oral testimonials—all forms of messaging pave the way for the cultural, political, and social encoding of a desire object. The more the image of the object is circulated, and becomes charged with a unified connotation, the more significance the object gains. It is only once images of a desire object are replicated and circulated that their meaning becomes culturally, politically, and socially charged and, to some extent, accepted globally. A single victim's shoe is nothing more than the individual story of an unjust death in an atrocity; a pile of shoes acts as testimony to the loss of life on a massive scale. But only once images of the pile of shoes become widely distributed does the single shoe become elevated to a level of abstraction such that it resembles a general sense of loss, death, and destruction.

EMOTIONAL LABOR VERSUS MORAL LABOR

A desire object generates varying levels of emotional charge within those who interact with it. However, both a desire object's value and the emotional energy it generates decrease once the object moves from the private to the public realm—the link to the immediate knowledge and lived experience of the object has been broken. To enhance the emotional energy in encounters between the object and strangers, the object's story must be added to and edited. When observers encounter a desire object in a museum display, they often have only a vague understanding of the context of its associated atrocity. They also most often lack intimate knowledge of the life of the deceased. Thus, for an object to generate emotional energy in the public sphere, those gaps in knowledge must be narrated for observers. Once a desire object leaves the home of a person close to the deceased, it lingers in a space that must be recontextualized with tools such as physical positioning and lighting within a space, photos of the deceased, and written or recorded testimonials. The effectiveness of a desire object in generating an emotional charge in observers depends on the capacity of the simulacrum to act as an "authentic replica," not necessarily of the event per se but the pain of the loss of the object's owner in horrific circumstances. In the public sphere, visitors are invited into a space that has been purposely designed to elicit an emotional response from them.[1]

Thus, once a desire object enters a public space open to visitors, two interrelated processes begin simultaneously. On one hand, the object becomes manipulated in such a way as to ignite emotional energy in people who interact with it. On the other hand, visitors are encouraged to engage in moral labor—the simulacrum drives them to regulate their emotional response. They adjust their emotional energy to fit the demands of the simulacrum.

What happens when a desire is displayed in a public space is quite extraordinary. Commemorative spaces, whether embedded in

a nationalistic or human rights worldview (or a hybrid of the two, as is often the case), are regarded as sites of "dark tourism," a term that refers to places associated with death and its representation. However, only some of these sites use desire objects to enhance visitors' experiences.[2] I am restricting my discussion to dark tourism (or memorial) sites that use desire objects extensively (1) to narrate the story of an atrocity, (2) as an educational tool to promote messaging aligned with human rights, and (3) to generate emotional energy with the potential to be translated into discourses and symbols. It is this particular work of processing affect into conscious emotions that is at the heart of the encounter between audience, desire object, and staged surroundings.

People who visit sites of dark tourism where atrocities are commemorated are encouraged to engage in a kind of emotional labor, which I regard as *moral* labor. This concept builds on the preexisting sociological notion of *emotional labor*, a term coined in 1983 by the sociologist Arlie Hochschild in her classic book, *The Managed Heart*. This book and the extensive literature on the subject address how people in various service jobs are forced to commit themselves to emotional labor. Hence, emotional labor is found primarily, in the service economy. Simply put, emotional labor is what employees perform when they are required to feel, or at least project, the appearance of certain emotions as they engage in job-relevant interactions. In other words, emotional labor refers to an unacknowledged component of a service worker's job requires "skilled, effort-intensive, and productive labor."[3] Thus, emotional labor is labor-intensive, skilled, and productive work. It creates value, affects productivity, and generates profit.[4] Jobs requiring emotional labor typically necessitate contact with other people within or external to the organization, usually in face-to-face or verbal contact. Emotional labor involves efforts to understand others, to empathize with them, to feel their feelings as one's own.[5] To perform emotional labor, in contrast with mental and physical work, employees must give something of themselves to others with whom they have no ongoing personal or instrumental

relationship.[6] Nowadays, when neoliberal logic has become prevalent in almost all sectors of employment, emotional labor is increasingly becoming a prevailing aspect of the experience of working and thus merits more attention than ever before.[7]

Hochschild differentiates between "surface acting" and "deep acting" in the performance of emotional labor.[8] In surface acting, an employee feigns emotion so that the displayed emotion differs from the emotion actually felt. Deep acting, by contrast, involves attempting to invoke the displayed emotion, as a method actor does. This two-faceted model of emotional labor has recently been expanded to include five emotional labor profiles—nonactor, low actor, surface actor, deep actor, and regulator—and suggests that these profiles are distinguished by several antecedents of emotional labor, such as positive affectivity, negative affectivity, display rules, customer orientation, and alignment between the emotional demands of a situation and one's ability to convey or experience the expected emotion.[9]

While Hochschild uses the term *feeling rules* to describe societal norms about the appropriate type and amount of feeling that should be experienced in a particular situation, J. Andrew Morris and Daniel Feldman conceptualize emotional labor in terms of four dimensions—frequency of appropriate emotional display, attentiveness to required display rules, variety of emotions to be displayed, and emotional dissonance generated by having to express organizationally desired emotions not genuinely felt—and argue that emotions are variable and context dependent.[10] However, in all cases, people work to manage their emotions to accommodate feeling rules. This work involves attempting to align privately felt emotions with normative expectations or aligning the outward expression of emotions with felt emotions.[11]

But how does this relate to people who visit sites of dark tourism? How are visitors encouraged to undertake moral labor, and by whom? And to what end? Visitors are not service workers; they are the opposite. Moral labor differs from emotional labor in several ways. First,

it is undertaken voluntarily, and people actually pay to engage in it. Moreover, it is work that people choose to pay for because it is associated with a particular ideological worldview. Visitors to sites of dark tourism are consumers, not service workers, and once they visit a museum or memorial site, they are encouraged to engage in a type of moral labor defined by the structure and norms applied in that place. This is because tourism-based activities in general, and visits to sites of dark tourism in particular, are increasingly focused on creating authentic experiences through visitor engagement in a type of tourism now widely regarded as the "experience business."[12] This transformation in the tourism industry further supports Hochschild's claim that emotions are not only shaped by broad cultural and societal norms but also increasingly regulated by employers with an eye on the bottom line. What is of particular significance here is the idea of emotion management in terms of how people—in this case, visitors to a site of dark tourism—actively shape and direct their feelings. Importantly, social structures and institutions influence the management of emotions and are fundamental to the emotions themselves. And although emotions function as signals for understanding an experience or situation, these signals are filtered through people's expectations about themselves and the world. Therefore, though people who visit sites that commemorate atrocities are consumers, not service workers, being a consumer is at the core of the experience of what they seek to gain by their visit. They choose to engage in moral labor and manage their emotions according to the social context of the site. In other words, once visitors enter a structured site that narrates an atrocity in a particular way, their emotional labor becomes framed and is navigated by the setting itself.

Hence, despite the fact that visitors are not there in a service role, their moral labor is placed in the service of the agenda of the institution. It is both the context—the encounter with desire objects and the narratives surrounding them—and the influence of other visitors and their emotional reactions that initiate a visitor's moral labor. It is

useful to understand moral labor through both simulation theory and interaction ritual theory. Both maintain that an individual represents the mental state and activity of others by generating those same states and activities in oneself.[13] As Collins argues, these body-on-body actions intensify one's feelings and enhance the interaction rituals through which human beings gain fulfillment: "The strongest human pleasures come from being fully and bodily absorbed in deeply synchronized social interaction."[14] Face-to-face interaction is crucial for this process because it allows for participation in a shared emotional experience, focuses the mutual attention of those involved, and can ultimately generate physical rhythmic synchronicity, all of which contribute to the generation of emotional energy. The emotional energy produced is contagious because it is built into newly formed rituals and is closely connected to emotional labor. Elaine Hatfield, John Cacioppo, and Richard Rapson define *emotional contagion* as "converging emotionally," meaning that emotion is transmitted from one person to another and, conversely, that one person "catches" emotion from another.[15] Lauren Wispé explains that emotional contagion involves an involuntary spread of feelings without conscious awareness.[16] Similarly, micro-sociologists and social psychologists have provided ample evidence that human beings often express their emotional highs and lows through physical interactions with others, such as in political demonstrations, football matches, concerts, and religious events.[17]

As mentioned, visits to site of dark tourism are voluntary; visitors are not paid for their labor. The act is understood as both a civic duty and personally beneficial. Visitors work to leave their mundane selves outside the space and to self-regulate their emotional energy in accordance with the space, which can be defined as a manipulated space of hybrid authenticity. Further, visitors censor themselves, refraining from laughing, arguing, eating, and any other activity socially and culturally understood as disrespectful. However, this strict self-regulation does not necessarily mean that the emotional energy generated by an

exhibit will be experienced consistently by or homogenized across visitors: some might cry; some might remain stoic; some might giggle in discomfort; some might even act annoyed. However, regardless of their reactions, are all engaging in a type of intense moral labor that legitimizes one set of emotions and delegitimizes others. It is this process of intense *emotional* labor, coupled with the particular ideological staging of the desire objects, that constitutes visitors' *moral* labor.

Exhibit spaces are manipulated to enhance the authenticity of the desire objects on display and thus provoke an emotional charge, which encourages people to engage in moral labor. These manipulated spaces are designed to elicit emotional energy, which consequently defines the value of a given desire object: the more emotional energy generated, the greater the value of the desire object. Importantly, while the emotional energy generated by a desire object in a public setting is less intense than that generated in a private setting, a greater amount of energy is accumulated across the hundreds and thousands of visitors to a memorial site. Here, the value of a desire object is directly connected to the plurality and synchronization of emotional energy generated through the moral labor of visitors. Thus, the value of a desire object increases as the collective emotional energy generated by the object grows.

Desire objects as evocative objects are closely linked to our memories and how we filter, process, and reconstruct them.[18] The model I use here gives us some idea as to why some desire objects are better suited to engaging us in moral labor than others and consequently to being transformed into symbols. The link between moral labor and symbols, however, is not straightforward.

My core argument here is that the more a desire object is linked not only to a specific event but also to an array of similar events across various geopolitical settings, the greater their symbolic potential. In Collins's view, symbols capable of the successful emotional coordination of mutually synchronized feelings and emotional experiences are a significant trigger for moral actions. Symbols are central features of

organized human life, helping to define perception by shaping how we view the world as well as how we understand what goes on in it.[19] For example, the crushed helmet belonging to the FDNY Squad 18 firefighter David Halderman who lost his life on September 11, 2001, which is on display at the National September 11 Memorial & Museum in New York City, can take us back instantly to the chaos and catastrophe of that terrorist attack.[20] By highlighting one firefighter's story, this single object allows us to connect with relative ease to the destinies of other firefighters in particular and first responders in general. Through this one object, we can also relate emotionally to all the victims and survivors of the September 11 attack on the Twin Towers. However, the specificity of the event and our acquired knowledge of it actually prevent us from broadening the scope of our emotional charge. While Halderman's helmet provides a clear associative link to the entire event of the terrorist attacks on the World Trade Center, it is less able to generate emotion regarding other terrorist attacks or other types of mass atrocities.

Similarly, seeing a small pink Sarah Kay toy suitcase on display at the War Childhood Museum in Sarajevo is likely to be a sentimental and heartbreaking moment for most. Seeing this and other such objects, accompanied by stories and photos describing the experiences of the children affected by the Bosnian War, most of us are likely to immediately be transported to our own childhoods and to contemplate what it would be like if we or our loved ones were faced with a situation similar to that experienced by the Bosnian children. This is how moral labor works: it encourages us to align our emotional energy with that of the narrative of the environment—an environment created for the purpose of encouraging moral labor. As with David Halderman's helmet, the Sarah Kay toy suitcase could subsume other toys marking the loss of childhood and resonate emotionally with the experience of children in other wars, it has a limited set of associations. Some will not be familiar with Sarah Kay. For others,

the suitcase will not be recognizable as a children's toy. Some will not relate to its gendered form.

Since our understanding of objects in general is influenced by our cultural and societal backgrounds, is that not also the case with desire objects? The answer is both yes and no. Yes, all objects are unique, thus making them more culturally and socially impactful to some and less to others. Even in highly staged environments such as museums, some people will pick up more contextual clues than others, meaning that the emotional energy charge of a given desire object can vary significantly across visitors.

But the "no" part of the answer is more intriguing here. What makes some desire objects stand out among many others? The litmus test is as follows: if you were to see an image of a desire object without any explanation provided, would you know instantly what it represents? If the answer is yes, we are talking about an object that we can regard as a symbol. This hypothesis can easily be put to the test: if you saw a photo of the Sarah Key toy suitcase just as it appears in the Sarajevo Children's Museum, slightly bent out of shape and stained, but on a neutral background and without any accompanying explanation, would you be able to link it to the experience of children during the siege of Sarajevo from 1992 to 1996? Most likely not. If you are not provided with contextual "crutches," it is unlikely that you would be able to connect an object with its event. Consequently, viewing only an image of a desire object is not likely to result in an intense emotional response. When viewed out of context and only as an image, a bloody t-shirt discovered in a mass grave could be associated with a number of possible scenarios—a crime scene, a car crash, a workplace injury—and a wide range of events. In other words, in a staged environment, desire objects can function as signifiers as the form that sign takes (rather than symbols, as a type of sign that has a specific meaning within a particular context or culture) of a given event, but once displaced, they go back to being just "stuff."

The public display of desire objects has one main function: to provoke an emotional and cognitive response that can be linked to an ideological message. Desire objects are there to educate us in some way by linking the "lessons" of a past atrocity to the apparent "needs" of the present (what we need to learn from the event) and a particular vision of the future (how to achieve a particular moral vision). Hence, the work of moral labor, and how it assumes a symbolic value when in relation to desire objects, requires an understanding of the ideological framework through which desire objects operate. And although desire objects tell us about past events, their main purpose is forward looking.

CONCLUSION

Distinguishing between the biographies and potential agency of desire objects and between the emotional labor and moral labor they ignite in people is crucial for understanding human–object relations. While all desire objects start their new life at the moment of their rediscovery, only a few will come to generate meaningful political action. For most, their biographical trajectories will at some point reach the limit of their potential to generate emotional energy and thus will not gain the agency needed to translate emotional energy into political action. But what kind of political action can those few, more powerful desire objects initiate? To answer this question, we must look at the trajectories of desire objects from their rediscovery to entering a particular ideological pathway. In the next chapter, I will contextualize the ideological "noise" that defines the meaning of desire objects.

3

IDEOLOGICAL COATINGS

Human Rights and Nationalism

Ideological worldviews are embedded directly or indirectly in all three societal circuits in which desire objects circulate: rediscovery, private homes, and public display. These background ideologies shape the meanings that people allocate to their encounters with desire objects. Throughout their journeys—from the moment of their rediscovery to their placement in forensic or court storage spaces, to their possible transition into the private homes of family members of the killed or missing, to their potential public display in museums and other sites that commemorate victims of atrocities—desire objects are used to promote particular ideological worldviews. Desire objects are equally important for two competing forms of remembrance: one in which they serve nationalism and another in which they serve human rights.

On one hand, the main foundation of human rights is their alleged universalism, meaning that human rights are moral principles meant to apply to all people equally across the globe, regardless of historical, political, or cultural contexts. Nationalism, on the other hand, is an ideology grounded in beliefs and practices that understand the nation as the most important unit of political legitimacy and collective solidarity. Thus, the most basic difference between human rights and nationalism is that human rights stand for the worldwide inclusion of all people in one moral community, whereas nationalism presumes

nationally bounded collectives.[1] Consequently, although human rights and nationalism offer competing visions when it comes to commemorating past events, it is true that "actors professing different ideologies can use 'human rights' as a tool to achieve their contrary aims."[2]

CONTEXTUALIZING IDEOLOGIES AND MEMORY

Since the late eighteenth century, national memory has been largely regarded as an internal matter for nation-states. However, the past several decades have witnessed a growing global trend supporting the idea that societies must inevitably address their troubled pasts to prevent the reoccurrence of violence and to promote democratic and human rights values. It has been argued that memorialization has become "a critical element in current struggles for human rights and democracy."[3] The term *memorialization* covers a range of initiatives that aim "to preserve the memory of past abuses for present and future generations, by such means as monuments, museums, commemorative ceremonies, and rituals."[4] Attempts at the level of the world polity to find and implement appropriate policies and modes of memorialization for societies involved in significant human rights abuses from the time of World War II onward have given birth to myriad approaches that promise to secure a sustainable peace and a gradual transition to democracy. The global human rights memorialization agenda, promoted through various institutions, policies, discourses, and practices, is closely connected with and gains its power and legitimacy from the transnational human rights regime. Approaches such as peace building, transitional justice, and conflict transformation, management, resolution, and reconciliation are broadly speaking the offspring of the presumption by the human rights agenda (or regime) that the implementation of human rights values and norms is a condition for the proper memorialization of

atrocities.[5] Such approaches are implemented under the assumption that a proper, morally driven memorialization can direct nationalistic realities in conflict-ridden and post-conflict societies toward a nonviolent course, placing them on a safe path to a brighter, democratic future. Memorialization efforts have become core issues in the quest for post-conflict justice, peace, and reconciliation, gaining in significance and becoming an inseparable part of any human rights agenda.

How we understand historical injustice around the world today is shaped predominantly by human rights memorialization standards, referred to here as *moral remembrance*, which over the years have adopted three main principles: (1) the necessity to collectively face a troubled past; (2) a collective duty to remember human rights abuses; and (3) a victim-centered approach that puts victims at the heart of memorialization efforts.[6] Though all three principles have very different sociological-historical trajectories and are rooted in distinct ethical and philosophical ideals, they have become the three pillars of the human rights memorialization agenda. In fact, the emergence of moral remembrance and its wide promotion via human rights bodies and advocates have shaped our current understanding of the "proper" way to remember atrocities and massive human rights abuses. Moral remembrance is the outcome of the accumulative, historical-sociological process of standardizing memorialization practices sponsored by human rights.[7]

Over the past four decades or so, a defining feature of the international human rights movement has become a concern for the suffering of specific others in distant lands—an agenda that to some extent displaces earlier, nation-specific struggles, even in those nations.[8] To this end, certain historical and social conditions had to be present to bring about the rise of the moral state of compassion, defined by Natan Sznaider as an active moral demand to address the suffering of others.[9] The moral demand to act in order to lessen the suffering of others, across spatial and temporal dimensions, became possible only at the intersection between "humanitarianism" and the

emergence of liberal society with its distinctive features of capitalism (the market) and democracy (civic equality and citizenship).[10] On one hand, through democratization and the blurring of profoundly categorical and corporate social distinctions, compassion has become more widespread. On the other, by widening the scope of exchange, the emergence of the market society has unintentionally extended the public scope of compassion.[11] Further, through memories of human rights abuses and their institutionalization in international conventions, cruelty has become understood as the "infliction of unwarranted suffering," and compassion, a public response to such evil, has been transformed into an organized campaign to reduce the suffering of strangers.[12] As a result, the human rights memorialization agenda, which incorporates a deep sensitivity for human suffering, has promoted and advanced abstraction for the sake of universalism: every person is endowed with the same set of basic rights, and, because of this, the suffering of others, no matter where or who they are, becomes "our" moral and political concern. The questions of whose suffering counts and whose suffering is valued and why are not straightforward but instead must be understood in the context of changing and competing ideological landscapes, primarily between those of human rights and nationalism. The discursive shift—from commemorating heroic sacrifices to acknowledging massive human rights abuses and human suffering—that began with the end of World War II has thus defined the focus of what the "proper way of remembrance" is.[13] For example, since the end of the Second World War, the Holocaust has become understood as a prime educational project and governmentality of human rights.[14] With the strengthening of human rights ideological worldviews at the global polity level, nation-state-sponsored memorialization practices or "national memory"—enforced through commemorations, monuments, national calendars, history textbooks, and national museums—has had to adapt to align with the growing international demand to implement moral remembrance, that is, the human rights memorialization agenda.[15]

It is this change in discourse—from commemorating heroic sacrifices to remembering victims and their suffering—that has resulted in vast changes not only in how victims of atrocities and their suffering are perceived but also in how they are recognized and valued in public spaces. The growing significance of the representation of victims in public spaces, as a marker of the establishment of human rights norms and values, means that victims have gained new value and appreciation, which is promoted through transitional justice mechanisms, established in the early 1990s, and via memorialization practices, such as the erection of monuments, public commemorations, and museum exhibitions.

The human rights memorialization agenda is in stark contrast to "the state-sponsored memory of a national past" or "national memory."[16] For nation-states, wars serve a decisive function in building the nation as a "sacred community of sacrifice," strengthening the connection between the nation and the notion of it as a "homeland." According to John Hutchinson, "The creation of war myths serves multiple functions including the creation of meaning out of suffering."[17] War-related practices are intended to valorize and promote what is considered a nationally suitable narrative in such a way as to justify those practices historically. The legacy of war is shaped by the nation-state, which exercises its power to recognize, commemorate, and incorporate only certain memories of the war within its national narrative while others are officially marginalized or forgotten. Hence, the main purpose of the nationalist project is to use a particular view of the past to reinforce the patriotic boundaries of a nation.

IDEOLOGICAL WORLDVIEWS AND THE BIOGRAPHIES OF DESIRE OBJECTS

Though my research started as an attempt to embrace a bottom-up approach, it soon became clear to me that throughout all stages of a

desire object's journey, its movement is deeply influenced by the ideological frameworks in place, both human rights–driven and nationalistic. These ideological frameworks also direct the trajectories of desire objects and set them on a course for ideological usage. Though at times the "ideological coatings" of desire objects may seem invisible or even nonexistent, they are of vast importance when it comes to how people allocate meanings to the objects and engage with them in moral labor.

The first societal circuit, in which desire objects are discovered at a site of atrocity and are transported to forensic facilities or courts of justice, is not an environment free of an ideological footprint—despite the medical, scientific, and legal procedures to which the objects will be subjected. In fact, humanitarian forensics, forensic anthropology, and forensic archaeology are supplementary projects of the human rights memorialization agenda. Locating, exhuming, and identifying human remains associated with acts of mass violence and genocide have come to occupy an important role in the panoply of transitional justice measures.[18] What is known as a "forensic turn" or "forensic humanitarianism" plays a critical role in bringing about justice and addressing human suffering.[19] Claire Moon points out that with "the practice of forensic humanitarianism, we can argue that the dead, now, can be understood to have human rights."[20]

The development of humanitarian forensics had its early beginnings in April 1943 with Germany's request to establish an investigative team of forensic pathologists to investigate the Katyn Forest Massacre of some twenty-two thousand Polish nationals during the Soviet occupation of Eastern Poland, mostly prisoners of war from the September Campaign, including Polish Army officers, members of the intelligentsia, civil servants, priests, police officers, and many other professionals.[21] The exhumation and examination of the bodies of the victims of the Katyn massacre in World War II represented the first comprehensive use of forensic pathology and scientific techniques to evaluate mass killings in wartime. However, the field of humanitarian

forensics was established in earnest with the creation of a forensic anthropology–focused nongovernmental organization in the aftermath of the regime that ruled Argentina between 1976 and 1983 to investigate the whereabouts of the "disappeared." In the mid-1980s, the Argentine Forensic Anthropology Team began to use forensic anthropology techniques to find and identify the bodies of some of the thousands of victims of the regime.[22] Those efforts became fully recognized by international humanitarian law and human rights law, which framed those actions as "rights": the rights to know the fate of one's relatives, to account for people reported missing as a result of armed conflict, to respect for family life, and to identify the dead before disposing of their remains.[23] Though the universal right to be identified after death is a relatively recent development, recognized in 1996 by Interpol's General Assembly, the development of humanitarian forensics over the past forty years has shaped and provided survivors and victims' families with a new vocabulary to frame their grievances in form of rights.[24]

Hence, the role that forensics play in the aftermath of atrocities is deeply engraved in the notions of moral remembrance, particularly the notion of "justice for victims." The evidence of such ideological practices stretches from Bosnia to Guatemala, Spain, and Rwanda, as well as various locations of terrorist attacks around the world.[25]

A similar proliferation of human rights–based ideological thinking can be seen in the rise of legal mechanisms meant to cement the principles of truth-seeking, accountability, and the justice-for-victims agenda. The Second World War, and in particular the Holocaust, led to a wide range of normative and institutional changes that focused primarily on preventing human suffering as a result of war and political persecution and took memory for granted. The importance of memory surfaced only gradually in the years afterward. In 1945 and 1946, some of those responsible for crimes committed during the Holocaust were brought to trial in Nuremberg, Germany. The Nuremberg trials resulted in twelve prominent Nazis being sentenced

to death; however, others who played key roles in the Holocaust, including high-level government officials and business executives who used concentration camp inmates for forced labor, received only short prison sentences or no punishment at all. The International Military Tribunal for the Far East (also known as the Tokyo Trials), a military trial convened in 1946, tried twenty-eight Japanese military and political leaders for "Class A" crimes including waging aggressive war and committing conventional war crimes. More than 5,700 lower-ranked personnel were also charged with conventional war crimes in trials convened by Australia, China, France, the Netherlands, the Philippines, the United Kingdom, and the United States. China held thirteen tribunals, resulting in 504 convictions and 149 executions. Poland (which held its most famous national postwar trial in 1947 in Krakow), the former Czechoslovakia, the former Soviet Union, Hungary, Romania, and France, among others, have also tried thousands of defendants—both Germans and indigenous collaborators—in the decades since 1945. The Soviet Union held its first trial of local collaborators, the Krasnodar Trial, in 1943, before World War II had ended. In Israel, after the introduction of the testimonies of hundreds of witnesses, Adolf Eichmann was found guilty of war crimes and crimes against humanity and executed in 1962.

These trials resulted in the establishment of permanent infrastructures such as the International Court of Justice (in 1945), the principal judicial organ of the United Nations, later to be followed by three principal regional human rights instruments: the European Convention on Human Rights (1953), the American Convention on Human Rights (1969), and the African Charter on Human and Peoples' Rights (1979), all of which provided a wider infrastructure to frame past human rights abuses in legal terms. Further, in 1948, as the immediate effects of the post–World War II experience were felt around the world, the UN established the Convention on the Prevention and Punishment of the Crime of Genocide, in which genocide

was for the first time recognized as a crime under international law. Regardless of whether states have ratified the Genocide Convention, they are all become bound as a matter of law by the principle that genocide is a crime prohibited under international law. Hence, the International Criminal Tribunal for the Former Yugoslavia, the International Criminal Tribunal for Rwanda, and the Khmer Rouge Tribunal, among others, at which personal items were used as evidence and as a tool to identify victims, followed the logic established by the human rights regime.[26]

Of course, the establishment of such tribunals does not mean that DNA matching and prosecutions are solely the undertakings of transnational institutions and teams that promote human rights. On the contrary, these efforts are often supported by national governments. However, more than being interested in truth-finding, national governments tend to use these procedures to reframe nationhood, often through notions of victimhood and suffering. In fact, the excavation of mass graves and DNA identification are simultaneously projects for redefining nationhood and national identities of inclusion and exclusion. Just as in the cases of Bosnia and Lebanon, nation-states reinvigorate national boundaries by placing a narrative of suffering at the heart of the nationalist project.[27]

Both forensic excavations and court hearings determine the trajectory of desire objects. And the context in which these events take place, including the underlying ideological structures, also dictate the nature of the relationship between desire objects and those who encounter them. By incorporating them and ascribing them a central role in the effort to embrace principles of truth-telling, accountability, and the justice-for-victims agenda, desire objects gain value and are consequently set in motion. At this stage, their value is determined by their perceived quality: Are they in a good enough condition to help family members identify their loved ones? Do the objects provide evidence of violence that can help shed light on the event itself?

HUMAN RIGHTS INTERRUPTED: LURKING NATIONALISM

At any stage in its trajectory, a desire object can be discarded as useless.[28] However, at times, and in numerous expected and less expected ways, desire objects are returned to the families of the deceased or missing. Once they enter the homes of family members, private spaces become the loci of emotions. After an excruciating waiting period, whether several days or many years, the "evocative power of artefacts and their ability to symbolise the missing and the dead beyond all other evidence" generates heightened emotions.[29] For family members, desire objects represent a direct link between life and death: between the memories of the life of their loved one and the blatant act of violence that ended that life. Desire objects become precious possessions—but ones that are often also unbearable to keep. While private spaces are never ideologically neutral, in the early stages of grief following the return of a desire object, family members' homes primarily serve as emotional containers. However, though human remains and personal items are discovered through well-established human rights–supported forensic practices, numerous less seen and less debated issues emphasize the importance of community and nation over the individual. Family members face multiple dilemmas with no straight answer. How many bones are "enough" to bury a person? What happens if more bones are discovered after a burial? How much time must pass before a missing person is proclaimed dead? Can missing people whose bones have not been found be buried?[30] What happens when taking a garment from bodily remains is against religious traditions (as, for example, in Islam)? Should personal items found with bodily remains be buried with the remains? No one prepares survivors for such questions, and yet they must be answered.

Communal thinking takes place in various stages of grief. To start with, families of the killed and missing are naturally drawn to one other since it is easier to share their pain with those who share the

same experience. In addition, while the identification of individual victims is the primary purpose of personal items found at sites of atrocity, these objects also enable personal identification for legal purposes, which can further support the prosecution's evidence of the victims' collective identity.[31] For example, religious objects found with human remains clearly situate an individual within their religious or ethnic context, immediately ascribing them a particular collective identity.

Having said that, the most profound reason for the families of the killed and missing to come together in the wake of an atrocity is to share the burden of the unimaginable difficulties they face during the process of recovering remains. While families might want to commemorate their loved ones, it is likely that they will often hope to do so in ways that conform to practices that identify those individuals as members of a specific collectivity. Individuals and communities must reconcile their desire for a proper burial of their loved ones with the return of (usually partial) remains and identities through consecrated funerals.[32] To do so, they are forced to engage in what Tsipy Ivry and Elly Teman refer to as "shouldering moral responsibility through outsourcing," meaning turning to religious, political, or community leaders for guidance.[33] This division of labor is used as a strategy to both take on moral responsibility and liberate consultees from moral burdens.[34] In other words, families are seeking an authority to ease the decision of how to handle their loved ones' remains and personal items. Making this decision is key to homogenizing collective identities; and although this process is not intended to be political, it often is when religious and political leaders are involved.[35] The process through which political and religious authority is established and moral responsibilities are divided and outsourced to the appointed authorities is essential for reimagining a nation. By dividing moral responsibility for the hard decisions that must be made in the face of post-atrocity realities, and consequently for pain and grief, new boundaries for collectivities are forged. By ascribing religious, ethnic,

and national identities postmortem, the reinvention of a nation and nationhood takes place.[36] Sentiments of victimhood and suffering are given new life by "becoming part of"—when broken communities are reassembled for the sake of reimagining a nation.

Thus, personal items found at sites of atrocity become an extension of such reasoning. Although their value is first and foremost an emotional one for the affected families, they already carry ideological grains of intention. But before we see how people justify donating personal objects to museums, we should take a good look at why donating desire objects became so appealing and how doing so set the stage for their ideological appropriation.

THE EMERGENCE OF THE MUSEUM GENRE: FROM PRIVATE TO PUBLIC DISPLAY

To understand the movement of desire objects from the private to the public realm and consequently the change in their value, we need to understand how the emergence of the "museum genre" transformed how wars—and subsequently suffering, atrocities, and large-scale human rights abuses—are understood. Over the last century or so, museums have managed to position themselves as both the gatekeepers of memory and educators capable of reaching large audiences. With the development of the human rights memorialization agenda and the wide implementation of its three main pillars—"facing the past," "duty to remember," and "justice for victims"—museums significantly changed the way they addressed and incorporated broad issues of social justice and began to promote the realization of human rights. Their focus shifted to human rights issues relating to suffering, war, genocide, slavery, religion, and civil rights, as well as peace, memory, reconciliation, and tolerance. This new "museology," which emerged in the late 1980s, reflects a greater awareness of the social and political role that museums can play. It has allowed them not only

to raise awareness of issues faced by communities but also to intervene to reclaim or safeguard universal human rights.[37]

This human rights focus is in stark contrast to the central role that museums played in the eighteenth and nineteenth centuries and much of the twentieth century, when their prime function was to celebrate and homogenize the heroic past of a nation. Historically, museums emerged from private collections—both as a desire to advance educational exploration and as a display of wealth and power. The first corporate body to receive a private collection, erect a building to house it, and make it publicly available—generally considered the first museum—was the University of Oxford. This collection, which contained much of the Tradescant collection of natural and artificial rarities, came from Elias Ashmole, a royalist, lawyer, antiquarian, scholar, and collector, with the aim of advancing knowledge of the natural world. His donation was conditional on the request that a place be built to receive it, later known as the Ashmolean Museum, which opened in 1683. The Ashmolean became widely recognized as the first modern museum and housed displays of natural objects brought back from the sixteenth- and seventeenth-century voyages of discovery, placed in "cabinets of curiosities," and shown to the wealthy classes. The cabinet displays were designed to awe the viewers and glorify conquerors and their sponsors.

The following two centuries in Europe and beyond saw the opening of many such spaces to the public, first only to the aristocracy but gradually to a much broader audience. The eighteenth century witnessed the Enlightenment and the emergence of the encyclopedic spirit, as well as a growing taste for the exotic.[38] The impetus for opening these collections to the public came from the growth of the urban commercial societies of Holland and England, where, during the Scientific Revolution, Puritan reformers strove to improve trading, agriculture, and medicine. The landed gentry collected plants, animals, and minerals, as well as archaeological artifacts, coins, prints, and sculptures.[39] Such assemblages denoted wealth, order, and

intellect and, insofar as they commanded respect, helped naturalize the social order.[40]

Many museums were established in the mid-eighteenth century. For example, the Capitoline Museum was opened to the public in 1734, and the Palazzo dei Conservatori was converted to a picture gallery in 1749. The Pio-Clementino Museum, now part of the museum complex in Vatican City, opened in 1772. In 1773, in the United States, the first of its kind opened—the Charleston Library Society of South Carolina—followed by the Peale Museum in 1786 in Philadelphia. On the other side of the world, in Jakarta, Indonesia, the collection at the Batavia Society of Arts and Science was established in 1778, and in Calcutta, the Indian Museum opened in 1784. The British Museum in London opened its doors to the public in 1759, the Prado Museum in Madrid in 1785, and the Louvre in Paris in 1793.

The emergence of national museums across the globe was closely connected to the rise of nation-states, and the nineteenth century continued this trend. In 1807, the National Assembly of Hungary founded a national museum at Pest. The Museum of Northern Antiquities was opened in Copenhagen in 1819. The Moravian Museum in Brno opened in 1817, and others followed at Zagreb and Ljubljana in 1821. The national archaeological museum in Greece was opened on the island of Aegina in 1829. In 1812, in South America, the Argentine Museum of Natural Sciences was founded in Buenos Aires; in 1818, Brazil's National Museum opened in Rio de Janeiro; and national museums of natural history opened in Santiago, Chile, in 1839 and in Montevideo, Uruguay, in 1837. In South Africa, a museum based on the zoological collection of Sir Andrew Smith was founded in Cape Town in 1825. In Prussia, Friedrich Wilhelm III opened his private collection to the public in Berlin in 1830. In St. Petersburg in 1852, Nicholas I made the major collection of the Russian czars available to the public. The Royal Museums in Brussels, established by royal decree, opened in 1835. The famous Smithsonian Institution in Washington, DC, was inaugurated in 1846, followed by the opening of the

U.S. National Museum in 1858 as part of the Smithsonian's scientific program. The National Museum of Canada opened in 1843 in Montreal, and, in Toronto, the Ontario Provincial Museum was founded in 1855. In New York City, the American Museum of Natural History was founded in 1869, and the Metropolitan Museum of Art opened in 1870. In Cairo, the Egyptian Museum was established in 1858. The national museum of Poland opened in 1862. The National Museum of Denmark opened in 1892. The National Museum of Ceylon (now Sri Lanka) opened to the public in 1877, and the Sarawak Museum in Malaysia opened in 1891. The same year saw the opening of the Geological Museum in Lima, Peru, and, in 1895, the Geological Museum was founded in São Paulo, Brazil. In the following years, two regional museums opened in Argentina: one in Córdoba (1887), and one in Gualeguaychu (1898). Some years earlier, museums had opened in Ecuador (1862), Brazil (1876), and Chile (1882). During the second half of the nineteenth century, and largely because of the free education movement and the gradual development of nation-state infrastructures, museums in Europe began to flourish: about one hundred opened in Britain in the fifteen years leading up to 1887, while fifty were established in Germany between 1876 and 1880. This increase in the number of museums was not, however, a peculiarity of Europe and North America.[41] On the African continent, museums were founded early in the twentieth century. Zimbabwe's national museums at Bulawayo and Harare were founded in 1901; the Uganda Museum opened in 1908 with collections assembled by the British District Commissioners; and the National Museum of Kenya was opened in Nairobi in 1909. Mozambique's first museum, the Alvaro de Castro Natural History Museum in Maputo, was founded in 1913.[42]

I have provided this seemingly extensive yet very selective and dull list of museums to emphasize how many parallel but connected social processes, including the rise of nation-states, increasing literacy, the development of transportation and educational systems, the desire to widen our collective scientific knowledge, and an expanding interest

in "others," contributed to the boom of the museum genre. Despite their large numbers, the museums founded during the eighteenth and nineteenth centuries were highly selective, displaying specific types of collections such as artworks, natural science artifacts, archaeological findings, artifacts and specimens from the colonies, or items relating to royalty or wealthy families. Also during the eighteenth century, displays known as "cabinets of curiosities" gave way to different types of collections prized for their comprehensiveness, such as ranges of plants and animals. At this time, museums were also transforming into "sites of glory and podiums of state achievements."[43] Their purpose was to collect, preserve, interpret, and display objects of artistic, cultural, or scientific significance for the education of the public. During the first half of the nineteenth century, however, a number of museums of a more clearly anthropological character were established, or evolved out of previous collections, along several different lines. In the nineteenth century, museums, together with national calendars, gradually transformed into instruments of republican citizenship and social management, engineering national unity and cultural homogeneity, encouraging active political participation, and acting as a strong invitation to commemorate and remember heroes and victims.[44]

By the early twentieth century, particularly after World War I, national museums became more selective, focusing on the "national past," glorifying war achievements and justifying sacrifices and lives lost. The first such museum, which would serve as an example to many others that followed, was the Imperial War Museum, founded in 1917. This organization of British national museums, with branches at five locations in England, three of which are in London, was intended to record the civil and military war effort and the sacrifice of Britain and its empire during the First World War, though it has expanded to address all conflicts in which British or Commonwealth forces have been involved since 1914. Wars are directly connected to death, destruction, and suffering; hence, war museums, memorials, and other sites of commemoration became the main tools of the

meaning-making processes of nation building and national homogenization.[45] Although wars are in essence extraordinary, traumatic experiences permeated with extreme emotions and actions, they possess a decisive function in building an image of a nation as a "sacred community of sacrifice."[46] Both at the individual and group levels, war generates a wide range of emotional responses, including "sorrow, sacrifice, shame, pain, pride, suffering, victory, loss and genuine confusion about patriotism and the nation."[47] Warfare strengthens the connection between a nation and its homeland, and the creation of "war myths serve[s] multiple functions including the creation of meaning out of suffering."[48] What is more, questions regarding the moral boundaries of a nation are often posed through wars. Thus, wars serve to reclassify people and ensure continuity while signifying a group's "birth" or "origins."[49]

Whereas throughout the twentieth century, war museums became prominent in every part of the world, by the end of the century and at the beginning of the twenty-first century, with the establishment and global spread of the human rights memorialization agenda, new types of museums emerged. It was the popularity of museums as a genre that led to their becoming institutions serving various purposes, such as providing education on a wide variety of topics and serving as sites of commemoration and glorification of a nation but also as an inseparable part of a leisure culture and tourist experience. Over the past four decades, they have also become advocates of the human rights memorialization agenda. The strengthening of human rights ideologies at the global level, the widening of the scope of compassion in relation to the suffering of others beyond the nation-state, and demands for nation-states to face a contested past and take on the duty to remember it and focus on victims have all brought to the fore a new approach to remembering and teaching about the past.

Paul Williams and Amy Sodaro have described the emergence of the new museum genre of memorial museums, defining them as "focused on past violence, atrocity, and human rights abuses (that)

reflect a demand today that those darkest days in human history are not only preserved but interpreted in a way that is widely accessible to present and future audiences."[50] Whether such museums are intended to act as custodians of an evolving human rights culture or as memorial, commemorative, or activist frameworks to examine human rights transgressions, they aim to engage significantly in the political and social landscape of human rights.[51] The rise of memorial museums, whose main purpose is to advance human rights causes, was primarily a reaction to the perceived efficacy of museums to convey messages to wide audiences. The rationale for placing the "facing the past," "duty to remember," and "justice for victims" approach at the heart of addressing human rights abuses and post-conflict processes was based on the assumption that working through the past is necessary for healing, forgiveness, and reconciliation—the same principles adopted by the new memorial museums.[52]

The process of adopting these three pillars into the human rights memorialization agenda coincided with the globalization of Holocaust remembrance. Holocaust remembrance, as one of the key templates within the human rights and moral remembrance toolkit, has been enforced over the past three decades through various mechanisms and has been globally accepted as an important measurement for the appreciation of human rights. In the European context in particular, a process known as the "Europeanization of the Holocaust" was meant to serve as a means of unifying Europe's past. For countries in the European Union, memory of the Holocaust became an important bond in the attempt to forge a more homogenized European identity. The Europeanization of the memory of the Holocaust is promoted by transnational agents such as the European Parliament, the Council of Europe, the Organization for Security and Co-operation in Europe and its Office for Democratic Institutions and Human Rights, the United Nations, and, most significantly, the International Holocaust Remembrance Alliance, an intergovernmental organization that brings governments and experts together

to promote Holocaust education, research, and remembrance worldwide.[53] In the United States from the 1960s to the 1980s, Holocaust remembrance was shaped by the emergence of ethnic identity politics; the 1978 broadcast of the television miniseries *Holocaust*, a major turning point in the media's representation of the Holocaust; the "Americanization" of the Holocaust; and Claude Lanzmann's 1985 documentary *Shoah*. Consequently, memories of the Holocaust came to be regarded as unique when referring to the past and universal for the future.[54] However, beginning in the 1990s with the crystallization of the human rights memorialization agenda and the strengthening of human rights movements, the discourse around the Holocaust and the discourse around human rights no longer stood in opposition to each other.[55] In fact, they became almost synonymous.

Of course, these advances in Holocaust remembrance do not imply that Holocaust museums did not exist before. In fact, the first such institution, the Ghetto Fighters' House outside Acre, Israel, was founded by Holocaust survivors in 1949. A second museum, Yad Vashem, was founded in Jerusalem in 1953 as the world center for Jewish Holocaust remembrance.[56] And in Europe, several historical sites were restored and preserved in the years following World War II. The Auschwitz-Birkenau State Museum, located outside the town of Oświęcim, Poland, was created by former prisoners of the notorious camp. When it opened in 1947, visitors could for the first time see the gas chambers, burning pits, and crematoriums used to murder hundreds of thousands of people. In the same year, the Terezín Memorial opened in Czechoslovakia (now the Czech Republic) on the site of the former Theresienstadt concentration camp. The Buchenwald Memorial, the Sachsenhausen National Memorial, and the Dachau Concentration Camp and Memorial Site were opened in Germany between 1958 and 1965. The Amsterdam home where Anne Frank and her family hid for two years during the German occupation of the Netherlands was opened as a museum in 1960. In the United States, the Los Angeles Museum of the Holocaust—the first such American

institution—was founded by a group of survivors who had met in a class to learn English as a second language in Hollywood in 1961. In the 1970s and 1980s, further museums were founded in El Paso, Texas; Farmington Hills, Michigan; San Francisco, California; and Buffalo, New York; as well as in Montreal, Canada; and Melbourne, Australia.

However, only since the late 1990s and with the increased belief in moral remembrance as a "proper" way to commemorate past human rights atrocities, along with the promotion and protection of human rights, have Holocaust museums started to thrive and expand globally. In the 1990s, as the fifty-year anniversary of the end of the Holocaust approached, renewed interest was expressed in establishing institutions to memorialize, research, and educate. Around the world, several new Holocaust museums were founded, including the Fundación Memoria del Holocausto in Buenos Aires (1993); the United States Holocaust Memorial Museum in Washington, DC (1993); the Cape Town Holocaust & Genocide Centre in South Africa (1999); and the Holocaust Education Center in Fukuyama, Japan (1995). The Budapest Holocaust Memorial Center opened in 2002, and the Illinois Holocaust Museum and Education Center opened in 2009. However, until the 1990s, Holocaust museums were limited to remembering and commemorating one particular historical period and were often deeply immersed in the process of nation rebuilding. Only once the Holocaust became perceived as a universal template, through which other genocides and large-scale human rights abuses could be understood and remembered, did Holocaust remembrance and Holocaust museums become a necessary element in claiming, promoting, and defending human rights.

The evidence for the Holocaust becoming a universal template for other similar atrocities is the fact that, by the end of the second decade of the twenty-first century, Holocaust remembrance had become important around the world, including in places that historically had never been considered involved in the Holocaust experience. Though Holocaust museums had already been established in

numerous places, with the opening of the United States Holocaust Memorial Museum in April 1993, and in particular with the establishment of the International Holocaust Remembrance Alliance in 1998, the Holocaust became a unit of moral measurement in relation to human rights violations.[57] The Holocaust became a reference point for the "moral community of shared memories," which resulted in the opening of dozens of Holocaust memorial museums not only in Europe but also in distant places such as Argentina, China, Hong Kong, South Africa, and Uruguay.[58] Efforts to establish Holocaust remembrance as a meta-narrative of human rights efforts are apparent in the 2005 UN General Assembly's adoption of International Holocaust Remembrance Day, an international day of memorial on January 27 commemorating Holocaust victims. The significance of Holocaust remembrance is best illustrated by the fact that, by 2013, the Association of Holocaust Organizations, whose purpose is to advance Holocaust education, remembrance, and research, included more than three hundred organizations across thirty-three countries.[59] In 2020, despite the COVID-19 pandemic, Holocaust remembrance activities continued to grow. Countries that engaged in such activities include Austria, Belgium, Bosnia and Herzegovina, Brazil, Croatia, Colombia, the Democratic Republic of the Congo, Ghana, India, Kenya, Madagascar, Mexico, Myanmar, Nigeria, Panama, Paraguay, the Russian Federation, Senegal, Serbia, Switzerland, Tanzania, Trinidad and Tobago, and Zambia.[60]

By adopting Holocaust remembrance as a template for commemorating atrocities and historical injustices across the globe, human rights institutions have brought legitimacy to highlighting historical injustices across the globe. As Holocaust remembrance functions as a model, paradigm, or measure of representing other atrocities, it has also become a mechanism of enforcement: embracing Holocaust remembrance became a policy that must be followed (at least officially), and, for the European Union it is also an expected requirement (yet not grounded in policies) for joining the European free market.[61]

International human rights bodies often expect countries to adopt and promote Holocaust memorialization standards to foster democracy and human rights in general and minority rights in particular. Further, as Aleida Assmann has suggested, the Holocaust has become the template through which other genocides and historical traumas are often perceived or presented and the very foundation of globally promoted moral remembrance.[62] Holocaust remembrance has not replaced the memories of other atrocities but rather has provided a language for their articulation and a wider context that enables the reframing of selective fragments of the past.[63] In this way, it has suited many groups to use Holocaust-enabled language to frame and promote their own victimization while also sketching national boundaries of inclusion and exclusion.

Toward the end of the 1990s, as an extension of Holocaust remembrance as a measurement of human rights norms and values, many museums commemorating genocide and massive human rights abuses began to emerge. All focused on a particular historical event but were very much future oriented, creating their messages around reconciliation, peace building, and the promotion of human rights norms. In 2004, on the tenth anniversary of the genocide that tore Rwanda apart, the Kigali Genocide Memorial was inaugurated. This memorial site is one of six in Rwanda that commemorate the 1994 Tutsi genocide. The Museum of Memory and Human Rights in Santiago, Chile, opened in January 2010 as the national site of remembrance for and education about the dictatorship of Augusto Pinochet from 1973 to 1990. The National September 11 Memorial & Museum opened in May 2014 in New York City. In 2009, the Tuol Sleng Genocide Museum was added to the UNESCO Memory of the World Register (lists documentary heritage of world significance and outstanding universal value). The museum was established in 1995 through Yale University's Cambodian Genocide Program to research and document the crimes of the Khmer Rouge and became an independent organization in 1997. There, researchers have spent years translating confessions and paperwork from Tuol Sleng, mapping mass graves,

and preserving evidence of Khmer Rouge crimes. Its purpose is to engage with the country's harrowing past and establish a dialogue of social reconciliation and healing for Cambodia.

Other similar institutions include Lima's Place of Memory and Social Tolerance, Santiago's Museum of Memory and Human Rights, and Buenos Aires's Space of Memory and Human Rights. Colombia recently inaugurated its National Museum of Memory in downtown Bogotá. Budapest's *Terrorháza* ("House of Terror") opened in 2002 as a museum dedicated to telling the story of Hungary's violent twentieth century under fascist and then communist occupation and is at least declaratively dedicated to promoting human rights. The Srebrenica Memorial Center, officially known as the Srebrenica–Potočari Memorial and Cemetery for the Victims of the 1995 Genocide, was opened by the former U.S. president Bill Clinton on September 20, 2003. The War Childhood Museum, a history museum in Sarajevo, opened in January 2017. Many other museums have also been established, all with the purpose of promoting human rights and issues of social justice.[64]

To fully understand the emergence of the museum subgenre of memorial museums, we can look to the umbrella organization overseeing memorial sites, we can look to its umbrella organization, the International Coalition of Sites of Conscience, which groups memorial museums under the same ideological roof. This nonprofit organization is a global network of historic sites, museums, and memorials dedicated to promoting and protecting human rights in various regions of the world.[65] The coalition, an affiliated organization of the International Council of Museums, was founded in 1999 by Ruth Abram with a view to incorporating current social issues into museums and relating the past to the present and its human rights challenges.[66] In 2013, the coalition had more than two hundred member sites, and, by 2020, this number had grown to 250; it truly has a global spread.[67] The Global Initiative for Justice, Truth and Reconciliation, a flagship program of the coalition, is a multidisciplinary consortium of nine organizations that together serve as a new mechanism for responding in a cohesive manner to the transitional justice

needs of societies emerging from conflict or periods of authoritarian rule and those currently in conflict. Since the 2014 launch of the initiative, the coalition and the consortium have worked in forty-six countries, fostered ninety-four grassroots projects, and engaged 422 local civil society organizations in building capacity and laying the groundwork for community-wide participation in both formal and community-based transitional justice processes.[68]

Such efforts align with Williams's description of the new subgenre of memorial museums, in which *memorial* is used as "an umbrella term for anything that serves in remembrance of a person or event."[69] Sodaro suggests that memorial museums are in fact a form of historical truth-telling intended to preserve the past and serve as a record, complete with material and documentary evidence, of historical events; such sites are meant to be places of healing and restoration.[70] About memorial museums, she argues, "They are memorials and, as such, serve as symbolic reparations for the individuals, communities, and nations that were injured."[71] These museums also seek to harness the perceived power of memory to "heal" communities, promote reconciliation, and mend historical injustices. Accordingly, they span a wide variety of historical events—such as the Holocaust, genocides, slavery, and African American civil rights—as well as concepts such as peace and human rights. However, what is common to all is that they narrate and address past human rights abuses and focus on human suffering to promote human rights, healing, and reconciliation.[72] By doing so, they also situate desire objects within the normative, human rights–focused ideological point of view, which coats them with particular meanings and shapes the desires attached to them.

DONATING DESIRE OBJECTS

With the establishment of human rights memorial museums, the demand for personal items and objects associated with massive

human rights abuses grew tremendously, as did the perceived value of these objects. As mentioned, the donation and endowment of artifacts to museum collections dates back to the opening of collections to the public. But whereas at their inception, public exhibitions were mostly based on the endowments of the wealthy, by the twentieth century, museums were regularly asking for donations of artifacts of significance. In fact, many museums would not have existed without responses to such requests. Whereas early donations and endowments were typically of items of significant artistic value or value to collectors (e.g., rare books, natural history collections, archaeological artifacts), donations of single items or smaller collections of objects owned by "ordinary" people became common by the end of World War I.[73]

Desire objects, understood as objects that can be used both to glorify a nation via narratives of sacrifice and victimhood and to address universal human rights concerns such as suffering and compassion, have not always been sought after, but, since the emergence of human rights–oriented museums, they now have a preassigned a discursive charge. In other words, the emergence of memorial museums created a market for desire objects. In their new role, they were immediately ascribed the potential to direct the narration of an event away from a narrow patriotic memory toward fostering justice and reconciliation. It is important to stress that the assigning of such discursive value was initially quite novel and was enabled only after the human rights memorialization agenda of moral remembrance was established and became implemented globally across a variety of institutions.

To be sure, donating personal items is not a novel phenomenon. An enormous number of personal objects were collected and donated after World War II to establish facts and provide evidence for the atrocities committed by the Nazi regime. For example, at Auschwitz-Birkenau, "there are rooms full of clothes and suitcases, toothbrushes, dentures, glasses."[74] Yet those objects, at least until the mid- to late 1990s, were not displayed to advocate for human rights; on the contrary, they were used to testify to the vast destruction of the Holocaust

and to contextualize and situate the Holocaust within their own national histories. Their purpose, as James Young pointed out in his groundbreaking study of Holocaust memorial landscapes in Austria, Germany, Poland, Israel, and the United States, greatly varied "from land to land," and, more importantly, "in every nation's memorials and museums, a different Holocaust is remembered, often to conflicting political and religious ends."[75] Though we have plenty of evidence that even today Holocaust and genocide museums are used to whitewash the national past of the countries in which they are situated, all such museums, to varying degrees and with varying success, employ a narrative of human rights.[76]

Memorial museums reflect a new approach to remembering and teaching about the past. Their focus on past violence, atrocities, and large-scale human rights abuses reflects a demand that those darkest days in human history are not only preserved but musealized and interpreted in a way that is widely accessible to present and future audiences.[77] Memorial museums follow a similar, almost isomorphic form of representation, well established at Holocaust memorial sites. They display desire objects and artifacts, often at the actual sites of atrocities, and try to create controlled spaces where audiences are able to experience for themselves the gravity of massive human rights abuses while at the same time aiming to establish a clear link with the importance of human rights today.

CONCLUSION

The movement patterns of desire objects are largely dictated by the ideological frameworks, or "coatings," in place in a given context, both those of human rights and of nationalism. Each movement follows a particular sequence and logic embedded in ideological visions of the "world as it should be" and the moral orders we should aspire to reclaim. The ideological shift from heroic national past to massive

human rights abuses and the suffering of victims has created markets in which desire objects are very much in demand. Their physicality and their unique stories are inseparable from their innate character. Desire objects are closely associated with violence and as such have the potential to generate emotional energy and shape discourses to promote particular ideological values and norms. In the following chapters, I will show how the ideological messaging ascribed to desire objects is aimed at restoring particular visions of moral orders, as well as the kinds of memories such messaging constructs.

II
THE MOVEMENT AND BIOGRAPHIES OF DESIRE OBJECTS

4

THE FIRST CIRCUIT

The Survival of Personal Objects After an Atrocity

On April 6, 1999, a refrigerated truck containing fifty corpses of Kosovo Albanians killed in Kosovo and being transported to Serbia was pulled from the Danube River near the town of Tekija, Serbia. It was immediately declared a state secret, so the public learned about it only two years later.[1] Lists of items found on and around the bodies of Albanians buried in mass graves on the training ground of the special anti-terrorist units of Serbia's Ministry of Internal Affairs include, among other things, two pacifiers, bottle openers, marbles, gold jewelry and watches, pens, rosaries, and combs. Also found were "invalid metal coins from the Socialist Federal Republic of Yugoslavia time," bracelets and pendants, handkerchiefs, mirrors, two boxes of pain killers, razors, folding knives, a transistor radio with batteries, a telephone book, penknives, buttons, shoe horns, a screwdriver, a flashlight, business cards, packs of cigarettes, a whiskey flask, membership cards for various institutions, bus tickets, and keys.[2] In the attempt to cover up the massacre committed by the Serbian forces in Kosovo, these artifacts were stored in sauerkraut barrels in the basement of the District Court in Belgrade.

A record compiled on July 4, 2001, lists the items under the headings "things found in the wardrobe next to the corpses," "objects found next to the corpses and outside the wardrobe," "objects and small pieces of clothing, as well as hair removed from corpses," and "wardrobe." The

record of September 19, 2001, describes 547 objects, including "part of a strand of hair with a rubber band," "braided hair," "pubic hair," "foot bones and two socks," "several dental prostheses," "part of a projectile found in the pelvis," "projectile found in the thorax," and "pieces of metal from the fractured area of the cervical spine."[3]

Personal items discovered at sites where mass atrocities have taken place are found in both remarkable and utterly ordinary ways. Desire objects have appeared in eerie, shadowed woods, sunny fields, riverbeds, and misty swamps. In places of utmost beauty and places that send icy shivers down one's back. They resurface in abandoned buildings such as schools, factories, homes, and other facilities used for torture, rape, imprisonment, and execution. Yet without an understanding of the context, these items can easily be overlooked and seen as just garbage. A passerby or tourist might come across such objects but take no notice of them. But sometimes, desire objects are found easily and immediately understood for what they are. This may happen by chance but is more likely to occur as a part of an intentional effort to find the missing and dead in places where mass atrocities have taken place.

Their rediscovery and salvation from further decomposition marks the beginning of their new life in movement. The value that will be ascribed to them varies significantly and is a function of their current material condition, the demand for such items, and pure luck. To start with, pure luck is needed for an object to be rediscovered and not be overlooked or destroyed in the process of excavating a site of mass atrocity. Once rediscovered, it must then be linked to the atrocity, meaning that there must be an indication that it was involved in some way with the atrocity and did not just land there accidentally. The material condition of the object is then used to determine the object's initial value and demand: some will be collected and used as court evidence, and some will be used to establish identities, but those that are poorly preserved and in an advanced stage of decay will

be disposed of. Given the length of time that passes before a site is excavated, decomposition is often well under way. Even after just one year, bodies will have significantly decomposed; in most cases, by the time of their discovery, bodily remains are completely skeletonized. This means that soft tissue evidence of damage by bullets and other weapons cannot be harnessed. As a result, determining the cause and manner of death in many cases hinges on the artifacts associated with the remains; for example, a piece of clothing with bullet holes in it is considered a clear indicator of cause of death.[4]

Once rediscovered, desire objects await a rocky and uncertain journey. Many found in isolation or exhumed with bodily remains but not identified remain in a state of limbo. In places where an atrocity is suspected to have taken place, forensics specialists, activists, and even local residents search the area, looking for corpses, bodily remains, or personal objects that can be used to identify victims. Sites of mass execution are often known to locals and even preserved in oral histories, but for political, economic, or other reasons, they can remain "undiscovered" for years and even decades.

REDISCOVERY

The rediscovery of personal items often occurs decades after an atrocity has taken place. For example, in 2019, the remains of 1,214 people were discovered in a mass grave in Brest, a city on the border between Poland and Belarus, during construction works.[5] For weeks, construction workers prepared the foundation for a new luxury apartment building while soldiers in masks and gloves pulled skeletons from the earth.[6] Also in 2019, near the village of Logoza, pieces of clothing, shoes, ammunition, bone fragments, and even full skeletons were among the items Belarusian investigators uncovered at a previously unknown mass grave of civilians killed by the Nazis during World War II.[7] In 2021, more than seventy-five years after their execution,

the remains of about 1,400 Jewish men murdered by the Nazis in August 1941 were discovered in a mass grave in the Belarusian town of Luninets. The excavation was carried out by members of the Ministry of Defense's forensic unit; in addition to the human remains found, they also uncovered dozens of personal items, including combs, shoes, glasses, and dentures.[8] In June 2022, a team of archaeologists unearthed a ten-year-old girl's shoe at the site of the bunker in the Warsaw Ghetto where Jewish resistance fighters made their last stand before committing mass suicide in 1943 in what has become known as the "Warsaw Masada." The girl's leather shoe, its heel attached with nails, was found alongside floor tiles and fragments of dishes.[9] A number of objects were found hidden beneath a chimney at the Auschwitz concentration camp complex: knives, forks, scissors, and tools were among the objects discovered in Block 17, thought to have housed prisoners with handicraft skills.[10] In Cambodia, large piles of pants and shirts, along with a jumble of hats, children's clothes, shoes, belts, and other fragments of clothing, were among the detritus left behind in a prison when the Khmer Rouge fled ahead of the Vietnamese invasion in January 1979. Many items were grimy and stained with blood. All had remained virtually untouched for forty years.[11]

In some instances, bodily remains and personal items are discovered sooner. In 1997, for example, recovery workers descended into a cave to recover corpses—some with socks and shoes dangling off decaying limbs—from one of the largest mass graves yet discovered in Bosnia. According to an *AP News* article, "some remains still had identification cards."[12] It took two months of searching for the Bosnian government's team to find the cave, which was six miles from the nearest road. Close to three hundred bodies, mostly Muslim war victims, were believed to have been buried in this labyrinthine cave near the northwestern Bosnian village of Hrgar. "We won't have a real idea of what we are dealing with until all the material is removed," said Joseph Cruz, a human rights field worker and one of the UN officials monitoring the excavation. "There is no real idea of how far the hole goes down there."[13] Personal items belonging to victims of the 1995

Srebrenica massacre, such as a grandfather's cherished wristwatch, a missing husband's worn-out pair of pants, and the weathered ID of a teenage son, were recovered in a myriad of miraculous, dark, and surprising ways.

In Mexico on September 26, 2014, forty-three students from the Ayotzinapa Rural Teachers' College were kidnapped by police, handed over to cartel members, and later killed.[14] Also in Mexico, in early September 2018, authorities found the remains of children and adults in clandestine burial pits where each item of clothing was either found near a body or cut free from remains. The brutality of the increasing violence in Mexico was epitomized by a pair of pants for a baby no older than six months and a pair of shiny pink sandals for a toddler found among the personal items recovered at mass graves in the Gulf state of Veracruz.[15] In June 2020, "a human skull, a pair of worn trousers and a shoe were among the remains unearthed from a mass grave discovered . . . in northern Iraq, a remnant of the brutal rule of the Islamic State group."[16] The mass grave was discovered in the village of Humeydat, west of the city of Mosul, six years after the Islamic State group, at the height of its power, declared a caliphate that stretched across eastern Syria and much of northern and western Iraq.

The personal items of soldiers, perpetrators, and civilians are seldom discovered on battlefields or at sites of mass atrocities. More often, they are found in mass graves, ruins, detention camps, sites of terrorist attacks, or scattered in fields or forests. They survived what their owners did not, and, once rediscovered and recognized as a direct link to an atrocity, they depart from their mundane function to begin a journey with various possible trajectories. Many stories are documented in great detail. For example, on the morning of September 11, 2001, in New York City, fifty-five-year-old Robert Joseph Gschaar was working on the ninety-second floor of the South Tower of the World Trade Center. At the time of the attack, Gschaar called his wife to let her know what was happening and to reassure her that he would get out safely. But he did not make it out of the tower alive. A year after the attacks, his wallet and wedding ring were

recovered, and inside the wallet was a two-dollar bill. Gschaar and his wife, Myrta, had each carried a two-dollar bill in their wallets during their eleven-year marriage to remind each other that they were two of a kind.[17] A pager recovered from Ground Zero had belonged to Andrea Lyn Haberman, a Chicago resident in New York City on September 11 for a meeting at the Carr Futures offices, located on the ninety-second floor of the North Tower. It was Haberman's first time visiting New York; she was only twenty-five years old when she was killed.[18] A gold bracelet belonging to Yvette Nicole Moreno, a receptionist at Carr Futures, was also found. On her way out of the office, Moreno was struck by debris falling from the South Tower and died at just twenty-four years of age.[19] A recovered baseball cap that had belonged to James Francis Lynch, a twenty-two-year veteran of the Port Authority Police Department, who at the time of the attacks was off duty and recovering from surgery but felt the need to respond. He died that day at the age of forty-seven, and his body was not recovered until December 7.[20]

Regardless of the nature of the atrocity, both missing bodies and discovered remains have a broad social impact and carry numerous political implications. Bodily remains and the personal items that accompany them become multifaceted tools in various political projects: a settling of historical injustices, a cry for justice or revenge, closure on a painful past, or a lesson to be learned. As such tools, they are infused with a "political life" that endures beyond a person's unjust passing.[21] Desire objects come to reflect many unfulfilled desires. In the absence of the voices of the dead and missing, desire objects carry the promise of revealing the last, unheard cry of those whose lives were taken violently.

DESIRE OBJECTS AS FORENSIC EVIDENCE

Connected to the divergent trajectories of desire objects, which shape their value in myriad ways, is the question of what happens

when objects become a source of forensic evidence. The importance of material culture is that it "allows for a documentation of crimes, including those that have been subject to covering over and erasure."[22] Recovered material traces of the past are reconfigured into evidence and used to support (or challenge) claims for accountability and justice. Additionally, personal items and artifacts become a source of information about the victims and how they died and about the history of an atrocity.

Despite the mass graves that have been exhumed, the vast majority remain undiscovered. In countries like Guatemala, Rwanda, the Democratic Republic of the Congo, and Cambodia, the dead and disappeared number in the hundreds of thousands. Forensic anthropologists play a crucial role in identifying those who have been killed in an atrocity. When skeletonized remains are discovered, forensic anthropologists apply the principles of physical or biological anthropology to ascertain the identity of the victim and their cause of death by analyzing the trauma to the skeleton. They sometimes draw on the techniques of forensic DNA analysis or genetic fingerprinting, which uses DNA samples. Together, skeletal and DNA analysis have been deployed to establish the identities of victims of atrocities.[23] In many settings where individuals were not buried, natural dispersion occurs, meaning that remains are at the mercy of the natural environment, perhaps scattered as a result of a severe storm, carried away on a river current, or scavenged by animals. However, in the absence of soft tissue and skeletal remains, personal items become the focus loci in determining cause of death for legal purposes in the absence of evidence of physical injury, as well determining the crimes perpetrators are to be charged with. For example, a violent death by gunshot is categorized as murder and cannot therefore be classified as an accidental or natural death.[24]

The recognition process is the conscious act of identifying material in relation to its similarity to a person, place, or thing and involves physiology of sight. In Bosnia, for example, since 2001, the entire process has been led by DNA technology. Specifically, DNA obtained

from bone samples is compared with DNA from blood samples donated by survivors. Forensic scientists then confirm a positive DNA match by examining remains at the Podrinje Identification Project morgue in Tuzla.[25] In the Lazete mass grave in Bosnia, four uncovered watches were all found to have stopped on July 15, indicating that their owners had died at around the same time, thirty-two to forty-eight hours before their timepieces stopped running.[26] In addition, a metal box containing ammunition used in mass executions was found near the Lazete mass grave, clearly pointing to the violent cause of death. The Lazete 1 grave site was first investigated in 1998 in relation to cases linked to the Srebrenica massacre and was exhumed by the International Criminal Tribunal for the Former Yugoslavia between July 13 and August 3, 2000. Forensic investigations showed that the grave site had been disturbed and that bodies had been dug up and moved to other locations in an attempt to hide the crime. It has been estimated that the grave originally held 195 bodies and that about sixty-eight were removed. Forensic analyses of soil and pollen samples, blindfolds, ligatures, shell casings, and aerial images of creation or disturbance dates further revealed that bodies from the Lazete 1 and Lazete 2 graves had been removed and reburied at secondary graves about ten kilometers away.[27]

Alongside personal belongings like diaries, glasses, jewelry, and cigarette packs, forensic experts trace bullet fragments, ammunition boxes, blindfolds, and ligatures. Excavations entail embedding an artifact into a wider network of social arrangements, connotations, practices, and power relations—that is, the entire discursive system through which it emerged as an object.[28] Nonpersonal artifacts, including walls, pipes, and signs from concentration camps caught as bodies were bulldozed into mass graves, are also used to link primary and secondary graves.[29] Therefore, forensic work, though primarily focused on confirming cause of death, is, "the practice and skill of presenting an argument," and since "objects cannot actually speak, there is a need for a 'translator' or an 'interpreter' to give voice to the

inanimate objects—a role that rests on the shoulders of the scientist as expert witness."[30] Evidence is never simply self-evident; it must always be painstakingly created through the processes—investigative, discursive, and rhetoric—that enable the mediation of a thing and allow even mute entities to make convincing truth claims.[31] Hence, rediscovered objects provide a physical connection and testify to the life and death of the killed and missing. Humanitarian forensic work emerges from our shared responsibility for the dead, out of which arises "the humanitarian need for ensuring . . . a proper recovery, management, analysis and identification" of the dead to protect their dignity and prevent them "from becoming missing persons."[32]

Yet, paradoxically, as remains and objects are uncovered and separated, skeletal structures are fully disarticulated and the bones are pooled together, which often results in the loss of identity beyond DNA identification.[33] Once recovered and sorted, both human remains and objects are sterilized to preserve them as potential means of identifying victims and determining cause of death. Laura Major points out that sterilization is also carried out to preserve remains and objects as valid evidence in court, where tortured bodies, reduced to mere bones, magnify the emotional impact of the discovered objects. In the absence of a tangible bodies and complete skeletons, personal items discovered become, for family members, the focus of an emotional encounter that possesses material agency.[34]

STORAGE: LIMBO

In their work, forensic anthropologists carefully set aside and photograph all personal items and scraps of clothing they recover in the hope that some survivors will be able to identify their loved ones through their belongings. The objects are then categorized, packed up, stored, and classified as evidence. The Podrinje Identification Project forensic facility in Bosnia provides a valuable insight into

the standardized practices used in storing personal items.[35] Several months before the idea of building the facility was considered (established in 1999), the commissioner of the International Commission on Missing Persons (ICMP), Uffe Ellemann-Jensen, informed families of victims of the Srebrenica massacre that the tunnels of the salt mine were full, meaning no more body bags could be placed there, and recommended that families should consent to temporary burials. Otherwise, he said, the exhumations would have to be halted. The Srebrenica survivors rejected Ellemann-Jensen's proposal and requested that a facility be constructed with the capacity to receive ten thousand body bags so that the remains could be kept aboveground until they were identified.[36] Finally opening in 1999, the Podrinje Identification Project forensic facility was designed for the systematic examination and identification of recovered mortal remains. Its 3,500 body bags containing the remains of victims of the Srebrenica massacre, together with numerous personal items, give a sense of the devastating magnitude of the atrocity.[37] The personal items kept here tend not to be displayed but are instead neatly stored in brown paper bags, and just the thought of their presence alongside human remains is enough to evoke a strong emotional response. Storage units like this one are generally not open to the public, but victims' relatives are invited to visit to try to identify the objects. Forensic anthropologists occasionally provide tours of the mortuary to students, international volunteers, and members of peace-building projects. In the setting of this forensic facility, the authenticity of the stored objects appears to be preserved via the presence of visible stains of blood and mud and persistent smells that are difficult to bear, the experience of which easily triggers emotional reactions in visitors.[38] The stored possessions are washed, cataloged, and photographed for a "book of belongings" (of which there are several), an initiative of the ICMP and the International Committee of the Red Cross (ICRC) to assist with the identification of victims; any items recognized from the photos by family members would provide forensic experts with a strong lead.

The Podrinje Identification Project morgue has stored the remains of many victims of the Srebrenica massacre.

IDENTIFICATION

Munib Osmanović is a survivor of the Srebrenica massacre whose father, brother, and two sons went missing after being separated from Munib's mother and sister in front of a UN base in Potočari, Bosnia and Herzegovina, on July 12, 1995. After years of searching, Munib was called to the Podrinje Identification Project forensic facility to identify his sons. He says, "I was called to come to Tuzla to confirm the identification. They showed me one piece of clothing of my elder son. I just told them to stop, to put it back in the box. They offered to show me more pieces of clothes, but I said no. I signed the paper and I walked out."[39]

Clothing is often used to identify the missing.[40] For example, in 2017, the relatives of missing people in El Quiché, Guatemala (the area most affected by violence during the Guatemalan Civil War), were brought together to look at some personal possessions that had been exhumed in the hope that they might recognize the items and thus be able to identify some of the victims.[41] However, a number of factors contributed to difficulties in using artifact recognition to identify the missing: (1) a substantial period of time had passed since their disappearance; (2) victims may have swapped clothing at some point; (3) some of the clothing had been found was thus generic; and (4) most importantly, the clothing was already considerably degraded.[42] Clothing is often used to supplement DNA-based identification. For example, garments can been used in the reassembly of bodies from body parts found together in mass graves either by matching the material or unique patterns of items such as pairs of socks or by matching tears to reconnect the left and right sides of a pair of pants.[43]

In the aftermath of mass atrocities, objects may be rescued by survivors or the families of victims, retrieved by forensic experts, or looted. The humanitarian dimensions of exhumation and identification have long been acknowledged by practitioners. They were not initially adopted by experts but have since emerged in and through their close work with family members, some of whom originated searches themselves. Many excavations are collaborations between experts and local communities. Examples include the Argentine Forensic Anthropology Team supporting forensic-assisted family searches for missing people in the mid-1980s, villagers throughout Cambodia gathering bones and skulls in makeshift in shrines, and volunteer-led excavations in Spain.[44] Families of the disappeared in Mexico are using forensics techniques themselves—collecting DNA, creating databases, and locating and exhuming mass graves—because of the failure of the state to carry out investigations.[45] Despite years of intimidation during which victims and local residents could not even speak about the bodies they knew were buried nearby and despite attempts to tamper with grave sites, families of the disappeared in Guatemala worked with the Guatemalan Forensic Anthropology Foundation to establish clear evidence of the atrocities committed by the Guatemalan army in the 1980s. Similarly, the Peruvian Forensic Anthropology Team helps families establish the truth about the fate of loved ones killed between 1980 and 2000 in what is known as the Peruvian conflict.[46] The work of the Committee on Missing Persons in Cyprus, launched in 2004, relies on the same integrated approach to the forensic recovery and identification of those who died during the conflict of the 1960s and 1970s.[47] In Mexico, owing to the absence of adequate official inquiries, widespread corruption, and a lack of trust in state and legal institutions, families and forensic humanitarian organizations, such as the Argentine Forensic Anthropology Team and the Peruvian Forensic Anthropology Team, are driving investigations of mass graves.[48] Family members play a crucial part in the process of identifying victims of mass atrocities.

THE FIRST CIRCUIT 101

While neighbors often play a crucial role in the process of locating mass graves, they are often also a major obstacle as, for various reasons (e.g., fear, guilt, embarrassment, trauma), they are unwilling to share information. Fikret Bačić, who spent more than fifteen years searching for his two children, wife, and mother, expressed his frustration with such an experience: "I asked every one of my neighbors to tell me what happened with their bodies, but they don't want to say. I tried everything, begging, threatening to sue them, [but] nothing [happened]."[49] However, we also see groups and individuals volunteering to help. Their activism is fueled by a "sense of urgency in this 'aftermath.'"[50] For example, in the operation to recover human remains from Lake Perućac in eastern Bosnia from July 16 to October 5, 2010, as many as 2,400 volunteers assisted under the coordination of the Missing Persons Institute of Bosnia and Herzegovina and the ICMP.[51] There are also individuals like Ramiz Nukić, a human bone gatherer who lives in the village of Kamenica and decided to dedicate his life to finding human remains and artifacts that can help identify the missing. He claims that as many as three hundred missing people have been identified based on DNA samples extracted from the bones he has collected. When interviewed he said,

> As time goes by, it becomes more and more difficult to find remains. I find less than before, but I still do my best. It has been twenty-five years. I have to clean up ten centimeters of dead leaves to reveal the soil beneath it. When I find a trace, like a tin can or a shoe, I continue searching around that place. I use a stick, and sometimes I carry a rake with me. I find so many small bones, parts of human fingers. That doctor [forensic pathologist] from Tuzla who visits here says he admires my skills. I have never mistaken an animal bone for a human bone, for example.[52]

In Bosnia, the ICRC collected photographs of the clothing and other artifacts associated with the remains of victims of the Srebrenica

massacre, and in 2000 and 2001, they published two books of belongings. These photo books comprise 2,702 pictures of clothes, shoes, jewelry, and other personal effects found with 473 exhumed bodies and represent an attempt by the ICRC to elucidate the fate of more than eight thousand people, mostly men and boys, who disappeared when Srebrenica was overrun in July 1995. In all, 2,522 people who were searching for 4,488 missing people consulted the books, and items found with sixty-seven bodies were tentatively recognized.[53] In 2005, the ICRC published a third book of belongings of missing people from Republika Srpska, the Serb part of Bosnia and Herzegovina, containing 930 photographs of clothing and personal objects found with the mortal remains of some 350 people.[54]

Five mobile teams, each comprising three volunteers from the local Red Cross and one member of a family association, were trained to provide counseling and support to those in search of loved ones who had perished.[55] For example, Huso Halilović, a Bosniak survivor, managed to recognize the remains of his father, Bajro, found in a mass grave in Kamenica, near Zvornik, because of his father's artificial eye.[56] In 2001, eighteen cases were solved with ICRC help.[57] In another instance, Sudbin Musić, a member of a group that became actively engaged in the search for bodies near Čarakovo, described how the group found a female skeleton in an armchair: "It was our cousin. We had a hard time pulling her remains off the armchair. They were so tightly attached to it."[58]

A similar project, a cooperative effort between the Organization for Security and Co-operation in Europe and the ICRC, also involving the creation of a photo book, was conducted in 2001 to ascertain the fate of people reported missing in connection with the ethnic violence and conflict in Kosovo. The photo book contains 750 photos of clothing and personal effects found on some two hundred bodies recovered in 2000 and supplements other efforts to trace the missing and identify mortal remains. The ICRC tracing service collects requests from families regarding missing people, submits lists of the

missing to the relevant authorities, and matches them with details received from other sources of information.[59]

As mentioned, in Mexico in 2018, authorities found the remains of children and adults in clandestine burial pits at mass graves in the Gulf state of Veracruz. The National Commission of Missing Persons posted hundreds of pictures of recovered clothing online to give family members a chance of identifying missing loved ones. The photographed items included polo shirts with logos still intact, socks, shoes, colorful boxer briefs, and ladies' panties. One t-shirt has "Live Free" printed above a picture of a young woman and flowers. Photos also show many children's items, such as little sweaters and t-shirts with images of Tinkerbell, Tweety Bird, and Pokémon characters.[60]

How the personal objects found at sites of atrocity are managed depends largely on the political will of authorities and the available resources. We see, for example, large-scale engagement from government, expert teams, and local communities following the September 11 terrorist attacks, where, from the beginning, the goal was to recover and preserve as many objects as possible. But in places where an atrocity is contested and the authorities are involved in a cover-up or where the extent of political engagement is voluminous and costly, as in Bosnia, Cambodia, Iraq, and Mexico, excavations may take years or decades—or they may not take place at all.

DESTRUCTION

Some recovered artifacts and personal items will be used in court. For example, over the course of the trial of Radovan Karadžić, the former president of Republika Srpska, the court called 586 witnesses and admitted 11,481 exhibits. These exhibits were stored in the archives of the International Residual Mechanism for Criminal Tribunals in The Hague. But as part of the evidentiary process, before entering the court, the objects were stored in climate-controlled rooms on the

building's third floor where only authorized personnel could enter. The walls were lined with rows of boxes containing material confiscated in the Balkans by the tribunal's investigators. Most items were confiscated by investigators during raids, while some were brought to officials by witnesses and victims or found in mass graves.[61] These objects became crucial evidentiary witnesses in the trials. Their purpose was to shed light on the devastating human cost and political implications of the massive human rights abuses with which Karadžić had been charged.

Once the evidentiary process has ended, such artifacts are typically returned to the families of the missing or killed. But only a small percentage of recovered personal items find their way to courtrooms, and it is difficult to assess quantitatively how many personal items recovered from sites of atrocity are returned to the families of their killed or missing owners. We sometimes hear stories of people finding or recognizing items, but for each of those stories, there are hundreds and thousands of items that are never returned to families. And though obtaining personal items of lost loved ones is widely recognized as part of the grieving process, the destiny of most is rather gloomy. For many reasons, the majority of recovered personal items do not find their way into the hands and homes of families. A primary reason for this is that finding the family members is a costly process, and no systematic mechanisms are in place that help with this process.

Even worse, large numbers of objects are intentionally destroyed. For example, more than one thousand artifacts and personal items, including objects used as forensic evidence, found in 1996 and 1997 in mass graves with the remains of victims of the Srebrenica massacre were purposefully destroyed in 2005 and 2006 in The Hague by the International Criminal Tribunal for the Former Yugoslavia; of these, a quarter are yet to be identified.[62] The reasoning behind this destruction was that the objects were no longer needed as evidence for court proceedings and that the tribunal did not have the space to store them.[63] Olga Kavran, a tribunal spokesperson, said that the decision

was made in accordance with standard court procedure: "We're talking about artefacts that were disposed of at the end of 2005 and the beginning of 2006. The vast majority of these artifacts came from mass graves, were deteriorating, and presented a risk to health. . . . There's a suggestion somehow that this is something that doesn't happen. . . . And that isn't something unusual. And I'm referring you to domestic jurisdictions just to simply say that no, it's not unusual that something like this could happen. A court of law will dispose of certain artifacts."[64] This reasoning must be understood in light of the fact that courts rely on many means of establishing culpability in addition to recovered objects, such as war reporters' photographs, films, letters, emails, phone calls, voicemail messages, and texts, as well as forensic science, satellite imagery, and eyewitness testimony.

However, the destruction of recovered objects in this way has been perceived as an insult and as shameful and humiliating by survivors hoping to find tangible links to loved ones who have disappeared. Without those objects, mothers like Munira Subašić, whose son Nermin vanished without a trace, and Zumira Sehomerović, whose husband was killed at Srebrenica are left with nothing to remember their slain children by. "Each photo, each piece of clothing, each little object is extremely valuable," says Zumira.[65] The destruction of such precious items deprives families from obtaining desire objects in which they could have inscribed their memories and projected their desired futures.

The destruction of personal items can occur at any stage following their rediscovery. Even in the later stages of their second life, desire objects can be destroyed for a variety of bureaucratic and technical reasons, by natural causes, or because of a political agenda. We see, for example, that because of the paranoid politics of the Stalinist years, a large exhibition dedicated to the siege of Leningrad at the Museum of the Defense and Siege of Leningrad, which had permanent status and housed 37,654 items in thirty-seven galleries, was closed in 1949 and dismantled in 1953, its contents liquidated and its director

executed as part of the infamous "Leningrad Trials."[66] This example illustrates that the survival of desire objects once rediscovered is not guaranteed but embedded in a number of factors not easily foreseen.

THE VALUE OF DESIRE OBJECTS: IDEOLOGICAL PATHWAYS

The value of the desire objects upon rediscovery is determined within a complex network of social, economic, and political circumstances. If there are ongoing processes of truth finding that involve excavations and identifications of the killed or missing, if trials are taking place and the objects can be used for evidentiary purposes, or if the objects are recognized for their commemorative value, they might survive. But although their value is case dependent, their trajectories show us particular patterns in their movement. These patterns emerge as a consequence of the human rights memorialization agenda of moral remembrance. Moral remembrance places truth-finding efforts, accountability, and justice for victims at the forefront of its agenda.[67] In fact, forensic anthropology, or humanitarian forensics, as we know it today, developed hand in hand with the human rights memorialization agenda as an attempt to apply the knowledge and skills of forensic science to humanitarian activities following massive human abuses or disasters.[68] It has its early roots in the experiences of the Argentine Forensic Anthropology Team and the Grandmothers of Plaza de Mayo in Argentina during the 1980s and 1990s and was shaped by the international humanitarian law and international human rights law developed by the ICRC.[69] Managing the dead, including protecting their dignity and trying to identify them, is a core pillar of a humanitarian response, along with caring for survivors.[70] All humanitarian forensics efforts are grounded in notions of "truth, justice and guarantees of nonrepetition of mass human rights abuses"[71] and seek to "contribute to the consolidation of peace and democracy where grave

human rights violations have taken place by working alongside the families of the disappeared to find their love ones, gain access to justice and improve the conditions affecting their political and economic development."[72] Forensic expertise is placed in the service of human rights investigations (sometimes but not always led by states' official justice systems), historical truth-seeking processes, international tribunals and commissions, and human rights nongovernmental organizations.[73] Most of those who became involved in humanitarian forensics had experience with human rights activism and had professional training in archaeology and physical anthropology.[74] Hence, one of the main goals of humanitarian forensics is to train human rights nongovernmental organizations to use forensic tools to advance their investigations, to support victims, and to strengthen the credibility of their work against impunity.[75] Therefore, the role that forensics play in the aftermath of atrocities is grounded in the notions of moral remembrance, particularly justice for victims. Its work goes far beyond evidentiary medicine.

The junction between humanitarian forensics and moral remembrance sets a clear path for the movement of desire objects. It is the ideological foundations of human rights that pave the possible routes that desire objects will take and along which they will acquire their value. In other words, those ideological foundations establish the purpose of desire objects. Whereas the initial value of rediscovered items is either evidentiary or as a tool of identification, desire objects have a much wider ideological scope. Rediscovered personal items not only contribute to truth-finding processes but also contribute to such noble goals as the recovery of respect and dignity for both the dead and survivors. According to the Argentine Forensic Anthropology Team, their work also has a therapeutic dimension. The team aims "to maintain the utmost respect for the wishes of victims' relatives and communities concerning the investigations, and to work closely with them through all stages of exhumation and identification processes" with a keen awareness that "the identification of remains [is] a great

source of solace to families suffering from trauma caused by having a loved one 'disappeared.'"[76] Humanitarian forensics offers hope for the "forgotten" ones.[77]

CONCLUSION

How desire objects are set in motion once rediscovered is directly linked to ideological infrastructures of the "proper way to deal with the past."[78] While their movement is regulated and largely scripted through forensic and legal procedures (e.g., how to clean, preserve, sort, and classify them; how they change hands and places), it is also a trajectory of meaning making. Once recovered, desire objects start a journey in which they shape and are shaped by particular narrative schemata that ideologically frame their value to promote certain goals. By being associated with ideological infrastructures and discourses of truth and justice, desire objects are destined to take a specific route in which they serve as a direct link between an atrocity and human rights–based hopes of achieving justice and finding truth. However, as I will show in the coming chapters, the trajectories of desire objects can easily be redirected to serve other purposes; in some cases, they become tools of cultural homogenization in the service of nationalistic goals.

5

THE SECOND CIRCUIT

Desire Objects in Private Homes

Every time she looked at her husband's dirty, rusty flint, she would think back to how she was told that, after he was shot, he was probably buried alive.

THE WINDING DESTINIES OF DESIRE OBJECTS: THE MICRO PERSPECTIVE

Desire objects have various lifespans and trajectories. Objects encapsulate a "silent" trajectory of human–object relations, sustaining the past in the present in everyday domestic materiality and familial social relations.[1] In the private sphere, they generate intense emotions in those to whom they belong, but their movement from the private to the public realm is neither linear nor straightforward. The story of how and why desire objects are kept privately, donated and then preserved, collected, stored, reused, or left to decay or be destroyed is often obscured or taken for granted. Yet, their trajectories and biographies are indicative of how they produce discourses and meanings and manage, or fail, to become embedded in various ideological matrixes. In this chapter, I describe some possible and some most likely paths by which desire objects begin circulating and moving among social realms once they have been rediscovered. Each transition to a new

social arena is accompanied by at least two levels of social interaction, and with each transition, both the intensity of emotional energy they generate and their ascribed value change. The emotional energy that desire objects may generate always depends on their ability to initiate an associative process that links the deceased, the living, and the experience of violence. Family members who have lost loved ones to atrocities react automatically to desire objects as they narratively endow them with a wide spectrum of memories and emotions. The emotional response of a woman upon seeing her murdered husband's muddy and broken watch is immediate. By looking at it, touching it, and smelling it, she sees his face and his smile; she can also hear his screams. She sees not only their time together but also the future she desired for her family. Her response is not only emotional but also mental, biological, and physiological. Her body reacts instantly: her pupils dilate, she feels lightheaded, and her hands tremble. Her heart starts to pound, she starts breathing faster, her muscles tighten, and she starts to sweat. She cries. Such an intense emotional response to an object associated with death and violence causes the body to release the hormone cortisol, which affects blood pressure regulation and the functioning of several body systems, including the cardiovascular and circulatory systems.

DESIRE OBJECTS AND BEREAVEMENT

Objects encapsulating pasts that culminate in death cause ruptures in the texture of the self and the family.[2] In the process of mourning, people become attached to the personal items that belonged to the deceased, and these items play a crucial yet often ambiguous role. The bereaved, whether religious or not, are often deeply attached to the material legacies of the deceased, and the memory of the deceased is indelibly tied to places, objects, images, and bodies. Grieving is a meaning-making process in which one must relearn the world

and create a new life, one they never expected. Objects play a role in grieving because they are embedded in the construction of identity and "trajectories between persons."[3] Attachment theory explains the powerful bonds between humans and the disruption that occurs when those bonds are jeopardized or destroyed.[4] It has been well established that, for the grieving process, a "transitional object" or "melancholy objects" are crucial to understanding the experience and process of grief that transitions with and through objects. Melancholy objects are objects that are central to grieving, they are conceptualized as objects that memorialize mourning.[5] But they are also more than that. Melancholy objects link the array of meanings, understandings, and feelings bound up in a relationship, all of which must be transformed so that the surviving partner can move on with a new, refashioned bond with their deceased loved one.[6] Grieving people develop an emotional tenor with a range of objects, including those that seem mundane.[7] Since "material culture contains emotions and ideas of startling intensity,"[8] we must account for the inseparability of our thinking and emotions toward material goods. However, in the mourning process, objects also transition in terms of their status, value, and meaning.[9] Melancholy objects as mediators signify an absence. Françoise Dastur articulates the paradoxical effect of absence in relation to presence. She suggests that "the very fact that we have lost him or her [means that] the dead person is more totally present to us than he or she ever was in life."[10] In the context of mourning and remembering, objects function as metaphorical and metonymic traces of corporeal absence.[11]

Importantly, recovered objects belonging to those who perished in the distant past are qualitatively different from the melancholic objects used in the process of mourning those who have recently died. They operate in different temporal and spatial dimensions: the distant (or relatively distant) past versus the immediate past. This distinction means that the emotional intensity generated by the two types of objects differs; more importantly, the older objects have limited

power to generate feelings and discourses beyond the realm of the immediate family as they are often not linked any longer with the living experience. However, when personal items are recovered from sites of atrocity and relate to a sudden and unjust death, an emotional potency is generated that can resonate with a much wider audience. This is because the proximity of the atrocity and the explicit violence embedded in the objects are their main features and thus increase the relatability of the objects and the intensity of the emotional impact they are capable of having on a wide audience. A sudden and violent death is a specific case of loss that has unique characteristics and makes unique demands of survivors, in addition to the grief they generate.[12] This is because, compared with people who have lost loved ones in the natural course of life, relatives of those who have died suddenly and unexpectedly are more likely to experience what is considered abnormal or pathological grief, and their grief is more likely to endure longer and be more difficult to resolve.[13] This grief is not easily resolved, not only because of the sudden nature of the death but also because it is intrinsically associated with violence and deep feelings of injustice. Families of those whose deaths were sudden, violent, and outside the realm of the "normal" life experience have a strong need to understand why the death happened and how to make sense of their loss.[14] Hence, the few personal objects they have of their loved ones play a crucial role in the mourning process as they generate deep emotional power and attachment.

Therefore, objects relating to brutal and unjust deaths, even the most mundane ones, can have significant emotional, symbolic, and mnemonic value, often outweighing all other measures of value—particularly their initial economic value.[15] The value of objects found after atrocities is closely connected to their generative power and how they acquire the potency to transcend their original purpose. These objects develop biographies and careers of their own, and they are endowed with various qualities—sentimental, mnemonic, economic, evidentiary, and aesthetic—as they move among various contexts

and are exposed to a host of meanings, ownership claims, regimes of worth, and symbolic and ideological appropriations and interpretations. The forging of their value is often reflected in the development of the collectors' market as time passes.[16] Not only family members but also archaeologists, museologists, historians, and forensic anthropologists find themselves in direct competition with enthusiastic treasure hunters.[17] Thus, to understand the foregrounding of the trajectories of this specific category of objects, associated with sudden, unjust, and brutal death, against various biographical configurations, we must understand the many transformations in how they acquire meanings and values. In other words, how and under what circumstances does a shoe, a bag of marbles, or an old watch found after an atrocity give rise to discourse and an ideological worldview that paradoxically brings the dead back to life through the object's detachment from its initial meaning?

PERSON-OBJECT EMOTIONS: DID MY SON EVER EXIST?

Once this sweater was white like snow . . . I knitted it myself. . . . Now it's black from the dirt of the mass grave they found him in, and it is torn in the middle from the bullets that rattled through his stomach when the Serbs shot him.[18]

Though there is no meaning inherent in things (their meaning derives from their relationships with humans), desire objects are qualitatively different from other objects because they possess the inseparable attributes of innate violence.[19] One cannot engage with a desire object without instantly associating it with an act of violence: there is a guilty party who intentionally committed an act of violence; thus, the death of the person who owned the object is tightly connected to violence and injustice. For those who are grieving, including both

family members and the wider community, desire objects represent their hope for achieving some sort of justice; the surviving objects oblige the survivors never to forget those they have lost or the events surrounding their deaths; they also oblige survivors to learn from what happened.[20]

For objects used in court proceedings, once the evidentiary process has ended, these artifacts are returned to the families of the dead or missing with whom they retain meaning. Sometimes they are kept private; sometimes they are publicly displayed for remembrance and commemoration.[21] Raw emotions of deep sadness and loss usually accompany the discovery of desire objects. When Huso Halilovic, the Bosniak survivor mentioned in chapter 4, recognized the remains of his father, Bajro, in a mass grave in Kamenica, near Zvornik, he also found his father's watch and comb, and these instantly became Huso's most precious possessions: "When I see these items, I'm flooded with tears; I remember how his watch was always on his hand and he was combing his hair every morning. Those are the only mementos I have." Ahmed Hrustanović lost almost all of his male family members in the Srebrenica massacre. The only objects left from his father are some photos and about one hundred letters, which have become Ahmed's most important belongings:

> These letters and photographs are, to me, the most important thing in the world that I have. When I read these letters, they bring me back to my childhood, bringing me back to the moments when I knew I had a father. Many, many emotions are there. . . . Every time when I start to read these letters it awakens strong emotions in me. . . . Even when I talk about it now my eyes are full of tears. This is something priceless that I have. Every word that my dad wrote, every greeting and every question of "How are you?" and "What are you doing?" . . . somehow brings him back here with me to be, to live, to feel that he is here, that he was not some imaginary personality that I do not remember.[22]

Desire objects, well embedded in their cultural and social environments, create their own sensory habitat, physically by constructing a material world with its own set of sensory properties and culturally by emphasizing certain sense impressions over others.[23] Objects give memories physicality. Containing the smell, touch, and emotions of the dead, they hold memories of the landscapes in which their owners were executed. They contain scents of mountains and forests, particular soil and flora, suffocating prison cells, and other settings experienced by victims before their death. Diaries and letters, watches, shoes, and glasses: all have the distinct texture and smell of desire objects—whether a yellowing piece of paper covered with smudge marks from a doodling pencil or a scratched watch caked with dirt and dried blood. All capture the materiality of the absent and the imaginary potential to make sense of a sudden, violent, and unjust death. Small items such as wallets, photographs, coins, postcards, diaries, and letters are, in many instances, the only material things left for bereaved relatives; as such, they become substitutes for an absent body.[24]

The Importance of sensory stimuli in triggering emotions is apparent in the stories of survivors. For example, Fazila Efendić's husband, Hamed, was shot dead at the age of forty-six in a forest by Bosnian Serb troops. She keeps Hamed's old terra-cotta-colored shirt in the closet: "When I miss him, I open the closet, touch the shirt and I can't say if I feel better or worse then, but I must touch it." It's the same with the school diplomas of her only son, Fejzo, who was just twenty when he was killed in the Srebrenica massacre. She says, "He won several regional competitions in maths and physics. He was a very good child." A white handkerchief with blue stripes given to her by her son before Srebrenica fell is yet another desire object in her small but cherished collection of scarce possessions that link her with her deceased loved ones: "I carry it around wherever I go."[25] Djulka Jusupović carefully handles a tobacco box made of cans

of food delivered by the UN, along with a piece of flint used to make fire during the war.[26] She keeps the items in plastic bags. They are still as dirty as when they were found with her husband, Himzo, as his body was excavated from a mass grave.[27] But for her, the objects carry an emotional burden too heavy to face. She rarely looks at them because each time she does, she instantly remembers words too painful to process—what forensic experts told her when they handed the objects to her: "Himzo, after being shot, may have still been alive when buried."[28]

Similar stories of bereavement, the impossibility of coming to terms with prematurely ended lives, and connections made with desire objects are found across the globe. Andrea Haberman, the young woman mentioned in chapter 4, whose life ended on September 11, 2001, had been on a business trip and making her first visit to New York City. Her "ashen and damaged wallet, still smelling of Ground Zero—evoking unbearable sorrow to her family, lay mostly untouched in a drawer at her parents' Wisconsin home, along with a partly melted cell phone, her driver's license, credit cards, checkbook and house keys. Flecks of rust had formed on the rims of her eyeglasses, their lenses shattered and gone."[29] The substances and scents with which an object came into contact when its owner was killed become an inseparable part of the object and thus of the deceased. They become incorporated into the signifying power of the object and facilitate the shift from an object of evidence to an object filled with memories of and a longing for a deceased loved one. In the same way that the narratives of people's deaths become part of the story of their lives, the acquired attributes of desire objects—soil, blood, smells—and their changed physicality—missing or broken parts, indentations, scratches—become significant elements of a postmortem imagined personhood.

The importance of desire objects can be understood in their absence. Take, for example, Munira Subašić. Only in 2013 did Subašić finally bury the remains of her seventeen-year-old son, Nermin, one

of eight thousand Bosnian Muslim men and boys killed in 1995 when Bosnian Serb forces captured the UN-protected enclave of Srebrenica. These were two bone fragments found in grave sites twenty-five kilometers apart. For eighteen years, she had lived an ongoing nightmare. All other signs of Nermin's life had disappeared. There were no old photographs, no letters, no clothes. No remains. She had nothing to prove her son had ever existed.[30] The totality of the destruction of an atrocity often causes an unbearable feeling of the inability to distinguish reality from imagination. Objects may be simultaneously absent and present in a state akin to ambiguous loss, an unresolved state of grief felt by individuals toward a loved one who has disappeared and whose fate is uncertain.[31] Desire objects create a fragile link between these feelings of sanity and insanity, between real and imagined, between life and death. In his struggle to keep the memory of his father alive, Ahmed Hrustanović reflects on this fragility of being an "in-betweener": "Sometimes a man, in these fears and emotions, asks himself, 'Did I really have a father?' But then, when I see a letter, when I see a photo, I feel relieved."[32]

And while some find it difficult to keep desire objects because of their immediate associative link with the dead, some find it difficult to claim desire objects once they have been uncovered. As mentioned in chapter 4, many are destroyed, but the nature of the atrocity itself can also make it difficult for objects to reach the homes of surviving families. For many reasons, finding the families of the killed or missing is not always prioritized. In many cases, this has to do with limited human and material resources and time constraints, but it can also be because of a deliberate obliterating of the link between the possessions of the dead and their living relatives. For example, in Poland and Belarus, the personal belongings of Jewish people were appropriated by gentiles during and in the aftermath of the Holocaust. They were identified, demanded back, passed down through Jewish families from generation to generation, and commodified for the sake of profit.[33] But in the face of the scale of an atrocity, returning personal

belongings is not always possible given the many other urgent issues to be addressed.

A profound example of the unexpected difficulties in claiming possessions back is the story of Michel Lévi-Leleu, a retired engineer. While visiting an exhibition entitled *The Fate of Jews from France During World War II* at the Foundation for the Remembrance of the Shoah in Paris, he was astounded to recognize a small brown suitcase with a luggage tag reading, "86 Boul, Villette, Paris Pierre Levi." It was his father's suitcase.[34] Lévi-Leleu, shocked with this emotional discovery, decided that the suitcase should remain where it was: "I wanted it to stay here, not to put it in a cupboard at home, out of everyone's sight, but so it could be shown to everyone in Paris."[35] One might see this as an incredible story of a moment of hope coming from a tragic event. But no. It was not allowed to remain there. With the full support of the Polish government, the Auschwitz-Birkenau State Museum, situated on the grounds of Auschwitz, said that "it certainly understands, most profoundly, the feelings of the families of victims of the Shoah."[36] It argued that, with the passage of time, it had become all the more important to preserve physical remnants of the death camp to safeguard the memory of the genocide. It argued, "The suitcases belonging to people deported to Auschwitz are among the most priceless material testimony to the tragedy that occurred here. They constitute a small remainder of the property left behind by the victims of the gas chambers, and the names on some of them are among the few proofs of the death of specific individuals in Auschwitz."[37] The museum was worried that setting a precedent might have an avalanche effect in which many relatives would try to reclaim possessions from the museum collection. Lévi-Leleu explained, "I am not trying to empty the Auschwitz museum. . . . I didn't want it [the suitcase] to repeat the journey that it had already made to Auschwitz."[38] Fortunately, Lévi-Leleu's wish was granted. As a result of the settlement, "the Auschwitz Museum, which regards the suitcase as one of the rare objects symbolizing and representing the memory of the persons deported to the

camp, and which wishes to express the deepest understanding of the emotions of the families of Shoah victims, has decided to leave the suitcase in the Paris Shoah museum on a long-term basis."[39]

A similar argument was mobilized in the case of seven watercolor portraits of Roma prisoners (then called "Gypsies") that now hang in the Auschwitz museum. They were painted in 1943 by a prisoner, a young Czechoslovakian Jewish woman named Dina Gottliebova Babbitt, who was ordered by Josef Mengele to paint portraits of Auschwitz's Roma prisoners so that Mengele could support his racial theory "scientifically." For many years, she tried to claim her paintings back from Auschwitz, but time and time again, the museum categorically refused her request, arguing that the portraits serve "important documentary and educational functions" by testifying to the genocide of Roma people.[40]

DESIRE OBJECTS IN THE PRIVATE CIRCUIT

Of course, desire objects have biographies before they acquire that unique status. Some were bought, some were handmade, some were gifts. But the significance of their biographies before the event of a sudden, violent death is minimal. Only once associated with an atrocity do they become a focus of attention and do their origins gain significance. Their scarcity, the uniqueness of their condition, and their proximity to a scene of violent death make them a link bridging the physical disappearance of the deceased and their afterlife existence in the memory of surviving loved ones. Suddenly, a shoe found in a mass grave or a wallet found in the ruins of a building obtains new meaning far beyond that of their initial purpose. If those rediscovered objects fail to find their way to the families of the deceased, they are positioned as "silenced witnesses": they might generate significant attention, but their value as objects connecting a concrete atrocity with its abstract representations, is instantly appropriated by those

who frame atrocity in a particular way. The emotional energy they generate in that context differs greatly from that generated when they are reunited with family members of the dead. They instigate a deep personal, emotional response that provides a framework for survivors to speak out, to share their stories, and to motivate them to take action. Desire objects enable a bond between the dead and the grieving in which the objects simultaneously become embedded in newly acquired biographies and detached from their mundane meanings. In fact, once objects whose previous function was limited to their consumption become desire objects, their function is reversed—rather than being objects meant for consumption, they are now objects that consume those who are emotionally attached to them. Desire objects become loci of attention and emotional energy for their owners, regardless of the type of emotions they generate. As emotional energy is the main motivating force in social life, the emotional intensity generated by a desire object becomes the driving force of the meaning-making process for the grieving party, providing the object with the potential to be transformed from a representation of an individual story of loss to one with a wider ideological worldview.[41]

But how does this ideological transition occur? How do desire objects break through the first circuit of private and personal emotional attachment to become a locus of attention for a wider audience without a direct link to the atrocity with which it is associated? How do desire objects acquire meaning beyond the personal? These questions are crucial to our understanding of how complex social forms and distributions of knowledge at various points shape and alter the value of desire objects and consequently shape and alter their "careers."[42] To follow the trajectories and "career paths" of desire objects, we must understand how the value of desire objects is being transformed as they move from one arena to another. What constitutes the changing value of desire objects? How and when does their materiality transform into discourses and symbols? Under what conditions do they become an inseparable part of an ideological worldview?

DONATING DESIRE OBJECTS: A NEW LIFE ON THE HORIZON

Although desire objects are much needed and desired by grieving family members, they simultaneously produce opposite feelings. On one hand, they brings about immense happiness in allowing a person to see, touch, and smell one of the last things to have direct contact with the deceased; they automatically bring back memories and provide assurance that the person's loved one really existed when most or all other physical evidence of that life has been erased. Having that tangible proof provides a sense of security and continuation. The ability of desire objects to trigger joyful memories and connect the dispersed pieces of a past life into a more coherent narrative is of utmost importance for the meaning-making processes for grieving relatives who have lost loved ones in an atrocity. On the other hand, the tangible evidence provided by desire objects also buries the wild hope that loved ones will miraculously reappear. The return of desire objects to the families of the dead represents the end of a frantic search for signs of life and of the hope that the atrocity never actually happened. The very presence of desire objects means that the vanished are gone forever.

To an outside observer, a broken watch, a muddy shoe, a torn t-shirt, or a few dusty marbles might appear to be only refuse when, in fact, that cannot be further from the truth. Desire objects concentrate and generate an astonishing amount of emotional energy that, as I will show, has the potential to alter realities.

Once reunited with desire objects, survivors handle them with care, though in various ways depending on the emotional intensity they provoke. Some hide them away in drawers or closets; others display them reverently. Desire objects almost instantly become sacred possessions for the relatives of the deceased. They are the link between the dead and the living. But if that is the case, how and why do some people decide to part with such meaningful objects? But before we

start looking at why people decide to donate desire objects, we must acknowledge the existence of markets that place a certain value on such objects.

In the process of traveling among grieving family members, archaeologists, forensic experts, and state actors, recovered personal items are subject to symbolic and political repurposing. Museums are institutionalized facilities of making meaning of the past, and desire objects become subject to musealization (and appropriation) as collectivized icons of violence and suffering.[43] Memorial museums and sites of dark tourism are eager to get ahold of these objects because they provide these institutions with validation and lend perceived authenticity.[44]

But how desire objects end up in museums or exhibition displays varies greatly. For example, the Tuol Sleng Genocide Museum, administered by Cambodia's Ministry of Culture, displays many of the more obvious artifacts of mass crimes, such as torture implements, shackles, and documents that were immediately preserved in the genocide museum established in 2018 inside the S-21 prison by the Vietnamese administrators who occupied Cambodia following the overthrow of the Khmer Rouge. However, personal items, garments in particular, were largely ignored and stayed virtually untouched for forty years. With the proliferation of the new museum genre, the value of those garments and their potential to support the human rights discourse were recognized by the museum, which undertook a multiyear project, funded by a $55,000 grant from the U.S. government, to conserve thousands of cloth artifacts. For the first time, the clothes were sorted, preserved, and, in some cases, displayed as part of the memorial to the 1.7 million Cambodians who died—about 25 percent of the population—during Pol Pot's Khmer Rouge regime between 1975 and 1979.[45] Julia Brennan, an American textile conservation expert spearheading the project, said the effort would employ cutting-edge technology to ensure the clothes would be properly preserved without removing the stains that testify to their history: "The dirt, stains,

accretions, are a part of the genocide story and bear witness to the atrocities."[46] The importance of preserving the garments with their stains aligns with the human rights memorialization agenda, which focuses not only on the event itself but on the ideological message it conveys. Brennan says, "They [the clothes] are a testimony to the genocide.... Younger generations are going to certainly benefit from it, so that they know what happened here."[47]

In the United States after the September 11, 2001, terrorist attack on the World Trade Center in Manhattan, a pair of women's high-heeled shoes were found in the debris. They belonged to a Fiduciary Trust employee named Linda Raisch-Lopez, who survived the attacks. She began her evacuation from the ninety-seventh floor of the South Tower after seeing flames coming from the North Tower. She removed her shoes and carried them as she headed down the stairs, reaching the sixty-seventh floor when the South Tower was struck. As she headed uptown to escape, she put her shoes back on, and they became bloody from her cut and blistered feet. She then donated her shoes to the National September 11 Memorial & Museum.[48] In a similar fashion, the museum has acquired more than seventy thousand personal items that document the fate of victims, survivors, and first responders.[49] All around the world, desire objects are collected and donated. Their immense power extends beyond their narrative capability to the emotional recruitment of wide audiences. Boxes of clothes donated to the Johannesburg Holocaust and Genocide Centre demonstrates the emotional force of such objects: "When we opened those boxes for the first time, there was the most visceral sense of the lives that were no longer, because of the human remains and the blood and the smells. The first thing was our shock in having this tangible and very physical representation of death."[50]

The significance of desire objects as a means of evolving human rights culture and teaching and learning about human rights transgressions is captured in how human rights activists, museum curators, and artists speak about them. Lauren Segal, the curator of the

Johannesburg Holocaust and Genocide Centre, speaks about choosing objects to display: "These are objects of familiarity. We know them. Because we know them, we understand the survivors' and the victims' relationship to these things. Survivor Veronica Philips held onto a doll through the worst possible horrors. She donated it to the museum, enabling it to become an object of memorialisation."[51]

In the Rwandan section of the Johannesburg Holocaust and Genocide Centre, the display is dominated by clothing and other domestic objects. These are not unique items, and the people who owned them were not wealthy; the shoes, combs, clothes, and stationery they used are cheap, ordinary, and in common use. But as Robyn Sassen[52] has noted, "in the cacophony evoked around them, in the display's construction, these items, including the schoolbook of a child, optimistically dated for the beginning of the school year, four months before the genocide in Rwanda started, take on deeper significance; the dresses and trousers, shirts and shoes become ciphers of horror."

Individual motives for donating desire objects vary. Some will not be able to disentangle the materiality of an object from the death of a loved one and will simply be unable to look at them. However, desire objects that initially take on a significant role in the grieving process are often experienced ambivalently later on.[53] Both Dzejma Pašić's sons were killed in the Srebrenica massacre. While nearly all of the skeleton of the younger son, Muamer, was recovered, only the legs of the older son, Muhamed, were found. Muhamed was about to turn nineteen when he was killed; Muamer, was just seventeen. Of the personal items recovered, Pašić says, "I was thinking of giving [donating] these cards, the letter, and the pictures because I can never look at these. I try to take them, then I put them back . . . I can't look at them. I was thinking of giving them [to a museum] because after I die there is nobody [to care for them]. When we die, maybe everything will be thrown away."[54] Gordon Haberman, the father of Andrea Haberman, who died in the World Trade Center attack, donated his daughter's personal belongings found at Ground Zero to

the National September 11 Memorial & Museum. He says, "These are not the happy things you want to remember someone by."⁵⁵ For many grieving relatives, who often have little to remember their loved ones by, donating desire objects to a museum is difficult. In the trauma literature, one understanding of this situation is that the traumatized self's prolonged attachment to the material traces of a difficult past reinforces silence and prolongs trauma. This attitude can create a desire to get rid of desire objects.

On one hand, some individuals, like Meva Hodžić are not willing to or capable of donating precious desire objects. Meva has a tobacco box, a rusty Swiss Army knife, and a key, all of which are covered with bits of clay. She keeps the crumbled clay, too, because it is also a kind of relic, coming from the mass grave where her husband's body was found after he was killed by Serbs as he was fleeing, carrying the three objects. "It [the clay] belongs to these items and they should stay together. I was asked to give all this up for a museum of items found in mass graves," she says. "But, no, how can I do that if it's the only thing I have left from him?"⁵⁶

For others, with the passing of time, donating desire objects is seen as the only option against the biggest enemy of them all: oblivion. All who have lost loved ones in an atrocity face this ontological dilemma: after the living family members die, the entire existence of those who were killed is in jeopardy; in a way, the killed die a second time. Hence, donating desire objects can also be a crucial part of the meaning-making process in the face of a horrific atrocity. In public spaces, desire objects are assigned the role of witness, providing testimonial to a brutal event. Ahmed Hrustanović, the Bosnian genocide survivor mentioned earlier in this chapter who was so attached to photos and letters belonging to his deceased father, eventually decided to donate some of them: "I decided to donate these letters and some of the photos to the museum. I have already given some originals and I will give some copies [of others]." Hajra Ćatić never found the body of her younger son, aged only twenty when he was killed. More than two decades after

his death, she is still searching. She says, "I have his wallet, I have his vehicle registration certificate. In his wallet was an ID card belonging to my son that I couldn't find. Well, I only have those things, I have nothing more. I'll donate everything to the museum. It is of great importance that everything is collected in one place, that means a lot."[57] Amra Begić Fazlić, who lost her father, Resid, during the Srebrenica massacre, did not know how to protect her father's belongings and subsequently donated them: "I donated my father's last letter, wristwatch, and glasses that were sent us via Red Cross vehicles."[58] Personal documents, clothing, and photos belonging to Azem Delić, a father killed in the Srebrenica genocide, were recently donated to the Srebrenica Memorial Center, along with a belt he had made for his son Muhamed. "The items belong to the Srebrenica Memorial Center because they speak most about those killed if they are close to them," says Muhamed.[59] Zejneba Mešić, whose husband's body was found in 2002 in the Lazete mass grave in Bosnia (discussed in chapter 4), donated her husband's watch because "he is no longer here, but at least his belongings remain to tell his story."[60] Rejha Ademović's husband, Hakija, and her sons, Nezir and Muamer, were killed in the Srebrenica massacre. She remembers vividly the last words she said to her older son, whose remains were never found. "Put your jacket on son, you'll be cold." After twenty years of keeping them, she decided to donate some shoes and a jacket to the archives of the Srebrenica Memorial Centre for permanent retention and to honor her loved ones.[61] Ajiša Džananović donated a booklet, wallet, and workbook belonging to her son, Halid, who was also killed in Srebrenica. She says, "I am happy that there is a place where the things of our loved ones will be kept. Who else would take care of them when we are gone?"[62] Nura Vranjkovina's husband, Mehmed, was another victim of Srebrenica: "When I said goodbye to my husband, he told me, 'Here's my watch, give it to our child, so my grandchildren can have something that is mine.' I told him, 'Give it to them when you reach free territory,' to which he replied, 'I won't.' Along with the watch, he gave me a wedding ring."

She donated her passport and a picture of her husband to the Srebrenica Memorial Center archives for permanent retention because it is important to her that the items be there, close to her husband's graves and where she will be buried one day.[63] Some, like Begajeta Nukić, want to have something, anything, of their loved ones to display. For twenty-five years, Begajeta preserved a pair of her husband Sead's pants, the only thing left that had belonged to Sead, who tried to escape by fleeing through a forest from Srebrenica to Tuzla. Sead's corpse has still not been found, though Begajeta and her two children are still hopeful it will be some day. Although her only remaining possession of Sead's, she ultimately decided to donate them: "I brought these pants; I thought he would cross [the forest], that he would come to Tuzla. But he didn't come. I waited for him a [long] time. I am still waiting for him today and I am hoping . . . and then, after so many years have passed, he is gone, he is gone. . . . The museum opens down there, there is nothing of his, there is just a name on a plaque in Potočari. Well, I wish this to be there with his name."[64] Džemila Džananović donated two watches to the Srebrenica Memorial Center. She says, "My husband's and father-in-law's watches are the only mementos I have left of them. I have been carefully holding onto them for years. When the Memorial Center launched an action to collect the items, I decided to donate them." The watches have a symbolic meaning for Dzemila: time has stood still for her since 1995.[65]

When desire objects are donated to a museum, they become agents of authenticity, which makes them extremely emotionally powerful.[66] At first glance, the display of desire objects in a museum space can be easily seen as serving the human rights discourses of "never again" and "never forget." As discussed, many people align their justification for donating desire objects with Behija Hodžić's reasoning for giving away her most precious treasure: "I donated my father's razor to the Memorial, as well as a photo of the clothes in which he was found. The razor was found next to his body. I hope that the evil committed never happens again."[67]

For both family members and the wider community affected by an atrocity, the personal items recovered represent and express desires: a desire for justice and a desire that such events will never happen again. Desire objects oblige those who encounter them never to forget those who have been lost or the events surrounding their deaths— and to learn from what happened.[68] Although the messaging of "truth," "justice," and "never again" resonates deeply and demonstrates the ideological proliferation of human rights, at the same time, other messaging and another justification for donating desire objects are also put forward—those of a nationalism that frames the logic behind donations in terms of "us versus them." This is not just a semantic issue but instead points to the process of redefining and reimagining a nation and nationhood. As Rogers Brubaker and Frederick Cooper, Siniša Malešević, and Max Bergholz rightly state, national identities are not living things in the world but a *perspective* of the world.[69]

Upon donating a photograph of her husband Mahmut's clothes, a wooden cigarette case he had made himself, his ID card, and his military ID, Mevlija Smajić said, "I want *our* children and all visitors to be able to see what *we* went through, how many people were killed. That is the only truth, and that is why this is very important to me."[70] Hava Mustafić donated her husband Behadil's tobacco box: "I can only hope that no one will ever experience the horrors *we* have survived."[71] The language used by Mevlija and Hava is itself a display of power between "us" and "them."[72] From the perspective of Randall Collins's interaction ritual theory, the shift from "I" to "we" talk is contagious in that it legitimizes communities of inclusion and exclusion and delegitimizes others.[73] It creates and reaffirms identities rooted in categories of ethnicity, religion, and nation. Though subtle, such language clearly points to the process of reimagining and reassembling communities of suffering. This process, however, never happens in a vacuum. In fact, it is an extension of preexisting nation-state infrastructures. Razija Hrustanović, who lost four family members and donates photos of them, says, "This is all I have left of them, and

it's important to me that they are preserved as a memory of their lives and sacrifice."[74] Ramiza Bešić donated the only remaining copy of a photograph of her father Ramiz's clothes, which she received during the identification process of the International Commission on Missing Persons. Ramiza gave it to the archive of the Srebrenica Memorial Centre for permanent retention. She says, "I want to hand this over to the museum so that it can be displayed, so nobody forgets what happened and so that the truth can be seen. That's all I have."[75] Evoking sacrifice and suffering and singling out a particular community (i.e., any concrete ethnic, religious, or national community) create a context for a narrative that is significantly different from the one that individuals hold, and, consequently, desired moral order. To put it simply, it is the difference between saying "never again" and "never again *to us.*" These statements project very different moral orders: one in support of the human rights vision, the other grounded in nationalist thinking.

CONCLUSION

The vignettes presented in this chapter demonstrate the various and unique trajectories of desire objects. Most will disappear just as their owners did. Some will find their way to courtrooms, and some will reach family members. But only very few will enter public spaces. Once on public display, their value and inscribed meaning are suddenly altered. Desire objects that survive conflict invite artistic and commemorative refashioning. In the public sphere, they are no longer limited to the strictly personal meanings of a familiar group of users but come to represent collective values promoted by writers, artists, museum curators, and memory activists. Desire objects directly connected to death and violence are highly sought after because they have the ability to excite the imagination and inspire storytelling.

Desire objects, regardless of how unique they appear to be, do not tell a story. Only people, who ascribe them emotions and context, can tell their story. But what story will be told, and how this story may generate symbols for discourses and subsequently represent ideological worldviews, is not straightforward. Objects do not a priori become symbols. Most often, they do not transcend their materiality and function and simply remain "stuff." Stuff with a definite lifespan and limited emotional attachment. Yet some objects acquire a unique quality that, in unprecedented ways and through human–object relations, not only shapes interpersonal networks but also, at times, gains the power to create intercommunity relations and even to influence ideological mindsets.

However, in order for desire objects in the public sphere to generate emotional energy in those with no direct link to the biographies of the objects, the objects must be "narrated" and their context carefully constructed to intensify the emotional responses of wide audiences. But that is not the only change that occurs once desire objects move from the private to the public sphere. With their public appearance, their authenticity and their "burden of witnessing" alter their social value. Because desire objects possess certain innate qualities, such as the embodiment of the link among death, the living, and violence, their authenticity can be verified, and when put on display in public spaces, their significance changes. People's perceptions of desire objects are dictated by the meaning-making processes involved in their public narration and discursively shaped by the flow of emotional energy generated by various audiences.

In this chapter, I have attempted to demonstrate how the market for desire objects has been shaped in relation to the human rights memorialization agenda of moral remembrance but also how it has sowed the seeds of nationalism. The value of desire objects is created and sustained based on their authenticity and their direct link with death, the deceased, and violence. Hence, their move from the private to the public realm expands their value. In the next chapter, I will

describe how the market for desire objects and the transition from private to public spaces affects the ability of desire objects to generate emotional energy and further alter their value. The key questions I will address are as follows: What happens in an encounter between desire objects and an audience? What discourses are produced and replicated? What is lost in translation? Under what conditions are desire objects transformed into symbols that can promote certain ideological worldviews?

6

THE THIRD CIRCUIT

Public Display, Moral Labor, and the
Discursive Value of Desire Objects

Hava's husband Behadil (b. 1957) and son Osman (b. 1980) experienced the fate of many men from Srebrenica—they were killed in an attempt to reach free territory. They were found in the same mass grave. She donated her husband's tobacco box to the archives of the [Srebrenica Memorial Center].

Some desire objects end up in public spaces. However, those spaces, such as museums, differ significantly from the places where the objects were recovered, although exhibits are sometimes designed to recreate the same environment. The desire objects that reach public spaces have already acquired an initial value as objects embedded with innate features of violence, death, and destruction and potent with emotional energy, and they have been perceived through particular biographies. Once transferred to the public sphere, they gain a social value that goes beyond their unique significance to the family of the deceased, becoming artifacts of worth for a wider community. Now that they are artifacts of public importance, their symbolic value changes—from having value as a tool to identify remains or provide evidence of an atrocity or having emotional value for grieving families to having value as objects that transcend such immediate and private linkages to become meaningful to a wider audience. This transformation comes as a result of what

is perceived as their biggest virtue: authenticity. Authenticity, broadly understood as a "reliable, accurate representation," demarcates a new set of virtues for desire objects, first and foremost truthfulness.[1] Because of their authenticity as objects that carry traces of the people, places, and events associated with an atrocity, desire objects in public spaces are ascribed the virtue of "witnessing."

Once they enter a public space, their uniqueness is recognized as having value to the broader public. Because of their authenticity, desire objects are singled out as artifacts that transcend their simple materiality. This authenticity is perceived as a nexus between the spatial and temporal dimensions that provides a rare window into being simultaneously both here and there, both now and then.

However, as the value of a desire object grows in the public sphere, its emotional potency decreases. It has lost its contextual surrounding. Reinvigorating its narrative potential thus requires some manipulation. Without such efforts, they are in danger of becoming ossified artifacts no more important than any other dead thing.

It is important to stress here that to clearly describe the divergent trajectories of desire objects and the changes in value and in the emotional energy they generate, I am making some generalizations that overlook the (sometimes substantial) differences in museum spaces. Generalization allows us to apply knowledge from one situation to others. My intention is not to focus on one particular exhibit or museum but to illustrate the patterns in how museums communicate atrocities for the sake of conveying significant ideological concepts. As mentioned in the introduction, I am invested not in one particular object but desire objects as a category. I am interested in how they forge distinctive patterns that result in a broader ideological infrastructure that wraps human–object relations in a particular ideological coating. The memorial museums and sites of dark tourism addressed here are purely illustrative but have been chosen because they all belong to the category of museums that aim not only to narrate atrocities but also to convey certain messages about future desired

moral orders. In other words, they all try to educate their audiences in such a way as to direct their social engagement ideologically. Hence, the variations in how museums display desire objects are irrelevant as long as they point to the same structural logic of ideological messaging. Artistic and aesthetic choices naturally vary, but my claim is that all memorial museums and sites of dark tourism attempt to engage their audiences emotionally and encourage them to undertake extensive moral labor. By staging desire objects to generate as much emotional energy as possible, they hope to direct visitors' meaning-making processes regarding future moral orders. We have ample evidence to demonstrate how emotional energy shapes moral labor. The public display of desire objects increases their discursive value and tells visitors how to talk about them but does not reveal the ideological worldviews visitors will apply to their meaning-making processes. People may reference desire objects to spark political change, but only by examining the political action that follows can we understand which ideological visions of moral order have been adopted.

PUBLIC SPACES

Museums and exhibition spaces that aspire to provoke social change and empower human rights rely on desire objects. Therefore, their placement is carefully calculated to create a very particular reaction from visitors. As the goal of desire objects in this context is to trigger an emotional reaction that leads to knowledge production and discursive reflection aligned with the norms and values of human rights, these objects must be recontextualized and their value amplified. Their reimagining extends to how visitors engage physically, mentally, and emotionally with the items on display, how visitors perceive the venue and its location, and how interpretative tools and systems are used.[2]

Memorial museums, in particular those associated with massive human rights abuses, differ from traditional history museums in

several important ways, most notably in their dual mission to impose a moral framework for and contextual explanations of a violent event. Such spaces go against what is usually a major task for museums: reaffirming a well-established cultural and national mythos. Ideally, their mission goes beyond simply collecting, preserving, and interpreting the history of a particular historical event. Their dual mission causes curators to employ various techniques not only to educate the public about a particular historical event but also to change the way their audience understands that event, both cognitively and emotionally. Therefore, many techniques are used to amplify discursive messages, including the use of graphic imagery, extensive photo-documentation, video- and audio-recordings, written or recorded personal stories, and of course artifacts and the recreation of authentic spaces. Museums use significant human and financial resources to design exhibits and events that will appeal to visitors' need to have "something going on."[3] A variety of experts, such as curators, historians, anthropologists, sociologists, artists, architects, and marketing advisers, are often employed to create the "ultimate" experience for visitors and to evoke strong emotional responses in them. As museum visitors demand constant stimulation (beyond cognitive input), curators employ a wide variety of technological, educational, performative, and theatrical tools (and tricks) to encourage emotional labor and to create and harness emotional energy that can be translated into discursive and normative change.

To achieve that goal, all aspects of an exhibit are planned to the tiniest detail—where desire objects will be placed, how thick the glass of display cases should be, what font and font size should be applied to the text narrating the exhibit, whether colors should be highlighted or obscured, how motion and stillness should be contrasted, how the various desire objects on display should "communicate" with one other, how the flow between spatial sections should be designed, how the space should be divided, how all components of the exhibit can best be used to enhance the narrative flow, what visual and other

effects should be used to generate a strong emotional response, and how emotional responses should be sequenced—everything is calculated to simultaneously attract visitors and give them a worthy emotional experience, potent with a transformative effect.

Placing desire objects in spaces often viewed and experienced as controlled, safe, and sterile means that they must be manipulated to create the desired effect, emotional response, and narrative construct. Their display, together with other desire objects and artifacts, and the distancing from their biographical route, also displaces their value of authenticity by taking away their uniqueness. The tension of being valued for their authenticity and uniqueness while simultaneously being placed together with numerous other desire objects and artifacts, in a context that further dilutes their authenticity and uniqueness, causes desire objects to linger in limbo; thus, they must be grounded and bound by a precise narrative framework. A child's marbles, a muddy shoe, a stained garment: none can stand alone because, contrary to what is often claimed, none tells a story by virtue only of their existence.

Therefore, each desire object, once displayed, needs additional elements to provoke an emotional response, particularly text that narrates their story: what the object is, where it was found, who it belonged to and how they died, and who donated it. Connecting the visual experience with a story has greater potential to create an emotional response than an object on its own. Adding photos of where the object was found testifies to the authenticity of the object, and photos of the objects with their previous owners provide a complete narrative sequence.

Incorporating old photos showing a desire object with its owner in happier times provides a powerful contrast between an ideal and "innocent" past and the violence, death, and sorrow that the displayed object represents. A visitor's emotional and cognitive experience of such a display is the ultimate means of elevating the value of the displayed object. Imagine for a moment seeing a muddy shoe excavated

from a mass grave next to a photo of a man with his parents, his wife, and his children—a photo of an ordinary but happy family. Next to a desire object that represents violence, loss, and death, a photo that represents happiness, calm, and peace provides a stark emotional contrast and thus enhances a visitor's sense of unease. Once placed into a particular cognitive and emotional sequencing, desire objects encompass a full and rounded testimony in which the text that explains the object's biographical trajectory and the staging of the exhibit serve to contextualize the unimaginable loss and the horrific nature of the atrocity committed. Together, they shape the distinct story of what was, what is, and what has been lost.

Of course, a powerful and perfectly tailored narration is often not possible, and other means must be employed to elevate the emotional response of visitors, such as oral testimonials, maps, or three-dimensional models of sites of atrocity. In public spaces, desire objects gain value in terms of their authenticity (if properly narrated) but lose their emotional potential and can no longer stand alone; instead, they become an engine for simulation. Through personalization, with emphasis on giving control to the visitors, as a primary method of improving interaction opportunities, the simulation is carefully tailored to enhance visitors' emotional engagement with the subject.[4] The staging and narration of desire objects must be carefully managed to prevent visitors from feeling either indifferent or overwhelmed. Both present the danger of visitors no longer being able to recognize what is important.[5] Throughout his entire research, Donald Horne argues that projected authenticity can make all kinds of visitable objects "dangerously transcendent."[6] Narrated displays can arouse genuine curiosity about the world or spread their own wanton and material sickness. Hence, the line between exaggeration and saturation on one hand and indifference and passivity on the other is very fine, meaning museum experiences must be meticulously crafted. The idea that museums and exhibition spaces are in the "experience business" is well established.[7] Visitors want to feel a connection with

the environment they are experiencing. Because of this, and because the passive reception of information is no longer viewed as desirable, the goal is to create a "safe" space for manipulated visitors to have prescribed, controlled, and encouraged responses, both intellectually and emotionally.

The arrangement of desire objects in an exhibit influences both their value and their potential to generate emotional energy; consider, for example, the difference between an object situated in a space that replicates the site of an atrocity and one situated on a podium in an empty, sterile space. In fact, the manipulations made to exhibit spaces produce many distortions, inaccuracies, and oversimplifications, particularly because the ultimate aim of an exhibit is to tell a story that is bigger than an object itself.[8] When the individual stories of desire objects are subsumed under the umbrella of collective loss and atrocity, the objects are "upgraded" and become discursive signifiers that mark a desired moral order. However, the use of interpretive techniques, meant to facilitate the production of a desired emotional and cognitive response, also means that visitors must be encouraged to engage in emotional labor and "memory work." But before we examine the emotional and moral labor that constitute the particular discursive value of desire objects, we must understand who the audience is and what their motivations are in visiting memorial museums and sites of dark tourism.

VISITING MEMORIAL MUSEUMS AND SITES OF DARK TOURISM

The tourist is bad news for morality.[9]

Not all visitors to memorial museums and sites of dark tourism consider themselves tourists. However, a visit to such places always encompasses leisure and entertainment as well as and education and moral duty.

Zygmunt Bauman considers the persona of a tourist or a visitor to be an allegorical figure: an "every person" of postmodernity allegedly seeking a bit of excitement, entertainment, and fun.[10] Yet such a figure—the "promiscuous, amoral tourist"—fails to explain visits to places that are decidedly not fun, places that prompt critical reflection and somber remembrance.[11] In opposition to such imagery, Jim Butcher defines the "new moral tourist" as one who consciously seeks to mitigate against what are perceived to be the exploitative and harmful effects of mass tourism on host environments and cultures.[12] According to Butcher, new moral tourists promote and participate in alternative forms of tourism. Contrary to Bauman's belief, moral tourists, or dedicated audiences, are concerned about and aware of many current social and global issues and seek to feel involved in them. This new type of tourist can thus be linked to what Michael Rothberg defines as the "implicated subject," one located among the perpetrator, bystander, and victim and poised to question the complex direct and indirect connections to both histories of victimization and perpetration.[13] The concept of the implicated subject describes how people around the globe perceive their own place in the historical and political responsibility for massive human rights abuses within the particular intersection of power and justice. In other words, people became increasingly invested in their place in "markets of suffering" and their roles in them.[14]

However, to sustain a global engagement aligned with massive human rights abuses and their links with social justice in competing and saturated markets, the audience, whether local residents or international travelers, must be attracted and lured in. An interactive, authentic experience of proximity to death, violence, and destruction that offers the promise of a strong emotional imprint is often packaged as a "tourist attraction," a must-see destination that combines educational, moral, and emotional thrills. But visitors are also consumers, whose money spent should deliver an equivalent value. Therefore, the new moral tourist, or implicated subject, one who consciously grapples with and accepts their implication, is embedded in

the mixture of tourism for entertainment and tourism for education, moral engagement, and activism.[15]

The volume of educational tourism, which attracts numerous visitors worldwide, is large and continuing to grow exponentially. Data from the United States give an indication of the increase in the number of museums and in museum visiting over time. For example, in 1988, of 8,200 museums, 75 percent had been founded since 1950 and 40 percent since 1970. In the 1970s, nearly 350 million visits per year were made to American museums; by 1988, this figure had reached 566 million.[16] According to Michael Zils, by the end of twentieth century, there were some 40,000 such institutions worldwide.[17] And it is estimated that, in the mid-1990s, there were more than 19,000 museums in European Union countries, attracting about 370 million visits.[18]

Each year, large numbers of students and educators participate in activities at sites of dark tourism as part of educational field trips, including sites such as Hiroshima and Nagasaki, various Holocaust museums, the Củ Chi tunnels in Vietnam, the Guba Genocide Memorial Complex in Azerbaijan, and the Jasenovac Memorial Site in Croatia.[19] In 2007, about 1.2 million people visited Auschwitz-Birkenau, and 3.5 million visited Ground Zero in New York City, making it one of the city's top tourist attractions.[20] Ten years later, in 2017, more than 2 million visited the Auschwitz-Birkenau. Aegis Trust attendance statistics show that in 2012, more than 40,000 foreigners visited the Kigali Genocide Memorial in Rwanda.[21] Since its opening in 2011, the 9/11 Memorial at Ground Zero in New York City has attracted more than 37 million visitors. In Ukraine, because of the tense political situation in 2014, general tourism dropped by 48 percent, but in Chernobyl, the site of the 1986 nuclear disaster, tourism is on the rise: 50,000 people toured the area in 2017—a 35 percent increase over 2016.[22]

The central question, then, is as follows: What kinds of discourse do sites of dark tourism, situated within networks of human rights values, produce?

The places associated with death and violence, whether sites of atrocity themselves or secondary sites such as museums, come in many forms. However, what is common to all of them is visitor engagement with death and its representations. Visitors to sites of dark tourism make sense of their experiences through the overlapping and ever-changing relations among their bodies, emotions, thoughts, and social, cultural, and spatial interactions.[23] These sites provoke complex reactions in the people visiting them, and they are designed to have a strong impact on visitors and how they relate and interact with the space.[24] Places associated with death, violence, and massive human rights abuses are discursive formations that can influence or be influenced by perceptions, imageries, and bodily practices, which may bring with them connotations of the ghastly, negative, and destructive but also of the new or exciting.[25] Based on visitor observations and exit interviews, Doreen Pastor has suggested that it is the immediacy of the space that is the most important part of the visit.[26] The spaces of sites associated with death and violence tend to unsettle visitors, triggering shock and anger but also wonder and excitement. Most places of death, disaster, and atrocity negotiate painful pasts, ethically problematic situations, and politically oriented discourses of memory and heritage, as well as strong emotional reactions such as pain, fear, empathy, and catharsis.[27]

These emotional reactions are shaped by individual perceptions and visitors' relatedness to the event in question (i.e., whether they have a personal connection to the event) and by the cultural context. People's capacity for pain, fear, shame, anger, rage, hope, or happiness is randomly channeled through various cultural contexts that influence both individual and collective experiences and display of these emotions. For example, the level of emotional arousal generated by the exhibits of sites of dark tourism varies substantially across cultural contexts: in individualist societies in which "high arousal emotions are valued and promoted," people tend to "experience high arousal emotions more than low arousal emotions."[28] The anthropologist

Unni Wikan compared expressions of grief and mourning in Egypt and Bali, both of which have an Islamic culture.[29] She found that women in Bali were strongly discouraged from crying, whereas Egyptian women were considered abnormal if they did not incapacitate themselves with demonstrative weeping. Other research has shown that culturally embedded perceptions and expressions of suffering, pain, illness, memory, and forgetting that result in silence are far more likely to be effectively therapeutic than "working it through."[30]

However, regardless of one's cultural background, visiting sites of dark tourism can be considered a quest to experience a disaster from a safe place. When visiting such places, audiences can experience a sense of danger and a range of emotions including fear, thrill, disgust, empathy, rage, and hope, often mixed with excitement.[31] Indeed, fear and danger can make people feel alive, and sites of dark tourism allow visitors to engage with death and fear in safety. In many cases, such sites are consciously constructed to enhance such reactions.[32]

However, the "over-spectacularization" of death and violence has been widely criticized as a form of entertainment rather than education. The proximity to the magnitude of death, the thrill and the excitement, do not make visitors more empathetic and moral, or, as Bauman says, "Moral responsibility vanishes when 'everybody does it.'"[33] Similarly, Stephan Hopgood, talking about moral activism, asserts that a "sustainable ethical commitment" is untenable when an experience is reduced to consumption and the audience is a "flash mob" who moves quickly to the next thrill.[34] In New York City, tourists squeeze together against the mirrored panes of the 9/11 Memorial at Ground Zero, and its architect, Craig Dykers, takes pride in that scene: "It's proving a popular place for selfies. If we can get someone to smile or have a giggle at a place of such sorrow, we've done our job."[35] To extend this critique, purposeful visits to places of atrocity and human rights abuses can be seen as yet another component of a branded lifestyle, in which being in the "right places" has its own social capital.

Against this shallowness that comes with consumerism, or what is often called the "McDonaldization" of culture, stands vast research showing how places associated with death and violence shape not only real feelings but feelings that potentially can be extended into a moral action.[36] Several researchers have shown that physical proximity to actual sites of death and suffering engenders empathy.[37] Empathy engagements are likely to be enhanced by the perceived authenticity of a site, which emphasizes the distinction between visits to primary sites, where an atrocity was committed, and secondary sites associated with death and suffering. An experiential space where the "death experience" happens in "real time," whether a true site of atrocity or a convincing replica, shapes a variety of reactions and outcomes.[38] For example, a visit to a Holocaust site may be a prime motivator for a visitor to become more active in the cause of world peace.[39] Such responses to Holocaust sites have also been noted among non-Jewish visitors, even in spatially decontextualized settings such as the Holocaust Museum in Washington, DC, and Shoah sites in Jerusalem.[40] Senija Causevic and Paul Lynch call visits to such decontextualized spaces "phoenix tourism"; at such a site, the place of conflict is reimagined and reconstructed into a place that often performs as an unruly network in which identity is both performed and contested.[41] Sites of dark tourism strive for authenticity because it is essential to engendering empathy in visitors.[42]

IT'S NOT ONLY ABOUT GORILLAS AND BEAUTIFUL LAKES: VISITOR MOTIVATION

To understand how people respond emotionally to sties of dark tourism, we must take a closer look at visitor motivation. How and why do they decide to visit places of death? Here, it is useful to start with Yaniv Poria, Arie Reichel, and Avital Biran's[43] classification of tourist motivation, which identifies three types of visitors to historical sites.

Although designed to address tourism in general, it is also largely applicable to dark tourism. The three types of visitors the authors identified include those motivated to feel connected to history, those motivated by a desire to learn, and those with no particular motivation. The authors argue that visitors' expectations are closely linked to their perceptions.[44] Key motivators for tourists are relaxation, knowledge seeking, and family bonding; thus, tourists may experience both a psychological motivation to find an escape (and thrill) and a social motivation to seek knowledge or bond with loved ones.[45]

Visitors to sites of dark tourism have several motivations, including the desire for a new experience or adventure and the desire to gain knowledge and understanding of an event with which they are unfamiliar.[46] The psychologist Sheila Keegan, an expert in cultural trends, says that what people want to get out of a holiday has expanded: "People want to be challenged. It may be voyeuristic and macabre but people want to feel those big emotions which they don't often come across. They want to ask that very basic question about being human—'how could we do this?'"[47] Other motives, such as voyeurism and sensation seeking, can also lead tourists to disaster sites.[48] The fact that motivations other than education are often involved is apparent in a Tripadvisor review that described the Auschwitz-Birkenau State Museum experience as "fun for the family" (the company was later forced to delete the review and apologize for allowing it to be posted in the first place).[49] A. V. Seaton and J. John Lennon have identified two main motivations for visiting sites of dark tourism: schadenfreude (i.e., taking pleasure in others' misfortune) and thanatopsis (i.e., the contemplation of death).[50] However, although death is a crucial part of the story at such sites, it is not always the driving force behind people's motivations for their visits.[51]

William Miles has proposed distinguishing among dark attractions by classifying them according to several "shades" of darkness.[52] The "darkness" of an attraction is often defined by its authenticity and its temporal distance from the event. In addition to the performativity

of the authenticity of a site, the amount of time that has passed since the event contributes to the perception of how dark a site is. Sites focused on more recent events are considered darker than those focused on more distant events owing to the greater level of empathy shown by tourists toward the victims.[53] Richard Sharpley has created a similar typology that compares the consumption and supply of dark tourism.[54] In this typology, dark attractions are categorized into one of four quadrants ranging from "pale" to "dark" based on the extent to which interest in death is expressed in conjunction with how supply is directed toward consumer fascination. Sites focused on recent events or potent with contestation are thus regarded as darker; their temporal (and often spatial) proximity and contestation are considered better able to incite emotional reactions than sites focused on more distant and less potent events; thus, such sites are considered more effective at motivating visitors to get involved in various social issues. Clearly, visitors' interpretations of dark tourism are influenced by their personal backgrounds, the passage of time, and how sites of dark tourism are projected from the supply side.[55] Thus, it is important to differentiate heritage tourism, which is also based on interpretation and a need for authenticity, from dark tourism. A key point of differentiation between the two is that dark tourism is often associated with an atrocity.[56] Or, as the previous Hotel Rwanda manager, Marcel Brekelmans, says, "It's not only about gorillas and beautiful lakes. Something happened here and everything you encounter here on a daily basis has a history."[57]

MORAL LABOR AND STAGING DISCURSIVE VALUE

Emotions play a key role in encounters between visitors to sites of dark tourism and desire objects. Emotions can be understood as "a complex psychological phenomenon that motivates us to behave in a manner

consistent with our social beliefs about specific situations and which may also influence our decision making."[58] An emotion is a complex mental and physical phenomenon often directed toward a specific entity and defined by intense and subjectively experienced feelings.[59] Emotions can also be defined as intentional actions, ambiguous, of high intensity, and of brief duration.[60] However, human beings are tactile creatures who tend to express their emotions through physical interaction, which is always context dependent.[61] Most scholars differentiate between affect and emotion. *Affect* is a broader and more basic form of feelings considered in terms of ranges of arousal (from calm to agitated) and valence (from pleasant to unpleasant). *Affect* is also defined as an other-than-conscious potentiality that can be brought to the surface with an intensity that, when spiked, can be perceived as emotion. Further, affect is a politically crucial subject for understanding sociospatial processes.[62] Affect is unconscious—below, behind, and beyond cognition—whereas emotions are personal and social projections of an individual feeling: conscious, experienced, and expressed.[63] Affect differs from emotion in degree of intensity, rather than essence,[64] and when an affect is felt so intensely that it becomes consciously perceived, it becomes an emotion. However, regardless of whether emotions and affects can be considered separate entities, they are always experienced relationally and in connection with the body and its responses.[65] Encounters with death and disaster are shaped by intense affective engagements that are often processed as emotions, which are at the heart of dark tourism.

Once situated in a dark exhibit space, the audience is invited to engage in emotional labor. They are encouraged to interact with the environment, which, in has been staged to elicit affect and emotional energy. As the most intense emotions are often associated with violence, death, and unexpected, traumatic events, the audience may experience a wide spectrum of emotions. Intense emotional reactions are visible and often followed by behavioral and physiological changes such as an increased heart rate, muscle tightening, difficulty breathing, and an increase in adrenaline.[66]

Visitors to sites of dark tourism have various motives, move through exhibits in various ways, and interact with and react to the surrounding environment and other visitors in various ways. However, the site's emphasis on death, destruction, and violence is what encourages people to engage in emotional labor. For example, domestic visitors to the Jeju April 3rd Peace Park in South Korea, which commemorates the deaths of thirty thousand local residents at the hands of the government in the late 1940s, express feelings of fear, sorrow, sympathy, depression, and appreciation.[67] In a 2015 study of heritage museums, which collected responses from 137 people working in the museum and heritage field, as well as 190 visitors, two questions were asked: "Do emotions play a significant role in how these are created?," and "Do museums specifically target certain emotional responses?"[68] The authors found that emotions are indeed significant in this context and that they are closely connected to a need for personalization because it plays a significant role "in an individual's approach to learning and engagement . . . regardless [of] whether they are positive or negative experiences."[69] As explained by John Falk and Lynn Dierking, the visitor's experience is not just the result of interactions with the exhibits but the sum total of their constructed personal, social, and physical contexts.[70] Visitors do not catalog visual memories of objects and labels in academic order or in conceptual schemes, but they absorb events and observations in mental categories of personal meaning and character determined by events in their lives before and after the visit. As highlighted in Randall Collins's interaction ritual theory, it is really the excitement caused by the mutual presence of people within an exhibit space that furnishes a potential emotional weight, which, bit by bit, is reinforced as the gathered people begin to gain a mutual rhythm in a coordinated and synchronized manner as they follow repertoires of action regulated by a set of explicit and implicit prescriptions.[71] These prescriptions are crucial for setting the tone of both action and emotion. Emotions rise and transport those who participate in a ritual to a different world, away from their daily routine, transmitting to them the sensation of

being in contact with something "sacred," which they themselves are helping to create.[72]

What matters here is that the seemingly voluntary emotional labor with which visitors are burdened also synchronizes and homogenizes the emotional energy charge generated. This is not to say that all visitors will have the same emotional reaction to an exhibit, but the emotional labor involved sets clear boundaries regarding how to appropriately engage with sites of dark tourism. A certain unspoken etiquette applies in these settings, which the mutual emotional labor of visitors further emphasizes. Not only are some behaviors and emotional responses considered unacceptable (e.g., eating, laughing, sobbing loudly), but visitors' behavioral and emotional responses are also compartmentalized to encapsulate the "darkness" of the environment. People are influenced by socially mediated mental constructs, or social representations, that serve as the basic cognitive units for making sense of the world around them and constructing their reality.[73] However, as mentioned, emotional responses are always related to the individual positionality of the audience. For example, Black visitors to slavery-era sites on the coast of Ghana have been found to experience stronger and more personalized emotions than their white counterparts.[74] Similarly, the feelings of pride and a sense of loss among Australian visitors to Gallipoli, the site of a World War I military campaign, were reported to be especially animated during cemetery visits and when in the presence of other Australians.[75] At the Australian convict-era site of Port Arthur, the strongest emotions were generated when visitors learned about the on-site massacre of thirty-five people in 1996.[76] Visits to such sites elicit strong emotional responses, which can be induced or amplified by exposure to catalytic displays and through the emotional contagion effect.[77]

The Kigali Genocide Memorial in Rwanda comprises three exhibition spaces: the main historical exhibition, a children's memorial exhibition, and an exhibition on comparative genocide called "Wasted Lives." An analysis of the content of the 2012 visitors' book

suggests that a wide range of emotional and cognitive responses have been experienced by visitors.[78] The analysis of more than one thousand records of individual experiences examined how emotions and cognitive responses are shaped by cultural, religious, and societal traits. Sympathy was experienced by 3 percent of male and 2.9 percent female visitors, grief by 2.7 percent of male and 3.9 percent of female visitors, and hope by only 0.5 percent of male visitors and by no female visitors. These low figures are contrasted by a response rate of 7.2 percent for male and 7.4 percent for female visitors regarding feelings of remorse. The feeling most experienced by visitors—19.8 percent for male and 27.5 percent for female visitors—was a need for prayer. These included prayers for the resurrection of victims, for peace, and for forgiveness from God for sins committed and the wrongs of genocide. Instead of internalizing an active role they might play in their society, visitors regularly allocated agency to God. "May God forgive us from our sins and help us heal and live at peace with one another"; "Lord Jesus Christ remember the innocent deaths of your people. May their souls rest with you in peace. Bless Rwanda"; "May God give you the ability to forgive"; and "May the Lord grant all victims the ability and strength to put this behind you" are examples of commonly expressed sentiments in the visitors' book.[79] With cries expressed in religious terms, such as "Never! Never again! May Allah bless the souls," visitors articulate their wishes not only for Rwandans but for all of humanity.[80]

How visitors to sites of dark tourism display emotional energy and engage in emotional labor are key considerations for these sites because these sites have an aspirational capacity for tourism to function as a vehicle for global and bilateral peace. These structured frames of reference, in particular the link between past atrocities and the human rights regime, provide what are considered acceptable guidelines for reacting to and coping with otherwise traumatic or confounding new information.[81] Moreover, sites of dark tourism are meant to forge historical empathy, conceptualized as consisting of

both affective empathy, created by sharing emotional responses, and cognitive understanding, developed through perspective-taking.[82]

While emotional labor is omnipresent in sites of dark tourism, emotional engagement goes beyond simply provoking and syncing a certain emotional response. Visitors are in fact encouraged to do much more. Where Arlie Hochschild's notion of emotional labor is focused on the instrumentality of service jobs (e.g., forced smiles, artificial politeness), here, we see that the audience is forced to engage with the (enforced) morality of empathizing with victims.[83] They are compelled to engage in intense moral labor associated with a particular ideological worldview, which together constitute moral labor. This means that the emotions produced are linked to a particular ideological messaging. Emotions are generated not only for the sake of the experience but also to bridge the imaginary divide between the world as it is and the world as it should be. Moral labor is where emotions become linked to the meaning-making process of a desired world order. Further, moral labor shapes the discursive value of desire objects by telling the audience how to think and talk about them. Moral labor, experienced in spaces of dark tourism, has the potency to be transformed into a set of values that will instigate and advocate for a particular future moral order.

And though we lack precise measures to systematically assess moral labor and its outcomes in memorial spaces dedicated to atrocities, we do have an abundance of data linking visitors' experiences of sites of dark tourism with their emotional responses. Visits to Holocaust sites often generate intense and cathartic emotional responses from survivors, frequently triggered by catalytic moments such as seeing photos of members of survivors' families.[84] It is not a single shoe but a pile of shoes of the killed, displayed with the powerful stories of casualties and survivors, that molds affective responses by creating an awareness of human vulnerability and death and that resonates intimately and viscerally with the audience.[85] A study of German students' narratives of Auschwitz that examined Auschwitz as

an alternative teaching space, revealed that Auschwitz provided the students with learning opportunities, an affirming collective identity, emotional engagement, and moral reflection. Auschwitz was experienced as a moral space imbued with moral judgments.[86]

Such moral judgments, and attempts to link them with the ideological framework of human rights, can be seen across all memorial spaces that link past atrocities and massive human rights abuses with social change. We see, for example, in the Sydney Jewish Museum's permanent Holocaust exhibition on human rights, how Holocaust museums have begun to embody a more self-reflexive museology in an attempt to forge a direct link between Jewish and Aboriginal histories of dispossession, as well as with continuing instances of genocide and mass atrocities in the twentieth and early twenty-first centuries.[87] The Sydney Jewish Museum's permanent Holocaust exhibition allows visitors to explore human rights themes from various perspectives, including those of Indigenous peoples, people with a disability, asylum seekers and refugees, and those who identify as LGBTIQ (lesbian, gay, bisexual, transgender, intersex, or questioning).[88] Hence, from visits to Holocaust sites, we see that moral labor is carefully constructed; exhibits are meant not only to inform but also to provoke emotional, cognitive, and moral responses.

CONCLUSION

The emotional potency and value of desire objects changes as they migrate from private to public spaces. When memorial museums and other institutions committed to promoting the human rights agenda emerged in the second half of the twentieth century, they largely hewed to traditional museological practices and continued to focus on collecting and displaying authentic and unique objects. Thus, seemingly mundane, everyday items discovered at scenes of atrocity (which acquire evidentiary value upon their rediscovery) receive a new life

and gain new value as objects displayed in these new institutions. With the assistance of numerous curatorial, artistic, and technological tools, desire objects play a vital role in the structured sequences of emotional and cognitive narrations of past atrocities. Desire objects also play a crucial part in moral labor, which, in turn, plays a critical role in how audiences talk and think about them. They come to public display through channels with their own ideological underpinnings. Only rarely are visitors able to get a glimpse of their previous journeys and an understanding of why, how, and by whom the objects were donated. Yet their performative stillness, the narrative sequence in which they are positioned, and their careful staging in an environment recreated to appear as authentic as possible all guide visitors in how to incorporate the displayed desire objects into a particular ideological set of values.

However, how diverse audiences interact with and respond emotionally to the objects is not straightforward, being preconditioned by visitors' social, educational, and religious backgrounds, their proximity to the event in question, and their motivations for visiting. Moral labor is staged to harness empathy and tolerance in the context of a particular ideological worldview in the hope of encouraging people into social activism. However, the structured nature of sites of dark tourism, which use tactics of "programming behavior" that "emphasise strategic approaches to achieving positive outcomes for visitors including the provision of a variety of learning strategies" to encourage visitors to adopt a certain moral obligation via carefully narrated exhibits, has limitations.[89]

First, not all desire objects are capable of eliciting strong emotional energy. Hence, it is pivotal to understand why only certain subcategories of desire objects are elevated to the level of being considered potent symbols that can be used for ideological purposes and to encourage political actions. The value of a desire object is measured not by its monetary worth (though that can also change) but by its potential to induce discursive ideological messaging that will provoke

certain political actions. Second, how people forge meaning-making processes around desire objects and consequently a given atrocity, is influenced by the ideological coating of the exhibit, how desire objects and their representations are circulated, and the political, societal, and cultural meanings with which they are endowed.

In the final part of the book, I will focus on one particular category of desire objects—victims' shoes—to explain what happens once desire objects transform from tangible objects into symbols and how those symbols create a discourse that is advanced by various ideological actors and frameworks. Thus, I will explain what is necessary for desire objects to become integrated into political actions meant to claim and restore a desired moral order.

III

MORAL LABOR, POLITICAL ACTION, AND HUMAN RIGHTS

7

OTHER SHOES PAVED THE WAY
On the Circulation of Knowledge

This single shoe, separated from its other half, just one item from 40,000 cubic metres of shoes, has crossed the ocean to distant Australia, to represent the enormity of the genocide perpetrated in the four years that Auschwitz-Birkenau was in operation.

This is an exhibition that tells and reconstructs not only the Death March but also one story within that one great saga, stories about people who returned from the Baljkovica region and who waited for months to cross (to a safe region)[;] some of them lived through the winter and were forced to live in forests and caves. They lived by eating grass and snails, and were subjected to open hunting season.[1]

In 2021, the Srebrenica Memorial Center marked the twenty-sixth anniversary of the Srebrenica massacre by staging an exhibition entitled *Footsteps of Those Who Did (Not) Cross* composed of personal items illustrating the suffering of the victims and survivors of the 1995 genocide. The exhibition contains one hundred pieces of footwear, as well as items that people used in their makeshift refuges, including a handmade stove used for cooking in a cave where some were hiding.[2] The shoes on display are remarkable: they are beautiful and terrifying at the same time. The shoes have been placed under glass and illuminated to reflect shadow steps on a ground of concrete, creating an impression of intertwining steps, indicating presence and

absence. Covered with green moss, they almost look like dormant mythical creatures from an imaginary land.

Just before the anniversary, the Art Gallery of Bosnia and Herzegovina opened a photo exhibition of Armin Durgut's work called *Mrtvare* (*Dead Thing*). In more than fifty photos, the artist presented footwear worn by people running from an attack on Srebrenica by the Bosnian Serb general Ratko Mladić. Most of the shoes, which had come from humanitarian aid supplied by the Office of the UN High Commissioner for Refugees, were discovered along the forest escape route, what became known as the path of the Death March.[3] The name for the exhibition came from what appeared to be common knowledge during the siege of Srebrenica: shoes provided through humanitarian aid were of extremely poor quality. After several kilometers of walking in the rain, the upper part of the shoes would shrink and start to decompose. Hence, the fabric often had to be replaced with tent material.[4] Kemo Hajdarević, who managed to escape the Srebrenica massacre, had worn the *mrtvare* shoes. During his interview for a project on oral histories of genocide entitled *Životi iza polja smrti* (*Life Behind the Fields of Death*), he vividly recalled how, while crossing the Jadar River valley, his shoes had fallen apart, forcing him to continue his long journey barefoot.[5]

But for those with no direct experience of this story, the items in the photos are just shoes. Thus, the question that must be asked is, What in an encounter between a desire object and an observer enables the observer to engage, both emotionally and narratively, with an otherwise everyday object? Given the intimate relationship between humans and objects, a further question is, How does an object extend our personhood? Or, when and why do certain objects become elevated from their mundane function to become an organizing principle in the generation of emotions and the process of meaning-making?

In this chapter, I trace a particular desire object that is also a member of the most prominent category of desire objects: a victim's shoe. The first part of the chapter is dedicated to the desire object category

of footwear. I argue that the intensity of the emotional energy charge to which visitors to sites of dark tourism succumb is dictated by their preexisting knowledge, or preknowledge, not only of the desire object itself but also of its broader category. This is not to claim that visitors to staged environments such as museums necessarily have all the information presented here but to point out that the networks of meanings associated with an object's category are deeply embedded and culturally shared. Thus, all visitors share some collective preknowledge of the meanings of the category of objects they are viewing. In the second part of the chapter, I discuss the trope of victims' shoes: how the category emerged and, most importantly, how knowledge of the category has been widely circulated, both temporally and spatially. This chapter also sets the stage for the "escape" of desire objects from staged environments into political action.

CIRCULATING KNOWLEDGE: ON SHOES AND THEIR MANY MEANINGS

Shoes trigger a multiplicity of meanings that spark our imagination and enable us to navigate various layers of imaginative storytelling. Shoes are both a necessity and a luxury item, meaningless and meaningful at the same time. We associate shoes with comfort, social status, fashion, weather, sport, travel, erotica, (dis)taste, social rituals, gender relations, identity, attractiveness, group membership, and power.[6] As Giorgio Riello and Peter McNeil assert, shoes are and always have been far more than simple coverings for the feet.[7] Hence, a shoe is a commodity, a technology, a personal possession, a nonverbal sign defined in social spaces, a creatively and skillfully crafted material object, and an integral part of a larger sartorial system.[8] Similarly, Shari Benstock and Suzanne Ferriss have demonstrated that shoes go far beyond being simple commodities manufactured and retailed to satisfy physical and functional needs.[9] They come in many forms, are made

from various materials, and serve a variety of functions. As testimony to the importance of shoes, the Bata Shoe Museum in Toronto is devoted exclusively to the history and culture of shoes, to representing the diverse histories and cross-cultural lives of shoes and demonstrating shoes as a commodity and shoes as cultural or aesthetic artifacts.[10]

Shoes are all around us, and many people own many pairs. But despite their ubiquity in our day-to-day lives, they are utterly mundane. To understand, then, how a particular shoe becomes "extraordinary," having the potential to inspire our imagination and generate intense emotion, we must first understand the multiplicity of meanings inscribed in our thinking about shoes.

THE HISTORICAL-SOCIOLOGICAL TRAJECTORY OF SHOES

From archaeological and paleoarchaeological evidence, experts hypothesize that shoes were invented during the Middle Paleolithic period about twenty-six to thirty thousand years ago. In 1991, on the border of Austria and Italy, archaeologists found a naturally mummified human, whom they named Oetzi, who had lived in the Stone Age and died about 3,300 years BCE.[11] The social history of shoes reveals the strict division of society into classes and the changing fashion trends through various eras. Because of the level of craftsmanship required and the cost of materials, a new pair of shoes would be available only to the highest-ranking members of society. During the 1300s, *poulaines* became popular with male nobility. These were a low-cut, flat-soled, slip-on shoes with a pronounced pointed toe.[12] During the Middle Ages, a time characterized by feudalism, the first heeled footwear emerged and were widely used, though worn only by men at the time. Societies were divided into classes that dictated people's jobs and responsibilities, as well as their clothing and footwear. Many new types of footwear also appeared during this period, including

espadrilles, which came to Central Europe from the Pyrenees, and leather boots sewn up at the sole.[13] Spain and Italy played a great role in costume and shoe design in the sixteenth century, and the styles of shoes made in these countries later spread across Europe. Continuing into the Renaissance and Baroque periods, men's and women's shoes remained very similar. However, shoe styles still varied by social class. Peasants and nonnoble townspeople wore heavy, dark leather boots with a heel, whereas the nobility wore more elaborate and more decorative custom-made footwear, meaning each pair was unique.[14] The Baroque period saw a trend among Europe's royalty and elite of emphasizing the shapeliness of men's calves and thighs. Hence, colorful stockings and elaborately decorated shoes became a popular motif. Some shoes had an arched sole and small heel, whereas slip-ons were secured with latchet fastenings and typically laced with ribbons.[15] The first shoe with a distinct heel emerged in Europe around 1575, but the style didn't gain widespread favor until the 1600s. It was not a new invention, however; heeled shoes had been worn as early as the tenth century by Persian cavalry soldiers to keep their feet from slipping out of their stirrups.[16] Shoes for men and women began to differ during the 1700s. Men, spending more time outdoors, wore sturdy, practical shoes, whereas women, often limited to the domestic space, wore less sturdy, more ornamental shoes.[17] During the Renaissance, European kings often wore shoes with very high heels to demonstrate their supremacy. Expensive footwear was key to their performative display: a flash of an intricately decorated shoe, perhaps with jewels, feathers, and elaborate embroidery, might be glimpsed during a dance or promenade. Noble knights were the first to wear ankle boots because they were comfortable for horseback riding and fighting. In the eighteenth and nineteenth centuries, wooden clogs ("sabots") were synonymous with poverty and considered by the leather-shod freeborn Englishmen to be a tangible sign of French slavery.

In modern times, long-established shoemaking traditions were altered drastically because of advances in technology that made the

shoemaking process much simpler.[18] Anthony Barthelemy has described how, during most of the nineteenth century in the American South, brogans (a type of low-quality footwear) were synonymous with slavery.[19] By the beginning of the nineteenth century, men's and women's shoes began to differ more widely in terms of style, color, heel, and shape of the toe. During the Napoleonic era, fabric footwear became popular among the elite. However, the most significant breakthrough in footwear production came during the Industrial Revolution. Inventors and craftspeople in the United Kingdom and North America invented modern footwear sewing machines and began to mass produce fabric footwear.[20] Jan Ernst Matzeliger developed a shoemaking method that allowed about seven hundred pairs of shoes to be made each day. With the emergence of mass-produced footwear, shoes became accessible to everyone. Interestingly, only by the middle of the nineteenth century did shoes for the left and right foot start to be constructed differently.[21] With the mass production of shoes came large-scale importing and exporting, allowing industrially manufactured to be shipped to virtually every corner of the world. One of the world's largest sellers of footwear, the Bata Company of Zlin, Moravia, Americanized its production model and, in response to the Great Depression, managed to become the first shoe company to unlock the potential of globalization.[22] More recently, between 2015 and 2020, between twenty and twenty-five billion pairs of shoes were manufactured annually.[23] The globalization of the footwear market also allowed for racial and ethnic diversity in terms of design and style owing to increasingly sophisticated marketing strategies to gain or reinforce a particular cultural identity at the point of market consumption.[24]

SHOES IN SOCIAL RITUALS

With their functional and aesthetic development, shoes have gained an important role in various social rituals. In many places around the world, shoes have been assigned significance beyond their practicality:

they connect the outside world—a pollution—with the privacy of homes—purity—both literally and symbolically. Therefore, they can assume various religious connotations, as in the case of premodern Japan, where shoes were considered polluting agents but also placed at the center of purification rituals. Martha Chaiklin has analyzed the dualistic principles of purity and pollution within traditional Japanese footwear, architecture, and thought.[25] Paola Zamperini has sketched several centuries of "shoe heritage" in mainland China, focusing on the country's recent ascendancy in global commercial markets, especially those for inexpensive work shoes and designer forgeries.[26] In other societies, religious and moral values have both shaped and been shaped by footwear. In medieval Europe, for instance, moral precepts formulated from the Bible were used to limit the height of shoes and the wearing of luxurious, highly decorated footwear, such as those made of silk and decorated with embroidery and pearls.[27] In many societies even today, shoes have a central place in rituals and traditions.[28] Many Asian countries typically follow the tradition of removing one's shoes before entering a house.[29] In the cultural context of this narrative, shoes are seen as bringing dust into the home, so removing them is "a way of recognizing one's personal uncleanness in the presence of holiness."[30] Removing shoes before entering a house is also common in a wide array of countries such as Bosnia and Herzegovina, India, Japan, Malaysia, and Ukraine. Mary Douglas, in her book *Purity and Danger: An Analysis of Concepts of Pollution and Taboo*, writes about social and cultural systems using evidence of the everyday, discussing the excluded and the prohibited, and argues that shoes, even when new and unused, are captured as a "matter out of place."[31] Hence, shoes often act as filters or barriers marking the imaginary boundaries between public and private, between pollution and purity.

Footwear is also associated with the notions of gender and female beauty. The fashion historian James Laver contends that body parts concealed long enough can serve to gain "erotic capital."[32] Even

before the twentieth century, when women's legs and feet were often kept hidden out of modesty, feet and footwear played an important role in shaping gendered beauty. In her book *Every Step a Lotus*, Dorothy Ko embarks on a fascinating exploration of the practice of foot-binding in China: the custom of breaking and tightly binding the feet of young girls to change their shape and size, creating "lotus feet."[33] Focusing on the material aspects of foot-binding and shoemaking—the tools needed, the procedures involved, the wealth of symbolism invested in shoes, and the amazing regional variations in style—she contends that foot-binding was the most significant bodily experience for women in China at the time. The custom was embedded in the belief that bound feet enhanced a woman's beauty and made her movement more dainty.[34] Small was considered beautiful, so women often bound their feet to make them appear more petite, despite the pain of constriction, which could lead to fainting.[35] However, many researchers of fetishism, fashion, and foot-binding have commented on the practice as equating a women's foot with female genitalia.[36]

And while the relationship between women's feet and notions of beauty and erotica were present in various forms in many societies around the world, these notions were displayed subtly; one could offer an erotic glimpse of a physical part of themselves without fully revealing it. William Rossi explains that the sensitivity of feet to tactile stimulation increases their erotic value, as does ambivalent symbolism involved in the simultaneous desire to ornament and to cover.[37] Shoes also operated as clear markers between genders and of social status. For example, a Chinese woman with perfect lotus feet was "likely to make a more prestigious marriage."[38] In the American nuclear family after World War II, there was a clear expectation for women to abide to stereotyped rules of wearing high-heeled shoes not only in the workplace but even while performing household duties. In an era where feminine carriage became crucial, shoes were notoriously difficult to walk in, yet women were pressured to adopt strict beauty practices as part of their professional calling.[39]

The link between footwear and erotica is by no means new.[40] However, the full exposure of legs and feet throughout the twentieth century put a new spotlight on shoes.[41] By emphasizing the contours of the leg through the increased use of high heels, shoes began to openly link female sexuality with sexual appetite and "temptation."[42] The cumulative process of eroticizing female legs and feet, along with changes in the employment possibilities of women and the sexual revolution, culminated in 1990 in a climate of cultural minimalism in which shoes became mediators between body and place and between self and other in the human desire to situate identity within its realm of experience.[43] For example, for most Americans, their footwear is an extension and expression of themselves and is clearly differentiated by gender, with women being more alert to the symbolic implications of shoes than men.[44] Shoes provide a means of applying sex-typed attributes, and sex differences in the perception of shoes are consistent with traditional sex-role orientations.[45] In the twentieth century, shoes found a new and important space, "whether as fetish, sign, metaphor, objet d'art or collectible."[46] They came to be regarded as "candy for the eyes, poetry for the feet, icing on your soul."[47]

SHOES IN POPULAR CULTURE

Popular culture played an indispensable role in the evolution of shoes, cementing many recognizable meanings across the globe. Cheaper raw materials, new shoe structures, and new lifestyles shifted images of gender various ways. New trends were picked up quickly through popular culture, which linked various fashion styles with perceptions of masculinity and femininity. Popular culture cemented certain gendered perceptions and stereotypes, including romantic and violent perceptions of love, romance, and sex, as well as status signifiers and identity markers, through music, movies, and art. Numerous songs replicated and enforced the multiple meanings embedded

in shoes, including Elvis Presley's "Blue Suede Shoes," Paul Simon's "Diamonds on the Soles of Her Shoes," and, more recently, Jennifer Lopez's "Mile in These Shoes." All such songs use the shoe motif to narrate a range of stories—those of fashion, sexuality, and romance but also of poverty, military service, and "going places."

Famous actors and singers greatly influenced the style and popularity of certain types of footwear. For example, the Beatles popularized Chelsea boots and Audrey Hepburn popularized kitten heels. The popularization and increasing significance of shoes was reflected in the fact that the acquisition of a pair of good shoes has long been held as one of the most important considerations undertaken by any self-respecting male follower of fashion.[48] In fact, male boots figure in a small selection of mainstream Hollywood films as conveyors of masculinity and heterosexuality. Few other garments visually articulate, promote, and certify masculinity in film as much as a pair of boots does; thus, boots are central in genres designated "masculine," such as war films and westerns.[49] From *The Gay Show Clerk* in 1903 to *Clueless* (1995) and *High Heels* (1996), shoes have been central to representing gender differences and gendered interactions in cinema.[50] In *Saturday Night Fever* (1977), accompanied by the music of the Bee Gees, John Travolta walks down the street, paint can in hand, and stops at a shoe shop to compare his cool shoes to the other cool shoes in the window. In *Up Close and Personal* (1996), the journalist Warren Justice (played by Robert Redford) has a pair of boots with distinctive red laces that he uses while on dangerous assignments, which makes it possible for his wife, Tally Atwater (Michelle Pfeiffer), to identify his corpse via satellite link-up. When Tony Stark (Robert Downey Jr.) is getting ready to become Iron Man in the eponymous film (2008), we see his feet being incorporated into the boots of his armored suit. Dustin Hoffman's character in the life-affirming *Mr. Magorium's Wonder Emporium* (2007) is about to wear out the final pair of his favorite shoes and so tells his assistant that it's time for him to die: "Once the shoes have holes, the journey is over."[51] Cinderella's

glass slippers are among the most remembered shoes from Disney movies. In 2015, when a live-action version was released, Swarovski was the jewelry house chosen to bring the legendary crystal shoes to life, which they did with 1.7 million Swarovski crystals. The Nike Cortez sneakers that Tom Hanks wore in *Forrest Gump* (1994) are one of the most famous pairs of shoes in the world; sales of these shoes totaled more than $800,000 in the first year they were released. Marty McFly's auto-lacing sneakers with lights worn by Michael J. Fox in Back to the Future Part II (1989) became so iconic that Nike released a limited edition of them in 2011 and put them back on the market in 2016. In 2018, when Donald Trump banned Irn-Bru from his Scottish golf resorts, Vans released a sneaker in a blue, orange, and white pattern to match the branding of the famous Scottish beverage.[52]

And there are the ruby slippers that are magically transferred to Dorothy's feet from those of the dead Wicked Witch of the East in *The Wizard of Oz* (1939) and give her power. Similar transformations occur in Grease (1978), *Love Potion Number 9* (1992), and *She's All That* (1999). From Ariel's red boots in *Footloose* (1984), Vivian's thigh-high PVC boots in *Pretty Woman* (1990), and Elizabeth's Louboutins in *Bad Teacher* (2011), we can see that shoes have been a mark of individuality, and sexuality, for female film characters for at least the last forty years.[53]

Taking one's shoes off is often used as a symbol of freedom in films. For instance, in the strange town of Spectre in *Big Fish* (2003), shoes are tied together and thrown over telephone line as a reflection of ultimate freedom. In *Barefoot in the Park* (1967), the young uptight lawyer Paul Bratter (Robert Redford) is asked to take off his shoes and walk barefoot through Central Park to demonstrate that he is not a "stuffed shirt."

In the twentieth century, shoes were used as symbols and metaphors in numerous artworks. From William Nicholson, who was particularly interested in the revelation of personality through clothing, and Meredith Frampton, who used red shoes to contrast with the austere coldness of a white dress and flowers, to Allen Jones's

pop art–inflected *Wet Seal* (1966), in which the thin spiked heel of a stiletto is indistinguishable from the fabric of a latex-clad leg and buttock, epitomizing their sexualized potential, shoes have featured regularly in various forms of artwork.

Many artists have used the vast potential in the multiplicity of meanings embedded in shoes to reflect on the social realities around them. For example, throughout the 1950s, Andy Warhol made numerous advertisements for a shoe manufacturer. Diane Maclean's *Shoe* (1995), in which she created a monumental sandal from pine rods and galvanized steel, was made for the Scottish Sculpture Open at Kildrummy Castle.[54] Sexual power is articulated in a rather different manner in the many equestrian and military paintings and statues that feature soldiers, hunters, or men of fashion whose boots were cherished and their high gloss maintained at some expense.[55]

In fact, art history is rich with such examples.[56] Even before the twentieth century, shoes were used in various forms of art to depict issues of social class, desired beauty and eroticism, fashion, and gender relations. In art up to the twentieth century, shoes were also important as part of a costume or as props in erotica.[57] For example, the flamboyant rococo style produced a highly sought-after item: the Pompadour court shoe.[58] The shoe was notoriously difficult to walk in, being backless with a precariously curved high heel. The pink satin slipper flying through the air from the foot of the swinging woman in Fragonard's erotic masterpiece, *The Swing* (1767), illustrates the fascination with the Pompadour shoe, using the stray slipper as an allegory for the woman's sexuality and lost innocence. The popularity of footwear as a class of objects first occurred to Van Gogh, who painted a worn pair of lace-up boots in *A Pair of Boots* (1886).[59] My purpose in providing all these examples is to demonstrate how often shoes have been and continue to be used as representations of a variety of aspects of past and present realities.

Shoes are also often used in vernacular expressions and as such can teach us about their cultural meanings. Common sayings such as

"to walk a mile in someone else's shoes," "leaving footprints," "getting one's foot in the door," and "having one foot in the grave" show how closely cultural meanings and cultural representations are connected and how salient shoes are in our day-to-day realities.

THE TROPE OF VICTIMS' SHOES: THE EMERGENCE OF THE CATEGORY AND ITS CIRCULATION

We are the shoes, we are the last witnesses.
We are shoes from grandchildren and grandfathers.
From Prague, Paris and Amsterdam,
And because we are only made of fabric and leather
And not of blood and flesh, each one of us avoided the hellfire.

—MOSES SCHULSTEIN, "I SAW A MOUNTAIN"

Although shoes have made their mark on a good portion of human history and have carried multiple meanings beyond their mundane function, victims' shoes became significant markers of death and destruction only after World War II, particularly in relation to the Holocaust. In this context, shoes represent the absence of the humans who once wore them, their materiality a metonym for a corporality obliterated.[60]

The enormous piles of shoes found after the liberation of the concentration camps, photos of which were shown at the Nuremberg trials, had a profound impact in relaying the scale of the horror of what transpired during the Holocaust. An eyewitness report from the Majdanek concentration camp in Poland after its liberation described a storehouse at the site: "It was full of shoes. A sea of shoes. I walked across them unsteadily. They were piled, like pieces of coal in a bin, halfway up the walls."[61] The empty shoes of Holocaust victims bear

silent witness to the systematic attempt by Germany and its collaborators to exterminate the Jews of Europe, as well as other groups of people the Nazis deemed threatening or inferior.[62]

Once testimonials of the volume of the atrocities committed began to surface following the end of the war, the horrific trajectories of victims' shoes came to light. Their biographies, including the distinct ways they were collected, categorized, and distributed, show the dark side of the human capacity for destruction. Shoes became a thin line between life and survival, between death and disappearance. For example, German troops gathered the clothing and other belongings of the dead to be sorted, and repurposed, often by Jews forced to live in ghettos. A chronicle of the Lodz Ghetto from September 1943 with the heading "Old Shoes" reads as follows:

> More old shoes have come into the ghetto. Twelve freight cars had been unloaded as of September 5. The old-shoe warehouse will be busy for many months just sorting out this vast quantity. Think for a moment of the various categories that need to be dealt with: (1) leather and other shoes; (2) men's, women's and children's shoes; (3) right shoes and left shoes; (5) whole shoes and half shoes. Finally—and this is the hardest job of all, the matching pairs have to be ferreted out. Considering the mountains of second-hand shoes, one can hardly believe that such a job is possible.[63]

Similar stories were told by Abraham Bomba, a Treblinka survivor, who was ordered by the Nazis and their Ukrainian cohort to carry bundles of clothes, shoes, and other things to sort the valuable and reusable items.[64] In an untitled poem written in the Vilna ghetto on July 30, 1943, Abraham Sutzkever identifies a parallel between the arrival of shoes in the ghetto with the disappearance of the people who had worn them: "Once, through a cobblestone ghetto street, clattered a wagon of shoes, still warm from recent feet, a terrifying gift from the exterminators. . . . And among them, I recognized

my Mama's twisted shoe, with blood-stained lips on its grappling mouth. . . . The shoes, what's left of them, stand in for, take the place of, the bodies now lost."[65]

Primo Levi, in *Survival in Auschwitz* described the situation concisely: "Death begins with the shoes: for most of us, they show themselves to be instruments of torture."[66] Shoes are the objects that made human life disposable. The Nazi regarded slaves not as "a capital investment but as a commodity to be discarded and easily replaced."[67] Shoes became synonymous with systematic plunder accompanied by systematic slaughter.[68]

The volume of the public shock over what had transpired in the ghettos and concentration camps grew as more evidence was brought to light. Photos taken once the concentration camps were liberated were shown at the Nuremberg trials and distributed via the media to wider audiences. And Zinovii Tolkatchev, a Belarusian-born artist created about thirty works depicting the horrors he had witnessed and learned about at Majdanek.[69] These works were the first accounts of an artist who had witnessed Nazi atrocities, and Tolkachev, using his previous experience depicting the Russian Civil War and the German occupation of Poland, created highly individualized, emotionally charged artworks that were immediately recognizable as visual symbols of the Holocaust.[70] Tolkatchev joined the Red Army as an official artist in the autumn of 1944 to document war crimes. He accompanied soldiers at the liberation of both Majdanek and Auschwitz. While Tolkachev was preparing his drawings, watercolors, and gouaches for exhibition, Alexander Ford, a Polish filmmaker of Jewish origin, was directing the first postwar documentary entitled *Majdanek, the Cemetery of Europe*. Tolkatchev's *Preparations for the Massacre*, part of his Auschwitz series of 1945, stresses the fate of the inmates of Majdanek: camp uniforms placed next to a pile of shoes. Tolkatchev and Ford depicted similar scenes, such as a pile of human skulls and heaps of shoes, of which some eight hundred thousand pairs were found at the camp.[71]

Tolkatchev's works had a relatively wide audience and, in a sense, paved the way for many other artists to elaborate on the topic. Marc Klionsky's 1962 *Pile of Shoes*, for example, shows a pile of shoes set before a barbed-wire fence, the desolation of the shoes alluding to the fate of those imprisoned. From 1985 to 1989, an Austrian survivor named Elsa Pollak created her famous ceramic sculpture of a pile of old men's, women's, and children's shoes entitled *All That Remained*, which echoed the already globally well-known images of piles of shoes, at that time displayed in a number of Holocaust museums. The 1998 documentary *The Last Days* shows piles of abandoned, empty shoes, signaling to the viewer the enormity of the loss by metonymically materializing what had been rendered immaterial.[72]

By the end of the twentieth century, the global reception of the Holocaust had reached a cosmopolitan scale, although with different connotations in the United States, Germany, and Israel.[73] The following events illustrate the rapid growth in Holocaust memorialization, first in Europe and Israel, then throughout the world: the opening of the Auschwitz-Birkenau State Museum (1946), the Nuremberg trials (1947), the opening of the Ghetto Fighters' Museum in Israel (1949), the establishment of the Yad Vashem museum in Israel (1953), the trial of Adolf Eichmann (1960), the Auschwitz trial in Frankfurt (1963), the opening of the Los Angeles Museum of the Holocaust (1961), the broadcast of the American television miniseries *Holocaust* in 1978 (a major turning point in the media's representation and the Americanization of the Holocaust), the opening of the United States Holocaust Memorial Museum (1980), and Claude Lanzmann's documentary film *Shoah* (1985). Memories of the Holocaust came to be regarded as a unique measure for humanist and universalist identifications given their reference to the past and universal message for the future.[74]

Documentaries, photo exhibitions, artwork, literature, movies, commemorations, the establishment of Holocaust museums, survivors' testimonies and oral history projects, and history textbooks all greatly contributed to the near global recognition of the iconic

Holocaust images of the victim's shoe and piles of shoes. Over time, Holocaust victims' shoes gained various meanings and functions, acting as remnants, metonyms, and monuments, all of which became recognizable *lieux de mémoire* (i.e., objects that act as containers of memories).[75] The wide circulation of images of victims' shoes as a reference point was enabled by amassing artifacts (the shoes) from sites of atrocity such as concentration camps. In this process, museums repeated the conventions of metonymical displacement, the idea that the unconscious is structured like language, displaying shoes to "talk" instead of the dead. The recognizable trope of victims' shoes functions as a historical trace, a simulation of the past and its irretrievable loss in an overdetermination of history and memory.[76] Susan Henderson maps the material-discursive assemblages comprising a museum's exhibit of plundered shoes in relation to (1) shoes as hybrid recording devices; (2) shoes as exhibition space, where the sociomaterial physical things that comprise the exhibition are considered to be recounting a particular version of the Holocaust; and (3) shoes as performing a memorial script.[77]

The massive exposure and staging of victims' shoes and piles of shoes in museums across the globe significantly strengthened and grounded their value as "sacred mundane" objects. Shoes used in museums constitute a quintessential traveling trope.[78] A victim's shoe as a relic or memento mori serves "both metonymies and the authenticating evidence of our foothold in buried worlds."[79] Because of their ability to enable a full understanding of the scale and nature of the destruction of the Holocaust, the value of the authenticity of Holocaust victims' shoes increased, and they became must-have items in museum displays, almost gaining the status of religious significance. Their increasing value as meaning-bearing objects can best be illustrated by two examples. In the first, four thousand shoes were imported to the United States Holocaust Memorial Museum from the Majdanek concentration camp to enable the best possible representation of the scale of the Holocaust atrocities.[80] In the second, in 2014, eight

shoes belonging to Jewish Holocaust victims were reported to have been stolen from the Majdanek State Museum, a memorial museum founded at the site of the concentration camp.[81] Whereas in the first case, the value of victims' shoes to the American museum was in their purity and authenticity, in the second example, we can only speculate why the shoes were stolen. However, both cases clearly demonstrate the ascribed value that victims' shoes have generated. The elevation of victims' shoes to a near-sacred status is not a surprise. Museums are often compared with temples as religious sites for the modern age, and museum visiting is correspondingly regarded as a ritual enactment of communion with the sacred values of modern society. In fact, despite the reputation of museums as peak locations of scientific knowledge, these institutions can also be seen to contain, express, and even exploit many tenacious habits of the magical world.[82]

Victims' shoes as a reference point for death, loss, and destruction and as a resource to communicate past atrocities have continued to be widely exploited as the most potent tool to mark the Holocaust and other atrocities and historical injustices. In 2005, along the east bank of the Danube River in Budapest, not far from the Hungarian Parliament building, a memorial entitled *Shoes on the Danube Promenade* was erected that consists of sixty pairs of old-fashioned shoes lined up facing the water. The memorial represents the Budapest Jews who fell victim to the Arrow Cross militiamen in World War II and depicts the shoes they left behind on the bank after being forced to remove them before being shot and falling into the river. There are women's shoes, men's shoes, and children's shoes. They sit at the edge of the water, scattered and abandoned, as though their owners had just stepped out of them and left them there. If you look closely, you can see that the shoes, made of iron, are rusted and set into the concrete of the embankment.[83] In 2014, on International Holocaust Remembrance Day, and in honor of the seventieth anniversary of the liberation of the Majdanek camp, an exhibition entitled *Shoes of the Dead* was opened in Dresden. The title originates from a poem composed

by a twelve-year-old Jewish girl employed in the Majdanek camp to sort shoes in 1943.[84] In 2019, a large traveling exhibition, the first of its kind, opened at the Museum of Jewish Heritage in New York City. The artifacts displayed in the *Auschwitz. Not Long Ago. Not Far Away*. exhibition brought together more than seven hundred original objects and four hundred photos from more than twenty institutions around the world as "traces of genocide, the remnants of a murdered people, and the material evidence of crimes against humanity. They are what remain, despite the perpetrators' attempts to conceal their crimes."[85] Among the artifacts displayed were victims' shoes and photos of piles of shoes found at Auschwitz.

Victims' and survivors' shoes have become fully incorporated in the aesthetic and iconographic language of death, loss, and destruction that goes far beyond Holocaust remembrance. Their symbolic value has become an indispensable vocabulary for measuring the frailty of life and our own vulnerability. Hence, the motif of victims' shoes has been repeated as a refrain in many exhibitions, art installations, and museum displays. As part of the 2018 Imagine Festival in Belfast, an exhibition entitled *In Their Footsteps* showcased shoes of victims of the Troubles in Ireland.[86] Similarly, that the National September 11 Memorial & Museum in New York is also a "home to the shoes of survivors."[87] The Sydney Jewish Museum proudly reported in 2019 that one of the twelve artifacts received on loan from Auschwitz-Birkenau is a small shoe that once belonged to a young child that tells a much larger story.[88] The Kigali Genocide Memorial, as well as other memorials across Rwanda, also displays victims' shoes, and in 2021 the Tuol Sleng Genocide Museum launched an exhibition of victims' clothes and footwear.[89]

Sheryl Silver Ochayon describes the feelings elicited by *Shoes on the Danube Promenade*:

> The intimacy of this memorial is striking and poignant. The shoes are so tangible that it is easy to imagine the people who wore them, whose feet

shaped them, who were forced to take them off before they were killed. Each shoe has a personality; each has the imprint of the foot that wore it. The only thing missing is the owner. The shoes help us to conjure up something akin to the faces of the owners—those whose faces were obliterated—turning them from statistics into living, breathing human beings. They remind us that these were people. They may have lived long lives, fulfilling lives, lives filled with adventure or with boredom, rich lives or ordinary lives, but they lived, until they were murdered.[90]

Yet without exception, those words are applicable to all victims' shoes. Not only has this iconic trope become a recognizable landscape in visual culture, but victims' shoes have also come to subsume meanings of loss, destruction, death, and injustice. In fact, they have become an independent category as well as the antidote for well-established multiple meanings of shoes as a social object. Because they are deteriorating, victims' shoes also embody the disembodiment of the people they symbolize.[91] Their final disintegration is so threatening that Auschwitz-Birkenau launched a crowdfunding campaign to raise about $507,000 to preserve one of its most important monuments: the piles of ragged shoes that former prisoners wore in the death camp, including those of men, women, and children.[92] The desire to keep those shoes intact, frozen yet alive and communicative, is telling of the volume of emotional engagement they inspire. It is precisely this wide circulation of the shoes themselves and their replicas that has ascribed the category of victims' shoes with a symbolic value that can override the specificities of a particular event to become a signifier of abstract loss, death, and destruction.

EMOTIONAL MINING

Of course, other desire objects and their images have been and continue to be circulated. Wet garments and life jackets line the shores of

Greece and Italy, representing drowned migrants; t-shirts, watches, and shoes are displayed at mass graves in Ukraine; children's personal belongings spread on schoolgrounds after school shootings in the United States. Media and social media, popular culture, and the art world are all involved in the circulation and dissemination of images of desire objects. We know that viewing desire objects prompts a particular, short-lived emotional state of mind, whether of sadness, despair, helplessness, disgust, shock, or indifference. One might think that, apart from the emotion experienced in the moment of our engagement with them, these objects have little effect on us. However, each encounter with desire objects acts as an element of a series of feedback loops that are implicated in interaction ritual chains in which the collective emotional energy generated indicates a mutually recognizable code for desire objects.

In other words, and as I will show in the next chapter, what we perceive today as an instantly recognizable signifier (e.g., victims' shoes as death, loss, and destruction) in fact represents a long journey in a human–object relationship that has been filled with micro-encounters of interaction rituals, which, only after a period of time, acquire mutually recognizable codified meanings. This is true even if we have never been to a museum that displays desire objects. However, something sociologically extraordinary happens in museums once desire objects are put on display.

In museums, as staged and well-crafted environments, moral labor forces people to intuitively make a link between the desire objects on display and their owners' tragic stories. However, the emotions generated in these encounters are often short lived, and once a person is out of the simulacrum, it is likely they will reregulate their emotions to align with their current reality. While many desire objects are discursively represented as symbols, they have limited symbolic power because they are so tightly connected to the event in which they are embedded.

A public display of desire objects has one main function: to provoke an emotional and cognitive response that can be linked to an

ideological message. This approach relies on a "pedagogy of discomfort," meaning educational efforts to disrupt learners' deeply entrenched, often tacit understandings of how the world works to produce alternative ways of seeing, hearing, and "reading" the world.[93] The idea is that students' experiences of discomfort, pain, and suffering are pedagogically valuable in learning about victims of injustice.[94] Pedagogical discomfort is the feeling of uneasiness that arises as a result of learning about difficult topics; where one's ideas about the world are challenged, pedagogical discomfort seems to be a necessary and unavoidable step in pedagogical actions. The notion suggests that a pedagogy of difficult knowledge can inspire students to move outside their "comfort zones" and question their "cherished beliefs and assumptions."[95] Desire objects are thus used to educate us by linking a past atrocity's "lessons" with the purported "needs" of the present (what we need to learn from the event) and a desired future (how to achieve a particular moral vision). While desire objects tell us something about past events, their main purpose is forward looking.

My core argument here is that the more desire objects are linked not only to a specific event but also to an array of similar events across various geopolitical settings, the greater their symbolic potential. This is because of how associative mechanisms work and how interaction ritual chains operate—how the social mechanisms through which groups forge symbols of collective membership and enhance group-level emotional energies operate.[96] But for an object to become a symbol of a collective emotional energy charge, it must repeatedly be the focus of the situational dynamics of emotional energy. Some objects have the potential to become a Symbol with a capital "S" because they continually draw attention in human–object relations and consequently reinforce and synchronize the mutual emotional energy flow. But which desire objects qualify as Symbols? Which desire objects are self-explanatory? There is one answer: victims' shoes. It is hard to imagine seeing an image of a victim's shoe and not immediately recognizing its association with an atrocity. Most likely, the mind

will make a cognitive link with the Holocaust. This is even truer for images of piles of shoes. In fact, because of the widespread circulation of such images (both related and unrelated to the Holocaust), even people with little or no knowledge of the Holocaust are likely to make some connection to something bad that happened in the past. However, it is important to stress that the recognition of a desire object does not make the object emotionally communicative.

What makes a victim's shoe a symbol? How does it differ from the many other types of desire objects? To answer this question, we must understand not only what a victim's shoe represents as a recognizable set of meanings but also how it enables deep emotional mining for audiences with no direct link to the associated event. I argue that victims' shoes engage people's imaginations differently from other types of desire objects. Although all desire objects in staged environments encourage visitors to engage in moral labor, desire objects that have been elevated to the widely recognized status of a Symbol force visitors to engage more deeply emotionally in a process I call "emotional mining." To demonstrate how a victim's shoe, as a Symbol, penetrates our mental schemas (i.e., mental structures that help us understand the world), I need to explain the process of emotional mining. Emotional mining is a process through which people with no direct link to the event being memorialized by a given desire object reach an emotional energy peak in a face-to-face encounter with the object. When we experience emotional shock, the brain shuts down all nonessential systems and activates the sympathetic nervous system and the mammalian brain. To help us survive the shock, the brain releases stress hormones that can change the brain's delicate chemical balance and structure. While emotional energy homogenizes the rising sentiments, emotional mining is a process that enables a shortcut to our more guarded, nonregular emotions. These emotions are concealed on a day-to-day basis and can be reached only when faced with the extraordinary, meaning that in an encounter with victims' shoes, people experience an intense emotional energy charge. Emotional

mining needs real-life experiences. It can be rarely experienced through mediation; seeing a pile of victims' shoes in a highly staged environment such as a museum, being near them, being able to smell or touch them—all these factors contribute to a significantly more intense emotional engagement from that experienced via media.

The process of emotional mining happens at the intersection of two merging schemata as abstract generalizations or composites built from a collection of specific exposures or experiences. The first schema relates to the circulation of a desire object, in this case a victim's shoe, and its embedding into sets of well-defined, ideologically driven meanings. In that sense, a victim's shoe is immediately connected to a connotation of loss, death, and destruction. It is instantly associated with the "never again" script that unifies all humans under an umbrella of human suffering. The second schema has to do with previously acquired knowledge about the category to which the object belongs, in this case footwear. As discussed, shoes as a category of objects carry multiple meanings and layered contexts. The sight of shoes associatively pushes our minds in various directions. Any one or more of the previously described connotations in relation to the category of shoes can spark our imagination: shoes we are currently wearing, shoes that we just bought, shoes that we saw in a movie, an advertisement for a brand of shoes, winter shoes, high-heeled shoes, sexy shoes, expensive shoes—our reservoir of preknowledge is almost endlessly rich and compelling. However, whatever associative links we construct in an encounter with a victim's shoe that relate to the mundane are almost without exception associated with the liveliness of life: the joy of walking or running through a park, traveling, or sexual encounters, for example. Thus, what is most important is that most of our historical and societal connotations of shoes contrast starkly with the intersecting schemata: the joy of life and presence versus loss, death, destruction, and absence. The absence and void experienced in an encounter with a victim's

shoe are deeply unsettling. The process of contrasting schemata in a manipulated environment is intended and staged: museum planners term the objects involved in such experiences "object survivors" to strengthen the parallel with survivors and Holocaust victims to tell their story.[97] The idea is to frame the situational cues and interactional patterns of contrasting schemata to embed strong emotional potential in the object in the hope of encouraging visitors to engage in a meaning-making process and be receptive to ideological messaging. Once those cues are put in the service of the contrasting set of associative connotations, the process of emotional mining cuts though our performative emotional energy and suddenly reveals our deeply concealed emotions. Only by understanding the contrasting schemata of the object category and how thy cognitively, emotionally, and physically affect the people who encounter them can we start to understand why some—but not other—objects become the focus of interaction ritual chains.

The emotions and bodily reactions that one may experience as a result of these colliding schemata are sincere and impactful. What we might experience in such a setting at the crossroads of two opposing mental schemata is close to a mini-trauma: a rupture in our regular flow of emotions that leaves a strong emotional imprint. Emotions "rapidly organize the responses of different biological systems including facial expression, muscular tones, voice, autonomic nervous system activity, and endocrine activity" to prepare an organism for an appropriate response to salient sensory stimuli.[98] Since emotions are generated from limbic cortices outside our conscious control, they are difficult to fake.[99] Emotional mining, which enables us to dig into concealed emotions, goes hand in hand with the research of cognitive neuroscientists, who assume that schemata do not function in isolation. Rather, they cluster in the brain, forming associated networks that trigger other schemata in a network that allow us to "fill in the blanks" and make sense of new experiences.[100]

ONCE YOU'VE SEEN A PILE OF SHOES, YOU CANNOT UNSEE IT: VICTIMS' SHOES AS A FOCUS OF EMOTIONAL INTERACTION RITUAL CHAINS

The idea of emotional mining as enabled by colliding schemata might raise some eyebrows. What is the proof of this process? Though ample research shows the impact that strong and shocking emotions may have on our brains, the easiest way to assess the impact that victims' shoes have on interaction ritual chains—how they become the focus of emotional attention and how they encourage an audience to engage in moral labor—is to pay attention to how people narrate encounters with victims' shoes. A largely unexpected but highly useful resource in this context is Tripadvisor reviews from people who have had such encounters. Visitors to memorial museums and other sites of commemoration have posted hundreds if not thousands of reviews of their experiences. They often write extensively about their lived experiences and the emotional impact of their visits, which sheds light on the social mechanisms through which groups forge symbols of collective membership and enhance group-level emotional energies. The profound impact that encounters with victims' shoes have on visitors can be captured in Tripadvisor reviews of the United States Holocaust Memorial Museum. In fact, in my research, I found that one in every ten reviews addressed such encounters. Visitors narrate their emotional charge and the profound impact it had on them, which is described as both emotionally and physically overwhelming:

> There is no mistaking the impact the U.S. Holocaust Memorial Museum has on the mind, body, and soul. From being assigned a number, to seeing the shoes of those who died, it is one that really resonates.[101]

> It is unfortunate that the shoes exhibit was removed for renovation. My daughter talked about the impact on her many times.[102]

Anyone who even implies that the [H]holocaust was not real should be locked inside the room filled with shoes overnight.[103]

The shoes took my breath away. To think that even the simplest possession as a shoe was taken from them.[104]

The impact of the shoes and hair is immense.[105]

My question is: what does the health department have to say about the "shoes exhibit," and the smell in that place? How healthy it is and how it might impact the visitors? . . . I came back home [sick] for about a week with an ugly cough and chest pain.[106]

You may see artifacts that might make you emotional—there is, of course, the very well-known shoe exhibit of shoes belonging to [H]olocaust victims, artwork done by children of the [H]olocaust, and descriptions of some of the experiments conducted on Jewish victims. I saw some tearful guests during my visits, so I'd definitely recommend traveling with handkerchiefs or paper tissues if you think you'll need them.[107]

The shoe exhibit at the end is exceptionally difficult to observe.[108]

The beautiful eyes of innocence of the thousands of Jewish children who were brought to their death! There you see Nazi[s] standing around laughing as they watch hundreds die gassed in Chambers of death! Many of the original things used are here to see first hand. Including hundreds of thousands of shoes of those killed while the laughter of Satan loomed. I don't believe my heart stopped pounding for a second in hate for those who could even think to do this much less DO IT![109]

The shoe exhibit did me in and I couldn't stop crying.[110]

I felt like the evil should have been given a touch, a taste, a smell, a something that made it more personal to me. Is it weird to say, "if I could have touched that hair, if I could have smelled the leather of that shoe, if I could have tasted a safe simulation of that Zyklon B"? It probably is weird to say, but I feel like their memory, and the atrocity of The Holocaust, is deserving of me being more uncomfortable than I am comfortable being.[111]

The most haunting moment was entering the Shoe room.[112]

This memorial really created a connection between the visitor and the people who lived and died. What struck me the most was a single faded pink shoe in a sea of shoes. I thought about how the owner of the shoe must have loved the shoes when she first bought them never imagining someone would be looking at it in a memorial because of how she died. I could picture her trying them on, liking the color, thinking how fashionable they were. Such a simple every day thing, but it really got to me.[113]

The shoe room seems to be a favorite from everyone I've heard from.[114]

Consider one exhibit, a room filled from floor to ceiling with shoes taken from prisoners arriving at the Majdanek concentration camp, many of them children. A faint odor of shoe leather fills the air.[115]

The shoe exhibit will make you cry. It's so moving and emotional.[116]

The shoe exhibit really brought the experience to a level that could not be realized from the media or movies.[117]

The shoe exhibit leaves you breathless and the pictures and personal belongings of many of the prisoners is almost too much to bear.[118]

The most sobering experience is how the museum elected to represent the numbers and humanize the real tragedy. Very few people are not touched by the "shoe room."[119]

The shoe room is especially hard—shoes left by people who died in the ovens. One piece of advice: do not go alone. It's just too hard.[120]

The shoe exhibit is haunting. I think everyone should see come here to see what happens when we become immune to the suffering of others and ignore what is happening in the world around us.[121]

The shoe room left an indelible mark.[122]

I will forever remember the "shoe" display.[123]

The shoe exhibit—someone told us that it "smells of ghosts." What an apt description.[124]

The most moving part of the museum is the shoe room. In this room you walk on a narrow walkway through the center and on both sides of the walk on the floor are thousands of shoes that were taken from the Jews who [were] forced into the death camps. Every person experiences a different feeling walking through the museum and it was the shoe room that really drove the message of the museum home.[125]

The model of emotional mining and "crypto" emotions—emotions invoked through intense cognitive and bodily experience—resonates deeply with the material culturist Maurice Merleau-Ponty's theory of materiality. He connects an object's perceptual qualities with our bodily experience, which, in turn, enhances our empathetic understanding of the humanity embodied in the object.[126] His theory suggests that objects extend their attributes and biographies into our

perception. To dissolve the dichotomy between the objectivity of things and the subjectivity of perceptions, Merleau-Ponty proposes the notion of a "lived body," in which the body is a vehicle of being in the world that mediates between subject and object, and between consciousness and materiality, enabling one to be woven into a phenomenal world.[127] We can never experience the world outside our bodies, and objects from the world exist when we experience them.[128] Based on the premise that one's body is the center of one's world, Merleau-Ponty further suggests that our sense of being is an organic totality of mind and body, which correlates with a matrix of objects, peoples, and situations.[129] He claims that such state of "in-betweenness" of our bodies, on one hand, mediates our mind and body because it connects and places the world of things as an extension of our mind. On the other hand, the liminal state of in-betweenness engages us with the world through sensory activities. This reciprocity of object–human communication suggests that materiality shapes our bodily perceptions of the world and reveals parts of ourselves such as emotions, thoughts, and desires through bodily experience.[130] All our sensory and bodily experiences (e.g., the smells, textures, and imagery involved in an encounter with an object) allow us to engage in both human–object and human–human relationships. However, preknowledge of an object's category and its multiplicity of meanings is a necessary condition for amplifying the emotional shock of an encounter. Victims' shoes—their stillness and emptiness and their direct link to death, destruction, and absence—are potent focal loci because they are immediately contrasted with our notion of shoes that is associated with a joy for life, for walking, dancing, running, or hiking and as objects of status, erotica, or identity.

The extension of desire objects in general and desire objects that have acquired symbolical value to our bodily experience of an encounter with them is *how* desire objects gain agency. In short, the apparent "thingness" of things, the fact that they appear to just be there as given in some way, is the end product of a long chain of transformations that

changes their materiality into a coded system of emotional engagement.[131] By experiencing victims' shoes through their bodies and minds, visitors, once emotionally triggered, acquire meanings that map those objects as meaningful. And mapping this chain of transformation is key to our understanding of how people's mindsets shape mutually recognizable codes through the ideological worldview in which an object is situated. However, although we undoubtedly see the emotional impact that desire objects have on visitors, as well as the synchronization and homogenization of emotional energy, a question remains: To what extent does moral labor produce a human rights–centered moral order? In other words, once visitors leave a staged environment, what effect of moral labor do they take away with them?

BACK TO REALITY

Moral labor is ideologically driven. The staged environment that narrates an atrocity as a series of human rights violations directs visitors to engage in moral labor to adopt a particular ideological stance. The museum simulacrum imposes an "ad hoc choreography on the visitor, encouraging them to move their bodies in response to the dark ecology of a world turned by hate."[132] Memorial museums and other sites of dark tourism that narrate massive human rights abuses are experienced as moral spaces imbued with moral judgments.[133] For many visitors, the force of moral labor will encourage them to adopt and repeat the narratives presented to them. For many people, moral labor instigates broad human rights–oriented thinking. They view remembrance and justice as the key takeaways from their experience, often linking those ideals with the imperatives of our entire humanity. Many Tripadvisor reviews speak to this idea:

> Very moving indeed and a little difficult not to cry. A stark reminder that never again should we turn our backs on injustice or persecution.[134]

We were numb by the end but the victims of the [H]olocaust should not be forgotten, neither should unpleasant history be buried.[135]

Everyone on the planet should visit a museum like this as early in their life as possible and then we may not repeat the same mistakes over and over.[136]

It is moving—it is authentic—it is something that we all should experience.[137]

While this is a well put together museum, and evocative, it is very deficient when it comes to telling the story of the genocide of native Americans, Ukrainians during the Holodomor, the Armenian massacre, Rwanda, what's happening against Ukraine in 2022 and so on. Rather disappointed.[138]

Excellent Museum and a rather timely and important one too, but it has dated some and now pales in comparison to newer ones like the African American History.[139]

At times, the experience will be interpreted as a call for action. Visitors will link their experience with real-world problems such as racial discrimination or hatred.

Of course, persecution still exists in many forms today. My visit to the Holocaust museum made me emotional. Furious. But it also reminded me that although we have moved forward and have gone a long way, there is still a lot of work that needs to be done. I need to be more vigilant. To speak out when needed. And to be the voice of people who haven't found their voice. Tripadvisor reviews speak to this urge, as well:

Powerful. Haunting. Gut-wrenching.[140]

We cannot ignore what we know is happening around us, we must do something."[141]

We must remember especially in the current world climate of building walls.[142]

However, moral labor often falls within the context of preexisting knowledge and beliefs and can therefore end up cementing preexisting stereotypes and nationalistic sentiments by disconnecting what transpired in the past from what is happening today. In this context, an encounter with desire objects can trigger patriotic sentiments of exceptionalism (e.g., "we were never wrong," "this could never happen to us") or be used to support a particular political agenda:

> An absolutely unforgettable exhibition – and it should be. It is imperative that we know history so we do not repeat the mistakes of the past, but that we also recognize Evil when it is in our midst and make sure we do not allow it to take root. We are fortunate in this age, and country, that we have liberty and freedom. It is precious, needs to be protected! It does us no good when we make cheap comparisons between [today's] political challenges and this truly evil presence less than a century ago.[143]

> Everyone should see this sometime in their life so they can realize what these people went through and how blessed we are to live in North America.[144]

> I guess what bothered me was the historic slant—why didn't the US accept more refugees? They spent a lot of time showing how people had written and asked for help, only to not get it. It's definitely told from the side of the refugee, and sadly touches only lightly on the US urge to stay out of the wars after the losses experienced in the Great

Depression and World War I. Those events caused deep scars for the American people—to ignore those scars and say "You should have done more" really accomplishes nothing.[145]

We should look at the political situation in this county in 2018 while considering the message of this museum.[146]

Every American should see this museum and remember why we fought in Europe, twice, and continue to support Israel.[147]

Hopefully, America should use [its] might to stop genocide anywhere in the world. You do not need a coalition of governments to do the right thing.[148]

Go to this museum and be thankful you are an American.[149]

This museum opened my eyes to how very lucky we are to live in America . . . and gave me much needed insight to the horrible and unimaginable atrocities that were committed against humans by other humans.[150]

Everyone should at least go once in their lifetime to understand how lucky we are not to be born in that era.[151]

Finally, some visitors try to find refuge in God, detaching themselves from any real understanding of why atrocities occur:

God willing, this will never happen again.[152]

I pray that this type of atrocity never happens again.[153]

May God help us that we never have this history repeat itself.[154]

These examples provide just a taste of how visitors to memorial museums and other sites of dark tourism make sense of atrocities and cannot conclusively answer the question, What is the outcome of the moral labor that supposedly influences visitors' worldviews? However, they does give us some indications. Based on her study of the Canadian Museum for Human Rights and in the context of the Holocaust, Katrin Antweiler suggests that the historically aware human rights advocate is produced precisely at the intersections between Holocaust memory and human rights discourse that transcend the particularity of the Holocaust and turn it into a universally applicable narrative.[155] We know that many visitors adopt the proposed narrative of a memorial museum or other site of dark tourism and are able to link it to the topics of universal injustice and inequality; however, some take a more selective stance, connecting the narrative to a narrow nationalistic worldview. In the next chapters, I will show how this division becomes replicated and activated in political action.

CONCLUSION

Shoes as objects are grounded in our consciousness in many ways that enable us to associatively and selectively pick and choose their meanings from a large reservoir of representations. Their historical and social contexts define how we establish meanings about shoes; for example, we may link them to identity, consumption, social status, gender relations, group membership, or power. Depending on the context, they may generate numerous meanings simultaneously. Whether we associate a pair of red high-heeled shoes to fashion, fetish, and sexuality (e.g., at a fashion show); to poverty, inequality, and prostitution (e.g., at a crime scene); or to social status, power, and social rituals (e.g., at an elite gathering) is determined by the temporal and spatial contexts of the shoes.

However, the victim's shoe as an object of representation alters the meanings associated with footwear. Through their replicas, in the circulation of imagery and media representations, victims' shoes have become a recognizable trope associated with death, loss, destruction, absence, and void. By exemplifying how and why victims' shoes have become central in group interaction ritual chains through emotional mining and crypto emotions, I have shown how these processes affect the codification of meanings through which victims' shoes become mutually recognized as representing death, loss, destruction, absence, and void. In chapter 8, I will show why the contrasting networks of meanings for various categories of desire objects are important, how they define which desire objects will continue their journey beyond the staged environment, and how they link to political action.

8

DESIRE OBJECTS, POLITICAL ACTION, AND IDEOLOGY

In early December 2016, Bryan Sitch was sent on behalf of the Manchester Museum to the Greek island of Lesbos, where hundreds of thousands of refugees fleeing the civil war in Syria had made the crossing from Turkey to Greece. He was there to collect a refugee's life jacket for an upcoming exhibition. Refugees had been arriving every day, and, at the peak of the crisis, close to ten thousand people were arriving daily. Images of piles of life jackets, pieces of rubber dinghies, clothes, and abandoned damaged boats were televised globally and extensively reported, both in terms of the refugee crisis and the ecological crisis.[1] Says Sitch, "The choice to collect a life jacket was an intuitive one; the life jacket has come to symbolise the mass movement of people and the dangerous plight of refugees."[2]

But once the life jacket was placed in the museum display, the audience's reactions were underwhelming. The results of surveys conducted by a University of Manchester archaeology student showed that more than 95 percent of visitors had not even stopped to look at the life jacket.[3] Why? The primary reason is that the Manchester Museum is not a memorial museum or site of dark tourism. Rather, it focuses on archaeology, anthropology, and natural history. The exhibition in which the life jacket was displayed addressed themes of climate change and the contemporary debate on migration, which aligned with the museum's mission to "promote understanding

between cultures and to work towards a sustainable world."[4] However, given that the museum's main focus is not memorialization, the life jacket as a desire object was out of context; visitors to the Manchester Museum were not prepared, and had not paid, to engage in emotional or moral labor.

We know that desire objects on display require a staged environments to trigger interaction ritual chains in which people focus their emotional attention on the objects. We also know that, for most desire objects, some sort of exhibition display is going to be their final destination. They will stay there, reproducing and reinforcing interaction rituals as an integral part of a series of feedback loops in which changing audiences will be encouraged over and over again to engage in moral labor. It is a highly generative process in which the meanings of desire objects become coded and reinforced with each new wave of visitors.

But to understand the future trajectories of desire objects beyond museum displays and how they can influence political action, a number of things should be clarified first. The emotional energy generated in the staged environments of memorial museums and sites of dark tourism where desire objects play a starring role (1) enables the creation of interaction ritual chains with desire objects at their center and (2) is the driving force behind both emotional and moral labor; emotional labor puts people's emotions to work, and moral labor imbues those emotions with moral meanings. While desire objects come in various shapes and sizes, they all reinforce a similar representation of death, violence, destruction, injustice, absence, and void. And all desire objects serve the same purpose: to shape visitors' understanding of the past and to promote certain future moral orders. But, as discussed in chapter 7, most desire objects become subsumed within the trope of victims' shoes. Only a small number of object categories, such as victims' shoes, are incorporated into a widely recognizable vocabulary of political action. Not watches, wallets, or marbles because these items belong to categories of objects with limited preestablished social and cultural meanings. Although these objects tie us associatively to some

DESIRE OBJECTS, POLITICAL ACTION, AND IDEOLOGY

aspect of life, none is crucial for life itself. Shoes, on the other hand, cannot be separated from life and liveliness, and, regardless of cultural or religious background, social status, age, or gender, none of us could imagine modern life without shoes.

It is important to stress here that visits to memorial museums and sites of dark tourism and the moral labor that visitors engage in are key to reinforcing the meanings of desire objects and, through them, the atrocity being addressed. This is not to suggest that the meanings of desire objects cannot be created outside staged spaces. As discussed, desire objects can skip circuits in their journey and can become instantly recognized as a representation of a given atrocity. Some desire objects inspire immediate engagement. One example of an object instantly being used for political action is a blue-and-yellow bracelet. On September 16, 2022, more than four hundred bodies, including those of children, were unearthed at a mass burial site in liberated Izium in the Kharkiv region of Ukraine, many showing signs of torture. During the exhumations, a photo was taken of the hand of a man, who had likely been tortured, wearing a bracelet in the colors of the Ukrainian flag. The photo spread rapidly online and became synonymous with the atrocities committed by the invaders in Izium. In a social media campaign using the hashtag #Izyum-Massacre, Ukrainians posted photos of their wrists with Ukrainian symbols to mirror the photo. Some said that the picture represented the feeling that "it could have been any of us. Just because we are Ukrainians."[5] How does a bracelet in the colors of the Ukrainian flag become used in political action? What makes this bracelet different from other desire objects found at sites of atrocity?

OBJECTS AND POLITICAL ACTION

Disobedient Objects, an art exhibition that opened in July 2014 at the Victoria and Albert Museum in London, presented objects used

in grassroots social movements around the world as tools of social change from the late 1970s to the present. Although desire objects usually move through various circuits before surfacing in the public consciousness, the exhibition used the reverse process: it displayed objects that had already been used across a variety of political actions, including protests and riots.[6]

Objects are seldom used in political action, that is, action designed to achieve a goal through the use of political power or by activity in political channels. In political action, people come together to tackle an issue, support other people, and promote certain agendas. While political action can take various forms (e.g., lobbying or actively participating in political parties, professional organizations, or unions), protests, riots, and rallies are the most visible since they are collective in nature and occupy public spaces. In such a context, the potential of desire may be reactivated because public displays are theatrical, and they are most effective when most imaginatively theatrical and carnivalized. Public forms of social performance such as protests are constitutive of the social and are materialized through protest objects, including petitions, placards, puppets, and improvised projectiles.[7]

Objects used in political action come in a wide variety of shapes and forms. At times, they are purposefully created and tailored to a protest; other times, they appear as part of a seemingly spontaneous act of resistance or disobedience. These objects are time capsules, storage containers of memories.[8] The material culture of protest is often made from refashioned materials: preexisting materials that are repackaged and reused for new ends and purposes.[9] Craft objects, often made collectively, lend themselves to replication because they are usually constructed out of easily located resources and were anonymously made in the first place. Objects used in political action are "created from a heterogeneous repertoire of materials which have been lifted from their local and historical milieux, a combination of elements assembled not with the view of performing a particular project, but an umpteenth-hand combination of previous cultural

assemblages to produce something new."[10] Improvised objects are often fabricated by local social movements based on their traditions of political resistance and working with objects.[11] Objects of protest over the years have become markers that define our collective recall of significant moments in history. They are instant identifiers to a united cause, from everyday kitchen objects, keys, chains, whistles, and costumes to well elaborated, purposefully designed, and created objects for a particular protest.

Pots and pans are commonly used, as in the "balcony" protests in Serbia in 1997 to call out the lies of the Milošević government and in the protest of Argentinian residents outside the Argentine embassy in Mexico City in 2002, aimed at drawing attention to rising crime rates, inflation, and political corruption in South America. Similarly, whistles were used as a wake-up call for people against the war-silence in Serbia in the 1990s. Other examples of objects incorporated into protest movements include the tents of the anti-capitalist Occupy protests in London, New York, and elsewhere in 2011; the plastic water bottles refashioned into improvised tear-gas masks used in the anti-gentrification Taksim Gezi Park protests in Istanbul in 2013; and "lock-on" devices, first used in Australian demonstrations against forest destruction in 1989, used by protesters to shackle themselves to large, immovable objects such as trees.[12] Brushes, brooms, and buckets were used to "wash the shame and disgrace of lies" at student protests in Belgrade in 1996 and 1997. In 2021, the tractor became a symbol of mass protest when tens of thousands of farmers from far-flung areas took to Delhi's streets and a tractor was overturned and killed a protester. In Hong Kong in 2014, a wave of pro-democracy student protesters peacefully demonstrated against a decision by the Beijing government to rule out fully democratic elections. After being met with pepper spray and tear gas, thousands of protesters were encouraged to open their umbrellas to protect themselves, thus beginning the social media–fueled Umbrella Movement that turned the humble umbrella into a symbol of protest. Incidents like these illustrate how

various objects come to be used to convey political messages during protests. The most unlikely of items, even rubber ducks and pink woolly hats, can become highly potent signals of dissent. Objects used in political actions carry histories of tactics, blending practical function with the creativity of resistance.

Objects used in protests serve as elevated props: they amplify and homogenize the core idea of the discontent. They are there to be seen and heard and to enable disobedience or protect protesters and their goals, whether symbolically or literally. The performative and carnival-like nature of political action corresponds with both the functional materiality of the object used and the circulated knowledge in which the object is situated, such as that gained via popular culture, the news, global trends, and ideological clashes. Masks are commonly used in protests, too; for example, the most recognizable object featuring in the current pro-Palestinian protests is the keffiyeh, which has become a recognizable symbol worldwide.[13] And in 2012, protesters taking part in an Amnesty International flash mob demonstration wore masks in support of the Russian punk band Pussy Riot on the Royal Mile in Edinburgh, Scotland. The strategy of dressing in a particular way has also been widely used. For example, in 1988, ten thousand members of the Orange Alternative movement protesting against communist rule in Poland wore orange felt hats in what became known as the "Revolution of the Dwarves."[14] In February 2010, Palestinian activists in Bil'in painted themselves blue and dressed as characters from the movie *Avatar* to oppose imperialism. More recently, in May 2017, in a nod to Margaret Atwood's *The Handmaid's Tale*, eighteen women wore red cloaks and white bonnets and called themselves the "Texas handmaids" to protest proposed bills that would make it harder for women to access abortion.[15] Sarah Ahmed[16] writes that, as objects circulate, they become sticky with affect. Our feelings, attachments, and orientations toward an object become embedded, layered, and tangled as it moves, taking on new meanings. As objects of protest circulate, they are discussed and debated, soliciting further perspectives. What

is common to all objects used for political action, whether purposely designed objects or ad hoc objects that are easily accessible to the masses, is that they all have the same function: they magnify and reactivate certain desired moral orders.

Whether called "core symbols" (as in David Schneider's study of American kinship), "dominant symbols" (as in Victor Turner's study of Ndembu rituals), or "key symbols" (as in Sherry Ortner's study of Sherpa social relations), it is clear that symbols are central to all societal systems.[17] Though symbols can be classified in a variety of ways (e.g., natural, religious, cultural, political), there is never a single interpretation of a symbol that everyone within a community accepts. Various groups, political actors, and individuals interpret symbols differently because they all have the capacity to create individual realities within which they operate.[18] At the same time, social constructs are subject to the constant pressure of changing experiences.[19] However, symbols are not meaningful in and of themselves but rather as a function of the interpretation of situational context and history, in which the multivocality of symbols is rooted in the personal experiences of society as a whole and the constituent parts of it.[20] Hence, an object's positioning in a group is subject to the publicly available symbolic forms through which people experience meaning.[21]

THE SHOES THAT RAN AWAY

Of all objects used in political action, shoes are likely used in the most diverse way. Among other causes, they have been used to protest wars, gun laws, unemployment, sexual and domestic violence, COVID-19 policies, and environmental degradation. However, shoes are not like any other object used in political action. All objects have a history that, through their functionality or aesthetic form, enables people to engage with them in a meaningful and relatively coherent way. However, as demonstrated in the previous chapters, shoes as a category of

objects—and victims' shoes as a newly emerged subcategory—offer a vast array of meanings beyond their mundane function. Further, the trajectories of victims' shoes shape human–object relationships via moral labor: labor that molds strong emotions into a particular ideological worldview. The wide and continual repetition and circulation of the trope of victims' shoes has cemented their overarching meaning as containers of void, loss, and death. But once they manage to "escape" the staged, controlled spaces of museum environments to be used in political action, their meanings are significantly expanded, altered, and reappropriated. While their symbolic foundations remain strong, new layers of meanings are added—not independently but in constant dialogue with their conquest of public spaces around the world.

Staging shoes in public spaces is primarily the process of staging moral labor. At this stage in their biographical journey, shoes are ascribed agency; they are placed in public spaces to encourage audiences to engage in moral labor in order to reinforce particular moral claims. Despite the lack of a staged environment when used in political action, shoes engage audiences in interaction ritual chains in a similar way. They act as a unifying focus of ritual attention despite the fact that people recognize them as just ordinary shoes. In this context, authenticity can add value but is not a necessity. The fact that people respond emotionally to a pile of random shoes placed in a public space must be understood in terms of the specific biographical trajectories of victims' shoes that generate meanings that are easily replicated via performative mimicry. In that sense, the primary function of the emotional energy generated in encounters with victims' shoes, as an overarching category of all desire objects, is to cement their most profound meanings: void, loss, and death. Here, moral labor has a secondary function: to use the emotional energy needed to constitute meanings of void, loss, and death to give the audience a vocabulary for how to think and talk about desire objects. Put simply, void, loss, and death become templates or schemata, but they don't tell us much about desired worldviews. Only through moral labor can

people make sense of those templates. Was it a heroic death? Who were the victims? Who were the heroes? Who was responsible? Were these human rights abuses or patriotic sacrifices? Importantly, the answers to these questions are always about wider ideological worldviews, not just about the specific event being commemorated. Shoes used in protests ignite interaction ritual chains to reconfigure and reestablish moral communities of a particular ideological positioning.

Hence, once victims' shoes migrate to political action—the pinnacle of desire objects' trajectories—they most often no longer hold a clear and direct link to any particular atrocity. They become empty containers in which void, loss, and death can be related to various moral orders. In fact, once in an open space and mediated to large audiences via traditional and social media, shoes, as a focal point of interaction rituals chains and via their ascribed agency, create both local and global moral communities. Moral communities, regardless of their ideological underpinnings, shape their discourses around a rigid binary framework corresponding to the division between "us" and "them," from which political struggle is born.[22] James Jasper suggests that moral emotions are especially important when trying to "connect micromotives with broader political systems."[23] Moral commitments are ultimately relationships to others but also to certain institutions and principles.[24] Moral claims, put forward by various moral communities, are always linked to a value system embedded in ideological views and are expressed as rights or duties and as a cry for truth and justice. As moral claims are normative claims, grounded in a particular ideological worldview, they rely on and supply a stock series of metaphors, images, and symbols of good and evil, delineating a desired political and societal order.

Slogans such as "Never again," "*Nunca más,*" "Never forget," and "Justice now" are tightly linked to particular symbols and circulating images and have been appropriated and widely used by various political actors.[25] However, they often mean different things for different segments of society. Though moral claims often sound schematic and

similar in distinct sociopolitical settings, they can instigate very different political actions from demanding equality, transparency, and inclusive representation to instigating conflicts and violence. This is because the moral claims of truth and justice are multivocal and enable numerous interpretations; thus, they can easily be appropriated to justify various political agendas.

Shoes placed in a public space reads globally as void, loss, and death, but what does this messaging refer to, and how does it reflect various ideological positionings? Questions about whose voice the shoes are replacing, what has been lost, and who died are not as straightforward as they may seem. The answers depend on the purpose of the display and who is appropriating the shoes' agency. In all cases, shoes used in political action are placed in central public spaces to involve random passersby, protesters, or engaged activists in both real and virtual spheres. They activate people's participation in several stages of a protest, for example, in the planning phase, in working out logistics, or in the recruitment of well-worn shoes. Some might join in the protest spontaneously, and some might witness it from afar, whether at a physical distance or via traditional and social media. Shoes are burdened with the promise to deliver a moral shock once arranged in a display. Given the wide acceptance of the trope of victims' shoes across the globe, even those without knowledge of what a protest is about will understand that it has to do with a premature and unjust loss of life. This common understanding is significant because a "moral shock" is often the first step toward recruitment into a moral community.[26] Victims' shoes have accumulated the potential to generate a sense of outrage in people such that they become inclined toward political action. Displays of victims' shoes are meant to provoke emotional energy and moral outrage, which can be a powerful motivation for protest when there is someone to blame for an injustice.[27]

Displaying shoes in public spaces as a form of political action serves as a marker of belonging to a moral community. Regardless of

whether protesters' demands are local, national, or global, their struggles are most often conceptualized as good ("us") versus bad ("them"). The moral community of protesters, without exception, envisions and positions themselves as the good party, and they do so via three distinct presentations. In the first type, the moral community is forged in victimhood and injustices that have affected community members or their loved ones, or they are "implicated subjects" in wrongdoings,[28] such as the Holocaust and other genocides, terrorist attacks, slavery, and war. Thus, community members indirectly present themselves as "debt collectors" for a deserving party that was mistreated, the pretext being that society (whether a specific group or society as a whole) "owes" them. These groups are typically fighting for those whose lives were cut short prematurely. However, by relaying the voices of the dead through victims' shoes, they are in fact reestablishing hierarchies of belonging, most often along ethnic, religious, or national lines. Shoes are deeply embedded in past injustices, yet they project a desired moral order of the world as it should be. Shoes are ascribed agency to "stitch" broken national bodies together.

The second type of presentation built around the trope of victims' shoes involves moral communities that that portray themselves as guardians of morality and righteousness. In a similar way to moral communities forged in victimhood, they often position themselves as "truth holders" because they or their loved ones have experienced an injustice. Those injustices may vary in scale, but they are often aligned with contested political issues. Clifford Bob has described how various political groups, including right-wing groups, use the language of rights to promote their political and economic agendas while trampling over rival interests or community concerns.[29] At the same time, they deny abuses of which they are accused and continue portraying themselves as victims rather than violators. In this context, victims' shoes are used as in the two other types of presentations: to homogenize audiences, thus suggesting that the losses they are protesting affect all of us, rather than just the group directly involved in the

protest. The protests of these moral communities use the language of rights and duties, yet they do not promote human rights and are only indirectly interested in strengthening a nation. Their main interest is recruiting the general public in the struggle for what they see as major societal issues (but which may in fact be sectorial issues). The protests of these communities ground shoes in the here and now.

The third type of presentation in which shoes play a key role involves moral communities that fight climate change, and these groups are decidedly future oriented. In this context, shoes are used to associatively link widely circulated, generative, and deeply embedded knowledge of the trope of victims' shoes with a stark warning about the price of the upcoming "ecocide." The anti-government protests of these moral communities, unlike the other two, are global in their appeal and go beyond a single organization, political party, or nation-state. In this context, shoes complete the full circle of abstraction: from being found at sites where atrocities have taken place; to being substitutes for lost lives and circulated as containers of void, loss, death, and destruction; to representing lives yet to be lost. The trope of victims' shoes here is used as an embedding of human rights born out of necessity—yet it is the magnitude of the climate prophecy and the inequality of its effects on groups of people worldwide that stands between various political and national interests and the forging of a unified global community.

This division of political action into three types of protests that use shoes as a focus of interaction ritual chains is largely operational. Many, if not most, protests are some combination of the three. They may use shoes to commemorate the dead while simultaneously asking for recognition or a policy change. As discussed, protests are multivocal in their purpose, and it is fair to say that other types of analysis could have been conducted here. However, my main purpose here is to account for the agency accorded to victims' shoes in order to delineate desired moral orders, in particular those of human rights and nationalism.

Shoes for Nationalism: Stitching a Nation Back Together and Demarcating Moral Communities

In 2010, Women in Black, a worldwide network of women committed to peace and justice and actively opposed to injustice, war, militarism, and other forms of violence, created a memorial to the victims of the 1995 Srebrenica massacre in the Serbian capital of Belgrade.[30] The worn-out children's boots, shabby slippers, and tattered trainers strewn about, many with messages from Serbian citizens stuffed inside them, on Belgrade's central Knez Mihailo Street are meant to present a stark and jarring sight for passersby.[31] The shoes are meant to be a reminder of Serbian guilt, a burden that should not be hidden but displayed. This display rhetorically posits the shoes as a medium for fighting the Serbian government's silence and refusal to take accountability for the crimes committed in Srebrenica and elsewhere. Nadežda Gaće, the former president of the Independent Journalists' Association of Serbia, compared the shoe memorial with the former German chancellor Willy Brandt's act of contrition in Poland in 1970, in which he knelt before the monument to victims of the Warsaw Ghetto uprising: "Each pair of shoes is like some little Willy Brandt, only seeking reconciliation."[32]

The Belgrade shoe protest was inspired by a German-led initiative to build two eight-meter-tall bright white letters—"U" and "N" for "United Nations"—entirely out of shoes. Ahead of the fifteenth anniversary of the Srebrenica genocide on July 10, 2010, the *Pillar of Shame* was erected in front of the Brandenburg Gate in Berlin. But its goal was different from that of the monument in Belgrade: singling out the United Nations and international leaders as the ones most responsible for failing to prevent the mass killing of 8,372 people in what had been declared a UN safe zone.[33] The Society for Threatened Peoples collected 16,744 shoes from Bosnia, Austria, Switzerland, and Germany to build the monument. Zlata Konaković, a Bosnian Muslim, was one of the many who contributed to the project. She donated

seven pairs of shoes, including ones that her son and grandson mailed from Washington, DC: "I knew over eight thousand people were killed but only when you see this mountain of shoes do you get the picture of how many it is."[34] Philipp Ruch, the director of the Centre for Political Beauty, said, "The Srebrenica mothers have sought for three years now to erect a pillar of shame which would point to the guilt of the West, of Western officials and military, for not having engaged in 1995 to defend the people of Srebrenica."[35]

In April 2021, to mark the twenty-eighth anniversary of a massacre that took place when the Army of Republika Srpska bombarded a school playground in the eastern town of Srebrenica and to honor the victims, the Srebrenica Memorial Center organized an exhibition entitled *74 Pairs of Shoes for the 74 Lost Lives of the Youth of Srebrenica*.[36] "We do not forget the children of Srebrenica who were killed, we do not forget that only after their killing did the international community react and establish 'safe zones.' We do not forget all the betrayal that came later," the Memorial Center said, reaffirming the statement issued during the inauguration of *Pillars of Shame* in Berlin. Again, we see a display that clearly defines "us" as victims versus "them" as villains.

A protest using shoes with striking similarity to the Belgrade protest but with a different intention occurred in the heart of Ankara, Turkey, in 2012. Organized and supported by the Association of Young Bosnians and Ankara's Keçiören Municipality, the display featured 8,372 shoes to commemorate the 8,372 victims of the Srebrenica massacre.[37] Speaking during the ceremony, the mayor of Keçiören Municipality, Mustafa Ak, said the tragedy in Bosnia should never be forgotten: "What happened in Bosnia in 1995 was a massacre and Turkey has shared and will always share Bosnia's pain. Bosnian people are the Turkish people's brothers."[38] Here, the public display was meant not to point a finger at the culprits but to reaffirm political alliances and claim spheres of interest.

Although the four protests discussed here were organized by very different actors with with various intentions, all sketch similar

cosmologies of victims, perpetrators, and bystanders, at the heart of which is the process of establishing support and recruiting solidarity with the Bosniak nation via victimization. The four displays show who the victims are, who their supporters are, who the enemies are, and who is guilty and thus in debt to the victims and their supporters. In fact, these displays follow the same script used by Holocaust victims' shoes to enable the establishment of Israel as the Jewish nation. Despite the vocabulary of "never again," they serves as a force majeure for enforcing nationalist sentiments. They build communities based on a simplified matrix of victims, perpetrators, and bystanders that, though widely accepted in the human rights memorialization agenda of moral remembrance,[39] in fact strengthens nationalism and animosities along ethnic lines. Even the action taken by Women in Black, one of the most prominent human rights organizations in Serbia, falls into this trap. While they are doing what is right and moral from the point of view of human rights in offering solidarity and sympathy to victims and shaming the guilty party, it does not result in better appreciation of the human rights of those who suffered. On the contrary, their protest legitimizes the various national agendas and goals for reaching a much desired nation-state.

When shoe displays are put in public spaces for the purpose of commemoration and remembrance, they often become a vehicle for national sentiments or political alliances. On December 15, 2023, the main square in Zagreb, Croatia, was covered with children's shoes as a call for a ceasefire in Gaza and support for the Palestinians.[40] Similarly, in 2010, a memorial made of 6,830 cloth shoes was installed outside the Memorial Hall of the Victims in Nanjing Massacre by Japanese Invaders commemorating the lives of 6,830 Chinese people who died as victims of forced labor in Japan in the years following the invasion of Nanjing in 1937. Then, in 2017, eighty pairs of ceramic shoes, representing victims of the Nanjing massacre were put on display at the Memorial Hall. Such memorials help to convey the scale of an atrocity, which in return helps reinforce sentiments of nationalism and belonging.[41]

On the other side of the world, in a protest initiated by the American Friends Service Committee, a display entitled *Eyes Wide Open: The Human Costs of the Iraq War* presents eight hundred pairs of combat boots bearing the names of U.S. soldiers killed in Iraq. The display was part of a traveling exhibit first shown in Chicago's Federal Plaza in January 2004. On September 11, 2004, the boots flew to Indianapolis, where 1,007 pairs of combat boots adorned with American flags were placed at Monument Circle, an imposing war memorial in the center of downtown. In 2005, the boots were presented in Washington, DC. As of March 2007, the national exhibit contained more than 3,400 pairs of boots and had visited more than one hundred cities in forty states. Nearly every state now has its own boot display. The national exhibit in its entirety contains more than four thousand pairs of empty boots.[42] Each pair is tagged with its deceased owner's name, rank, and home state; together, they symbolize the American lives lost in the Iraq war. In an additional feature of the exhibit, Iraqi civilian deaths were symbolized by a pile of hundreds of civilian shoes to address the general loss of human life in the war. However, the civilian shoes occupied only a marginal place in the visual field.[43] Here, again, we see an exhibit reduced to repatriotizing a nation by ascribing the boots agency to direct the audience's solidarity toward nationalistic sentiments.

Placing shoes in public spaces is often meant to heal national wounds. In May 2021, in British Columbia, Canada, just days after the remains of 215 children were found buried near a former residential school for Indigenous children in Kamloops, the country tried to acknowledge the enormity of the horrific discovery. The Department of Canadian Heritage said flags at all federal buildings across Canada would be lowered until further notice "in memory of the thousands of children who were sent to residential schools, for those who never returned and in honour of the families whose lives were forever changed."[44] Memorials emerged across the country, many featuring rows of tiny children's shoes to represent the magnitude of the loss and

as a nod to a tribute of 215 pairs of shoes that had been organized in Vancouver. Shoes were placed on the steps of churches and government buildings, establishments that once ran the very schools that forcibly separated Indigenous children from their families for many years.

Even in political actions where overtly nationalistic symbols are missing, shoes are used to unite a wounded nation. In 2020, a vigil for nurses who died from COVID-19 was held on the lawn of the Capitol in Washington, DC, featuring 164 pairs of nurses' shoes—one for every nurse who had died. In an interview with CBS News, Jean Ross, a co-president of National Nurses United, said that many people had called nurses "heroes" during the pandemic but that "your heroes should not be dispensable. We're not expendable."[45]

One might think that shoes used in the service of antiwar protests must rely on human rights–based moral orders. Although they do, their primary function is to shape the moral communities and solidarities of "us," the morally righteous, versus "them," the villains. To a large degree, these displays are about asking, "What do I stand for?" and "Who belongs to my moral community?" However, these are questions that inevitably minimize the complexities of the reality. The displays are performances that interpret shoes as a borderline between like-minded communities. For example, in April 2021, protests were held against Myanmar's ruling junta, which had stepped up its campaign against celebrities who supported nationwide protests against its seizure of power, publishing wanted lists in the state press and warning against using their work.[46] Rows of shoes were adorned with bouquets of flowers in memory of the nearly six hundred killed at the hands of Myanmar's security forces during demonstrations against the military junta. One message in the display read, "How many shoes have been left behind when people run? How many people can no longer march with us?"[47] The struggle to recruit an audience to a particular moral community becomes crucial to protests because they are ultimately a battle for the vision of a nation. Protests aim to create a simplified division between those who are "pro" and

those who are "anti" as part of the labeling of moral communities of solidarity. But they ignore or compress large political, societal, and economic differences between those who are divided and subsumed under national, ethnic, or religious categories.

The building of moral communities in which shoes are the focal point of communication can be seen clearly in how interaction ritual chains are multiplied both spatially and temporally. An excellent example of the trope of victims' shoes taking center stage in a political action is provided by the recent antiwar protests over Russia's invasion of Ukraine. These protests started in Budapest at the *Shoes on the Danube Promenade* memorial discussed in chapter 7. On March 27, 2022, just days after the Russian attack on Ukraine, the Ukrainian Association *"Yednist"* ("unity") organized a political protest in honor of the victims of the siege of Mariupol in which people brought new shoes to the Danube memorial. This protest was made in response to recent comments made by the Ukrainian president, Volodymyr Zelenskyy, to the prime minister of Hungary, Viktor Orbán.[48] Speaking with representatives of European Union member states, Zelenskyy criticized the Hungarian government's actions. Addressing Hungary's prime minister directly, he said, "Listen, Viktor. You know what is happening in Mariupol. Please, if you can, go to your bank in Budapest. Look at the shoes. You will see how mass murders can be repeated in today's world. In Mariupol, there are people too: Adults and children. Grandfathers and grandmothers. There are thousands of them."[49]

During the first few weeks of the Russia–Ukraine war, more and more people brought shoes to the Danube memorial, and in a chain reaction, in April 2022, the Ukrainian Association in Finland organized an identical protest. Rows of small shoes, 210 pairs in total, were placed alongside candles outside the Finnish National Theatre in Helsinki to draw attention to the children killed in Mariupol during Russia's invasion of Ukraine.[50] Activists worldwide also began to make shoe memorials as a protest against the Russian invasion, including

in Georgia, Japan, and Serbia. Shoes draw clear lines between moral orders. In protests, they become undisputed markers of moral alignment and solidarity, dividing people along lines of nationality and asserting victimhood and heroism on one hand and guilt and shame on the other. Shoes are used to forge bonds of national solidarity and to strengthen the boundaries of the moral community of belonging to a nation. Shoes as the focus of interaction ritual chains represent sorrow, loss, and death and strengthen national boundaries of suffering. As long as human life is conceptualized by protesters through their belonging to a nation, ethnicity, or religion, those struggles will always, without exception, reinforce nationalistic sentiments.

Shoes as Rights and Duties: Awareness and Demand for Recognition

Despite the use of a human rights vocabulary, as long as the shoes used in protests are used to address a specific event, they will always reinforce nationalism. But shoes are also often used to tackle highly contested issues at the local or national level.

The idea of using shoes to illustrate the human toll wrought by gunfire originated in 1994 with a small group in New York City led by Katina Mantis Johnstone. In their "Silent March," the group collected and displayed forty thousand pairs of shoes to symbolize the number of Americans killed by guns in a year. These were placed in a circle around the Capitol Reflecting Pool in Washington, DC. One contributor donated a pair of yellow suede shoes. Holding them up before a gathering of about one thousand people, she said "Here are Willie's shoes, they are empty. We should have the right as human beings not to be killed by guns."[51]

In the coming years, the victims' shoe display gained traction. In 2012, on the lawn of the Capitol building, thousands of small shoes were placed to memorialize the seven thousand children estimated to

have died from gun violence. The *Monument for Our Kids* was part of an effort to increase pressure on Congress to pass stricter gun control legislation. The shoes, all worn, were donated by thousands of people across the United States. A similar scene was recreated in 2018 with thousands of empty pairs of shoes laid on the lawn of the Capitol to again commemorate children killed by gun violence, this time in the wake of the mass shooting at Marjory Stoneman Douglas High School in Parkland, Florida.[52] At the Winspear Opera House in Dallas, Texas, volunteers sorted through some seven thousand donated shoes on the floor, including sneakers, flip-flops, high heels, hiking boots, and baby shoes. "We will hang the number of shoes of people that have been touched by gun violence in America to that given day," Bart McGeehon, the production designer of a student play about gun violence called *Babel* said. "Gun violence," said McGeehon, "touches us all."[53] Mara Richards Bim, the founder and director of the Cry Havoc Theater Company said the idea had come from the shoes on display at the United States Holocaust Memorial Museum.[54] The emotionally potent replica of the pile of shoes at the Holocaust museum was meant as a reframing of the urgency of gun reform and to convey gun violence as a large-scale atrocity.

The trope of victims' shoes is used in a wide variety of political actions, both local and global. In Canada, for example, empty shoes have been used to memorialize the victims of drunk drivers.[55] An event called "Shoes That Remain Empty Forever" was part of the shoe campaign of Families for Justice, an organization that raises awareness and demands justice for people killed by impaired drivers in Canada each year. Similarly, the Australian Road Safety Foundation's 2012 "Fatality-Free Friday" campaign involved a display of 1,400 pairs of shoes representing the average number of people killed on Australian roads each year.[56] In Milan, Italy, and Grand Rapids, Michigan, victims of sexual violence have been memorialized in hundreds of red shoes lining the streets. Speaking about the shoes, Elina Chauvet, a Mexican artist and the creator of the *Los Zapatos Rojos* (*The Red Shoes*)

art installation, said "They're not there to see the sights, but to take up space. Especially when the women or girls who would have worn them no longer take up any space, except in the lives of their loved ones."[57] Building on this idea, in 2020, many pairs of women's shoes were hung on a city wall in Istanbul. The number of pairs, 440, represented the number of women murdered by their husbands in Turkey during the previous year.[58] The same idea was used in a different context in San Francisco in 2012, when 1,558 pairs of shoes were laid in front of the Golden Gate Bridge to represent those who had jumped to their deaths from the bridge and raise awareness of suicide.[59]

In 2022, on Suffrage Day, installations made up of hundreds of women's shoes lined the routes to the Catholic cathedrals in Auckland and Wellington, Australia, to protest at the treatment of women in the Church.[60] Among the messages accompanying the shoes were "Hoping for a truly inclusive Church which values the gifts of all," and "All the paths I travelled were mostly dead ends leading nowhere, or overgrown and full of obstacles. Come Holy Spirit and renew your Church!"[61] In Mexico, shoes were again used in a new context: to bring to public attention the victims of drug cartels. In 2016, boots, sneakers, and sandals donated by families seeking missing loved ones found their place in a hanging shoes exhibition to symbolize how far they had walked in their desperate search.[62] Protests against unemployment have also used the trope of victims' shoes. In May 2016, in Croatia's capital, Zagreb, unions staged a shoe protest for people forced to leave the country in search of work.[63]

Shoe protests that demand justice or reform of some kind operate in the same vector division, namely, to effect change fundamental to human rights but also restricted to a specific national context. The blurring and convergence of the two ideological worldviews is often masked by constructed interaction ritual chains meant to promote a general awareness and forge solidarity around a given topic. Although we rarely see protests referencing human rights per se, we do regularly see the use of the language of rights. Demands are vocalized as

demands based on rights. While in many protests, the trope of victims' shoes operates as a synonym for massive human rights abuses, there is a subtype of protests in which human rights are simply translated as rights of some kind that can and should be claimed in the local or national context. Even the 2021 protests against COVID-19 policies that spread across the United States extensively used the trope of victims' shoes. In September 2021, fifty-one pairs of shoes were left outside the Spokane Public Schools building in Washington state in protest of a state vaccine mandate. And in November 2021, shoes were placed outside a Middletown, New Jersey, school to protest a vaccine mandate.[64] A sign reading "My Child, My Choice" was spread on the front lawn of Brookside School in Merrick, New York, where parents from more than fifty school districts took part in "Operation Shoe Drop," an initiative protesting COVID-19-related mandates in schools.[65] In December 2021, a demonstration called "Shoes on the Steps" was carried out on the steps of the Bend-La Pine Schools administration building: "Each pair of shoes [represents] a child being pulled from the school system if vaccine mandates are enforced," states a description of the protest on the Facebook page for the "Moms for Liberty" group. "Globalists, utopians, socialists, totalitarians and the UN are using public schools to undermine freedom and Christianity," a borderline conspiracy theory slideshow at a "Moms for Liberty" event declared, according to Media Matters.[66]

How can we make sense of the widespread and diverse use of shoes in political actions? What are the desired moral orders demanded by those highly versatile communities of solidarity? The same objects are placed in central public spaces, embodying the same basic meanings of loss and death but seemingly with endless appropriations to different ends. Once shoes are released into open spaces from the staged environments of museums, their repeated use in political actions enables the emotional energy they generate to become a focus of interaction ritual chains. They become ascribed with hope and with lessons that can be applied in the promotion of human

rights–oriented moral orders. People interact with them, making the shoes the focus of interaction ritual chains, potent with symbolic intensity. Yet once the trope of victims' shoes is appropriated for different kinds of struggles that move away from the original meanings and once their nationalistic and human rights ideological wrapping becomes altered, amplified, or replaced, shoes become entangled in local disputes among various moral communities or against local or national governments. Those struggles are best explained using the language of rights and duties; for example, "we have a duty to remember . . . ," or "we have a right to. . . ." The language of assigning duties and claiming rights attributes shoes with the power to homogenize solidarities of the like-minded to fight a particular sectorial struggle.

So far, we have seen two major outcomes of protests in which shoes are employed. First, protests by moral communities created around the trope of victims' shoes, whether intentionally or not, lead to the strengthening of nationalistic sentiment. Though they often rely on a human rights vocabulary, in reality they end up promoting nationalism. As convincingly argued by Siniša Malešević, nationalism has become deeply grounded in every aspect of human life by an ever-increasing organizational capacity, greater ideological penetration, and networks of micro-solidarity.[67] And it is the trope of victims' shoes that reveals the embeddedness and depth of nationalism in protest efforts; it shows the limits of human imagination and people's inability to reenvision moral orders beyond frameworks of nations since the concept of nations has come to dominate ideas of how the world should look. Second, shoes are burdened with duties of recognition and awareness for the dead and missing, as well as the duty to claim rights for those who position themselves as oppressed or as victims of a party that is violating their rights. Here, shoes step away from their immediate connection with atrocities and are refashioned to accommodate a group's demands and complaints, whether for recognition, awareness, or reforms. Here, the use of the trope of victims' shoes shrinks significantly, and their accumulated ideological

attainment is reduced. Shoes are no longer embedded in human rights, but neither are they embedded in nationalism. They are just an easily recognizable and shocking tool that is used pragmatically to address a wide variety of issues. Next, we will examine protests in which the ideology of human rights is dominant.

Shoes for Human Rights: Environmental Action and Accounting for the Future Dead

In Paris in 2015, following the terrorist attacks in November and before the climate summit in December, more than eleven thousand empty pairs of shoes were placed at the Place de la République to symbolize the canceled march environmental activists had planned to hold before the climate change talks. There was a pair of shoes from Pope Francis and trainers from the UN secretary-general, Ban-Ki Moon, but most were from ordinary citizens. In the absence of the march and other events, the shoes provided a silent demonstration of support for action against climate change. The installation represented "a collection of millions of steps marching in the same direction," said Gloria Montenegro, a sixty-five-year-old Paris citizen who had donated two pairs of shoes.[68] The *Marching Shoes* installation was meant to show the commitment of the French people to climate issues, according to Emma Ruby-Sachs, the deputy director of Avaaz, the global organizing movement that began the shoe collection. The march was expected to bring two hundred thousand people to the city's streets but had been prohibited by French authorities in light of security concerns. Still, thousands marched in Hong Kong, Seoul, and Sydney.[69] Coalition Climat 21, a group of 130 nongovernmental organizations, started March4Me, an online platform that allowed Parisians to connect with people marching abroad in cities such as Berlin, London, and Melbourne.[70]

In London in 2016, a sea of empty shoes filled the grounds of the Department of Health and Social Care to represent the millions of

uninsured people globally who die each year from treatable conditions. The "Millions Missing" protest was part of the International Day of Action highlighting the plight of people unable to access health care and calling for greater funding from governments. Activists remained completely silent, some wearing gags over their mouths.[71] In Bristol, empty shoes were the centerpiece of a "Millions Missing" demonstration outside city hall focused on the millions of people worldwide living with myalgic encephalomyelitis (chronic fatigue syndrome).[72] "Millions Missing" protests also took place in Belfast, Melbourne, and cities throughout the United States.[73]

Five years after the Paris climate summit, a wave of climate protests took place, again using shoes. In April 2020, activists placed rows of boots and shoes in a Zurich square to take the place of protesters who would protest in person on Fridays to demand action on climate change. "Let us show solidarity for every crisis, including towards those people who are already suffering from the consequences of the climate crisis," said Fiona Chiappori from Climate Strike Switzerland, part of the global "Fridays for Future" movement. She continued, "We demand that every crisis is seen as such and treated appropriately."[74] In May 2020, the global climate activism group Extinction Rebellion placed two thousand pairs of children's shoes in London's Trafalgar Square to urge the government to "remember children during coronavirus recovery" and to protest against the government having bailed out carbon-intensive industries. Campaigners argued that the government was "writing off the chances of keeping within Paris Climate Agreement promises."[75] In July 2020, Albania's Institute for Environmental Policy organized a shoe protest to demand climate action in line with millions of people across the globe holding similar protests. Because of the COVID-19 pandemic, protests were banned—but not displays of shoes.[76] In August 2020, in Coventry in the United Kingdom, 168 pairs of shoes representing local pollution-related deaths were placed outside a transport museum by Extinction Rebellion Coventry to "give a sense of the tragedy."[77] In September 2020, a group of young activists held a climate protest in Tokyo,

laying about one hundred pairs of shoes on a footpath outside Japan's National Diet Building along with messages demanding stronger global warming countermeasures.[78] In February 2021, students from in and around Toronto, Canada, gathered shoes to protest the fast-tracked destruction of ecologically significant wetlands.[79]

Surprisingly, the further the protests move away from a focus on contextualized violence bound to a specific historical, political, and societal setting, such as an atrocity, the more they take on a human rights–based moral worldview. Staging shoes for environmental political actions to represent the effects of environmental inequality on millions of people around the world is a striking example of how human–object relations are constructed via the movement of objects and the circulation of meanings. Despite the move away from a context of atrocity in environmental protests, the logic of the use of shoes remains the same: shoes as void, loss, and death. However, in the environmental context, the agency given to victims' shoes is oriented toward the future, not the past. These protests are not about commemoration, building a nation, demanding recognition, settling accounts, or bringing about sectorial reform. They are about warning of future losses. They are a recognition that environmental violence is among the main driving forces of collective violence and that climate change will dramatically increase the likelihood of genocide occurring in areas at risk.[80] Environmental issues are global issues. These protests are about human rights for all.

CONCLUSION

At the time of writing, Getty Images maintained 7,576 images in which shoes were used in various protests. The examples I have provided in this chapter are just a tip of an iceberg; victims' shoes as a symbol of death, loss, and destruction have become widely appropriated to mark a wide array of political agendas and ideological worldviews. This is

the case for all political symbols that direct and maintain shared, yet often contested, meanings in public spaces. The symbols that leaders and societies use often tell a more powerful story about what those leaders and societies want to believe rather than what can be empirically verified.[81] Political symbols convey complex sets of beliefs and ideas that indicate what is considered to be the "right thing to do."[82] Political symbols are linked to their physical manifestations and political performances (e.g., in commemorations, protests, or official ceremonies) during which these symbols are reevaluated, redesigned, politicized, or used to promote certain moral claims and values. The affective content of political symbols, with their cognitive and emotional components, enables the creation of complex phenomena that appear simple and thus potent for various political agendas because symbols are based on indirect meanings.[83] Symbols can trigger a wide range of emotions. Jasper argues that "emotions accompany all social action, providing both motivation and goal."[84] Symbols embedded in desire objects become emotionally potent because desire objects are directly linked to "innocent civilians" and acts of unjust brutality and violence. Moral claims are formulated as demands and appeal to a change of social or political status for a segment of society, an entire society (i.e., a nation), or all of humanity.

Moral claims are directly linked to statements describing the world as it should be, such as "Muslim lives matter," "No land! No house! No vote!," *"Arbeit mach frei,"* and *"Que se vayan todos!"*[85] These are recognizable slogans embedded in common cultural knowledge that promote a particular political and ideological agenda. Though at this stage, desire objects are nearly invisible or subsumed within different objects, the emotional energy they generate across temporal and spatial dimensions is inscribed in the foundations of the symbols associated with desire objects and thus in the slogans.

As discussed throughout the book, many desire object journeys end before the objects reach a museum display. It takes a number of circumstantial and structural conditions for a desire object to get to

a museum display, and, of those that do, most will end their journey there. They will remain static in a staged environment to be replaced or moved to storage when proclaimed outdated or unneeded. Yet, regardless of the circuit within which a desire object ends its journey, all desire objects, as a category, will continue to occupy spaces of emotional involvement. It is their individual trajectories that instigate an emotional energy charge in the human–object encounter. However, regardless of the type of desire object or its trajectory, once on display in a staged environment, it will encourage people to engage in moral labor via the voluntary emotional labor of visitors.

In this chapter, I have shown how all desire objects have become subsumed into what appears to be the simple and mundane category of shoes. Although the ideological positioning of desire objects in staged environments, particularly memorial museums, is meant to encourage people to adopt a specific moral order, what happens once victims' shoes are appropriated for political action is that their ideological coating of human rights is diluted, altered, or replaced. When used in political action, much of a desire object's initial forensic or evidentiary value, so formative for its ideological coating of human rights, is ignored or forgotten. Rather, it is the generative value accumulated through its biography and in its encounters with people that constitutes the value of a desire object in political protests. Thus, the audience does not necessarily need to know the individual trajectories of desire objects to understand the meanings that have been ascribed to them. Although all desire objects can be reduced to their accumulated meanings of void, loss, and death to some extent, it only the category of victims' shoes that has crystalized and essentialized a message of death and destruction such that these objects can be used in a wide array of contexts without the audience first needing to understand the objects' trajectories. In contrast, a bracelet in the colors of the Ukrainian flag relies on the audience's accumulated knowledge of what this desire object stand for to be appropriated for political action; because of its narrow association, it can be used only

to communicate messaging regarding atrocities committed against the Ukrainian people. Shoes, however, become the focus of interaction ritual chains in which their fundamental meaning is preserved despite being repurposed for a wide variety of political actions. Some claim human rights but promote nationalism; some are detached from human rights but invested in the language of rights and duties; some speak to grave human rights concerns for the future.

9

CONCLUDING REMARKS

Desire Objects, Moral Labor, Ideologies, and Tacit Memory

Tying the world together, one pair of shoes at a time.

ON DESIRES CAPTURED BY PERSONAL ITEMS FOUND WHERE ATROCITIES HAVE TAKEN PLACE

The concept of desire brings to the fore wishful pathways that shape human–object relations. The desires embedded in personal items found where atrocities have occurred differ significantly from those emphasized in Jacques Lacan's psychoanalytic theory and practice. Lacan's notion of desire is inherent to the ethics of psychoanalysis and is concerned with a practice whose operation is defined as a function of the analyst's desire.[1] Lacan, following Freud, sees the question of desire as the basis of analytic experiences—as a domain beyond reason. Desires here follow a logic quite different from that used in the context of desire objects. The notion of desire sheds light on the emotions and meanings that people ascribe to personal items directly linked to atrocities. As I have shown, desires in the context of atrocity reflect wishful thinking about the world as it should be. These desires relate to the social context of the objects, and they change with the movement of desire objects and with their encounters with various

audiences. The desires reflected in desire objects are not independent of the ideological infrastructures that shape their movement and value. In fact, those ideological infrastructures direct and mold the emotional and cognitive responses of people in their encounters with desire objects.

This book addresses the historical-sociological process of how various human rights paradigms and practices pave the way for predetermined patterns in the movement of desire objects. After World War I, desire objects were predominantly items of military memorabilia and soldiers' letters and were used to promote nationalistic narratives of heroism and sacrifice. After World War II, desire objects primarily focused not on military power but on civilian loss of life. The shift in focus to the effects of atrocities on civilians was enabled through the collection of mundane personal items left behind after the war. Though significant, this shift was narrow and not driven by a human rights ideology. Only since the mid-1980s have personal items found at sites of atrocity gradually become sought after and fully understood as the necessary mediator between an atrocity and the growth of human rights.

Since the shift toward a human rights focus, desire objects have become imbued with an ideological narrative that burdens them with the promise of justice as an integral part of the ethos of human rights. In the early life of desire objects, when they are exhumed from sites of atrocity along with human remains, their value is determined by their forensic function. However, despite the strictly scientific nature of this work, it is justified via the language of human rights. The process of exhumation is directly connected to the vague yet commonly used notion of dignity, which forensics brings to both the dead and their surviving relatives. Themes of justice and dignity are embedded in ethics and ethical obligations that go beyond the technicalities of forensic procedures. As part of its 2003 conference, the International Commission on Missing Persons articulated an ethical cornerstone of forensic practice: that it is wrong to investigate the dead from armed

conflicts or disasters if the investigation focuses exclusively on the cause and manner of death of the victims (for accountability purposes) and does not include efforts to identify the remains (for humanitarian purposes).[2] Those who work in humanitarian forensics have an ethical obligation to advocate for identification and an ethical duty to observe and record all information potentially relevant to identification; they must consider the families' rights and needs before, during, and after exhumation and provide advice on the relationship between forensic practitioners and bereaved families and communities.[3] A part of this ethical humanitarian duty is to try to return recovered personal objects to family members of the killed or missing.

The spillover effect of aligning medical forensics with human rights is evident not only in how humanitarian forensics practitioners narrate their moral duties of excavation but also in how families and communities affected by an atrocity internalize and homogenize the emotions and meanings that they apply to desire objects. The vocabulary of justice, rights (e.g., to know the truth, to a dignified burial, to remember), and dignity appears to shape desires for envisioned moral orders. Since the mid-1990s, transitional justice mechanisms, particularly legal and memorialization practices, have added to this vocabulary accountability and the notion of justice for victims, making space for victims to voice their feelings. Many desires articulated once personal objects are returned to the families of the killed or missing relate to an imperative to remember both those who vanished and the atrocity, as well as to collectively recognize people's private pain.

With the emergence of memorial museums as a widespread genre that explicitly promotes human rights, global markets for desire objects have opened up. The movement of desire objects has now become almost entirely predictable. Both requests for donations of desire objects and the donations themselves tell us a lot about the expansion of the human rights infrastructure and its organizational and ideological capacities. Once desire objects are put on public display in carefully manipulated spaces potent with ideological

worldviews designed to encourage the generation and synchronization of collective emotional energy, the ever-changing audiences engage in moral labor and become recipients of the ideological narratives presented to them. Whereas in private spaces, desire objects project a desire for remembrance and recognition, in public spaces, they project a desire for societal change.

Though the movement of most desire objects stops with public display, some do have a life beyond the walls of a commemorative simulacrum. Similarly to how aspirational skeuomorph objects operate, the circulation of images and replicas of desire objects (e.g., via the media and popular culture), acting as proxies to evoke the properties of the original, gives desire objects a new life. Though desire objects follow trajectories embedded in the logic of human rights, once they are used in political action, their meanings diverge and become conflated with other ideological worldviews, stretching the range of desires to encompass vastly diverse moral orders. In political action, we see fused temporalities: those who use desire objects (or their replicas) to convey a message about past atrocities, those who use them to fight current atrocities, and those who use them to warn of future atrocities. While the basic fixed meanings of desire objects and their inherent link to death and atrocity remain, the desires they now project relate to various moral orders. Some of those desires align with a human rights worldview, whereas others align with nationalistic sentiments or narrow day-to-day issues. However, regardless of the moral order in question, what is common to all desire objects used in political action are the vocabulary of justice and rights and the embedded traces of their human rights–centered trajectories. While all political protests demand some sort of change and the objects used in protests may have multiple purposes, all desire objects used in public spaces come to those spaces already ascribed with historical-sociological meanings of death, loss, and violence.

It is important to stress that the patterned movements of desire objects emerged only with the liberation of the concentration camps

at the end of World War II. In the 1980s, forensic procedures became involved, and in the 1990s courts and tribunals started using desire objects as evidence of atrocities committed. With the emergence of memorial museums, the collection of desire objects, and pleas for donations of desire objects—and as a consequence of the widening scope of human rights—desire objects became irreplaceable as evidence and as warnings of the potential for future massive human rights violations. But we see little or no evidence of such practices when it comes to instances of structural violence such as slavery, colonialism, racism, institutional abuse, or gender inequality. What we do see is the mimicry and appropriation of desire objects to become symbolically linked to various forms of structural violence, such as in protests related to the discover of Indigenous children's bodies on the grounds of residential schools in Canada, agricultural reforms in France, the toll of femicide in Mexico, and clerical abuse in Ireland. Although desire objects are bound to particular contextualized mass atrocities, they can simultaneously become appropriated as symbols representing a wide variety of injustices.

DESIRE OBJECTS AND MORAL LABOR

This book expands the notion of the biographies of objects to account for not only their past but also their possible future trajectories. As demonstrated in my case study of desire objects, the patterned movements of objects define and, in a way, determine their future possible movements. Desire objects matter because they reveal the social mechanisms through which people become invested in moral labor, which is always bound to a particular ideological worldview. Emotions and emotional energy play an important role in moving people from an ordinary to an extraordinary realm of experience. However, while an emotional energy charge is necessary for agency to be ascribed to desire objects, this alone is not enough. Desire objects are

attributed with agency only when the emotional energy is associated with a particular ideological worldview. Only when people interacting with desire objects engage in moral labor are the objects granted a voice—the voice of the ideological underpinning of the object, which shapes people's desires regarding the world as it should be.

Desire objects also matter because they illustrate the distance between a concrete atrocity and an abstract desired moral order. The emotional energy they generate in each circuit of their journey defines their value: early on to assist with forensic and evidentiary procedures or to help with bereavement and then later, their discursive value in staged museum environments or their generative value in political actions. With each movement, desire objects are transformed, and their meanings are altered. Yet only at one stage in their journeys do they become the focus of interaction ritual chains, which encourage an audience to carry out moral labor—in which emotions are harvested to an ideological end and objects becomes ascribed with agency. It is precisely their agency that captures the generative value of desire objects and makes them different from all other objects used in political actions. Their agency is what connects distant spatial and temporal axes. This agency fortifies their essential meaning while transforming a damaged helmet found at Ground Zero, a rusty watch found in a mass grave in Bosnia, or a bracelet in the colors of the Ukrainian flag found on the wrist of a dead soldier into a potent symbol of death and destruction. It is the desire objects that stimulate emotional mining that instantly bridge the realms of the dead and the living.

Moral labor is often invisible. It is hidden between the organizational structures surrounding desire objects and the emotional energy charge of the objects. It is designed to equip us with a vocabulary, understanding, and meaning for a given context. Moral labor is under-researched and unappreciated as a vehicle of ideologization. But it occurs in many contexts. Official commemorations, particularly of contested elements of the past or of more recent events that spark emotional engagement, all tend to be ideologically situated to promote

nationalistic sentiments and strengthen nationalism. Other types of state-sponsored memorialization, such as leaders' funerals or political rallies, often encourage participants to engage in a type of moral labor that dictates how people should feel, think, and talk about a certain issue. But it is not only state-sponsored events that are designed to ideologically influence their participants. It often happens in a bottom-up way, such as in sporting events. Even concerts and festivities can be staged to shape ideological worldviews. Randall Collins wrote extensively about the importance of emotional energy in interaction ritual chains in events such as football matches and political demonstrations.[4] However, moral labor that incorporates ideology has never been recognized per se. Emotional, symbolic, and value-oriented behavior is determined by a social mechanism: the dynamics of interaction rituals. In contrast to Collins, Arlie Hochschild wrote extensively on emotional labor: the process of managing feelings and expressions to fulfill the emotional requirements of a job. Her work largely focused to service jobs and thus paid little attention to situations in which emotional labor is engaged in by people not in the service sector. Moral labor is a unique form of engagement that carries ideological underpinnings. Participants engage in moral labor voluntarily and without tangible compensation because they see it as moral (i.e., the right thing to do), whereas participants often expect to pay to engage in moral labor, as in the context of visiting a memorial museum.

Moral labor is used in a wide variety of contexts, such as political protests and social movements, and is not unique to desire objects. However, when desire objects are put on display in memorial museums and other sites of dark tourism that promote a human rights agenda, engagement with moral labor is encouraged but is not acknowledged as such. A crucial question with no straightforward answer is, How effective is the moral labor encouraged by memorial museums (i.e., that which positions human rights values at the heart of understanding atrocities)? In other words, to what extent do people who engage in moral labor in their encounters with desire

objects internalize human rights–oriented worldviews? Further, after leaving a memorial museum, how willing are people to promote and act on those worldviews? As shown in the previous chapter, because there is a significant degree of homogenization and appropriation when it comes to the language of human rights, it is not uncommon for people to use that language to reinforce contrasting ideological worldviews, particularly those in support of nationalism.

DESIRE OBJECTS: HUMAN RIGHTS AND NATIONALISM

Desire objects and their predestined biographies are a novel phenomenon that has emerged from clashes between two dominant ideological worldviews: human rights and nationalism. It is the affirmation of nation-states and their capacity to conduct atrocities on a massive scale that brought desire objects into the open and straight to the main stage of political action. The nation-state, with its cumulative bureaucratization of coercion as "an open-ended historical process that encompasses the constant increase of organizational power and competence for coercive action and the ability to internally pacify the social environment under one's control," is centrally situated and irreplaceable in the human capacity to imagine the world as it should be.[5] Terrorism, regardless of motivation, is a result of the artificial nation-states created during the interwar period and is of novel origins.[6] In all mass atrocities, the most decisive factor is modernity itself. Zygmunt Bauman argues that the modern era "has been founded on genocide, and has proceeded through more genocide."[7] Nationalism has gradually penetrated the organizational structures of the state and as such has become the dominant ideological doctrine and practice of modernity.[8] Hence, nationalistic infrastructures are omnipresent and often contradict (though sometimes overlap with) human rights–oriented visions of the world.

Desire objects are the harbingers of the clash between the ideological worldviews of human rights and nationalism while simultaneously limiting their ideological underpinnings. Although desire objects have been appropriated by a human rights–focused ideological stance, no alternative other than imagining the world via the nation-state is viable or easily imagined. The profound message of "never again" embedded in desire objects has proven to be an impotent signifier of belonging to a moral community that doesn't have a stronghold in social reality. According to Siniša Malešević, the organizational and ideological power of nationalism is hardly penetrable for different ideological worldviews, particularly ones in which nation-states cease to exist.[9]

The trajectory of desire objects burdens them with the potential of bringing about a human rights–oriented ideological alternative to envision the world in global terms, but once human rights *are* in place, the nation-centric principles of social organization start proliferating and penetrating the social order. The principal ideology of the nation-state—nationalism—has historically proven highly malleable and resilient, allowing it to eventually dominate the political space and replace its ideological competitors. The success of nationalism resides in its doctrinal flexibility and its capacity to incorporate the interests and values of various social strata. Human rights, often seen as apolitical or beyond politics, can and should be understood as an opposing ideological force that promotes ideas and ideals that in many ways collide with nationalistic ideologies. Instead of supporting clear national boundaries and advocating the idea of a "natural territory" for a limited group of people, human rights as an ideology supposedly rejects the claim that rights should be privileged and ascribed by any categorical division of humankind based on ethnicity, religion, class, or gender. For Michael Freeden, political ideologies comprise "identifiable clusters" of concepts.[10] People who belong to a moral community, or "ideologically identifiable cluster," share a particular interest and use a special vocabulary, in this case that of

human rights, to communicate with one other and recruit others into the community. Political ideologies also constitute communities in this sense, and anyone who wants to understand a particular ideology must learn its vocabulary.[11] The difference in the ideological projects of human rights and nationalism is best illustrated by their vocabularies. From a nationalistic outlook, atrocities are often presented as righteous and inevitable wars, whereas from a human rights point of view, wars are treated as massive human rights abuses. These different approaches to interpreting the past consequently lead to the creation of distinct communities of suffering. For nationalistic understandings of the past, those communities are most commonly defined by ethnic and national boundaries, whereas from the perspective of the human rights memorialization agenda, communities of suffering aim to create universal solidarities beyond ethnicity and nations.

Human rights–based ideologies promote the worldwide inclusion of all people into a single moral community that stands against the narrow, exclusionist idea of limited peoples defined by their belonging to a certain national body. Not only do the ideologies of human rights and nationalism provide distinct and conflicting norms and values but, even more importantly, they are also embedded in different sources of power. Whereas nationalism's strength lies in the nation-state, the power of human rights is found at the level of the global polity. This is because the system of creating value through the collective conferral of authority often seems to force states to bend their nationalist ideologies and enforce human rights at both the state and global levels. Several researchers have argued that the social structures of the global polity provide a sociological institutionalist reflection of global relations that prescribes actions and goals and provides a set of cultural norms or directions.[12] As the ideological doctrine of human rights gradually started to dictate norms and behaviors at the level of the global polity, many states started adopting human rights principles. It has been generally recognized that the power of human rights discourse stems from what Michael Elliott calls the "triumph

of the individual" and a "belief in the inherent dignity and equality of each individual person."[13]

It is the power of the ideological core of each worldview—for nationalism at the level of the nation-state and for human rights at the level of the global polity—that clashes and intersects with the increasing value of desire objects. These objects are found in places where mass atrocities have taken place—atrocities that are the direct product of the ideological and organizational capacities (or limitations) of nation-states. But in their trajectories, we can see how desire objects have come to be embraced by the organizational capacities of human rights. Starting from their role in forensic investigations, which are aligned with human rights principles; to their use in courts, in which they play a part in the human rights–sponsored process of transitional justice; to their display in memorial museums, which act as educational institutions to promote democracy, social change, and human rights, desire objects move through societal circuits and change in value in accordance with the logic embedded in human rights. Their ideological coating of human rights tells the people who interact with them how to talk and think about the atrocities with which they are linked. Hence, desire objects are the tangible evidence of the coercive capacities of nation-states and nationalism, and, throughout their trajectories, they are embraced and appropriated by human rights to send a clear message of the dangers posed by nation-states and nationalism. But once they reach the sphere of political action, they are most often reappropriated by nationalistic ideology.

Desire objects are truth-tellers: about lives taken prematurely, about atrocities committed, about injustices that remain unresolved. The recognizable trope of victims' shoes functions as a historical trace, as a simulation of the past and its irretrievable loss, in an overdetermination of history and memory.[14] Desire objects' trajectories through the first three circuits are meant to cement truth. But once they move beyond the staged environments of museum spaces, the contextualized grounding of their associated atrocity gets diluted. In

many political actions, the meaning of the given atrocity becomes hollow, and the object becomes detached from its genealogical roots. Shoes, as the pinnacle of all desire objects, are refashioned to connect and tackle unrelated issues, such as COVID-19 policies, gun violence, unemployment, climate change, and war. Shoes constitute a quintessential traveling trope and signal the absence of the humans who once wore them, their materiality a metonym for a corporality obliterated.[15] Their symbolic value has become an indispensable vocabulary for the measurement of the frailty of life and our own vulnerability. Not only has the wide circulation of shoes as desire objects (and of their images and replicas) created a recognizable landscape in visual culture, but shoes have also subsumed meanings of loss, destruction, death, and injustice—and they are able to be associated with various desired moral orders because of this essentialized meaning.

As discussed, the desires embedded in desire objects vary by circuit and include the desire to identify those who have been killed and bring the culprits to justice, the desire to comfort the grieving, and the desire to establish the facts of the past. Once they migrate to the realm of political action, they are ascribed agency to reflect particular moral orders. All desired moral orders, regardless of their ideological underpinnings, present a vision of the world as it should be. In this context, desire objects are used to reveal deep desires, whether hidden or explicit, and to link those desires with particular moral orders. Although all desire objects originate in mass human rights abuses linked with the coercive capacities of nation-states, when used in political action, they develop a wide range of ideological alignments that are often detached from their historical and political origins. On one hand, when used in protests directly connected to a given atrocity, their appearance in public spaces reinforces nationalistic sentiments. This may seem surprising since, in many of cases, the main and explicit motivator of the action is based in human rights. In fact, when desire objects are used as performative evidence of an atrocity, they actually bind the involved community to a narrow ethnic, religious,

or national category, intentionally or unintentionally but effectively reinforcing a nationalistic logic of belonging. On the other hand, it is the protests themselves that decontextualize and essentialize the geopolitical and historical origins of the desire objects: the objects move away from their association with a concrete and context-specific past atrocity to abstract, future atrocities. This is the case in environmental political actions, which manage, at least temporarily, to forge moral communities beyond nation-states. Paradoxically, the hollower the content of the victims' shoes becomes, the more potential they have to envision moral orders beyond the constraints of nationalism and nation-states.

By promoting a particular vision of the world, participants and audiences of a political action claim a new societal order of who is deserving, who has suffered, who should be privileged, and who should be blamed. The desired cosmologies, regardless of their ideological standpoint, always prioritize some at the expense of others. Shoes, as a focus of interaction ritual chains, are used in political actions to draw attention to an issue, group, or political agenda while at the same time minimizing others.

DESIRE OBJECTS AND TACIT MEMORY

Desire objects represent a societal layer shaped by the rise of both nationalism and human rights, as well as by their collisions and points of overlap. Thus, desire objects should be seen as both material and symbolical traces of an ideological intersection directly linked to how schemas of memory are forged.

In their exponential spread across disciplines, continents, and themes over the past thirty years or so, memory studies have yet to move away from commemorations and abuses of memory and pay much needed attention to tacit memory. However, desire objects are situated between two exciting new directions in the field of memory

studies. The first, guided by Jenny Wüstenberg, is called "slow memory." The slow memory project moves our attention from remembrance and commemorations of political violence and other atrocities to the issue of "how to reckon with slow-moving transformations that may be just as impactful, such as climate change, deindustrialization, or the gradual expansion of social and political rights."[16] The second emerging field is implicit collective memory. Already, Aleida Assmann[17] has distinguished between active and passive cultural forgetting. The former is an intentional act such as destruction. In the latter, objects are not materially destroyed but "fall out of the frames of attention, valuation, and use": they are lost, hidden, neglected, or abandoned. However, according to Astrid Erll, *implicit collective memory* refers to the unnoticed ways in which (colonial) remains—unintentionally, unconsciously, and invisibly—are affecting our knowledge via implicit memory schemata.[18] Elements of this invisible world include narrative schemata, stereotypes, patterns of framing, and models of the world, which usually are not explicitly known or addressed but get passed on from generation to generation and shape perception and action in new situations.[19] Erll suggests that much of our remembrance, both individual and collective, rests on our "blind spots," where much of our reasoning is "taken for granted" because that is how we ensure the continuity and reliability of the world around us.

Desire objects bridge these two emerging concepts. First, they reflect slow memory in their temporal flow: they need time, movement, and circulation to acquire meanings and become widely adopted. Atrocities, and the desire objects left behind in their wake, although historically bound, have no single location and no precise beginning or end; thus, they can be seen as a form of repetition and reoccurrence. As such, they also possess the imaginative capacity to reconfigure moral orders. Because they have a disproportionate impact on particular communities, their potential to bring about various moral orders comes from their generative power, which is

accumulated through their circulation and via their encounters with humans. The apparent "thingness" of things—that it seems to be a given that they are just there—is an end product of a long chain of transformations that changes the material into a concrete set of meanings ascribed to objects.[20] Mapping this chain of transformation in all its detail is the key to understanding the type of society in which the objects were produced and the ideological pathways through which their meanings were constructed.[21]

However, because desire objects are embedded in human–object relations, they surface as a schema, a blind spot, that is largely invisible in their capacity to forge memories without their presence. Gabriel Ignatow, for example, has examined how schemata order discourses that can establish broader cultural beliefs and thereby guide collective action.[22] He found that a group's discourse is shaped by historical context, situational factors, and elements of social structure. But he has also shown that shared schemata in which there is collective consensus powerfully contribute to the coherence of a group's discourse.[23] It is further claimed that patterns repeatedly elicit certain schemata, keeping them foregrounded, or "in the ready," in our brains. Others suggest that schemas can be deliberately activated via a process called priming: presenting a concept (often subliminally) to steer individuals toward related or similar ideas.[24]

It is the generative power of tacit memory, embedded in the human–object relations of desire objects, that defines the underlying conditions for how memory schemata are used to promote certain moral orders. The variability in the outcomes of moral labor (i.e., whether one is directed toward a human rights–based or nationalistic ideological worldview) is a result of the embodiment of tacit memory within the particular preexisting, already engraved patterns of remembrance. Finally, how the value and meanings of desire objects change and how these objects become attached to political action in an age of ideological clashes inevitably brings us to how people create meaning in memory recollection.

EPILOGUE

The Holocaust Shoe Project, inspired by a Holocaust survivor named Chaim Baruch, one of only two Jews from his hometown of Kobryn, Poland, to survive the Holocaust and World War II, is an excellent example of the transformation desire objects may go through.[25] It demonstrates how desire objects operate on spatial and temporal axes, bringing together the past, present, and future across geopolitical areas.

In 2000, Chaim's son, Alan Morawiec, started the Holocaust Shoe Project as a way to teach people about the horrors of the Holocaust and help those around the world who are less fortunate. So far, his organization has collected more than 44,290 pairs of new and serviceable shoes. Each year during Holocaust Awareness Week, the shoes are displayed in a school lobby. They are then distributed locally and internationally to organizations that give them to people in need. The donated shoes have so far reached many places distant and close, from Colorado, Georgia, and Wisconsin to Belarus, Botswana, Haiti, and Mexico. This example highlights the alteration of desire objects; in this case, shoes are being used as a concrete tool to fight poverty and inequality. This example also demonstrates ideological convergences, from a story that happened to "us" as a specific nationally or ethnically bound group to a story of bettering the lives of unknown communities in need. The Holocaust Shoe Project has transformed the trope of victims' shoes: shoes used for political action become wearable shoes that can make a difference in people's lives. The project shows how desire objects accumulate and generate meanings over time and how they can ignite political action. However, it also shows both the slow pace of human rights progress and striking limitations of what they can achieve. But maybe a steady way of moving forward toward a human rights–oriented moral order is simply one pair of shoes at a time.

NOTES

PROLOGUE

1. Lea David, *The Past Can't Heal Us: The Dangers of Mandating Memory in the Name of Human Rights* (Cambridge: Cambridge University Press, 2020).

INTRODUCTION: DESIRE OBJECTS AND HUMAN RIGHTS

1. "How to Protect Witnesses Who Are Seen by Public and Police as Traitors?," Humanitarian Law Centre, February 7, 2004, http://www.hlc-rdc.org/?p=13581&lang=de.
2. Zuzanna Dziuban and Ewa Stańczyk, "Introduction: The Surviving Thing: Personal Objects in the Aftermath of Violence," *Journal of Material Culture* 25, no. 4 (2020): 381–90, https://doi.org/10.1177/1359183520954514.
3. Tanja Luckins, "Collecting Women's Memories: The Australian War Memorial, the Next of Kin and Great War Soldiers' Diaries and Letters as Objects of Memory in the 1920s and 1930s," *Women's History Review* 19, no. 1 (2010): 21–27, https://doi.org/10.1080/09612020903444635.
4. Stephen Cordner and Morris Tidball-Binz, "Humanitarian Forensic Action – Its Origins and Future," *Forensic Science International* 279 (2017): 65–71, https://doi.org/10.1016/j.forsciint.2017.08.011; Paige Arthur, "How 'Transitions' Reshaped Human Rights: A Conceptual History of Transitional Justice," *Human Rights Quarterly* 31, no. 2 (2009): 321–67, https://doi.org/10.1353/hrq.0.0069; Amy Sodaro, *Exhibiting Atrocity: Memorial Museums and the Politics of Past Violence* (New Brunswick, NJ: Rutgers University Press, 2018);

Paul Williams, *Memorial Museums: The Global Rush to Commemorate Atrocities* (New York: Berg, 2007).

5. Kathryn Sikkink, *Evidence for Hope: Making Human Rights Work in the 21st Century* (Princeton, NJ: Princeton University Press, 2017), 33–37; Todd Landman, "Measuring Human Rights: Principle, Practice, and Policy," *Human Rights Quarterly* 26, no. 4 (2004): 906–31.
6. "UN Publishes Guide for Measuring Human Rights," International Justice Resource Center, February 19, 2013, https://ijrcenter.org/2013/02/19/un-publishes-guide-for-measuring-human-rights/; Klaus Starl et al., *Human Rights Indicators in the Context of the European Union* (Brussels: European Commission, 2014), https://repository.gchumanrights.org/server/api/core/bitstreams/8c067be2-0646-4a59-a476-3987938393d3/content.
7. Christopher J. Fariss, "Respect for Human Rights Has Improved Over Time: Modeling the Changing Standard of Accountability," *American Political Science Review* 108, no. 2 (2014): 297–318.
8. Sikkink, *Evidence for Hope*, 37–38; Christian Staerklé and Alain Clémence, "Why People Are Committed to Human Rights and Still Tolerate Their Violation: A Contextual Analysis of the Principle–Application Gap," *Social Justice Research* 17, no. 4 (2004): 389–406, https://doi.org/10.1007/s11211-004-2058-y.
9. Trevor Owens, "Tripadvisor Rates Einstein: Using the Social Web to Unpack the Public Meanings of a Cultural Heritage Site," *International Journal of Web Based Communities* 8, no. 1 (2012): 40–56, https://doi.org/10.1504/IJWBC.2012.044681; Stephan Jaeger, "Visitor Emotions, Experientiality, Holocaust, and Human Rights: Tripadvisor Responses to the Topography of Terror (Berlin) and the Kazerne Dossin (Mechelen)," in *Visitor Experience at Holocaust Memorials and Museums*, ed. Diana I. Popescu (London: Routledge, 2023), 31–45; Amy Sodaro, "'Bring Your Kleenex and Plan Something Fun for Later . . .': Social Media Reviews of the 9/11 Museum," in *The Memorial Museum in the Digital Age*, ed. Victoria Grace Walden, 414–41 (Sussex: Reframe, 2022); Susanne Buckley-Zistel and Timothy Williams, "A 5* Destination: The Creation of New Transnational Moral Spaces of Remembrance on Tripadvisor," *International Journal of Politics, Culture, and Society* 35, no. 2 (2022): 221–38, https://doi.org/10.1007/s10767-020-09363-7.
10. Randall Collins, *Interaction Ritual Chains* (Princeton, NJ: Princeton University Press, 2005), 35–42.
11. Collins, *Interaction Ritual Chains*, 42.

INTRODUCTION 241

12. Arlie Hochschild, *The Managed Heart: Commercialization of Human Feeling*, 3rd ed. (Berkeley: University of California Press, 2012); Arlie Hochschild, "Emotion Work, Feeling Rules, and Social Structure," *American Journal of Sociology* 85, no. 3 (1979): 551–75; Arlie Hochschild, *The Second Shift: Working Families and the Revolution at Home*, revised ed. (New York: Penguin, 2012).
13. Joan Acker, *Doing Comparable Worth: Gender, Class, and Pay Equity* (Philadelphia: Temple University Press, 1989); Ronnie Steinberg and Deb Figart, "Emotional Demands at Work: A Job Content Analysis," *Annals of the American Academy of Political and Social Science* 561 (1999): 177–91, https://doi.org/10.1177/0002716299561001012.
14. Alan Bainbridge and Linden West, "A Key? Conflict, and the Struggle for an Ecology of Dialogue, Learning and Peace Among Israeli Jewish and Palestinian Educators," in *Discourses, Dialogue and Diversity in Biographical Research: An Ecology of Life and Learning*, ed. Alan Bainbridge, Laura Formenti, and Linden West (Leiden: Brill, 2021), 121–40; Nels Johnson, "Palestinian Refugee Ideology: An Enquiry Into Key Metaphors," *Journal of Anthropological Research* 34, no. 4 (1978): 524–39; Evan Renfro, "Stitched Together, Torn Apart: The Keffiyeh as Cultural Guide," *International Journal of Cultural Studies* 21, no. 6 (2018): 571–86, https://doi.org/10.1177/1367877917713266; Fernando J. Bosco, "Human Rights Politics and Scaled Performances of Memory: Conflicts Among the Madres de Plaza de Mayo in Argentina," *Social & Cultural Geography* 5, no. 3 (2004): 381–402, https://doi.org/10.1080/14649 3604000252787; Karen A. Foss and Kathy L. Domenici, "Haunting Argentina: Synecdoche in the Protests of the Mothers of the Plaza de Mayo," *Quarterly Journal of Speech* 87, no. 3 (2001): 237–58, https://doi.org/10.1080 /00335630109384335.
15. Here, I am not talking about the "throwing shoes" phenomenon, which is an act of disobedience and is culturally rooted. It does not originate in the trope of the victims' shoes and is distant from the concept of desire objects.
16. Nicholas J. Saunders and Paul Cornish, eds., *Contested Objects: Material Memories of the Great War* (London: Routledge, 2013).
17. Sophie Baby and François-Xavier Nérard, "Objects from the missing. Exhumations and uses of the material traces of mass violence," trans. Clare Ferguson, *Les Cahiers Sirice* 19, no. 2 (2017): 5–20; Layla Renshaw, "The Open Grave: Exposed Bodies and Objects in New Representation of Dead," in *Exhuming Loss: Memory, Materiality and Mass Graves of the Spanish Civil War* (Walnut Creek, CA: Left Coast, 2011), 147–84.

1. DESIRE OBJECTS

1. Midhat Poturović, "Srebrenica Victims' Personal Items Help Keep Memories Alive," February 7, 2020, *Radio Free Europe/Radio Liberty*, https://www.rferl.org/a/srebrenica-massacre-victims-personal-items-help-keep-memories-alive/30416483.html.
2. Aafke Komter, "Heirlooms, Nikes and Bribes: Towards a Sociology of Things," *Sociology* 35, no. 1 (2001): 59–75.
3. Arjun Appadurai, "Introduction: Commodities and the Politics of Value," in *The Social Life of Things*, ed. Arjun Appadurai (Cambridge: Cambridge University Press, 1986), 3–63.
4. Merriam-Webster, s.v. "political action (*n.*)," accessed January 12, 2022, https://www.merriam-webster.com/dictionary/political%20action.
5. Randall Collins, *Interaction Ritual Chains* (Princeton, NJ: Princeton University Press, 2005), 48.
6. Collins, *Interaction Ritual Chains*, 48–53.
7. Collins, *Interaction Ritual Chains*, 42–43.
8. Randal Collins, "Emotional Energy as the Common Denominator of Rational Action," *Rationality and Society* 5, no. 2 (1993): 203–30, https://doi.org/10.1177/1043463193005002005; Collins, *Interaction Ritual Chains*.
9. Jeff Goodwin, James M. Jasper, and Francesca Polletta, eds., Introduction, "Why Emotions Matter," in *Passionate Politics: Emotions and Social Movements* (Chicago: University of Chicago Press, 2001), 1–26; Collins, "Emotional Energy"; Catherine Milne and Tracey Otieno, "Understanding Engagement: Science Demonstrations and Emotional Energy," *Science Education* 91, no. 4 (2007): 523–53, https://doi.org/10.1002/sce.20203; Lea David, "Human Rights, Micro-solidarity and Moral Action: 'Face-to-Face' Encounters in the Israeli/Palestinian Context," *Thesis Eleven* 154, no. 1 (2019): 66–79, https://doi.org/10.1177/0725513619874928; Michael R. Smith et al., "Stress and Performance: Do Service Orientation and Emotional Energy Moderate the Relationship?," *Journal of Occupational Health Psychology* 17, no. 1 (2012): 116–28, https://doi.org/10.1037/a0026064; Wendy A. Goldberg et al., "Emotional Energy as an Explanatory Construct for Fathers' Engagement with Their Infants," *Parenting* 2, no. 4 (2002): 379–408, https://doi.org/10.1207/S15327922PAR0204_03.
10. Collins *Interaction Ritual Chains*, 49.
11. Goodwin, Jasper, and Polletta, *Passionate Politics*, 10.
12. Collins, "Emotional Energy as the Common Denominator of Rational Action," April 1, 1993, 206.

1. DESIRE OBJECTS 243

13. Goodwin, Jasper, and Polletta, Introduction to *Passionate Politics*.
14. David Boyns and Sarah Luery, "Negative Emotional Energy: A Theory of the 'Dark-Side' of Interaction Ritual Chains," *Social Sciences* 4 (2015): 148–70, https://doi.org/10.3390/socsci4010148.
15. William A. Gamson, *Talking Politics* (Cambridge: Cambridge University Press, 1992), 32.
16. Davide Sterchele, "The Limits of Inter-religious Dialogue and the Form of Football Rituals: The Case of Bosnia-Herzegovina," *Social Compass* 54, no. 2 (2007): 211–24, https://doi.org/10.1177/0037768607077032.
17. Milne and Otieno, "Understanding Engagement."
18. Gamson, *Talking Politics*, 29–33.
19. Leora Auslander, "Beyond Words," *American Historical Review* 110, no. 4 (2005): 1015–45, https://doi.org/10.1086/ahr.110.4.1015; Leora Auslander, Tara Zahra, and Alice Goff, eds., Introduction to *Objects of War: The Material Culture of Conflict and Displacement*, 1–21 (Ithaca, NY: Cornell University Press, 2018). Jane Bennett, *Vibrant Matter: A Political Ecology of Things* (Durham, NC: Duke University Press, 2010), 1–19.
20. Chris Gosden, "Making Sense: Archaeology and Aesthetics," *World Archaeology* 33, no. 2 (2001): 163–67.
21. Michael Shanks, "Symmetrical Archaeology," *World Archaeology* 39, no. 4 (2007): 589–96, https://doi.org/10.1080/00438240701679676; Christopher L. Witmore, "Symmetrical Archaeology: Excerpts of a Manifesto," *World Archaeology* 39, no. 4 (2007): 546–62, https://doi.org/10.1080/00438240701679411; Christopher Witmore, "Symmetrical Archaeology," in *Encyclopedia of Global Archaeology* (Cham: Springer, 2019), 1–15; Jennifer Cotter, "New Materialism and the Labor Theory of Value," *Minnesota Review* 2016, no. 87 (2016): 171–81, https://doi.org/10.1215/00265667-3630928; N. J. Fox and P. Alldred, "Sociology, Environment and Health: A Materialist Approach," *Public Health* 141 (2016): 287–93, https://doi.org/10.1016/j.puhe.2016.09.015; Christopher N. Gamble, Joshua S. Hanan, and Thomas Nail, "What Is New Materialism?," *Angelaki* 24, no. 6 (2019): 111–34, https://doi.org/10.1080/0969725X.2019.1684704.
22. Gosden, "Making Sense."
23. Wiebe E. Bijker, *Of Bicycles, Bakelites, and Bulbs: Toward a Theory of Sociotechnical Change*, 3rd ed. (Cambridge, MA: MIT Press, 1997), 3.
24. Carl Knappett, "Photographs, Skeuomorphs and Marionettes: Some Thoughts on Mind, Agency and Object," *Journal of Material Culture* 7, no. 1 (2002): 100, https://doi.org/10.1177/1359183502007001307.

25. Bruno Latour, *We Have Never Been Modern* (Cambridge, MA: Harvard University Press, 1993), 1–3; Bruno Latour and Peter Weibel, eds., *Making Things Public: Atmospheres of Democracy* (Cambridge, MA: MIT Press, 2005), 23.
26. Latour, *We Have Never Been Modern*; Alan Radley, "Artefacts, Memory and a Sense of the Past," in *Collective Remembering*, ed. David Middleton and Derek Edwards (London: Sage, 1990), 46–59; Mihaly Csikszentmihalyi and Eugene Halton, *The Meaning of Things: Domestic Symbols and the Self* (Cambridge: Cambridge University Press, 1981), 1–19; Elizabeth Hallam and Jenny Hockey, *Death, Memory, and Material Culture* (Oxford: Berg, 2001), 98.
27. Knappett, "Photographs."
28. Knappett, "Photographs."
29. Chris Gosden and Yvonne Marshall, "The Cultural Biography of Objects," *World Archaeology* 31, no. 2 (1999): 169–78.
30. Janet Hoskins, *Biographical Objects: How Things Tell the Stories of People's Lives* (New York: Routledge, 1998).
31. Hoskins, *Biographical Objects*, 8.
32. Nicholas J. Saunders and Paul Cornish, eds., *Contested Objects: Material Memories of the Great War* (London: Routledge, 2013), 1–11.
33. Komter, "Heirlooms."
34. Appadurai, "Introduction."
35. Appadurai, "Introduction."
36. Bronislaw Malinowski, *Argonauts of the Western Pacific: An Account of Native Enterprise and Adventure in the Archipelagoes of Melanesian New Guinea; [Robert Mond Expedition to New Guinea, 1914–1918]* (London: Routledge, 1922); Marcel Mauss, *The Gift: The Form and Reason for Exchange in Archaic Societies*, reprint of the 1954 American edition (Mansfield, CT: Martino, 1925); Peter M. Blau, *Exchange and Power in Social Life* (London Routledge, 2017).
37. Malinowski, *Argonauts of the Western Pacific*.
38. Appadurai, "Introduction."
39. Appadurai, "Introduction."
40. Zuzanna Dziuban and Ewa Stańczyk, "Introduction: The Surviving Thing: Personal Objects in the Aftermath of Violence," *Journal of Material Culture* 25, no. 4 (2020): 381–90, https://doi.org/10.1177/1359183520954514.
41. Layla Renshaw, "Unrecovered Objects: Narratives of Dispossession, Slow Violence and Survival in the Investigation of Mass Graves from the Spanish Civil War," *Journal of Material Culture* 25, no. 4 (2020): 428–46, https://doi.org/10.1177/1359183520954499.

1. DESIRE OBJECTS 245

42. Gilly Carr, "The Small Things of Life and Death: An Exploration of Value and Meaning in the Material Culture of Nazi Camps," *International Journal of Historical Archaeology* 22, no. 3 (2018): 531–52, https://doi.org/10.1007/s10761-017-0435-0.
43. Zuzanna Dziuban, ed., *Mapping the "Forensic Turn": Engagements with Materialities of Mass Death in Holocaust Studies and Beyond* (Vienna: New Academic, 2017); Rebecca L. Stein, "Retour sur la dépossession Israël, la *Nakba*, les Choses," *Ethnologie française* 45, no. 2 (2015): 309–20, https://doi.org/10.3917/ethn.152.0309; Alice von Bieberstein, "Treasure/Fetish/Gift: Hunting for 'Armenian Gold' in Post-genocide Turkish Kurdistan," *Subjectivity* 10, no. 2 (2017): 170–89, https://doi.org/10.1057/s41286-017-0026-x.
44. Dziuban and Stańczyk, "Introduction."
45. Appadurai, "Introduction."
46. Georg Simmel, *The Philosophy of Money*, 2nd ed., ed. David Frisby (London: Routledge, 1900), 67.
47. Marianne Hirsch and Leo Spitzer, "What's Wrong with This Picture?," *Journal of Modern Jewish Studies* 5, no. 2 (2006): 229–52, https://doi.org/10.1080/14725880600741615; Nefissa Naguib, "Storytelling: Armenian Family Albums in the Diaspora," *Visual Anthropology* 21, no. 3 (2008): 231–44, https://doi.org/10.1080/08949460801986228.
48. Santanu Das, "Reframing Life/War 'Writing': Objects, Letters and Songs of Indian Soldiers, 1914–1918," *Textual Practice* 29, no. 7 (2015): 1265–87, https://doi.org/10.1080/0950236X.2015.1095446.
49. Zuzanna Dziuban, "Atopic Objects: The Afterlives of Gold Teeth Stolen from Holocaust Dead," *Journal of Material Culture* 25, no. 4 (2020): 408–27, https://doi.org/10.1177/1359183520954462.
50. Susan Schuppli, *Material Witness: Media, Forensics, Evidence* (Cambridge, MA: MIT Press, 2020); Dziuban and Stańczyk, "Introduction."
51. Schuppli, *Material Witness*; Dziuban and Stańczyk, "Introduction"; Paul Williams, *Memorial Museums: The Global Rush to Commemorate Atrocities* (New York: Berg, 2007).
52. James G. Carrier, *Gifts and Commodities: Exchange and Western Capitalism Since 1700* (London: Routledge, 2012).
53. Erving Goffman, *Relations in Public: Microstudies of the Public Order* (New Brunswick, NJ: Transaction, 1971).
54. Sophie Baby and François-Xavier Nérard, "Les objets des disparus. Exhumations et usages des traces matérielles de la violence de masse," *Cahiers Sirice*

19, no. 2 (2017): 5–20, https://doi.org/10.3917/lcsi.019.0005; Layla Renshaw, *Exhuming Loss: Memory, Materiality and Mass Graves of the Spanish Civil War* (Walnut Creek, CA: Left Coast, 2011).
55. This is not an attempt to compare or equate these leaders but to point out the tremendous social impact of their passing.
56. Mary Douglas, *Purity and Danger: An Analysis of Concepts of Pollution and Taboo* (London: Routledge, 1966), 2.

2. A THEORETICAL MODEL: DESIRE OBJECTS AND MORAL LABOUR

1. Elizabeth Ellsworth, *Places of Learning: Media, Architecture, Pedagogy* (New York: Routledge, 2005), 15–35.
2. Philip Stone, "Dark Tourism Scholarship: A Critical Review," *International Journal of Culture, Tourism and Hospitality Research* 7, no. 3 (2013): 307–18, https://doi.org/10.1108/IJCTHR-06-2013-0039; Philip Stone, "A Dark Tourism Spectrum: Towards a Typology of Death and Macabre Related Tourist Sites, Attractions and Exhibition," *Tourism: An International Interdisciplinary Journal* 54, no. 2 (2006): 145–60; Annaclaudia Martini and Dorina Maria Buda, "Dark Tourism and Affect: Framing Places of Death and Disaster," *Current Issues in Tourism* 23, no. 6 (2020): 679–92, https://doi.org/10.1080/13683500.2018.1518972.
3. Joan Acker, *Doing Comparable Worth: Gender, Class, and Pay Equity* (Philadelphia: Temple University Press, 1989); Ronnie Steinberg and Deb Figart, "Emotional Demands at Work: A Job Content Analysis," *Annals of the American Academy of Political and Social Science* 561 (1999): 177–91, https://doi.org/10.1177/000271629956100128.
4. Steinberg and Figart, "Emotional Demands at Work."
5. Paula England and George Farkas, *Households, Employment, and Gender: A Social, Economic, and Demographic View* (New York: Routledge, 2017), 91.
6. Steinberg and Figart, "Emotional Demands at Work."
7. This is best seen in sectors previously not regarded as part of the service industry, such as in academia where academic staff are now responsible for students' well-being in addition to their education. Blake E. Ashforth and Ronald H. Humphrey, "Emotional Labor in Service Roles: The Influence of Identity," *Academy of Management Review* 18, no. 1 (1993): 88–115, https://doi.org/10.2307/258824; Robin Leidner, "Emotional Labor in Service Work," *Annals of the American Academy of Political and Social Science* 561, no. 1 (1999): 81–95, https://doi.org/10.1177/000271629956100106.

2. A THEORETICAL MODEL 247

8. Arlie Russell Hochschild, "Emotion Work, Feeling Rules, and Social Structure," *American Journal of Sociology* 85, no. 3 (1979): 551–75; Arlie Russell Hochschild, *The Managed Heart: Commercialization of Human Feeling*, 3rd ed. (Berkeley: University of California Press, 2012).
9. Allison Gabriel et al., "Emotional Labor Actors: A Latent Profile Analysis of Emotional Labor Strategies," *Journal of Applied Psychology* 100, no. 3 (2015): 863–79, https://doi.org/10.1037/a0037408.
10. Hochschild, *The Managed Heart*; J. Andrew Morris and Daniel C. Feldman, "The Dimensions, Antecedents, and Consequences of Emotional Labor," *Academy of Management Review* 21, no. 4 (1996): 986–1010, https://doi.org/10.2307/259161.
11. Amy Wharton, "The Sociology of Emotional Labor," *Annual Review of Sociology* 35 (2009): 147–65, https://doi.org/10.1146/annurev-soc-070308-115944.
12. Kjell Olsen, "Authenticity as a Concept in Tourism Research: The Social Organization of the Experience of Authenticity," *Tourist Studies* 2, no. 2 (2002): 159–82, https://doi.org/10.1177/146879702761936644; J. Gadsby, "The Effect of Encouraging Emotional Value in Museum Experiences," *Museological Review* 15 (2011): 1–13.
13. Joe Cruz and Robert Gordon, "Simulation Theory," in *Encyclopedia of Cognitive Science*, ed. L. Nagel (Nature, 2002).
14. Randall Collins, *Interaction Ritual Chains* (Princeton, NJ: Princeton University Press, 2005), 66.
15. Elaine Hatfield, John T. Cacioppo, and Richard L. Rapson, "Emotional Contagion," *Current Directions in Psychological Science* 2, no. 3 (1993): 96–99; Amy Coplan, "Catching Characters Emotions: Emotional Contagion Responses to Narrative Fiction Film," *Film Studies* 8, no. 1 (2006): 26–38, https://doi.org/10.7227/FS.8.5.
16. Lauren Wispé, *The Psychology of Sympathy* (New York: Plenum, 1991), 1–33.
17. Randall Collins, *Violence: A Micro-sociological Theory* (Princeton, NJ: Princeton University Press, 2009); Randall Collins, "Social Movements and the Focus of Emotional Attention," in *Passionate Politics: Emotions and Social Movements*, ed. Jeff Goodwin, James M. Jasper, and Francesca Polletta (Chicago: University of Chicago Press, 2001), 27–44; David Boyns and Sarah Luery, "Negative Emotional Energy: A Theory of the 'Dark-Side' of Interaction Ritual Chains," *Social Sciences* 4 (2015): 148–70, https://doi.org/10.3390/socsci4010148; Clark McPhail and Ronald T. Wohlstein, "Individual and Collective Behaviors Within Gatherings, Demonstrations, and Riots," *Annual Review of Sociology* 9 (1983): 579–600.

18. Ruth Rosengarten, *Second Chance: My Life in Things* (Open Book, 2022), 2–17.
19. Symbols, as a concept of varying meaning and changing value, have been extensively researched across many disciplines, including anthropology, archaeology, communication studies, history, philosophy, political sociology, and religious studies. In particular with the rise of anthropology as a discipline, symbols became a central focus of research. Starting with James G. Frazer (1854–1941) and Franz Boas (1858–1942), the study of the importance of symbols in various cultures became prominent. Alfred Radcliffe-Brown (1881–1955), for example, relied heavily on Émile Durkheim's work in his approach to symbols as meanings that give expression to sentiments in individuals in order to regulate collective needs or preserve relations and interests important to a particular society. Bronislaw Malinowski (1884–1942) shared many of Radcliffe-Brown's views but approached symbols with a keener sensitivity for their linguistic implications and a more complex theoretical understanding of them. Victor Turner (1920–1983) developed an important theory of symbolism from his studies of rituals in the late twentieth century. Claude Lévi-Strauss's structuralism resurrected interest in myths and symbols as phenomena more basic than the meanings they convey, the social functions they fulfil, or the social systems that give them shape. Symbols belong to their own systems, he argued, within which they are subject to certain basic relationships and patterns of transformation. Others, such as Mircea Eliade (1907–1986), Mary Douglas (1921–2007), and Sigmund Freud (1856–1939), who founded his psychoanalytic movement on a theory of symbols whose refinement he pursued throughout his life, also placed symbols at the core of their research. Others who wrote extensively on symbolism and their constructed meanings in politics include Kenneth Burke, Jacques Derrida, Harold Lasswell, Walter Lippmann, and George Herbert Mead. Graeme Gill and Luis F. Angosto-Ferrandez, "Introduction: Symbolism and Politics," *Politics, Religion & Ideology* 19, no. 4 (2018): 429–33, https://doi.org/10.1080/21567689.2018.1539436.
20. Madison Horne, "9/11 Lost and Found: The Items Left Behind," National September 11 Memorial & Museum, last updated September 7, 2023, https://www.history.com/.amp/news/9-11-artifacts-ground-zero-photos.

3. IDEOLOGICAL COATINGS: HUMAN RIGHTS AND NATIONALISM

1. Lea David and Siniša Malešević, "Ideology and Nation-States," in *The Routledge Handbook of Ideology and International Relations*, ed. Jonathan Leader Maynard and Mark L. Haas (London: Routledge, 2022), 23–39.

3. IDEOLOGICAL COATINGS 249

2. Lea David, *The Past Can't Heal Us: The Dangers of Mandating Memory in the Name of Human Rights* (Cambridge: Cambridge University Press, 2020); Clifford Bob, "Ideology and Human Rights," in *The Routledge Handbook of Ideology and International Relations*, ed. Jonathan Leader Maynard and Mark L. Haas (London: Routledge, 2022), 219–32.
3. Sebastian Brett et al., *Memorialization and Democracy: State Policy and Civic Action* (New York: International Center for Transitional Justice, 2007), 1.
4. Jeffrey M. Blustein, "Human Rights and the Internationalization of Memory," in *Forgiveness and Remembrance: Remembering Wrongdoing in Personal and Public Life* (New York: Oxford University Press, 2014), 19.
5. David, *The Past Can't Heal Us*.
6. Lea David, "Moral Remembrance and New Inequalities," *Global Perspectives* 1, no. 1 (2020): 11782, https://doi.org/10.1525/001c.11782.
7. David, "Moral Remembrance"; David, *The Past Can't Heal Us*.
8. Samuel Moyn, *The Last Utopia: Human Rights in History* (Cambridge, MA: Belknap, 2012), 9.
9. Natan Sznaider, "The Sociology of Compassion: A Study in the Sociology of Morals," *Cultural Values* 2, no. 1 (1998): 117–39, https://doi.org/10.1080/14797589809359290.
10. Sznaider, "The Sociology of Compassion," 118.
11. Sznaider, "The Sociology of Compassion," 119.
12. Natan Sznaider, "Compassion, Cruelty, and Human Rights," in *World Suffering and Quality of Life*, ed. Ronald E. Anderson (Dordrecht: Springer, 2015), 55–64.
13. David, *The Past Can't Heal Us*.
14. Katrin Antweiler, *Memorialising the Holocaust in Human Rights Museums* (Boston: De Gruyter, 2023).
15. James Edward Young, *The Texture of Memory: Holocaust Memorials and Meaning* (New Haven, CT: Yale University Press, 1994); David, *The Past Can't Heal Us*; David, "Moral Remembrance."
16. Young, *The Texture of Memory*.
17. John Hutchinson, "Warfare and the Sacralisation of Nations: The Meanings, Rituals and Politics of National Remembrance," *Millennium: Journal of International Studies* 38, no. 2 (2009): 409, https://doi.org/10.1177/0305829809347538.
18. Nicky Rousseau, "Identification, Politics, Disciplines: Missing Persons and Colonial Skeletons in South Africa," in *Human Remains and Identification: Mass Violence, Genocide, and the "Forensic Turn,"* ed. Élisabeth Anstett and Jean-Marc Dreyfus (Manchester: Manchester University Press, 2015), 175–202.
19. Élisabeth Anstett and Jean-Marc Dreyfus, eds., *Human Remains and Identification: Mass Violence, Genocide, and the "Forensic Turn"* (Manchester: Manchester University Press, 2015).

250 3. IDEOLOGICAL COATINGS

20. Claire Moon, "Human Rights, Human Remains: Forensic Humanitarianism and the Human Rights of the Dead," *International Social Science Journal* 65, nos. 215–216 (2014): 49, https://doi.org/10.1111/issj.12071.
21. "International Katyn Commission Findings" (transcript), Smolensk, April 30, 1943.
22. Stephen Cordner and Morris Tidball-Binz, "Humanitarian Forensic Action—Its Origins and Future," *Forensic Science International* 279 (2017): 65–71, https://doi.org/10.1016/j.forsciint.2017.08.011.
23. Cordner and Tidball-Binz, "Humanitarian Forensic Action," 67.
24. Interpol, ICPO–Interpol General Assembly, 65th session, *Resolution AGN/65 /RES/13* (1996).
25. Claire Moon, "Human Rights, Human Remains"; Sarah Wagner and Rifat Kesetovic, "Absent Bodies, Absent Knowledge: The Forensic Work of Identifying Srebrenica's Missing and the Social Experiences of Families," in *Missing Persons: Multidisciplinary Perspective on the Disappeared*, ed. Derek Congram (Toronto: Canadian Scholars', 2016), 42–73; Admir Jugo and Sari Wastell, "Disassembling the Pieces, Reassembling the Social: The Forensic and Political Lives of Secondary Mass Graves in Bosnia and Herzegovina," in *Human Remains and Identification: Mass Violence, Genocide, and the "Forensic Turn,"* ed. Élisabeth Anstett and Jean-Marc Dreyfus (Manchester: Manchester University Press, 2015), 142–74; Kirsten Juhl, *The Contribution by (Forensic) Archaeologists to Human Rights Investigations of Mass Graves* (Stavanger: Arkeologisk museum i Stavanger, 2005); Admir Jugo, "Artefacts and Personal Effects from Mass Graves in Bosnia and Herzegovina: Symbols of Persons, Forensic Evidence or Public Relics?" *Cahiers Sirice* 19, no. 2 (2017): 21, https://doi.org/10.3917/lcsi.019.0021; William D. Haglund, "Archaeology and Forensic Death Investigations," *Historical Archaeology* 35, no. 1 (2001): 26–34; Ermengol Gassiot Ballbé and Dawnie Wolfe Steadman, "The Political, Social and Scientific Contexts of Archaeological Investigations of Mass Graves in Spain," *Archaeologies* 4, no. 3 (2008): 429–44, https://doi.org/10.1007/s11759-008-9081-9; Jonah S. Rubin, "Transitional Justice Against the State: Lessons from Spanish Civil Society-Led Forensic Exhumations," *International Journal of Transitional Justice* 8, no. 1 (2014): 99–120, https://doi.org/10.1093/ijtj/ijt033; José-Paulino Fernández-Álvarez et al., "Discovery of a Mass Grave from the Spanish Civil War Using Ground Penetrating Radar and Forensic Archaeology," *Forensic Science International* 267 (2016): e10–17, https://doi.org/10.1016/j.forsciint.2016.05.040; Remi Korman, "Bury or Display? The Politics of Exhumation in Post-genocide Rwanda," in *Human Remains and*

Identification: Mass Violence, Genocide, and the "Forensic Turn," ed. Élisabeth Anstett and Jean-Marc Dreyfus (Manchester: Manchester University Press, 2015), 203–20; Pal Ahluwalia, "Reflections on the Rwandan Genocide," *African Identities* 13, no. 2 (2015): 1–2, https://doi.org/10.1080/14725843.2015.10622 67; Antoine Tracqui et al., "An Overview of Forensic Operations Performed Following the Terrorist Attacks on November 13, 2015, in Paris," in "Forensic Multidisciplinary Involvement After Terrorist Attacks," special issue, *Forensic Sciences Research* 5, no. 3 (2020): 202–7; Gérald Quatrehomme et al., "Forensic Answers to the 14th of July 2016 Terrorist Attack in Nice," *International Journal of Legal Medicine* 133, no. 1 (2019): 277–87, https://doi.org/10.1007/s00414-018-1833-5; Herawati Sudoyo et al., "DNA Analysis in Perpetrator Identification of Terrorism-Related Disaster: Suicide Bombing of the Australian Embassy in Jakarta 2004," *Forensic Science International: Genetics* 2, no. 3 (2008): 231–37, https://doi.org/10.1016/j.fsigen.2007.12.007; C. H. Brenner and B. S. Weir, "Issues and Strategies in the DNA Identification of World Trade Center Victims," *Theoretical Population Biology* 63, no. 3 (2003): 173–78, https://doi.org/10.1016/S0040-5809(03)00008-X; Leslie G. Biesecker et al., "DNA Identifications After the 9/11 World Trade Center Attack," *Science* 310, no. 5751 (2005): 1122–23, https://doi.org/10.1126/science.1116608; Amy Z. Mundorff, Eric J. Bartelink, and Elaine Mar-Cash, "DNA Preservation in Skeletal Elements from the World Trade Center Disaster: Recommendations for Mass Fatality Management," *Journal of Forensic Sciences* 54, no. 4 (2009): 739–45, https://doi.org/10.1111/j.1556-4029.2009.01045.x.

26. Guénaël Mettraux, "13 Genocide and International Criminal Tribunals," in *International Crimes and the Ad Hoc Tribunals*, ed. Guénaël Mettraux (Oxford: Oxford University Press, 2006), 193–205.
27. Ger Duijzings, "Commemorating Srebrenica: Histories of Violence and the Politics of Memory in Eastern Bosnia," in *The New Bosnian Mosaic: Identities, Memories and Moral Claims in a Post-war Society*, ed. Xavier Bougarel, Elissa Helms, and Ger Duijzings (Aldershot: Ashgate, 2007), 141–66; Roschanack Shaery-Yazdi, "Erasing Traces with DNA Tests: Syrian Military Security and Mass Grave Politics in Post-2005 Lebanon," *Anthropological Quarterly* 94, no. 1 (2021): 65–93.
28. Useless not only for the legal procedures it is supposed to enhance but also for various ideological uses.
29. Jugo, "Artefacts and Personal Effects," 23.
30. "TV Liberty: Dilema Koja Tišti Porodice Ubijenih u Genocidu: Ukopati Nekoliko Kostiju Ili Čekati?," *Radio Free Europe*, 2023, https://www.slobodna evropa.org/a/tv-liberty-srebrenica-mostar-ratni-zlocin-proslost/32544218.html.

252 3. IDEOLOGICAL COATINGS

31. Jugo and Wastell, "Disassembling the Pieces."
32. Sarah Wagner, Introduction to *To Know Where He Lies: DNA Technology and the Search for Srebrenica's Missing* (Berkeley: University of California Press, 2008), 1–16.
33. Tsipy Ivry and Elly Teman, "Shouldering Moral Responsibility: The Division of Moral Labor Among Pregnant Women, Rabbis, and Doctors," *American Anthropologist* 121, no. 4 (2019): 857–69, https://doi.org/10.1111/aman.13314.
34. Ivry and Teman, "Shouldering Moral Responsibility."
35. Jugo and Wastell, "Disassembling the Pieces," 161.
36. An example of this is the Srebrenica genocide burial in which those who had been killed were assigned Muslim religious identities though most had not been religious and many had in fact been communists. In the case of the September 11 attacks, the dead collectively became a symbol of the American nation even though they were ethnically and religiously diverse and some were not American citizens.
37. Jennifer A. Orange and Jennifer J. Carter, "'It's Time to Pause and Reflect': Museums and Human Rights," *Curator: The Museum Journal* 55, no. 3 (2012): 259–66, https://doi.org/10.1111/j.2151-6952.2012.00150.x.
38. Geoffrey Lewis, *For Instruction and Recreation: Centenary History of the Museums' Associations* (London: Quiller, 1989).
39. John Senior, "The Rise of Museums," Open Learn, July 4, 2010, https://www.open.edu/openlearn/history-the-arts/history/the-rise-museums.
40. Senior, "The Rise of Museums".
41. Lewis, *For Instruction and Recreation*.
42. Lewis, *For Instruction and Recreation*.
43. Belavusau 2014, 7.
44. Tony Bennett, *The Birth of the Museum: History, Theory, Politics* (London: Routledge, 1995).
45. George L. Mosse, *Fallen Soldiers: Reshaping the Memory of the World Wars*, reprint ed. (New York: Oxford University Press, 1991); Alex King, *Memorials of the Great War in Britain: The Symbolism and Politics of Remembrance* (Oxford: Berg, 1998); Adrian Gregory, *The Silence of Memory: Armistice Day, 1919–1946* (Oxford: Berg, 1994); Jay Winter, *Sites of Memory, Sites of Mourning: The Great War in European Cultural History* (Cambridge: Cambridge University Press, 1995).
46. Hutchinson, "Warfare and the Sacralisation of Nations."
47. Kristin Ann Hass, *Carried to the Wall: American Memory and the Vietnam Veterans Memorial*, 1998.

3. IDEOLOGICAL COATINGS 253

48. Hutchinson, "Warfare and the Sacralisation of Nations," 409.
49. Pierre Nora, "Between Memory and History: Les Lieux de Mémoire," *Representations*, no. 26 (1989): 7–24, https://doi.org/10.2307/2928520.
50. Paul Williams, *Memorial Museums: The Global Rush to Commemorate Atrocities* (Oxford: Berg, 2007); Amy Sodaro, *Exhibiting Atrocity: Memorial Museums and the Politics of Past Violence* (New Brunswick, NJ: Rutgers University Press, 2018), 3.
51. Orange and Carter, "'It's Time to Pause and Reflect.'"
52. David, "Moral Remembrance and New Inequalities"; David, *The Past Can't Heal Us*.
53. Marek Kucia, "The Europeanization of Holocaust Memory and Eastern Europe," *East European Politics and Societies* 30, no. 1 (2016): 97–119, https://doi.org/10.1177/0888325415599195.
54. Daniel Levy and Natan Sznaider, "Memory Unbound: The Holocaust and the Formation of Cosmopolitan Memory," *European Journal of Social Theory* 5, no. 1 (2002): 87–106, https://doi.org/10.1177/1368431002005001002.
55. Levy and Sznaider, "Memory Unbound."
56. Further, in 1959, the Knesset (i.e., the Israeli parliament) made *Yom Hashoah* (Holocaust Remembrance Day) a national public holiday.
57. Levy and Sznaider, "Memory Unbound."
58. Avishai Margalit, *The Ethics of Memory* (Cambridge, MA: Harvard University Press, 2004). A partial list of museums can be found here: http://www.nj.gov/education/holocaust/resources/world.pdf.
59. Amos Goldberg and Haim Hazan, eds., *Marking Evil: Holocaust Memory in the Global Age* (New York: Berghahn, 2015).
60. "2020 Holocaust Remembrance Week," United Nations, January 2020, https://www.un.org/en/holocaustremembrance/observance/2020.
61. Henry Rousso, "History of Memory, Politics of the Past: What For?," in *Conflicted Memories: Europeanizing Contemporary Histories*, ed. Konrad Jarausch and Thomas Lindenberger (Oxford: Berghahn, 2007).
62. Aleida Assmann, "Europe: A Community of Memory?," *Bulletin of the German Historical Institute* 40 (2007): 11–25.
63. Jovan Byford, "When I Say 'The Holocaust,' I Mean 'Jasenovac': Remembrance of the Holocaust in Contemporary Serbia," *East European Jewish Affairs* 37, no. 1 (2007): 51–74, https://doi.org/10.1080/13501670701197946.
64. Many museums that pursue social justice are part of the Social Justice Alliance for Museums. Since its creation in November 2013, more than eighty museums worldwide have joined.

65. The nine founding members are the Tenement Museum (United States), the Gulag Museum at Perm-36 (Russia), the House of Slaves (Senegal), the Workhouse (England), Memoria Abierta (Argentina), the District Six Museum (South Africa), the National Park Service (United States), the Terezin Memorial (Czech Republic), and the Liberation War Museum (Bangladesh).
66. "History of the Tenement Museum," C-SPAN American History TV, September 5, 2018, https://www.c-span.org/video/?451106-1/history-tenement-museum.
67. Viv Golding, "Collaborative Museums: Curators, Communities, Collections," in *Museums and Communities: Curators, Collections and Collaboration*, ed. Viv Golding and Wayne Modest (London: Bloomsbury, 2013), chap. 1. The coalition organizes its members into seven regions: Africa, Asia, Europe, Latin America and the Caribbean, the Middle East and North Africa, North America, and Russia. Members conduct joint projects and create exhibits.
68. "International Coalition of Sites of Conscience," GuideStar, accessed March 17, 2022, https://www.guidestar.org/profile/20-4874389.
69. Williams, *Memorial Museums*, 7.
70. Sodaro, *Exhibiting Atrocity*.
71. Sodaro, *Exhibiting Atrocity*, 9.
72. Terence M. Duffy, "Museums of 'Human Suffering' and the Struggle for Human Rights," *Museum International* 53, no. 1 (2001): 10–16, https://doi.org/10.1111/1468-0033.00292.
73. Tanja Luckins, "Collecting Women's Memories: The Australian War Memorial, the Next of Kin and Great War Soldiers' Diaries and Letters as Objects of Memory in the 1920s and 1930s," *Women's History Review* 19, no. 1 (2010): 21–37, https://doi.org/10.1080/09612020903444635; Anne-Marie Condé, "Capturing the Records of War," *Australian Historical Studies* 36, no. 125 (2005): 134–52, https://doi.org/10.1080/10314610508682915.
74. J. John Lennon and Malcolm Foley, *Dark Tourism: The Attraction of Death and Disaster* (New York: Cengage, 2001), 57.
75. Young, *The Texture of* Memory, ix.
76. However, J. John Lennon and Malcolm Foley argue that there is a lack of explanation, historical documentation, and orientation for visitors to support the display of such disturbing objects. As a result, they believe that some of these museums' exhibits can become spectacles rather than having an educational purpose. See J. John Lennon and Malcolm Foley, *Dark Tourism: The Attraction of Death and Disaster* (New York: Cengage, 2001).
77. Williams, *Memorial Museums*; Sodaro, *Exhibiting Atrocity*; Máté Zombory, "The Birth of the Memory of Communism: Memorial Museums in Europe,"

Nationalities Papers 45, no. 6 (2017): 1028–46, https://doi.org/10.1080/00905992.2017.1339680; Ljiljana Radonić, "Post-Communist Invocation of Europe: Memorial Museums' Narratives and the Europeanization of Memory," *National Identities* 19, no. 2 (2017): 269–88, https://doi.org/10.1080/14608944.2016.1264377.

4. THE FIRST CIRCUIT: THE SURVIVAL OF PERSONAL OBJECTS AFTER AN ATROCITY

1. "Od zataškavanja zločina do ukopavanja leševa u Batajnici," *Danas*, April 8, 2020, https://www.danas.rs/vesti/drustvo/suocavanje/od-zataskavanja-zlocina-do-ukopavanja-leseva-u-batajnici/.
2. Tamara Skrozza, "Tragovi prikrivene smrti," *Vreme*, July 9, 2003, https://www.vreme.com/vreme/tragovi-prikrivene-smrti/.
3. Skrozza, "Tragovi prikrivene smrti."
4. Admir Jugo, "Artefacts and Personal Effects from Mass Graves in Bosnia and Herzegovina: Symbols of Persons, Forensic Evidence or Public Relics?," *Cahiers Sirice* 19, no. 2 (2017): 21, https://doi.org/10.3917/lcsi.019.0021.
5. Andrew Higgins, "Belarus Building Site Yields the Bones of 1,214 Holocaust Victims," *New York Times*, April 27, 2019, https://www.nytimes.com/2019/04/27/world/europe/belarus-holocaust-mass-grave.html; Charlotte Mitchell, "Mass Grave Containing Bones, Clothes and Shoes of Nazi Massacre Victims Is Uncovered Near Belarus Village Where 1,000 Women, Children and Pensioners Were Slaughtered," *Daily Mail*, April 30, 2021, https://www.dailymail.co.uk/news/article-9530131/Mass-grave-containing-bones-clothes-shoes-Nazi-victims-uncovered-near-Belarus-village.html.
6. Higgins, "Belarus Building Site."
7. Mitchell, "Mass Grave."
8. Itamar Eichner, "Remains of 1,400 Jews Murdered in Holocaust Discovered in Mass Grave in Belarus," *Ynet News*, October 17, 2021, https://www.ynetnews.com/article/h1hw9athy.
9. Stuart Dowell, "Jewish Girl's Shoe Found at Site of WWII Ghetto Bunker," *First News*, 2022, https://www.thefirstnews.com/article/archeologists-unearth-jewish-girls-shoe-at-site-of-wwii-ghetto-bunker-31117.
10. "Coronavirus: 'We Are at War' – Macron," *BBC News*, March 16, 2020, https://www.bbc.com/news/av/51917380.
11. Ten Soksreinith, "Cambodia's Genocide Museum Conserves Clothing of Khmer Rouge Victims," *VOA*, February 9, 2018, https://www.voanews.com/a/cambodia-genocide-museum-begins-conserving-clothing-of-khmer-rouge-victims/4245122.html.

12. Eugene Brcic, "Excavators Remove Corpses from Large Bosnian Mass Grave," *AP News*, 1997, https://apnews.com/article/89754bbc181ec18f47d47033ddd5d093.
13. Brcic, "Excavators Remove Corpses."
14. Claire Moon, "Extraordinary Deathwork: New Developments in, and the Social Significance of, Forensic Humanitarian Action," in *Forensic Science and Humanitarian Action: Interacting with the Dead and the Living*, ed. Roberto C. Parra, Sara C. Zapico, and Douglas H. Ubelaker (Hoboken, NJ: Wiley, 2020), 37–48.
15. Amy Guthrie, "Children's Remains Found in Mexican Mass Graves," *Seattle Times*, September 23, 2018, https://www.seattletimes.com/nation-world/childrens-remains-found-in-mexican-mass-grave/.
16. Farid Abdulwahed and Samya Kullab, "New Mass Grave Unearthed in Iraq's North from Brutal IS Rule," *ABC News*, July 2, 2020, https://abcnews.go.com/International/wireStory/mass-grave-unearthed-iraqs-north-brutal-rule-71578252.
17. Madison Horne, "9/11 Lost and Found: The Items Left Behind," National September 11 Memorial & Museum, last updated September 7, 2023, https://www.history.com/.amp/news/9-11-artifacts-ground-zero-photos.
18. Horne, "9/11 Lost and Found."
19. Horne, "9/11 Lost and Found."
20. Horne, "9/11 Lost and Found."
21. Katherine Verdery, *The Political Lives of Dead Bodies: Reburial and Postsocialist Change* (New York: Columbia University Press, 2000), 1–22.
22. Zuzanna Dziuban and Ewa Stańczyk, "Introduction: The Surviving Thing: Personal Objects in the Aftermath of Violence," *Journal of Material Culture* 25, no. 4 (2020): 381–90, https://doi.org/10.1177/1359183520954514.383.
23. Moon, "Extraordinary Deathwork," 51.
24. Ariana Fernandez Munos and Derek Congram, "The Evidentiary Value of Cultural Objects from Mass Graves: Methods of Analysis, Interpretation, and Limitations," in *Missing Persons: Multidisciplinary Perspective on the Disappeared*, ed. Derek Congram (Toronto: Canadian Scholars', 2016), 269–87.
25. Julia Adeney Thomas, "The Evidence of Sight," *History and Theory* 48, no. 4 (2009): 151–68.
26. Jorie Horsthuis, "Evidence of Atrocities: Fragments of the Bosnian War," *Politico*, March 20, 2019, https://www.politico.eu/interactive/evidence-of-atrocities-fragments-of-the-bosnian-war/.
27. "Bitter Land: Interactive Map of Mass Graves from the Wars in the Former Yugoslavia," Mass Graves Map, 2000, https://massgravesmap.balkaninsight.com.

28. Thomas, "The Evidence of Sight."
29. Fernandez Munos and Congram, "The Evidentiary Value of Cultural Objects."
30. Eyal Weizman, "Chapter Fifty-Two from Forensic Architecture: Notes from Fields and Forums (2012)," in *Posthumanism in Art and Science: A Reader*, ed. Giovanni Aloi and Susan McHugh (New York: Columbia University Press, 2021), 308–10.
31. Susan Schuppli, *Material Witness: Media, Forensics, Evidence* (Cambridge, MA: MIT Press, 2020), 3.
32. Moon, "Extraordinary Deathwork," 38.
33. Laura Major, "Unearthing, Untangling and Re-articulating Genocide Corpses in Rwanda," *Critical African Studies* 7, no. 2 (2015): 164–81, https://doi.org/10.1080/21681392.2015.1028206.
34. Carl Knappett and Lambros Malafouris, *Material Agency: Towards a Non-anthropocentric Approach* (Berlin: Springer, 2008).
35. A similar facility, the Krajina Identification Project forensic facility, was established in 2001 in the town of Sanski Most, a half-hour drive from Prijedor. The project was implemented by the state authorities of Bosnia and Herzegovina and local authorities in Sanski Most with the assistance of the International Commission on Missing Persons. The mortuary at this facility is tasked with examining human remains uncovered primarily in the Krajina region of northwestern Bosnia, including the remains of victims from the ethnic cleansing in Prijedor. Christopher Bobyn, "If Bones Could Talk: Reassembling the Remains of Srebrenica," *Balkanist*, July 11, 2016, https://balkanist.net/if-bones-could-talk-srebrenica/.
36. Hasan Nuhanovic, "Missing People, Missing Stories in the Aftermath of Genocide and 'Ethnic Cleansing' in Srebrenica and Prijedor" (master's thesis, RMIT University, 2022), 88.
37. Jugo, "Artefacts and Personal Effects."
38. Sarah Wagner and Rifat Kesetovic, "Absent Bodies, Absent Knowledge: The Forensic Work of Identifying Srebrenica's Missing and the Social Experiences of Families," in *Missing Persons: Multidisciplinary Perspective on the Disappeared*, ed. Derek Congram (Toronto: Canadian Scholars', 2016), 42–73; Laura Yazedjian and Rifat Kešetović, "The Application of Traditional Anthropological Methods in a DNA-Led Identification Process," in *Recovery, Analysis, and Identification of Commingled Human Remains*, ed. Bradley J. Adams and John E. Byrd (Totowa, NJ: Humana, 2008), 271–84.
39. Nuhanović, "Missing People," 96.
40. Jugo, "Artefacts and Personal Effects."

41. "Guatemala: Belongings Provide Answers to Families of the Missing," International Committee of the Red Cross, 2017, https://www.icrc.org/en/document/guatemala-belongings-provide-answers-families-missing.
42. Yazedjian and Kešetović, "The Application of Traditional Anthropological Methods."
43. Jugo, "Artefacts and Personal Effects."
44. Moon, "Extraordinary Deathwork," 41; Helen Jarvis, "Powerful Remains: The Continuing Presence of Victims of the Khmer Rouge Regime in Today's Cambodia," *Human Remains and Violence: An Interdisciplinary Journal* 1, no. 2 (2015): 36–55, https://doi.org/10.7227/HRV.1.2.5; Francisco Ferrandiz, "Exhuming the Defeated: Civil War Mass Graves in 21st-Century Spain," *American Ethnologist* 40, no. 1 (2013): 38–54.
45. Moon, "Extraordinary Deathwork."
46. José Pablo Baraybar and Franco Mora, "Forensic Archaeology in Peru: Between Science and Human Rights Activism," in *Forensic Archaeology: A Global Perspective*, ed. W. J. Mike Groen, Nicholas Márquez-Grant, and Robert C. Janaway (Hoboken, NJ: Wiley, 2015), 463–69.
47. Paul Sant-Cassia, *Bodies of Evidence: Burial, Memory and the Recovery of Missing Persons in Cyprus* (New York: Berghahn, 2007).
48. Moon, "Extraordinary Deathwork."
49. Nuhanović, "Missing People," 101.
50. Lara J. Nettelfield and Sarah E. Wagner, *Srebrenica in the Aftermath of Genocide* (New York: Cambridge University Press, 2013), 29.
51. Hikmet Karčić, "Uncovering the Truth: The Lake Perućac Exhumations in Eastern Bosnia," *Journal of Muslim Minority Affairs* 37, no. 1 (2017): 118, https://doi.org/10.1080/13602004.2017.1294374.
52. Nuhanović, "Missing People," 105.
53. "Bosnia-Herzegovina: Srebrenica Victims – Photo Book Campaign Leads to Encouraging Results," International Committee of the Red Cross, August 9, 2001, https://www.icrc.org/en/doc/resources/documents/news-release/2009-and-earlier/57jr8g.htm.
54. The ICRC presented the first *Book of Belongings* for Republika Srpska on January 27, 2002, in Banja Luka, in the northwest of Republika Srpska, Bosnia and Herzegovina.
55. The project is supported by the Republika Srpska Commission for Tracing Missing and Detained Persons, the local Red Cross, an association of the families of detained soldiers and missing civilians, and the authorities. According to information the ICRC has collected from families, 17,376 people are still unaccounted for in Bosnia and Herzegovina.

56. Midhat Poturović, "Srebrenica Victims' Personal Items Help Keep Memories Alive," *Radio Free Europe/Radio Liberty*, February 7, 2020, https://www.rferl.org/a/srebrenica-massacre-victims-personal-items-help-keep-memories-alive/30416483.html.
57. "Bosnia-Herzegovina: First 'Book of Belongings' for the Republika Srpska," International Committee of the Red Cross, January 31, 2002, https://www.icrc.org/en/doc/resources/documents/news-release/2009-and-earlier/57jrks.htm.
58. Nuhanović, "Missing People," 99.
59. "ICRC Central Tracing Agency: Half a Century of Restoring Family Links," International Committee of the Red Cross, April 7, 2010, https://www.icrc.org/en/doc/resources/documents/interview/centra-tracing-agency-interview-070410.htm. The International Tracing Service, managed by the ICRC, was established in 1955 to help discover accurate information about Holocaust victims Its primary mandate is to trace and preserve historical records and make them available for research. By 1960, its work no longer corresponded with the activities the ICRC had undertaken during the Cold War, such as with the uprising in Hungary in 1956 and in conflicts related to decolonization, such as the Algerian War and the Mau-Mau rebellion in Kenya. The ICRC considered the possibility of the International Tracing Service extending its activities to searching for victims of natural disasters, as it had done in Morocco after the Agadir earthquake in 1960. Its mission later expanded to include work in places such as Rwanda, Somalia, and Yemen, primarily to identify victims and find missing people. Other international and local organizations, in conjunction with governmental efforts, are also employed in the process of exhuming mass graves. "Yugoslavia: Families of Kosovo Missing Can Consult New Book of Belongings," International Committee of the Red Cross, February 8, 2001, https://www.icrc.org/en/doc/resources/documents/news-release/2009-and-earlier/57jquv.htm.
60. Guthrie, "Children's Remains Found in Mexican Mass Graves."
61. Horsthuis, "Evidence of Atrocities."
62. Kristin Deasy and Dzenana Halimovic, "Srebrenica Survivors Feel Pain After Evidence Destroyed," *Radio Free Europe/Radio Liberty*, September 3, 2009, https://www.rferl.org/a/1814205.html.
63. Olivera Simić, "Memorial Culture in the Former Yugoslavia: Mothers of Srebrenica and the Destruction of Artefacts by the ICTY," in *The Arts of Transitional Justice: Culture, Activism, and Memory After Atrocity*, ed. Peter D. Rush and Olivera Simić (New York: Springer, 2014), 155–72.
64. Deasy and Halimović, "Srebrenica Survivors."

65. Deasy and Halimović, "Srebrenica Survivors."
66. Antonio Monegal, "Exhibiting Objects of Memory," *Journal of Spanish Cultural Studies* 9, no. 2 (2008): 239–51, https://doi.org/10.1080/14636200802283761.
67. Lea David, *The Past Can't Heal Us: The Dangers of Mandating Memory in the Name of Human Rights* (Cambridge, Cambridge University Press, 2020).
68. Stephen Cordner and Morris Tidball-Binz, "Humanitarian Forensic Action—Its Origins and Future," *Forensic Science International* 279 (2017): 65–71, https://doi.org/10.1016/j.forsciint.2017.08.011; Moon, "Extraordinary Deathwork."
69. Cordner and Tidball-Binz, "Humanitarian Forensic Action."
70. Cordner and Tidball-Binz, "Humanitarian Forensic Action."
71. Luis Fondebrinder, *Uncovering the Evidence: The Forensic Sciences in Human Rights* (St. Paul, MN: New Tactics in Human Rights, 2004), https://www.newtactics.org/resource/uncovering-evidence-forensic-sciences-human-rights.
72. "Equipo Peruano de Antropología Forense" (website), accessed October 12, 2022, https://epafperu.org/.
73. Fondebrinder, *Uncovering the Evidence*.
74. Baraybar and Mora, "Forensic Archaeology in Peru."
75. Fondebrinder, *Uncovering the Evidence*.
76. Moon, "Extraordinary Deathwork," 51.
77. Nicole Iturriaga, "How Forensic Science Can Aid the Human Rights Movement," Aeon, 2021, https://aeon.co/essays/how-forensic-science-can-aid-the-human-rights-movement.
78. David, *The Past Can't Heal Us*.

5. THE SECOND CIRCUIT: DESIRE OBJECTS IN PRIVATE HOMES

Aida Cerkez and Amel Emric, "Srebrenica Women Tell Tale of Loss Through Objects of Memory," *AP News*, July 9, 2015, https://apnews.com/article/f46c3715e175403a964bf1147f1b9daa.

1. Osnat Shalev Nizri and Carol A. Kidron, "Taking the Soldier Home: Sustaining the Domestic Presence of Absent Fallen Soldiers in Israel," *Memory Studies* 15, no. 5 (2022): 1232–47, https://doi.org/10.1177/17506980221094511.
2. Antonius C. G. M. Robben, ed., *Death, Mourning, and Burial: A Cross-Cultural Reader* (Malden, MA: Wiley–Blackwell, 2004).
3. Aafke Komter, "Heirlooms, Nikes and Bribes: Towards a Sociology of Things," *Sociology* 35, no. 1 (2001): 59.

4. John Bowlby, "The Making and Breaking of Affectional Bonds: I. Aetiology and Psychopathology in the Light of Attachment Theory," *British Journal of Psychiatry* 130, no. 3 (1977): 201–10, https://doi.org/10.1192/bjp.130.3.201.
5. Donald W. Winnicott, *The Maturational Processes and the Facilitating Environment: Studies in the Theory of Emotional Development* (London: Routledge, 2018); Margaret Gibson, "Melancholy Objects," *Mortality* 9, no. 4 (2004): 285–99, https://doi.org/10.1080/13576270412331329812.
6. George Hagman, "Beyond Decathexis: Toward a New Psychoanalytic Understanding and Treatment of Mourning," in *Meaning Reconstruction and the Experience of Loss*, ed. Robert A. Neimeyer (Washington, DC: American Psychological Association, 2001), 13–31.
7. Darach Turley and Stephanie O'Donohoe, "The Sadness of Lives and the Comfort of Things: Goods as Evocative Objects in Bereavement," *Journal of Marketing Management* 28, nos. 11–12 (2012): 1331–53, https://doi.org/10.1080/0267257X.2012.691528.
8. Sherry Turkle, ed., *Evocative Objects: Things We Think With* (Cambridge, MA: MIT Press, 2011), 6.
9. Gibson, "Melancholy Objects."
10. Françoise Dastur, *Death: An Essay on Finitude* (London: Athlone, 1996), 46.
11. Juliet Ash, "Memory and Object," in *The Generated Object*, ed. Pat Kirkham (Manchester: Manchester University Press, 1996), 219–25; Elizabeth Hallam and Jenny Hockey, *Death, Memory, and Material Culture* (Oxford: Berg, 2001).
12. A landmark study of sudden death was conducted in 1944 by Erich Lindemann, who, with his colleagues, counselled the families of 101 college students who had lost their lives during a tragic fire at a local nightclub called the Coconut Grove. The majority of those counselled exhibited somatic distress, preoccupation with images of the deceased, guilt relating to the deceased, hostile reactions, and an inability to regain their pre-loss level of functioning. See Erich Lindemann, "Symptomalology and Management of Acute Grief," *American Journal of Psychiatry* 101 (1944): 144–48.
13. J. D. Fast, "After Columbine: How People Mourn Sudden Death," *Social Work* 48, no. 4 (2003): 484–91, https://doi.org/10.1093/sw/48.4.484.
14. J. William Worden, *Grief Counseling and Grief Therapy: A Handbook for the Mental Health Practitioner*, 5th ed. (New York: Springer, 2018).
15. Gibson, "Melancholy Objects."
16. This is particularly true of objects from World War II, especially those connected to Germany.

17. Suzie Thomas, Oula Seitsonen, and Vesa-Pekka Herva, "Nazi Memorabilia, Dark Heritage and Treasure Hunting as 'Alternative' Tourism: Understanding the Fascination with the Material Remains of World War II in Northern Finland," *Journal of Field Archaeology* 41, no. 3 (2016): 331–43, https://doi.org/10.1080/00934690.2016.1168769; Vesa-Pekka Herva et al., "'I Have Better Stuff at Home': Treasure Hunting and Private Collecting of World War II Artefacts in Finnish Lapland," *World Archaeology* 48, no. 2 (2016): 267–81, https://doi.org/10.1080/00438243.2016.1184586; Michael Hughes, *The Anarchy of Nazi Memorabilia: From Things of Tyranny to Troubled Treasure* (London: Routledge, 2022).
18. Cerkez and Emric, "Srebrenica Women Tell Tale of Loss."
19. Komter, "Heirlooms, Nikes and Bribes."
20. Admir Jugo, "Artefacts and Personal Effects from Mass Graves in Bosnia and Herzegovina: Symbols of Persons, Forensic Evidence or Public Relics?," *Cahiers Sirice* 19, no. 2 (2017): 21, https://doi.org/10.3917/lcsi.019.0021.
21. Jugo, "Artefacts."
22. Midhat Poturović, "Srebrenica Victims' Personal Items Help Keep Memories Alive," *Radio Free Europe/Radio Liberty*, February 7, 2020, https://www.rferl.org/a/srebrenica-massacre-victims-personal-items-help-keep-memories-alive/30416483.html.
23. Chris Gosden, "Making Sense: Archaeology and Aesthetics," *World Archaeology* 33, no. 2 (2001): 163–67.
24. Tanja Luckins, "Collecting Women's Memories: The Australian War Memorial, the Next of Kin and Great War Soldiers' Diaries and Letters as Objects of Memory in the 1920s and 1930s," *Women's History Review* 19, no. 1 (2010): 21–37, https://doi.org/10.1080/09612020903444635.
25. Fazila found the remains of Hamed and Fejzo years ago and had them buried at the Srebrenica Memorial Centre, where they now lay with nearly seven thousand other victims. She found Hamed's remains in 2003 in a mass grave and Fejzo's—just two of the bones from one of his legs—in 2013 in another mass grave. Cerkez and Emric, "Srebrenica Women Tell Tale of Loss."
26. After three years of the Serbian siege, the population ran out of lighters and matches and improvised: "Someone would make a fire with this in their garden in the morning, then everybody would come with a piece of wood to light it and take it home to make a fire," Djulka said, describing life in a town that was on the brink of starvation before the bloodletting began.
27. Cerkez and Emric, "Srebrenica Women Tell Tale of Loss."
28. Cerkez and Emric, "Srebrenica Women Tell Tale of Loss."

29. Ciana Bobby Calvan, "9/11 Artifacts Share 'Pieces of Truth' in Victims' Stories," *AP NEWS*, September 8, 2021, https://apnews.com/article/lifestyle-travel-new-york-museums-2d1d1f9e9ed4ee3777012cba21dad602.
30. Kristin Deasy and Dzenana Halimovic, "Srebrenica Survivors Feel Pain After Evidence Destroyed," *Radio Free Europe/Radio Liberty*, September 3, 2009, https://www.rferl.org/a/1814205.html
31. Pauline Boss, *Ambiguous Loss: Learning to Live with Unresolved Grief* (Cambridge, MA: Harvard University Press, 2000).
32. Poturović, "Srebrenica Victims' Personal Items."
33. Magdalena Waligórska and Ina Sorkina, "The Second Life of Jewish Belongings–Jewish Personal Objects and Their Afterlives in the Polish and Belarusian Post-Holocaust Shtetls," *Holocaust Studies* 29, no. 3 (2023): 341–62, https://doi.org/10.1080/17504902.2022.2047292.
34. Alan Riding, "The Fight Over a Suitcase and the Memories It Carries," *New York Times*, September 16, 2006, https://www.nytimes.com/2006/09/16/arts/design/16ridi.html.
35. Riding, "The Fight Over a Suitcase."
36. Riding, "The Fight Over a Suitcase."
37. "Settlement Reached Over Auschwitz Suitcase," Auschwitz-Birkenau State Museum, June 4, 2009, http://auschwitz.org/en/museum/news/settlement-reached-over-auschwitz-suitcase,568.html.
38. Riding, "The Fight Over a Suitcase."
39. "Settlement Reached Over Auschwitz Suitcase."
40. Ron Grossman, "Woman Seeks Return of Paintings She Did at Auschwitz," *Washington Post*, October 29, 2006, https://www.washingtonpost.com/archive/politics/2006/10/29/woman-seeks-return-of-paintings-she-did-at-auschwitz/e267a564-a22a-4fa8-8de2-1e3185c6521c/; Riding, "The Fight Over a Suitcase."
41. Randall Collins, *Interaction Ritual Chains* (Princeton, NJ: Princeton University Press, 2005).
42. Arjun Appadurai, "Introduction: Commodities and the Politics of Value," In *The Social Life of Things*, ed. Arjun Appadurai (Cambridge: Cambridge University Press, 1986), 3–63.
43. Sandra H. Dudley, "Paku Karen Skirt-Cloths (Not) at Home: Forcibly Migrated Burmese Textiles in Refugee Camps and Museums," in *Objects of War: The Material Culture of Conflict and Displacement*, ed. Leora Auslander and Tara Zahra, 277–309 (Ithaca, NY: Cornell University Press, 2018).
44. Only some sites of dark tourism use desire objects to enhance the visitor experience. I restrict my discussion to "dark" or memorial sites that (1) use

desire objects to narrate the story of an atrocity; (2) use desire objects as educational tools to promote messages aligned with human rights; and (3) create emotional energy around desire objects that has the potential to be translated into discourses and symbols.

45. Ten Soksreinith, "Cambodia's Genocide Museum Conserves Clothing of Khmer Rouge Victims," *VOA*, February 9, 2018, https://www.voanews.com/a/cambodia-genocide-museum-begins-conserving-clothing-of-khmer-rouge-victims/4245122.html.
46. Soksreinith, "Cambodia's Genocide Museum."
47. Soksreinith, "Cambodia's Genocide Museum."
48. Madison Horne, "9/11 Lost and Found: The Items Left Behind," National September 11 Memorial & Museum, last updated September 7, 2023, https://www.history.com/.amp/news/9-11-artifacts-ground-zero-photos.
49. "The Collection," National September 11 Memorial & Museum, accessed July 7, 2022, https://www.911memorial.org/visit/museum/collection.
50. Robyn Sassen, "'Dark Choreography' of the Johannesburg Holocaust and Genocide Centre," *Performance Research* 25, no. 2 (2020): 93, https://doi.org/10.1080/13528165.2020.1752581.
51. Sassen, "'Dark Choreography,'" 91.
52. Sassen, "'Dark Choreography,'" 93.
53. Gibson, "Melancholy Objects."
54. Poturović, "Srebrenica Victims' Personal Items."
55. Calvan, "9/11 Artifacts."
56. Cerkez and Emric, "Srebrenica Women Tell Tale of Loss."
57. Poturović, "Srebrenica Victims' Personal Items."
58. Vesna Besic and Talka Ozturk, "Srebrenica Genocide Victims' Belongings to Be Shown as Lesson," *Anadolu Ajansı*, February 8, 2020, https://www.aa.com.tr/en/europe/srebrenica-genocide-victims-belongings-to-be-shown-as-lesson/1728124.
59. Ahmo Mehmedović, "Keeping the Belongings of Genocide Victims Near Their Graves," *Balkan Diskurs*, February 21, 2022, https://balkandiskurs.com/en/2022/02/21/the-belongings-of-genocide-victims/.
60. "Zejneba Mešić," Srebrenica Memento, 2021, https://srebrenicamemento.com/people/zejneba-mesic/.
61. "Rejha Ademović," *Srebrenica Memento*, 2021, https://srebrenicamemento.com/people/rejha-ademovic/.
62. "Ajiša Džananović," *Srebrenica Memento*, 2021, https://srebrenicamemento.com/people/ajisa-dzananovic/.

63. "Nura Vranjkovina," Srebrenica Memento, 2021, https://srebrenicamemento.com/people/nura-vranjkovina/.
64. Poturović, "Srebrenica Victims' Personal Items."
65. "Džemila Džananović," Srebrenica Memento, 2021, https://srebrenicamemento.com/people/dzemila-dzananovic/.
66. Jugo, "Artefacts."
67. Srebrenica Memorial Center; "Behija Hodžić," Srebrenica Memento, 2021, https://srebrenicamemento.com/people/behija-hodzic/.
68. Jugo, "Artefacts."
69. Rogers Brubaker and Frederick Cooper, "Beyond 'Identity,'" Theory and Society 29, no. 1 (2000): 1–47; Siniša Malešević, *Identity as Ideology: Understanding Ethnicity and Nationalism* (New York: Palgrave Macmillan, 2006); Max Bergholz, *Violence as a Generative Force: Identity, Nationalism, and Memory in a Balkan Community* (Ithaca, NY: Cornell University Press, 2016).
70. "Mevlija Smajić," Srebrenica Memento, 2021, https://srebrenicamemento.com/people/mevlija-smajic/, my italics.
71. "Hava Mustafić," Srebrenica Memento, 2021, https://srebrenicamemento.com/people/hava-mustafic/.
72. This concept is brilliantly illustrated in Bergholz, *Violence as a Generative Force*.
73. Collins, *Interaction Ritual Chains*.
74. "Razija Hrustanović," Srebrenica Memento, 2021, https://srebrenicamemento.com/people/razija-hrustanovic/.
75. "Ramiza Bešić," Srebrenica Memento, 2021, https://srebrenicamemento.com/people/ramiza-besic/.

6. THE THIRD CIRCUIT: PUBLIC DISPLAY, MORAL LABOR, AND THE DISCURSIVE VALUE OF DESIRE OBJECTS

Srebrenica Memorial Center (@SrebrenicaMC), "Hava's husband Behadil (b. 1957) and son Osman (b. 1980) experienced the fate of many men from Srebrenica – they were killed in an attempt to reach free territory," Twitter, May 18, 2021, 3:38 a.m., https://twitter.com/SrebrenicaMC/status/1394557941659934725?s=03.

1. Somogy Varga and Charles Guignon, "Authenticity," in *The Stanford Encyclopedia of Philosophy*, ed. Edward N. Zalta (Stanford, CA: Metaphysics Research Lab, Stanford University, 2020), https://plato.stanford.edu/archives/spr2020/entries/authenticity/. The most familiar conception of authenticity comes

to us mainly from Heidegger's *Being and Time* (1927). The translation of *authenticity* comes from the neologism *Eigentlichkeit*, invented by Heidegger, based on *eigentlich*, meaning "really" or "truly"; the stem, *eigen*, means "own" or "proper." Varga and Guignon describe the notion of authenticity as having been developed via the cultural changes of the seventeenth and eighteenth centuries that led to the emergence of new ideals in the Western world related to the new understanding of individualism.

2. Kirsten M. Bedigan, "Developing Emotions: Perceptions of Emotional Responses in Museum Visitors," *Mediterranean Archaeology and Archaeometry* 16, no. 5 (2016): 87–95, https://doi.org/10.5281/ZENODO.204969.

3. Thomas A. Woods, "Getting Beyond the Criticism of History Museums: A Model for Interpretation," *Public Historian* 12, no. 3 (1990): 78, https://doi.org/10.2307/3378200.

4. Andrea Bandelli, "Virtual Spaces and Museums," *Journal of Museum Education* 24, nos. 1–2 (1999): 20–22.

5. John H. Falk and Lynn D. Dierking, *The Museum Experience* (London: EDS, 2011), 61.

6. Donald Horne, *The Great Museum: The Representation of History* (London: Pluto, 1984).

7. J. Gadsby, "The Effect of Encouraging Emotional Value in Museum Experiences," *Museological Review* 15 (2011): 1–13.

8. Thomas J. Schlereth, "Collecting Ideas and Artifacts: Common Problems of History Museums and History Texts," *Roundtable Reports* (1978): 1–12.

9. Zygmunt Bauman, "Morality in the Age of Contingency," in *Detraditionalization*, ed. Paul Heelas, Scott Lash, and Paul Morris (Cambridge, MA: Blackwell, 1996), 54.

10. Bauman, "Morality in the Age of Contingency."

11. Rachel Hughes, "Dutiful Tourism: Encountering the Cambodian Genocide," *Asia Pacific Viewpoint* 49, no. 3 (2008): 318–30, https://doi.org/10.1111/j.1467-8373.2008.00380.x.

12. Jim Butcher, *The Moralisation of Tourism: Sun, Sand . . . and Saving the World?* (London: Routledge, 2002).

13. Michael Rothberg, *The Implicated Subject: Beyond Victims and Perpetrators* (Stanford, CA: Stanford University Press, 2019).

14. Natan Sznaider, "The Sociology of Compassion: A Study in the Sociology of Morals," *Cultural Values* 2, no. 1 (1998): 117–39, https://doi.org/10.1080/14797589809359290.

15. Butcher, *The Moralisation of Tourism*; Rothberg, *The Implicated Subject*.
16. Cecilia Lazzeretti, *The Language of Museum Communication: A Diachronic Perspective* (London: Palgrave Macmillan, 2016), 11.
17. Michael Zils and Marco Schulze, eds., *Museums of the World*, 9th ed. (Munich: K. G. Saur, 2002), 34.
18. Stephen W. Creigh-Tyte and Sara Selwood, "Museums in the U.K.: Some Evidence on Scale and Activities," *Journal of Cultural Economics* 22, no. 2 (1998): 151–65, https://doi.org/10.1023/A:1007562103987; Peter Johnson and Thomas Barry, "The Economics of Museums: A Research Perspective," *Journal of Cultural Economics* 22, nos. 2–3 (1998): 75–85.
19. Rudi Hartmann, "Dark Tourism, Thanatourism, and Dissonance in Heritage Tourism Management: New Directions in Contemporary Tourism Research," *Journal of Heritage Tourism* 9, no. 2 (2014): 166–82, https://doi.org/10.1080/1743873X.2013.807266; Sarah Hodgkinson, "The Concentration Camp as a Site of 'Dark Tourism,'" *Témoigner entre histoire et mémoire* 116 (2013): 22–32, https://doi.org/10.4000/temoigner.272; Kaori Yoshida, Huong T. Bui, and Timothy J. Lee, "Does Tourism Illuminate the Darkness of Hiroshima and Nagasaki?," in "Special Issue on Marketing and Branding of Conflict-Ridden Destinations," special issue, *Journal of Destination Marketing & Management* 5, no. 4 (2016): 333–40, https://doi.org/10.1016/j.jdmm.2016.06.003; Paula Cowan and Henry Maitles, "'We Saw Inhumanity Close Up.' What Is Gained by School Students from Scotland Visiting Auschwitz?," *Journal of Curriculum Studies* 43, no. 2 (2011): 163–84, https://doi.org/10.1080/00220272.2010.542831; Kelly L. Le, "Cu Chi Tunnels: Vietnamese Transmigrant's Perspective," *Annals of Tourism Research* 46 (2014): 75–88, https://doi.org/10.1016/j.annals.2014.02.007; F. Israfilova and C. Khoo, "Sad and Violent but I Enjoy It: Children's Engagement with Dark Tourism as an Educational Tool," *Tourism and Hospitality Research* 19, no. 4 (2019): 478–87, https://doi.org/10.1177/1467358418782736; Ljiljana Radonić, "Slovak and Croatian Invocation of Europe: The Museum of the Slovak National Uprising and the Jasenovac Memorial Museum," *Nationalities Papers* 42, no. 3 (2014): 489–507, https://doi.org/10.1080/00905992.2013.867935; Jovan Byford, "When I Say 'The Holocaust,' I Mean 'Jasenovac': Remembrance of the Holocaust in Contemporary Serbia," *East European Jewish Affairs* 37, no. 1 (2007): 51–74, https://doi.org/10.1080/13501670701197946; Jelena Subotić, "Remembrance, Public Narratives, and Obstacles to Justice in the Western Balkans," *Studies in Social Justice* 7 (2013): 265–83, https://doi.org/10.26522/ssj.v7i2.1047.

20. Eun-Jung Kang et al., "Benefits of Visiting a 'Dark Tourism' Site: The Case of the Jeju April 3rd Peace Park, Korea," *Tourism Management* 33, no. 2 (2012): 257–65, https://doi.org/10.1016/j.tourman.2011.03.004.
21. Fiona Gasana, "Gisozi Memorial Site: Voices of the Past Immortalised," IGIHE, April 25, 2011, https://en.igihe.com/arts-culture/gisozi-memorial-site-voices-of-the-past.
22. Annaclaudia Martini and Dorina Maria Buda, "Dark Tourism and Affect: Framing Places of Death and Disaster," *Current Issues in Tourism* 23, no. 6 (2020): 679–92, https://doi.org/10.1080/13683500.2018.1518972.
23. Dorina Maria Buda, Anne-Marie d'Hauteserre, and Lynda Johnston, "Feeling and Tourism Studies," *Annals of Tourism Research* 46 (2014): 102–14, https://doi.org/10.1016/j.annals.2014.03.005.
24. Simon Cooke, "Sebald's Ghosts: Traveling Among the Dead in the Rings of Saturn," *Journeys* 11, no. 1 (2010): 55, https://doi.org/10.3167/jys.2010.110103.
25. Joy Sather-Wagstaff, *Heritage That Hurts: Tourists in the Memoryscapes of September 11* (Walnut Creek, CA: Routledge, 2011), 72; Tim Edensor, "Reconnecting with Darkness: Gloomy Landscapes, Lightless Places," *Social & Cultural Geography* 14, no. 4 (2013): 446–65, https://doi.org/10.1080/14649365.2013.790992.
26. Doreen Pastor, *Tourism and Memory: Visitor Experiences of the Nazi and GDR Past* (London: Routledge, 2021).
27. Nataliia Godis and Jan Henrik Nilsson, "Memory Tourism in a Contested Landscape: Exploring Identity Discourses in Lviv, Ukraine," *Current Issues in Tourism* 21, no. 15 (2018): 1690–1709, https://doi.org/10.1080/13683500.2016.1216529.
28. Nangyeon Lim, "Cultural Differences in Emotion: Differences in Emotional Arousal Level Between the East and the West," *Integrative Medicine Research* 5, no. 2 (2016): 105–9, https://doi.org/10.1016/j.imr.2016.03.004; William Tsai and Anna S. Lau, "Cultural Differences in Emotion Regulation During Self-Reflection on Negative Personal Experiences," *Cognition & Emotion* 27, no. 3 (2013): 416–29, https://doi.org/10.1080/02699931.2012.715080.
29. Unni Wikan, "Bereavement and Loss in Two Muslim Communities: Egypt and Bali Compared," *Social Science & Medicine* 27, no. 5 (1988): 451–60, https://doi.org/10.1016/0277-9536(88)90368-1.
30. Lea David, *The Past Can't Heal Us: The Dangers of Mandating Memory in the Name of Human Rights* (Cambridge, Cambridge University Press, 2020), 176.
31. Ganna Yankovska and Kevin Hannam, "Dark and Toxic Tourism in the Chernobyl Exclusion Zone," *Current Issues in Tourism* 17 (2013): 929–39, https://doi.org/10.1080/13683500.2013.820260.

32. David Weaver et al., "Dark Tourism, Emotions, and Postexperience Visitor Effects in a Sensitive Geopolitical Context: A Chinese Case Study," *Journal of Travel Research* 57, no. 6 (2018): 824–38, https://doi.org/10.1177 /0047287517720119.
33. Bauman, "Morality in the Age of Contingency," 54.
34. Stephen Hopgood, *The Endtimes of Human Rights* (Ithaca, NY: Cornell University Press, 2015), 108.
35. Oliver Wainwright, "9/11 Memorial Museum: An Emotional Underworld Beneath Ground Zero," *Guardian*, May 14, 2014, https://www.theguardian .com/artanddesign/2014/may/14/9-11-memorial-museum-new-york.
36. George Ritzer, *The McDonaldization of Society*, 8th ed. (Los Angeles: Sage, 1993).
37. J. John Lennon and Malcolm Foley, *Dark Tourism: The Attraction of Death and Disaster* (New York: Cengage); Philip Stone, "A Dark Tourism Spectrum: Towards a Typology of Death and Macabre Related Tourist Sites, Attractions and Exhibitions," *Tourism: An International Interdisciplinary Journal* 54, no. 2 (2006): 145–60.
38. Jeffrey S. Podoshen et al., "Dystopian Dark Tourism: An Exploratory Examination," *Tourism Management* 51 (2015): 316–28, https://doi.org/10.1016/j.tourman .2015.05.002.
39. Weaver et al., "Dark Tourism."
40. Britta Knudsen, "Thanatourism: Witnessing Difficult Pasts," *Tourist Studies* 11 (2011): 55–72, https://doi.org/10.1177/1468797611412064; Lennon and Foley, *Dark Tourism*; Erik H. Cohen, "Educational Dark Tourism at an *In Populo* Site: The Holocaust Museum in Jerusalem," *Annals of Tourism Research* 38, no. 1 (2011): 193–209, https://doi.org/10.1016/j.annals.2010.08.003.
41. Senija Causevic and Paul Lynch, "Phoenix Tourism: Post-conflict Tourism Role," *Annals of Tourism Research* 38, no. 3 (2011): 780–800, https://doi.org /10.1016/j.annals.2010.12.004; Buda, d'Hautesserre, and Johnston, "Feeling and Tourism Studies."
42. Richard Sharpley and Philip R. Stone, "Chapter 6. (Re)presenting the Macabre: Interpretation, Kitschification and Authenticity," in *The Darker Side of Travel: The Theory and Practice of Dark Tourism*, ed. Richard Sharpley and Philip R. Stone (Bristol: Channel View, 2009), 109–28; Lennon and Foley, *Dark Tourism*.
43. Yaniv Poria, Arie Reichel, and Avital Biran, "Heritage Site Management: Motivations and Expectations," *Annals of Tourism Research* 33, no. 1 (2006): 162–78, https://doi.org/10.1016/j.annals.2005.08.001.

44. Poria, Reichel, and Biran, "Heritage Site Management."
45. Charles R. Goeldner and J. R. Brent Ritchie, *Tourism: Principles, Practices, Philosophies*, 12th ed. (Hoboken, NJ: Wiley, 2012); Philip L. Pearce and Uk-Il Lee, "Developing the Travel Career Approach to Tourist Motivation," *Journal of Travel Research* 43, no. 3 (2005): 226–37, https://doi.org/10.1177/0047287504272020.
46. Sharpley and Stone, " (Re)Presenting the Macabre," 109–28.
47. Clare Spenser, "The Rise of Genocide Memorials," *BBC News*, June 11, 2012, https://www.bbc.com/news/magazine-16642344.
48. Tim Cole, *Selling the Holocaust: From Auschwitz to Schindler; How History Is Bought, Packaged and Sold* (New York: Routledge, 1999); Chris Rojek, "Indexing, Dragging and the Social Construction of Tourist Sights," in *Touring Cultures: Transformation of Travel and History*, ed. Chris Rojek and John Urri (New York: Routledge, 1997), 52–74.
49. "TripAdvisor Sorry for Auschwitz Review Error," *BBC News*, May 7, 2021, https://www.bbc.com/news/technology-57023794.
50. A. V. Seaton and J. J. Lennon, "Thanatourism in the Early 21st Century: Moral Panics, Ulterior Motives and Alterior Desires," *New Horizons in Tourism: Strange Experiences and Stranger Practices* (2004): 63–82, https://doi.org/10.1079/9780851998633.0063.
51. Martini and Buda, "Dark Tourism and Affect."
52. William F. S. Miles, "Auschwitz: Museum Interpretation and Darker Tourism," *Annals of Tourism Research* 29, no. 4 (2002): 1175–78, https://doi.org/10.1016/S0160-7383(02)00054-3.
53. Miles, "Auschwitz."
54. Richard Sharpley, "Chapter 1. Shedding Light on Dark Tourism: An Introduction," in *The Darker Side of Travel: The Theory and Practice of Dark Tourism*, ed. Richard Sharpley and Philip R. Stone (Bristol: Channel View, 2009), 3–22.
55. Anna Farmaki, "Dark Tourism Revisited: A Supply/Demand Conceptualisation," *International Journal of Culture, Tourism and Hospitality Research* 7, no. 3 (2013): 281–92, https://doi.org/10.1108/IJCTHR-05-2012-0030.
56. G. J. Ashworth, "Holocaust Tourism: The Experience of Krakow-Kazimierz," *International Research in Geographical and Environmental Education* 11 (2002): 363–67, https://doi.org/10.1080/10382040208667504.
57. Known as "Hotel Rwanda," the Hôtel des Mille Collines became famous because of the film *Hotel Rwanda*, based on the story of the general manager of the five-star hotel, Paul Rusesabagina, who sheltered 1,268 people inside the building during the Rwandan genocide of 1994, including both Tutsis and

moderate Hutus who were in danger of being slaughtered. Spenser, "The Rise of Genocide Memorials."
58. Nathan K. Austin, "Managing Heritage Attractions: Marketing Challenges at Sensitive Historical Sites," *International Journal of Tourism Research* 4, no. 6 (2002): 448, https://doi.org/10.1002/jtr.403.
59. Siniša Malešević, "The Act of Killing: Understanding the Emotional Dynamics of Violence on the Battlefield," *Critical Military Studies* 7, no. 3 (2021): 313–34, https://doi.org/10.1080/23337486.2019.1673060.
60. Carmen de Rojas and Carmen Camarero, "Visitors' Experience, Mood and Satisfaction in a Heritage Context: Evidence from an Interpretation Center," *Tourism Management* 29, no. 3 (2008): 525–37, https://doi.org/10.1016/j.tourman.2007.06.004.
61. Malešević, "The Act of Killing."
62. Nigel Thrift, "Intensities of Feeling: Towards a Spatial Politics of Affect," *Geografiska Annaler: Series B, Human Geography* 86, no. 1 (2004): 57–78, https://doi.org/10.1111/j.0435-3684.2004.00154.x; Nigel Thrift, *Non-representational Theory: Space, Politics, Affect* (London: Routledge, 2008); Sianne Ngai, *Ugly Feelings* (Cambridge, MA: Harvard University Press, 2007); Francesca Ansaloni and Miriam Tedeschi, "Understanding Space Ethically Through Affect and Emotion: From Uneasiness to Fear and Rage in the City," *Emotion, Space and Society* 21 (2016): 15–22, https://doi.org/10.1016/j.emospa.2016.09.006.
63. Joyce Davidson and Liz Bondi, "Spatialising Affect; Affecting Space: An Introduction," *Gender, Place & Culture* 11, no. 3 (2004): 373–74, https://doi.org/10.1080/0966369042000258686; Ben Anderson, "Becoming and Being Hopeful: Towards a Theory of Affect," *Environment and Planning D: Society and Space* 24, no. 5 (2006): 733–52, https://doi.org/10.1068/d393t.
64. Ngai, *Ugly Feelings*.
65. Martini and Buda, "Dark Tourism and Affect."
66. David Klinger, *Into the Kill Zone: A Cop's Eye View of Deadly Force* (San Francisco: Wiley, 2013); Randall Collins, *Violence: A Micro-sociological Theory* (Princeton, NJ: Princeton University Press, 2009); Jonathan H. Turner, *Human Emotions: A Sociological Theory* (London: Routledge, 2007).
67. Kang et al., "Benefits of Visiting a 'Dark Tourism' Site."
68. Of all participants, more than half were North American. Bedigan, "Developing Emotions."
69. Bedigan, "Developing Emotions," 92.
70. Falk and Dierking, *The Museum Experience*.

71. Randall Collins, *Interaction Ritual Chains* (Princeton, NJ: Princeton University Press, 2005).
72. Davide Sterchele, "The Limits of Inter-religious Dialogue and the Form of Football Rituals: The Case of Bosnia-Herzegovina," *Social Compass* 54, no. 2 (2007): 211–24, https://doi.org/10.1177/0037768607077032.
73. Serge Moscovici, *Social Representations: Essays in Social Psychology* (New York: NYU Press, 1984).
74. Austin, "Managing Heritage Attractions"; Aaron Yankholmes and Bob McKercher, "Understanding Visitors to Slavery Heritage Sites in Ghana," *Tourism Management* 51 (2015): 22–32, https://doi.org/10.1016/j.tourman.2015.04.003.
75. Felicity Cheal and Tony Griffin, "Pilgrims and Patriots: Australian Tourist Experiences at Gallipoli," *International Journal of Culture, Tourism and Hospitality Research* 7, no. 3 (2013): 227–41, https://doi.org/10.1108/IJCTHR-05-2012-0040.
76. Tanaya Preece and Garry G. Price, "Motivations of Participants in Dark Tourism: A Case Study of Port Arthur, Tasmania, Australia," in *Taking Tourism to the Limits: Issues, Concepts and Managerial Perspectives*, ed. Chris Ryan, Stephen J. Page, and Michelle Aicken (Oxford: Elsevier, 2005), 191–98.
77. Jeffrey S. Podoshen, "Dark Tourism Motivations: Simulation, Emotional Contagion and Topographic Comparison," *Tourism Management* 35 (2013): 263–71, https://doi.org/10.1016/j.tourman.2012.08.002; A. V. Seaton, "Guided by the Dark: From Thanatopsis to Thanatourism," *International Journal of Heritage Studies* 2, no. 4 (1996): 234–44, https://doi.org/10.1080/13527259608722178; Carol Kidron, "Being There Together: Dark Family Tourism and the Emotive Experience of Co-presence in the Holocaust Past," *Annals of Tourism Research* 41 (2013): 175–94, https://doi.org/10.1016/j.annals.2012.12.009; Cheal and Griffin, "Pilgrims and Patriots."
78. Liberata Gahongayire and Anne Marie Nyiracumi, "Breaking Silence: Documenting Individual Experiences Based on Visitors' Book of Kigali Genocide Memorial Centre, Rwanda," *International Journal of Innovation and Applied Studies* 7, no. 4 (2014): 1444–57.
79. Gahongayire and Nyiracumi, "Breaking Silence," 1451.
80. Gahongayire and Nyiracumi, "Breaking Silence."
81. Gianna Moscardo, "Exploring Social Representations of Tourism Planning: Issues for Governance," *Journal of Sustainable Tourism* 19, nos. 4–5 (2011): 423–36, https://doi.org/10.1080/09669582.2011.558625.
82. Keith C. Barton and Linda S. Levstik, *Teaching History for the Common Good* (New York: Routledge, 2004).

83. Arlie Russell Hochschild, "Emotion Work, Feeling Rules, and Social Structure," *American Journal of Sociology* 85, no. 3 (1979): 551–75; Arlie Russell Hochschild, *The Managed Heart: Commercialization of Human Feeling*, 3rd ed. (Berkeley: University of California Press, 2012).
84. Kidron, "Being There Together."
85. Martini and Buda, "Dark Tourism and Affect."
86. Emma Dresler and Jochen Fuchs, "Constructing the Moral Geographies of Educational Dark Tourism," *Journal of Marketing Management* 37, nos. 5–6 (2021): 548–68, https://doi.org/10.1080/0267257X.2020.1846596.
87. Rosanne Kennedy and Sulamith Graefenstein, "From the Transnational to the Intimate: Multidirectional Memory, the Holocaust and Colonial Violence in Australia and Beyond," *International Journal of Politics, Culture, and Society* 32, no. 4 (2019): 403–22, https://doi.org/10.1007/s10767-019-09329-4; Avril Alba, "Transmitting the Survivor's Voice: Redeveloping the Sydney Jewish Museum," *Dapim: Studies on the Holocaust* 30, no. 3 (2016): 243–57, https://doi.org/10.1080/23256249.2016.1251681.
88. Sydney Jewish Museum, "One of the First Permanent Human Rights Exhibitions to Open in a Museum in Australia" (press release), February 15, 2018, https://sydneyjewishmuseum.com.au/wp-content/uploads/2018/01/Final-MEDIA-RELEASE-Sydney-Jewish-Museums-new-Holcoaust-and-Human-Righ . . .-2.pdf.
89. Des Griffin and Morris Abraham, "The Effective Management of Museums: Cohesive Leadership and Visitor-Focused Public Programming," *Museum Management and Curatorship* 18, no. 4 (2000): 336, https://doi.org/10.1080/09647770000301804.

7. OTHER SHOES PAVED THE WAY: ON CIRCULATION OF KNOWLEDGE

The epigraph to this chapter is from Roslyn Sugarman, "Shoes: A Matter of Life or Death," Sydney Jewish Museum, November 21, 2019, https://sydneyjewishmuseum.com.au/news/shoes-a-matter-of-life-or-death/.

1. Vedran Bosnjak, "Memorijalni centar Potočari: Otvorena izložba 'Koracima onih koji (ni)su prešli,'" *Anadolu Ajansı*, 2012, https://www.aa.com.tr/ba/balkan/memorijalni-centar-potocari-otvorena-izlozba-koracima-onih-koji-nisu-presli/2369559; Emir Suljagić, director of the Srebrenica Memorial Centre, speaking at the opening of the *Footsteps of Those Who Did (Not) Cross* exhibition, September 20, 2021.

2. Lamija Grebo, "Cipele 'Mrtvare': Otisak Vremena i Svjedočenje o Srebrenici," *Detektor*, 2021, https://detektor.ba/2021/06/22/cipele-mrtvare-otisak-vremena-i-svjedocenje-o-srebrenici/.
3. Republika Hrvatska Ministarstvo kulture i medija, "Uoči 27. Obljetnice Tragedije u Srebrenici Otvorena Izložba Fotografija 'Mrtvare,'" min-kulture.gov.hr, 2022, https://min-kulture.gov.hr/vijesti-8/uoci-27-obljetnice-tragedije-u-srebrenici-otvorena-izlozba-fotografija-mrtvare/22450.
4. Lamija Grebo, "Cipele 'Mrtvare': Otisak Vremena i Svjedočenje o Srebrenici," *Detektor*, 2021, https://detektor.ba/2021/06/22/cipele-mrtvare-otisak-vremena-i-svjedocenje-o-srebrenici/.
5. A collaborative project of the Balkan Investigative Network for Bosnia and Herzegovina and the Srebrenica Memorial Centre; Grebo, "Cipele 'Mrtvare.'"
6. Ruth Barnes and Joanne B. Eicher, eds., *Dress and Gender: Making and Meaning* (Oxford: Berg, 1993); Kim K. P. Johnson and Sharron J. Lennon, eds., *Appearance and Power* (New York: Bloomsbury Academic, 1999); Giorgio Riello and Peter McNeil, eds., *Shoes: A History from Sandals to Sneakers* (Oxford: Berg, 2011).
7. Riello and McNeil, *Shoes*.
8. Riello and McNeil, *Shoes*.
9. Shari Benstock and Suzanne Ferriss, eds., *Footnotes: On Shoes* (New Brunswick, NJ: Rutgers University Pres, 2001).
10. Julia Emberley, "The Ends of Fashion; or Learning to Theorise with Shoes in the Bata Shoe Museum," in *Footnotes: On Shoes*, ed. Shari Benstock and Suzanne Ferriss, First Edition (New Brunswick, N.J: Rutgers University Press, 2001), 17–40.
11. Chie Mihara, "The History and Evolution of Shoes," *Dolita* (blog), 2022, https://www.dolitashoes.com/blogs/news/the-history-and-evolution-of-shoes-blog.
12. Philomena Epps, "If the Shoe Fits: The Gendered Connotations of Footwear in Art History," Art UK, 2020, https://artuk.org/discover/stories/if-the-shoe-fits-the-gendered-connotations-of-footwear-in-art-history.
13. Mihara, "The History and Evolution of Shoes."
14. Mihara, "The History and Evolution of Shoes."
15. Epps, "If the Shoe Fits."
16. Epps, "If the Shoe Fits."
17. Epps, "If the Shoe Fits."
18. Mihara, "The History and Evolution of Shoes."
19. Anthony Barthelemy, "Brogans," in *Footnotes: On Shoes*, ed. Shari Benstock and Suzanne Ferriss (New Brunswick, NJ: Rutgers University Press, 2001), 179–97.

20. Mihara, "The History and Evolution of Shoes."
21. Mihara, "The History and Evolution of Shoes."
22. Zachary Austin Doleshal, *In the Kingdom of Shoes: Bata, Zlín, Globalization, 1894–1945* (Toronto: University of Toronto Press, 2021).
23. "Footwear Production Worldwide 2021," Statista, 2021, https://www.statista.com/statistics/1044823/global-footwear-production-quantity/.
24. Hedrick Tace, "Are You a Pura Latina? Or, Menudo Every Day: Tacones and Symbolic Ethnicity," in *Footnotes: On Shoes*, ed. Shari Benstock and Suzanne Ferriss (New Brunswick, NJ: Rutgers University Press, 2001), 135–56.
25. Marth Chaklin, "Purity, Pollution and Place in Traditional Japanese Footwear," in *Shoes: A History from Sandals to Sneakers*, ed. Giorgio Riello and Peter McNeil (Oxford: Berg, 2011), 160–82.
26. Paola Zamperini, "A Dream of Butterflies? Shoes in Chinese Culture," in *Shoes: A History from Sandals to Sneakers*, ed. Giorgio Riello and Peter McNeil (Oxford: Berg, 2011), 196–206.
27. Riello and McNeil, *Shoes*.
28. On St. Nicholas Day, in Germany and many other Catholic countries, children wake up to a special treat in their shoes, a three-hundred-year-old tradition.
29. Jason Wordie, "Why Homes in Asia Maintain a Strict Shoes-Off Rule, Often Opting for Slippers Instead," *South China Morning Post*, December 13, 2019, https://www.scmp.com/magazines/post-magazine/short-reads/article/3041781/why-homes-asia-maintain-strict-shoes-rule-often.
30. Daniel Lioy, ed., *International Bible Lesson Commentary 2008–2009: The New Standard in Biblical Exposition Based on the International Sunday School Lessons (ISSL)* (Colorado Springs, CO: David C. Cook, 2008), 321.
31. Mary Douglas, *Purity and Danger: An Analysis of Concepts of Pollution and Taboo* (London: Routledge, 1966).
32. James Laver, *A Concise History of Costume* (London: Thames & Hudson, 1969).
33. Dorothy Ko, *Every Step a Lotus: Shoes for Bound Feet* (Berkeley: University of California Press, 2002).
34. Patricia Buckley Ebrey, *The Cambridge Illustrated History of China*, 2nd ed. (Cambridge: Cambridge University Press, 2010).
35. Epps, "If the Shoe Fits."
36. Beverley Jackson, *Splendid Slippers: A Thousand Years of an Erotic Tradition* (Berkeley, CA: Ten Speed, 1998); William A. Rossi, *Sex Life of the Foot and Shoe* (Malabar, FL: Krieger, 1993).
37. Rossi, *Sex Life of the Foot and Shoe*.

38. Gail Hershatter, *Women and China's Revolutions* (Lanham, MD: Rowman & Littlefield, 2018), 45.
39. Deborah L. Rhode, *The Beauty Bias: The Injustice of Appearance in Life and Law* (New York: Oxford University Press, 2010).
40. Ann M. E. Haentjens, "Ritual Shoes in Early Greek Female Graves," *L'Antiquité Classique* 71 (2002): 171–84; Alan Sumler, "A Catalogue of Shoes: Puns in Herodas 'Mime' 7," *Classical World* 103, no. 4 (2010): 465–75.
41. Linda O'Keefe, *Shoes: A Celebration of Pumps, Sandals, Slippers and More* (New York: Workman, 1996); Valerie Steele, *Fetish: Fashion, Sex and Power* (New York: Oxford University Press, 1997); Claudia Wobovnik, "These Shoes Aren't Made for Walking: Rethinking High-Heeled Shoes as Cultural Artifacts," *Visual Culture & Gender* 8 (2013): 82–92.
42. Christina Probert, *Shoes in Vogue Since 1910* (London: Thames & Hudson, 1981), 8.
43. Anne Brydon, "Sensible Shoes," in *Consuming Fashion: Adorning the Transnational Body*, ed. Anne Brydon and Sandra Niessen (Oxford: Berg, 1998), 1.
44. Russell Belk, "Shoes and Self," in *Advances in Consumer Research*, ed. Punam Anand Keller and Dennis Rook (Valdosta, GA: Association for Consumer Research, 2003), 27–33.
45. Susan B. Kaiser, Howard G. Schutz, and Joan L. Chandler, "Cultural Codes and Sex-Role Ideology: A Study of Shoes," *American Journal of Semiotics* 5, no. 1 (1987): 13–33.
46. Brydon, "Sensible Shoes."
47. Mimi Pond, *Shoes Never Lie* (New York: Berkley, 1985), 13.
48. Chris Breward, "Fashioning Masculinity: Men's Footwear and Modernity," in *Shoes: A History from Sandals to Sneakers*, ed. Giorgio Riello and Peter McNeil (Oxford: Berg, 2006), 206–23.
49. Louise Wallenberg, "Men in Boots: On Spectacular Masculinity and Desublimation," in *Shoe Reels: The History and Philosophy of Footwear in Film*, ed. Elizabeth Ezra and Catherine Wheatley (Edinburgh: Edinburgh University Press, 2020), 148–65.
50. Maureen Turim, "High Angles of Shoes: Cinema, Gender and Footwear," in *Footnotes: On Shoes*, ed. Shari Benstock and Suzanne Ferriss (New Brunswick, NJ: Rutgers University Press, 2001), 58–92.
51. Aliya Whiteley, "The Symbolism of Shoes in the Movies," *Den of Geek*, April 30, 2013, https://www.denofgeek.com/movies/the-symbolism-of-shoes-in-the-movies/.
52. "Foot Talk: When a Shoe Is Not a Shoe: Empty Shoe Protests," *Foot Talk* (blog), September 11, 2021, http://foottalk.blogspot.com/2005/06/when-shoe-is-not

-shoe.html; Kim Parker, "Swarovski Recreates Cinderella's Crystal Shoe for Disney," Something about Rocks, August 2, 2023, https://somethingaboutrocks.com/article/swarovski-recreates-cinderellas-crystal-shoe-for-disney/.
53. Whiteley, "The Symbolism of Shoes in the Movies."
54. Epps, "If the Shoe Fits."
55. Janice West, "The Shoe in Art, the Shoe as Art," in *Footnotes: On Shoes*, ed. Shari Benstock and Suzzane Ferriss (New Brunswick, NJ: Rutgers University Press, 2001), 42.
56. Margo DeMello, Introduction to *Feet and Footwear: A Cultural Encyclopedia*, xix–xxii (Santa Barbara, CA: Greenwood, 2009).
57. West, "The Shoe in Art."
58. The Pompadour shoe was named after Madame de Pompadour, an official mistress of the French king, Louis XV.
59. West, "The Shoe in Art."
60. Ellen Carol Jones, "Empty Shoes," in *Footnotes: On Shoes*, ed. Shari Benstock and Suzzane Ferriss (New Brunswick, NJ: Rutgers University Press, 2001), 203.
61. Barbie Zelizer, *Remembering to Forget: Holocaust Memory Through the Camera's Eye* (Chicago: University of Chicago Press, 1998), 55. Zelizer quotes Richard Lauterbach, "Murder, Inc.," *Time*, September 11, 1944.
62. Jones, "Empty Shoes," 197.
63. Jones, "Empty Shoes," 204.
64. Jones, "Empty Shoes," 204.
65. Lawrence L. Langer, *Holocaust Testimonies: The Ruins of Memory* (New Haven, CT: Yale University Press, 1993), 568. Langer quotes an untitled poem by Abraham Sutzkever.
66. Levi Primo, *Survival in Auschwitz: If This Is a Man* (New York: Simon and Schuster, 1958), 34.
67. Michael Berenbaum, *The World Must Know: The History of the Holocaust as Told in the United States Holocaust Memorial Museum*, revised ed. (Baltimore, MD: Johns Hopkins University Press, 2006), 108.
68. Jones, "Empty Shoes."
69. Yehudit Shendar, "Private Tolkatchev at the Gates of Hell," Yad Vashem Museum, accessed September 22, 2022, https://www.yadvashem.org/yv/en/exhibitions/tolkatchev/about-exhibition.asp.
70. Mirijam Rajner, "From the Shtetl to the Flowers of Auschwitz and Back: The Creation, Reception and Destiny of Zinovii Tolkatchev's Art," in *Images of Rupture Between East and West: The Perception of Auschwitz and Hiroshima in*

Eastern European Arts and Media, ed. Urs Heftrich et al. (Heidelberg: Universitatsverlag Winter, 2016), 155–85.
71. Rajner, "From the Shtetl."
72. Jones, "Empty Shoes."
73. Daniel Levy and Natan Sznaider, "Memory Unbound: The Holocaust and the Formation of Cosmopolitan Memory," European Journal of Social Theory 5, no. 1 (2002): 87–106, https://doi.org/10.1177/1368431002005001002
74. Levy and Sznaider, "Memory Unbound."
75. Sharon B. Oster, "Holocaust Shoes: Metonymy, Matter, Memory," in The Palgrave Handbook of Holocaust Literature and Culture, ed. Victoria Aarons and Phyllis Lassner (Cham: Springer, 2020), 761–84.
76. Jones, "Empty Shoes," 215.
77. Susan Henderson, "Clogs, Boots and Shoes Built to the Sky," in Identities and Citizenship Education: Controversy, Crisis and Challenges; Program and Abstract Book, ed. Peter Cunningham, 15th Annual CiCe Network Conference, Lisbon (London: London Metropolitan University, Institute for Policy Studies in Education, 2013), 678–89.
78. Jones, "Empty Shoes," 216.
79. Sidra DeKoven Ezrahi, "Conversation in the Cemetery: Dan Pagis and the Prosaics of Memory," in Holocaust Remembrance: The Shapes of Memory, ed. Geoffrey H. Hartman (Hoboken, NJ: Wiley, 1994), 121–34.
80. Jones, "Empty Shoes," 217.
81. "Thieves Steal Holocaust Victims' Shoes at Polish Museum," BBC News, November 25, 2014, https://www.bbc.com/news/world-europe-30202861.
82. Linda Young, "Magic Objects/Modern Objects: Heroes' House Museums," in The Thing About Museums: Objects and Experience, Representation and Contestation, ed. Sandra Dudley et al. (London: Routledge, 2011), 143.
83. Sheryl Silver Ochayon, "The Shoes on the Danube Promenade—Commemoration of the Tragedy," Yad Vashem, 2014, https://www.yadvashem.org/articles/general/shoes-on-the-danube-promenade.html.
84. "'Shoes of the Dead' – Exhibition in Dresden Devoted to the Victims of the Holocaust," Majdanek State Museum, February 3, 2014, https://www.majdanek.eu/en,2014,https://www.majdanek.eu/en/news/shoes_of_the_dead_____exhibition_in_dresden_devoted_to_the_victims_of_the/471.
85. Paul Salmons, "A Blanket, a Letter, a Shoe: Searching for Meaning in Traces of the Holocaust," Reform Judaism (blog), May 1, 2019, https://reformjudaism.org/blog/blanket-letter-shoe-searching-meaning-traces-holocaust.

86. Raquel Gomez, "Walk a Mile in Some Victim's Shoes to Build a Shared Future," *Shared Future News*, March 16, 2018, https://sharedfuture.news/walk-a-mile-in-some-victims-shoes-to-build-a-shared-future/.
87. Mikayla Sciscente, "The 9/11 Memorial Museum Is Home to the Shoes of Survivors," National September 11 Memorial & Museum, accessed June 10, 2021, https://www.911memorial.org/connect/blog/911-memorial-museum-home-shoes-survivors#:~:text=To%20walk%20a%20mile%20in,three%20varied%20tales%20of%20survival.
88. Sugarman, "Shoes."
89. Yim Soeum, "Tuol Sleng Launches Moving New Exhibition of Victims' Clothes," *Khmer Times*, December 27, 2021, https://www.khmertimeskh.com/50995959/tuol-sleng-launches-moving-new-exhibition-of-victims-clothes/.
90. Silver Ochayon, "The Shoes on the Danube Promenade."
91. Jones, "Empty Shoes," 215.
92. "Auschwitz-Birkenau Launches Crowdfunding Campaign to Preserve Important Monument," i24news, July 27, 2022, https://www.i24news.tv/en/news/international/europe/1658927209-auschwitz-birkenau-launches-crowdfunding-campaign-to-preserve-important-monument.
93. Megan Boler, *Feeling Power: Emotions and Education* (New York: Routledge, 1999).
94. Michalinos Zembylas, "'Pedagogy of Discomfort' and Its Ethical Implications: The Tensions of Ethical Violence in Social Justice Education," *Ethics and Education* 10, no. 2 (2015): 163–74, https://doi.org/10.1080/17449642.2015.1039274.
95. Megan Boler and Michalinos Zembylas, "Discomforting Truths: The Emotional Terrain of Understanding Differences," *Pedagogies of Difference: Rethinking Education for Social Justice* 1 (2003): 110–36; Boler, *Feeling Power*, 176.
96. Randall Collins, *Explosive Conflict: Time-Dynamics of Violence* (New York: Routledge, 2022).
97. Edward Linenthal, *Preserving Memory: The Struggle to Create America's Holocaust Museum* (New York: Columbia University Press, 2001), 145.
98. R. W. Levenson, "Human Emotions: A Functional View," in *The Nature of Emotion: Fundamental Questions*, ed. P. Ekman and R. J. Davidson (New York: Oxford University Press, 1994), 123; Candace S. Alcorta and Richard Sosis, "Ritual, Emotion, and Sacred Symbols," *Human Nature* 16, no. 4 (2005): 323–59, https://doi.org/10.1007/s12110-005-1014-3.
99. P. Ekman, R. W. Levenson, and W. V. Friesen, "Autonomic Nervous System Activity Distinguishes Among Emotions," *Science* 221, no. 4616 (1983): 1208–10, https://doi.org/10.1126/science.6612338.

100. Karen A. Cerulo, "Mining the Intersections of Cognitive Sociology and Neuroscience," in "Brain, Mind and Cultural Sociology," ed. Karen A Cerulo, special issue, *Poetics* 38, no. 2 (2010): 115–32, https://doi.org/10.1016/j.poetic.2009.11.005.
101. Tripadvisor review, smiller324, Indianapolis, IN, November 9, 2020.
102. Tripadvisor review, WC-Travelers-75, West Chester, PA, May 28, 2020.
103. Tripadvisor review, davidgross12, Pinckneyville, IL, October 9, 2019.
104. Tripadvisor review, rdburrows, Miami, FL, November 21, 2019.
105. Tripadvisor, Karlien K, The Hague, Written August 15, 2019.
106. Tripadvisor review, Mitrutz Norwalk, CT, July 24, 2019.
107. Tripadvisor review, DezP13_1, Woodbridge, VA, August 25, 2019.
108. Tripadvisor review, Powerful, Mesa, AZ, October 11, 2019.
109. Tripadvisor review, Perfect W, Titusville, FL, June 15, 2019.
110. Tripadvisor review, Natalia N, Miami, FL, October 21, 2017.
111. Tripadvisor review, JeffersonDavis, North Carolina, April 4, 2018.
112. Tripadvisor review, 24jennysmith, Shawnee, OK, August 6, 2017.
113. Tripadvisor review, Isabella M, Sparks, NV, July 12, 2017.
114. Tripadvisor review, pamelaL7, Boerne, TX, March 9, 2017.
115. Tripadvisor review, Jay R, Washington, DC, February 14, 2017.
116. Tripadvisor review, Debbie M, Wichita, KS, December 30, 2016.
117. Tripadvisor review, fallonsmom, Milano, TX, July 26, 2016.
118. Tripadvisor review, JanJ, Lisbon, NH, May 21, 2016.
119. Tripadvisor review, XCalifGal, Washington, DC, February 9, 2016.
120. Tripadvisor review, Susan M, Washington, DC, January 5, 2016.
121. Tripadvisor review, lornalynn, Mebane, NC, August 8, 2015.
122. Tripadvisor review, ChefCasey, Owings Mills, MD, April 23, 2015.
123. Tripadvisor review, Lila2007, Marysville, WA, September 15, 2014.
124. Tripadvisor review, Cocotel, Ottawa, Canada, April 18, 2015.
125. Tripadvisor review, Peter J. Ladue, Missouri, June 20, 2014.
126. Maurice Merleau-Ponty, *Phenomenology of Perception*, trans. Donald Landes (London: Routledge, 2013).
127. Vivian Ting Wing Yan, "Living Objects: A Theory of Museological Objecthood," in *The Thing About Museums: Objects and Experience, Representation and Contestation*, ed. Sandra Dudley et al. (London: Routledge, 2011), 172.
128. Wing Yan, "Living Objects," 173.
129. Merleau-Ponty, *Phenomenology of Perception*.
130. Wing Yan, "Living Objects," 173.
131. Graeme Gill and Luis F. Angosto-Ferrandez, "Introduction: Symbolism and Politics," *Politics, Religion & Ideology* 19, no. 4 (2018): 429–33, https://doi.org/10.1080/21567689.2018.1539436 2018

132. Robyn Sassen, "'Dark Choreography' of the Johannesburg Holocaust and Genocide Centre," *Performance Research* 25, no. 2 (2020): 87, https://doi.org/10.1080/13528165.2020.1752581.
133. Emma Dresler and Jochen Fuchs, "Constructing the Moral Geographies of Educational Dark Tourism," *Journal of Marketing Management* 37, nos. 5–6 (2021): 548–68, https://doi.org/10.1080/0267257X.2020.1846596.
134. Tripadvisor review, Toni D, Brisbane, Australia, July 18, 2019.
135. Tripadvisor review, Diane R, Chelmsford, UK, June 11, 2019.
136. Tripadvisor review, martyb1972, Calne, UK, August 14, 2018.
137. Tripadvisor review, 35jake2016, Dallas, TX, July 18, 2018.
138. Tripadvisor review, LYL0795, Kingston, Canada, October 22, 2022.
139. Tripadvisor review, Mdavey, Campbell, CA, February 21, 2020.
140. Tripadvisor review, Paolo B, February 13, 2019.
141. Tripadvisor review, Lezli P, March 31, 2018.
142. Tripadvisor review, Stevie G, Istanbul, Turkey, February 1, 2019.
143. Tripadvisor review, Weiberam, Denver, CO, April 24, 2019.
144. Tripadvisor review, Franklinmacd, Charlottetown, Canada, January 20, 2019.
145. Tripadvisor review, AvWriter, Rochelle, IL, July 26, 2019.
146. Tripadvisor review, rzoe Cambridge, MA, November 13, 2018.
147. Tripadvisor review, Battle_Ground_WA_Jim, Battle Ground, WA, April 1, 2018.
148. Tripadvisor review, GoGoRams, Saint Peters, MO, March 20, 2018.
149. Tripadvisor review, Meander5, Birmingham, AL, June 6, 2019.
150. Tripadvisor review, Destination747554, April 22, 2019.
151. Tripadvisor review, Neha P, Jersey City, NJ, March 28, 2018.
152. Tripadvisor review, TomDonna_11, Chester, CT, April 23, 2019.
153. Tripadvisor review, Franklinmacd, Charlottetown, Canada, January 20, 2019.
154. Tripadvisor review, maria198609, Effort, PA, October 3, 2018.
155. Katrin Antweiler, "Memory as a Means of Governmentality," *Memory Studies* 17, no. 2 (2023): 137–54, https://doi.org/10.1177/17506980221150892.

8. DESIRE OBJECTS, POLITICAL ACTION, AND IDEOLOGY

1. J. D. Martens, "The Life Jacket Graveyard," *Intrepid Times*, August 26, 2019, https://intrepidtimes.com/2019/08/the-life-jacket-graveyard/; Veera Vehkasalo, "Lifejacket Graveyard," *Crisis & Environment*, October 15, 2019, https://crisisandenvironment.com/lifejacket-graveyard/.

2. Bryan Sitch, "Radical Objects: A Refugee's Life Jacket at Manchester Museum," History Workshop, December 7, 2017, https://www.historywork shop.org.uk/radical-objects-a-refugees-life-jacket-at-manchester-museum/.
3. Sitch, "Radical Objects."
4. "Manchester Museum" (website), accessed October 18, 2022, https://www.museum.manchester.ac.uk/.
5. Kostia Andreikovets, "Relatives Recognized the Deceased with Blue-Yellow Bracelets from the Mass Burial in Izyum. He Is Probably a Military Man from Nikopol," 2022, https://babel.ua/en/news/84475-relatives-recognized-the-deceased-with-blue-yellow-bracelets-from-the-mass-burial-in-izyum-he-is-probably-a-military-man-from-nikopol.
6. While desire objects are put on display to reveal and amplify their material and emotional contexts, using them in protests in fact obscures and diminishes their emotional potential.
7. Durkheim, *The Elementary Forms of the Religious Life* (Oxford: Oxford University Press 1912 [2001]).
8. Anna Feigenbaum, "Moving Protests: The Stories Objects Can Tell," *Designabilities* (blog), November 1, 2018, https://designabilities.wordpress.com/2018/11/01/moving-protests-the-stories-objects-can-tell/.
9. Katy Soar and Paul-François Tremlett, "Protest Objects: Bricolage, Performance and Counter-archaeology." *World Archaeology* 49, no. 3 (2017): 423–34, https://doi.org/10.1080/00438243.2017.1350600.
10. Anwar Tlili, "Encountering the Creative Museum: Museographic Creativeness and the Bricolage of Time Materials," *Educational Philosophy and Theory* 48, no. 5 (2016): 459.
11. Soar and Tremlett, "Protest Objects."
12. Oliver Wainwright, "9/11 Memorial Museum: An Emotional Underworld Beneath Ground Zero," *Guardian*, May 14, 2014, https://www.theguardian.com/artanddesign/2014/may/14/9-11-memorial-museum-new-york.
13. "Current" refers to the time of writing in 2023 and 2024. Niloufar Haidari, "From Yasser Arafat to Madonna: How the Palestinian Keffiyeh Became a Global Symbol," *Guardian*, December 11, 2023, https://www.theguardian.com/world/2023/dec/11/keffiyeh-scarf-fashion-history-palestine.
14. Wainwright, "9/11 Memorial Museum."
15. Rebecca Ruiz, "Why 'Handmaid's Tale' Costumes Are the Most Powerful Meme of the Resistance Yet," *Mashable*, May 28, 2017, https://mashable.com/article/handmaids-tale-protests-costumes.
16. Sara Ahmed, *The Cultural Politics of Emotion*, 2nd ed. (New York: Routledge, 2015).

8. DESIRE OBJECTS, POLITICAL ACTION, AND IDEOLOGY 283

17. David M. Schneider, *American Kinship: A Cultural Account*, 2nd ed. (Chicago: University of Chicago Press, 1980); Victor Turner, *The Forest of Symbols: Aspects of Ndembu Ritual* (Ithaca, NY: Cornell University Press, 1970); Sherry B. Ortner, "On Key Symbols," *American Anthropologist* 75, no. 5 (1973): 1338–46.
18. Graeme Gill and Luis F. Angosto-Ferrandez, "Introduction: Symbolism and Politics," *Politics, Religion & Ideology* 19, no. 4 (2018): 429–33, https://doi.org /10.1080/21567689.2018.1539436.
19. Rozann Rothman, "Political Symbolism," in *The Handbook of Political Behavior*, vol. 2, ed. Samuel L. Long (Boston: Springer, 1981), 285–340.
20. Roy E. Carter, "Murray Edelman. Politics as Symbolic Action: Mass Arousal and Quiescence. Pp. 188. Chicago, Ill.: Markham, 1971. (University of Wisconsin, Institute for Research on Poverty.) No Price. Paperbound," *Annals of the American Academy of Political and Social Science* 406, no. 1 (1973): 236–37, https://doi.org/10.1177/000271627340600170; Lea David, *The Past Can't Heal Us: The Dangers of Mandating Memory in the Name of Human Rights* (Cambridge: Cambridge University Press, 2020).
21. Ann Swidler, "Culture in Action: Symbols and Strategies," *American Sociological Review* 51, no. 2 (1986): 273–86, https://doi.org/10.2307/2095521.
22. Jeffrey Alexander, "Citizen and Enemy as Symbolic Classification: On the Polarizing Discourse of Civil Society," in *Cultivating Differences: Symbolic Boundaries and the Making of Inequality*, ed. Michèle Lamont and Marcel Fournier (Chicago: University of Chicago Press, 1992), 289–308.
23. James M. Jasper, *The Emotions of Protest* (Chicago: University of Chicago Press, 2018), 129.
24. Jasper, *The Emotions of Protest*.
25. "Never again" is associated with the Holocaust but also with a variety of other massive human rights abuses. "*Nunca más*" (also meaning "never again") was used as the title of a 1984 report from the National Commission on the Disappearance of Persons in Argentina and became a widely used slogan in Latin America, appropriated by various political actors to promote civil struggles for justice and truth-finding. "Never forget" has been used in many postconflict societies to memorialize victims, as in the cases of Srebrenica and September 11. "Justice now" is used widely across protests against human rights abuses.
26. James M. Jasper and Jane D. Poulsen, "Recruiting Strangers and Friends: Moral Shocks and Social Networks in Animal Rights and Anti-nuclear Protests," *Social Problems* 42, no. 4 (1995): 493–512, https://doi.org/10.2307/3097043; Kristin Luker, *Abortion and the Politics of Motherhood* (Berkeley: University of California Press, 1985).

27. William A. Gamson, *Talking Politics* (Cambridge: Cambridge University Press, 1992).
28. Michael Rothberg, *The Implicated Subject: Beyond Victims and Perpetrators* (Stanford, CA: Stanford University Press, 2019).
29. Clifford Bob, *Rights as Weapons: Instruments of Conflict, Tools, and Power* (Princeton, NJ: Princeton University Press, 2019).
30. "Women in Black" (website), accessed November 11, 2020, https://women inblack.org/.
31. Iva Martinovic, "Serbs Honor Srebrenica Victims with Shoe Memorial," *Radio Free Europe/Radio Liberty*, July 10, 2010, https://www.rferl.org/a/Serbs_Honor _Srebrenica_Victims_With_Shoe_Memorial/2096026.html.
32. Martinovic, "Serbs Honor Srebrenica Victims."
33. Associated Press, "Pillar of Shame: Memorial of 16,000 shoes blames U.N for not preventing Srebrenica massacre," July 11, 2010, https://www.foxnews .com/world/pillar-of-shame-memorial-of-16000-shoes-blames-u-n-for-not -preventing-srebrenica-massacre.
34. Martinovic, "Serbs Honor Srebrenica Victims."
35. Martinović, "Serbs Honor Srebrenica Victims."
36. N1 Sarajevo, "Anniversary of Srebrenica Playground Massacre: 74 Pairs of Shoes for 74 Victims," *N1*, April 12, 2021, https://ba.n1info.com/english/news /anniversary-of-the-srebrenica-playground-massacre-74-shoes-for-74-victims/.
37. "Foot Talk: When a Shoe Is Not a Shoe: Empty Shoe Protests," *Foot Talk* (blog), September 11, 2021, http://foottalk.blogspot.com/2005/06/when-shoe -is-not-shoe.html.
38. "Memorial of Shoes Honoring Srebrenica Opens in Ankara," *Dünya*, July 9, 2012, https://www.dunya.com/gundem/memorial-of-shoes-honoring-srebrenica -opens-in-ankara-haberi-178948.
39. David, *The Past Can't Heal Us*, 61; Lea David, "Moral Remembrance and New Inequalities," *Global Perspectives* 1, no. 1 (2020): 11782, https://doi.org /10.1525/001c.11782.
40. Anadolija, "(FOTO) Zagreb: Od cipelica podignut memorijal djeci ubijenoj u Palestini, obratila se bosanska izbjeglica u Hrvatskoj," *N1*, December 15, 2023, https://n1info.ba/regija/foto-zagreb-od-cipelica-podignut-memorijal-djeci -ubijenoj-u-palestini-obratila-se-bosanska-izbjeglica-u-hrvatskoj/.
41. Barbara Brownie, *Acts of Undressing: Politics, Eroticism, and Discarded Clothing* (London: Bloomsbury, 2016), 93.
42. "Foot Talk."

43. Harry van der Linden, "From Combat Boots to Civilian Shoes: Reflections on the Chickenhawk Syndrome," *Radical Philosophy Review* 13, no. 2 (2010): 173–80, https://doi.org/10.5840/radphilrev201013219.
44. Ian MacLennan, "Powerful Memorial at the Spirit Catcher in Barrie for the 215 Children of Former B.C. Residential School," *Barrie 360*, May 31, 2021, https://barrie360.com/powerful-memorial-at-the-spirit-catcher-in-barrie-for-the-215-children-of-former-b-c-residential-school/.
45. Caitlin O'Kane, "164 Pairs of Shoes Placed on the Lawn of the Capitol, Representing Nurses Who Died from Coronavirus," *CBS News*, July 22, 2020, https://www.cbsnews.com/news/nurses-shoes-died-coronavirus-capitol-lawn-164-health-care-workers-pandemic/.
46. "Myanmar Junta Charges Celebrities with Promoting Protests," *AP News*, April 20, 2021, https://apnews.com/article/myanmar-junta-charge-celebrities-promoting-protests-50fcb59c57f041930eac17b793e3c369.
47. La Prensa Latina, Myanmar Protests Junta with Shoes, as Celebrity Is Arrested Over Support, accessed November 7, 2022, https://www.laprensalatina.com/myanmar-protests-junta-with-shoes-as-celebrity-is-arrested-over-support/.
48. "Protest for Ukraine: New Shoes Laid at Memorial of Jewish Victims," *Hungary Today*, March 28, 2022, https://hungarytoday.hu/ukrainian-war-protest-budapest-hungary-embassy-of-ukraine-shoes-on-the-danube-bank-genocide-zelenskyy-orban/.
49. "Protest for Ukraine."
50. Jennifer Hassan, "Hundreds of Tiny Shoes: Protest Spotlights Child Death Toll in Ukraine's Mariupol," *Washington Post*, April 10, 2022, https://www.washingtonpost.com/world/2022/04/10/mariupol-child-death-toll-helsinki-protest-ukraine-war/.
51. Fox Butterfield, "'Silent March' on Guns Talks Loudly: 40,000 Pairs of Shoes, and All Empty," *New York Times*, September 21, 1994, https://www.nytimes.com/1994/09/21/us/silent-march-on-guns-talks-loudly-40000-pairs-of-shoes-and-all-empty.html.
52. Nadra Nittle, "The Empty Shoes at the Capitol Have a Long, Grim History," *Racked*, March 14, 2018, https://www.racked.com/2018/3/14/17121658/empty-shoes-symbol-death-capitol-school-shootings.
53. Jerome Weeks, "7,000 Shoes and Counting: Dallas Teen Actors Build Public Set for New Play on Gun Violence," *KERA News*, July 6, 2018, https://www.keranews.org/arts-culture/2018-07-06/7-000-shoes-and-counting-dallas-teen-actors-build-public-set-for-new-play-on-gun-violence.

54. Lyndsay Knecht, "A Dallas Theater Company Needs Your Shoes to Honor Victims of Gun Violence," *Cry Havoc Theater Company*, November 8, 2018, https://www.cryhavoctheater.org/important-articles/2018/11/8/a-dallas-theater-company-needs-your-shoes-to-honor-victims-of-gun-violence.
55. Lisa MacGregor, "Hundreds of 'Empty Shoes' a Reminder of Those Killed by Drunk Drivers," *Global News*, September 20, 2014, https://globalnews.ca/news/1574436/empty-shoes-in-tomkins-park-represent-those-killed-by-drunk-drivers/.
56. "Foot Talk."
57. Joshua Barajas, "This Artist's Red Shoes Stand in for All the Women Lost to Violence," *PBS NewsHour*, March 10, 2020, https://www.pbs.org/newshour/arts/this-artists-red-shoes-stand-in-for-all-the-women-lost-to-violence.
58. "Foot Talk."
59. "Golden Gate Bridge Turns 75," UPI, May 27, 2012, https://www.upi.com/News_Photos/view/upi/12cb2d3f355409a7584f3fc6c6ae55a5/Golden-Gate-Bridge-turns-75/.
60. "Pink Shoes Protests About Women in Church," *NZ Catholic*, October 28, 2022, https://nzcatholic.org.nz/?p=26121.
61. "Pink Shoes Protests."
62. "Mexican Drug Cartels' Victims Tell Their Stories in Hanging Shoes Exhibition," *ABC News*, May 11, 2016, https://www.abc.net.au/news/2016-05-11/shoes-of-mexican-missing-people-hang-in-museum-exhibition/7404944.
63. Lovorka Šošić, "Say It with Your Shoes: Croatians Protest for Better Jobs," *Liberties*, May 17, 2016, https://www.liberties.eu/en/stories/say-it-with-your-shoes/8435.
64. Carly Baldwin, "Shoes Placed Outside Middletown School in Vaccine Mandate Protest," *Patch*, November 29, 2021, https://patch.com/new-jersey/middletown-nj/shoes-placed-outside-middletown-school-vaccine-mandate-protest.
65. Jordan Vallone, "Parents Leave Shoes to Protest Covid-19 Mandates in Schools," *LI Herald*, November 24, 2021, https://www.liherald.com/stories/parents-leave-shoes-to-protest-covid-19-mandates-in-schools,136481.
66. "The 'Shoes' Protest Was About Something Not Happening in Bend. Is It a Frontload to a Bigger Fight?," *Source Weekly*, December 8, 2021, https://www.bendsource.com/bend/the-shoes-protest-was-about-something-not-happening-in-bend-is-it-a-frontload-to-a-bigger-fight/Content?oid=15872972.
67. Siniša Malešević, *Grounded Nationalisms: A Sociological Analysis* (Cambridge: Cambridge University Press, 2019).

68. Elian Peltier, "With Marches Banned, Shoes Carry a Message," *New York Times*, November 29, 2015, https://www.nytimes.com/interactive/projects/cp/climate/2015-paris-climate-talks.
69. Reuters, "Paris Climate Protesters Banned but 10,000 Shoes Remain – Video," *Guardian*, November 29, 2015, http://www.theguardian.com/environment/video/2015/nov/29/paris-climate-protesters-banned-but-10000-shoes-remain-video.
70. Peltier, "With Marches Banned."
71. Tom Marshall, "Sea of Empty Shoes Left in Whitehall as Part of Global ME Protest," *Evening Standard*, May 25, 2016, https://www.standard.co.uk/news/london/millionsmissing-sea-of-empty-shoes-left-outside-department-of-health-in-global-me-protest-a3256756.html.
72. "Silent Shoe Protest at Lack of Funding for ME," *ITV News*, September 27, 2016, https://www.itv.com/news/westcountry/2016-09-27/silent-shoe-protest-at-lack-of-funding-for-me.
73. Marshall, "Sea of Empty Shoes."
74. "Shoes Replace Protesters as Swiss Climate Activists Obey Virus Curbs," *Reuters*, April 24, 2020, https://www.reuters.com/article/us-health-coronavirus-swiss-climatechang-idUSKCN226206.
75. Maeve Campbell, "Thousands of Kids' Shoes Appear in London Square as a Form of Protest," *Euro News*, May 19, 2020, https://www.euronews.com/green/2020/05/19/thousands-of-kids-shoes-appear-in-london-square-as-a-form-of-protest.
76. "Protest with Shoes," Institute for Environmental Policy, August 5, 2020, https://iep-al.org/protest-with-shoes/.
77. Benjamin Russell, "Coventry Climate Change Protest Features 168 Pairs of Shoes," *BBC News*, August 2, 2020, https://www.bbc.com/news/uk-england-coventry-warwickshire-53628335.
78. "Japanese Youth Demand Action on Global Warming in 'Shoe Protest' Outside Diet," *Mainichi Daily News*, September 26, 2020, https://mainichi.jp/english/articles/20200926/p2a/00m/0na/008000c.
79. Morgan Sharp, "Students Gather Shoes for Pickering Wetlands Protest," *Canada's National Observer*, February 25, 2021, https://www.nationalobserver.com/2021/02/25/news/students-gather-shoes-pickering-wetlands-protest.
80. Jürgen Zimmerer, "Climate Change, Environmental Violence and Genocide," *International Journal of Human Rights* 18, no. 3 (2014): 265–80, https://doi.org/10.1080/13642987.2014.914701.

81. Carter, "Murray Edelman."
82. Such symbols are often called ideological symbols.
83. Tzvetan Todorov, *Theories of the Symbol*, trans. Catherine Porter (Ithaca, NY: Cornell University Press, 1984).
84. James M. Jasper, "The Emotions of Protest: Affective and Reactive Emotions in and Around Social Movements," *Sociological Forum* 13, no. 3 (1998): 397.
85. "Muslim lives matter" was used in protests following the September 11, 2001, terrorist attacks. "No land! No house! No vote!" was used in apartheid-era protests across South Africa. The German *"Arbeit macht frei,"* translates as "Work sets you free" or "Work makes one free." The slogan appeared at the entrances to Auschwitz and other concentration camps and is widely used in protests as a direct reference to the Holocaust or more generally to a loss of freedom. The Spanish *"Que se vayan todos!"* means "They must go!" and was used frequently in protest across Argentina demanding accountability for the "disappeared."

9. CONCLUDING REMARKS: DESIRE OBJECTS, MORAL LABOR, IDEOLOGIES, AND TACIT MEMORY

"The Holocaust Shoe Project," https://holocaustshoeproject.com/.

1. Julieta De Battista, "Lacanian Concept of Desire in Analytic Clinic of Psychosis," *Frontiers in Psychology* 8 (2017), https://www.frontiersin.org/articles/10.3389/fpsyg.2017.00563.
2. Stephen Cordner and Morris Tidball-Binz, "Humanitarian Forensic Action—Its Origins and Future," *Forensic Science International* 279 (2017): 65–71, https://doi.org/10.1016/j.forsciint.2017.08.011.
3. Cordner and Tidball-Binz, "Humanitarian Forensic Action."
4. Randall Collins, *Interaction Ritual Chains* (Princeton, NJ: Princeton University Press, 2005); Randall Collins, "Emotional Energy as the Common Denominator of Rational Action," *Rationality and Society* 5, no. 2 (1993): 203–30, https://doi.org/10.1177/1043463193005002005; Randall Collins, "Social Movements and the Focus of Emotional Attention," in *Passionate Politics: Emotions and Social Movements*, ed. Jeff Goodwin, James M. Jasper, and Francesca Polletta (Chicago: University of Chicago Press, 2001), 27–44, https://doi.org/10.7208/chicago/9780226304007.003.0002.
5. Siniša Malešević, "Is Nationalism Intrinsically Violent?," *Nationalism and Ethnic Politics* 19, no. 1 (2013): 22, https://doi.org/10.1080/13537113.2013.761894.

6. William F. Shughart, "An Analytical History of Terrorism, 1945–2000," *Public Choice* 128 (2006): 7–39; Siniša Malešević, "Is Nationalism Intrinsically Violent?"
7. Zygmunt Bauman, *Modernity and the Holocaust* (Ithaca, NY: Cornell University Press, 2002), 227.
8. David and Malešević, "Ideology and Nation-States," in *The Routledge Handbook of Ideology and International Relations*, ed. Jonathan Leader Maynard and Mark L. Haas (London: Routledge, 2022), 23–39.
9. Malešević, "Is Nationalism Intrinsically Violent?"; Malešević, *Grounded Nationalisms: A Sociological Analysis* (Cambridge: Cambridge University Press, 2019); David and Malešević, "Ideology and Nation-States." At times, nation-states may adopt human rights policies and principles but only as long as they serve their nationalistic agenda.
10. Michael Freeden, "Assembling: From Concepts to Ideologies," in *Ideologies and Political Theory: A Conceptual Approach*, ed. Michael Freeden (Oxford: Oxford University Press, 1998).
11. Richard Dagger, "Ideological Communities and Conceptual Contests: The Case of Rights," *Journal of Political Ideologies* 4, no. 3 (1999): 397–402, https://doi.org/10.1080/13569319908420805.
12. John W. Meyer and Brian Rowan, "Institutionalized Organizations: Formal Structure as Myth and Ceremony," *American Journal of Sociology* 83, no. 2 (1977): 340–63; John W. Meyer et al., "World Society and the Nation-State," *American Journal of Sociology* 103, no. 1 (1997): 144–81, https://doi.org/10.1086/231174; Paul J. DiMaggio and Walter W. Powell, "The Iron Cage Revisited: Institutional Isomorphism and Collective Rationality in Organizational Fields," *American Sociological Review* 48, no. 2 (1983): 147–60, https://doi.org/10.2307/2095101.
13. Michael A. Elliott, "The Institutionalization of Human Rights and Its Discontents: A World Cultural Perspective," *Cultural Sociology* 8, no. 4 (2014): 410, https://doi.org/10.1177/1749975514541099.
14. Ellen Carol Jones, "Empty Shoes," in *Footnotes: On Shoes*, ed. Shari Benstock and Suzzane Ferriss (New Brunswick, NJ: Rutgers University Press, 2001), 215.
15. Jones, "Empty Shoes," 216, 203.
16. Jenny Wüstenberg, "Slow Memory," accessed December 10, 2022, https://jennywustenberg.com/slow-memory/.
17. Aleida Assmann, "Canon and Archive," in *Cultural Memory Studies: An International and Interdisciplinary Handbook*, ed. Astrid Erll and Ansgar Nünning (Berlin: De Gruyter, 2008), 97.

18. Astrid Erll, "The Hidden Power of Implicit Collective Memory," in *Memory, Mind & Media*, ed. Andrew Hoskins and Amanda J. Barnier (Cambridge: Cambridge University Press, 2022), e14, https://doi.org/10.1017/mem.2022.7.
19. Erll, "The Hidden Power."
20. Andreas Roepstorff, "Things to Think With: Words and Objects as Material Symbols," *Philosophical Transactions of the Royal Society B: Biological Sciences* 363, no. 1499 (2008): 2049–54, https://doi.org/10.1098/rstb.2008.0015.
21. Colin Renfrew and Ezra B. W. Zubrow, eds., *The Ancient Mind: Elements of Cognitive Archaeology* (Cambridge: Cambridge University Press, 1994).
22. Gabriel Ignatow, "Speaking Together, Thinking Together? Exploring Metaphor and Cognition in a Shipyard Union Dispute," *Sociological Forum* 19, no. 3 (2004): 405–33, https://doi.org/10.1023/B:SOFO.0000042555.15713.4d.
23. Ignatow, "Speaking Together."
24. Karen A. Cerulo, "Mining the Intersections of Cognitive Sociology and Neuroscience," in "Brain, Mind and Cultural Sociology," ed. Karen A. Cerulo, special issue, *Poetics* 38, no. 2 (2010): 126, https://doi.org/10.1016/j.poetic.2009.11.005.
25. "The Holocaust Shoe Project," accessed December 15, 2022, https://holocaustshoeproject.com/.

BIBLIOGRAPHY

Abdulwahed, Farid, and Samya Kullab. "New Mass Grave Unearthed in Iraq's North from Brutal IS Rule." *ABC News*, July 2, 2020. https://abcnews.go.com/International/wireStory/mass-grave-unearthed-iraqs-north-brutal-rule-71578252.

Acker, Joan. *Doing Comparable Worth: Gender, Class, and Pay Equity.* Philadelphia: Temple University Press, 1989.

Ahluwalia, Pal. "Reflections on the Rwandan Genocide." *African Identities* 13, no. 2 (2015): 1–2. https://doi.org/10.1080/14725843.2015.1062267.

Ahmed, Sara. *The Cultural Politics of Emotion*, 2nd ed. New York: Routledge, 2015.

Alba, Avril. "Transmitting the Survivor's Voice: Redeveloping the Sydney Jewish Museum." *Dapim: Studies on the Holocaust* 30, no. 3 (2016): 243–57. https://doi.org/10.1080/23256249.2016.1251681.

Alcorta, Candace S., and Richard Sosis. "Ritual, Emotion, and Sacred Symbols." *Human Nature* 16, no. 4 (2005): 323–59. https://doi.org/10.1007/s12110-005-1014-3.

Alexander, Jeffrey. "Citizen and Enemy as Symbolic Classification: On the Polarizing Discourse of Civil Society." In *Cultivating Differences: Symbolic Boundaries and the Making of Inequality*, ed. Michèle Lamont and Marcel Fournier, 289–308. Chicago: University of Chicago Press, 1992.

Anadolija. "(FOTO) Zagreb: Od cipelica podignut memorijal djeci ubijenoj u Palestini, obratila se bosanska izbjeglica u Hrvatskoj." *N1*, December 15, 2023. https://n1info.ba/regija/foto-zagreb-od-cipelica-podignut-memorijal-djeci-ubijenoj-u-palestini-obratila-se-bosanska-izbjeglica-u-hrvatskoj/.

Anderson, Ben. "Becoming and Being Hopeful: Towards a Theory of Affect." *Environment and Planning D: Society and Space* 24, no. 5 (2006): 733–52. https://doi.org/10.1068/d393t.

Andreikovets, Kostia. "Relatives Recognized the Deceased with Blue-Yellow Bracelets from the Mass Burial in Izyum. He Is Probably a Military Man from Nikopol." *Babel*, September 20, 2022. https://babel.ua/en/news/84475-relatives-recognized-the-deceased-with-blue-yellow-bracelets-from-the-mass-burial-in-izyum-he-is-probably-a-military-man-from-nikopol.

Ansaloni, Francesca, and Miriam Tedeschi. "Understanding Space Ethically Through Affect and Emotion: From Uneasiness to Fear and Rage in the City." *Emotion, Space and Society* 21 (2016): 15–22. https://doi.org/10.1016/j.emospa.2016.09.006.

Anstett, Élisabeth, and Jean-Marc Dreyfus, eds. *Human Remains and Identification: Mass Violence, Genocide, and the "Forensic Turn."* Manchester: Manchester University Press, 2015.

Antweiler, Katrin. *Memorialising the Holocaust in Human Rights Museums*. Boston: De Gruyter, 2023.

———. "Memory as a Means of Governmentality." *Memory Studies* 17, no. 2 (2023): 137–54. https://doi.org/10.1177/17506980221150892.

Appadurai, Arjun. "Introduction: Commodities and the Politics of Value." In *The Social Life of Things*, ed. Arjun Appadurai, 3–63. Cambridge: Cambridge University Press, 1986.

Arthur, Paige. "How 'Transitions' Reshaped Human Rights: A Conceptual History of Transitional Justice." *Human Rights Quarterly* 31, no. 2 (2009): 321–67. https://doi.org/10.1353/hrq.0.0069.

Ash, Juliet. "Memory and Object." In *The Generated Object*, ed. Pat Kirkham, 219–25. Manchester: Manchester University Press, 1996.

Ashforth, Blake E., and Ronald H. Humphrey. "Emotional Labor in Service Roles: The Influence of Identity." *Academy of Management Review* 18, no. 1 (1993): 88–115. https://doi.org/10.2307/258824.

Ashworth, G. J. "Holocaust Tourism: The Experience of Krakow-Kazimierz." *International Research in Geographical and Environmental Education* 11 (2002): 363–67. https://doi.org/10.1080/10382040208667504.

Assmann, Aleida. "Canon and Archive." In *Cultural Memory Studies: An International and Interdisciplinary Handbook*, ed. Astrid Erll and Angsar Nünning, 97–98. Berlin: De Gruyter, 2008.

———. "Europe: A Community of Memory?" *Bulletin of the German Historical Institute* 40 (2007): 11–25.

"Auschwitz-Birkenau Launches Crowdfunding Campaign to Preserve Important Monument." i24news, July 27, 2022. https://www.i24news.tv/en/news/international/europe/1658927209-auschwitz-birkenau-launches-crowdfunding-campaign-to-preserve-important-monument.

Auslander, Leora. "Beyond Words." *American Historical Review* 110, no. 4 (2005): 1015–45. https://doi.org/10.1086/ahr.110.4.1015.

Auslander, Leora, Tara Zahra, and Alice Goff, eds. *Objects of War: The Material Culture of Conflict and Displacement*. Ithaca, NY: Cornell University Press, 2018.

Austin, Nathan K. "Managing Heritage Attractions: Marketing Challenges at Sensitive Historical Sites." *International Journal of Tourism Research* 4, no. 6 (2002): 447–57. https://doi.org/10.1002/jtr.403.

Baby, Sophie, and François-Xavier Nérard. "Les objets des disparus. Exhumations et usages des traces matérielles de la violence de masse." *Cahiers Sirice* 19, no. 2 (2017): 5–20. https://doi.org/10.3917/lcsi.019.0005.

Bainbridge, Alan, and Linden West. "A Key? Conflict, and the Struggle for an Ecology of Dialogue, Learning and Peace Among Israeli Jewish and Palestinian Educators." In *Discourses, Dialogue and Diversity in Biographical Research: An Ecology of Life and Learning*, ed. Alan Bainbridge, Laura Formenti, and Linden West, 121–40. Leiden: Brill, 2021.

Baldwin, Carly. "Shoes Placed Outside Middletown School in Vaccine Mandate Protest." *Patch*, November 29, 2021. https://patch.com/new-jersey/middletown-nj/shoes-placed-outside-middletown-school-vaccine-mandate-protest.

Bandelli, Andrea. "Virtual Spaces and Museums." *Journal of Museum Education* 24, nos. 1–2 (1999): 20–22.

Barajas, Joshua. "This Artist's Red Shoes Stand in for All the Women Lost to Violence." *PBS NewsHour*, March 10, 2020. https://www.pbs.org/newshour/arts/this-artists-red-shoes-stand-in-for-all-the-women-lost-to-violence.

Baraybar, José Pablo, and Franco Mora. "Forensic Archaeology in Peru: Between Science and Human Rights Activism." In *Forensic Archaeology: A Global Perspective*, ed. W. J. Mike Groen, Nicholas Márquez-Grant, and Robert C. Janaway, 463–69. Hoboken, NJ: Wiley, 2015.

Barnes, Ruth, and Joanne B. Eicher, eds. *Dress and Gender: Making and Meaning*. Oxford: Berg, 1993.

Barthelemy, Anthony. "Brogans." In *Footnotes: On Shoes*, ed. Shari Benstock and Suzanne Ferriss, 179–97. New Brunswick, NJ: Rutgers University Press, 2001.

Barton, Keith C., and Linda S. Levstik. *Teaching History for the Common Good*. New York: Routledge, 2004.

Bauman, Zygmunt. *Modernity and the Holocaust*. Ithaca, NY: Cornell University Press, 2002.

———. "Morality in the Age of Contingency." In *Detraditionalization*, ed. Paul Heelas, Scott Lash, and Paul Morris, 49–58. Cambridge, MA: Blackwell, 1996.

Bedigan, Kirsten M. "Developing Emotions: Perceptions Of Emotional Responses In Museum Visitors," *Mediterranean Archaeology and Archaeometry* 16, no. 5 (2016): 87–95. https://doi.org/10.5281/ZENODO.204969.

Belk, Russell. "Shoes and Self." In *Advances in Consumer Research*, ed. Punam Anand Keller and Dennis Rook, 27–33. Valdosta, GA: Association for Consumer Research, 2003.

Bennett, Jane. *Vibrant Matter: A Political Ecology of Things*. Durham, NC: Duke University Press, 2010.

Bennett, Tony. *The Birth of the Museum: History, Theory, Politics*. Culture: Policies and Politics. London: Routledge, 1995.

Benstock, Shari, and Suzanne Ferriss, eds. *Footnotes: On Shoes*. New Brunswick, NJ: Rutgers University Pres, 2001.

Berenbaum, Michael. *The World Must Know: The History of the Holocaust as Told in the United States Holocaust Memorial Museum*, revised ed. Baltimore, MD: Johns Hopkins University Press, 2006.

Bergholz, Max. *Violence as a Generative Force: Identity, Nationalism, and Memory in a Balkan Community*. Ithaca, NY: Cornell University Press, 2016.

Besic, Vesna, and Talka Ozturk. "Srebrenica Genocide Victims' Belongings to Be Shown as Lesson." *Anadolu Ajansı*, February 8, 2020. https://www.aa.com.tr/en/europe/srebrenica-genocide-victims-belongings-to-be-shown-as-lesson/1728124.

Bieberstein, Alice von. "Treasure/Fetish/Gift: Hunting for 'Armenian Gold' in Post-genocide Turkish Kurdistan." *Subjectivity* 10, no. 2 (2017): 170–89. https://doi.org/10.1057/s41286-017-0026-x.

Biesecker, Leslie G., Joan E. Bailey-Wilson, Jack Ballantyne, Howard Baum, Frederick R. Bieber, Charles Brenner, Bruce Budowle, et al. "DNA Identifications After the 9/11 World Trade Center Attack." *Science* 310, no. 5751 (2005): 1122–23. https://doi.org/10.1126/science.1116608.

Bijker, Wiebe E. *Of Bicycles, Bakelites, and Bulbs: Toward a Theory of Sociotechnical Change*, 3rd ed. Cambridge, MA: MIT Press, 1999.

"Bitter Land: Interactive Map of Mass Graves from the Wars in the Former Yugoslavia." Mass Graves Map, 2000. https://massgravesmap.balkaninsight.com.

Blau, Peter M. *Exchange and Power in Social Life*. London: Routledge, 2017.

Blustein, Jeffrey M. "Human Rights and the Internationalization of Memory." In *Forgiveness and Remembrance: Remembering Wrongdoing in Personal and Public Life*. New York: Oxford University Press, 2014.

Bob, Clifford. "Ideology and Human Rights." In *The Routledge Handbook of Ideology and International Relations*, ed. Jonathan Leader Maynard and Mark L. Haas, 219–32. London: Routledge, 2022.

———. *Rights as Weapons: Instruments of Conflict, Tools, and Power*. Princeton, NJ: Princeton University Press, 2019.

Bobyn, Christopher. "If Bones Could Talk: Reassembling the Remains of Srebrenica." *Balkanist*, July 11, 2016. https://balkanist.net/if-bones-could-talk-srebrenica/.

Boler, Megan. *Feeling Power: Emotions and Education*. New York: Routledge, 1999.

Boler, Megan, and Michalinos Zembylas. "Discomforting Truths: The Emotional Terrain of Understanding Differences." *Pedagogies of Difference: Rethinking Education for Social Justice* 1 (2003): 110–36.

Bosco, Fernando J. "Human Rights Politics and Scaled Performances of Memory: Conflicts Among the Madres de Plaza de Mayo in Argentina." *Social & Cultural Geography* 5, no. 3 (2004): 381–402. https://doi.org/10.1080/1464936042000252787.

"Bosnia-Herzegovina: First 'Book of Belongings' for the Republika Srpska," January 31, 2002. https://www.icrc.org/en/doc/resources/documents/news-release/2009-and-earlier/57jrks.htm.

"Bosnia-Herzegovina: Srebrenica Victims – Photo Book Campaign Leads to Encouraging Results." International Committee of the Red Cross, August 9, 2001. https://www.icrc.org/en/doc/resources/documents/news-release/2009-and-earlier/57jr8g.htm.

Bošnjak, Vedran. "Memorijalni centar Potočari: Otvorena izložba 'Koracima onih koji (ni)su prešli.'" *Anadolu Agency*, 2012. https://www.aa.com.tr/ba/balkan/memorijalni-centar-potočari-otvorena-izložba-koracima-onih-koji-nisu-prešli/2369559.

Boss, Pauline. *Ambiguous Loss: Learning to Live with Unresolved Grief*. Cambridge, MA: Harvard University Press, 2000.

Bowlby, John. "The Making and Breaking of Affectional Bonds: I. Aetiology and Psychopathology in the Light of Attachment Theory." *British Journal of Psychiatry* 130, no. 3 (1977): 201–10. https://doi.org/10.1192/bjp.130.3.201.

Boyns, David, and Sarah Luery. "Negative Emotional Energy: A Theory of the 'Dark-Side' of Interaction Ritual Chains." *Social Sciences* 4 (2015): 148–70. https://doi.org/10.3390/socsci4010148.

Brcic, Eugene. "Excavators Remove Corpses from Large Bosnian Mass Grave." *AP News*, 1997. https://apnews.com/article/89754bbc181ec18f47d47033ddd5d093.

Brenner, C. H., and B. S. Weir. "Issues and Strategies in the DNA Identification of World Trade Center Victims." *Theoretical Population Biology* 63, no. 3 (2003): 173–78. https://doi.org/10.1016/S0040-5809(03)00008-X.

Brett, Sebastian, Louis Bickford, Liz Ševčenko, and Marcela Rios. *Memorialization and Democracy: State Policy and Civic Action*. New York: International Center for Transitional Justice, 2007.

Breward, Chris. "Fashioning Masculinity: Men's Footwear and Modernity." In *Shoes: A History From Sandals to Sneakers*, ed. Giorgio Riello and Peter McNeil, 206–23. Oxford: Berg, 2006.

Brownie, Barbara. *Acts of Undressing: Politics, Eroticism, and Discarded Clothing*. London: Bloomsbury, 2016.

Brubaker, Rogers, and Frederick Cooper. "Beyond 'Identity.'" *Theory and Society* 29, no. 1 (2000): 1–47.

Brydon, Anne. "Sensible Shoes." In *Consuming Fashion: Adorning the Transnational Body*, ed. Anne Brydon and Sandra Niessen, 1–17. Oxford: Berg, 1998.

Buckley-Zistel, Susanne, and Timothy Williams. "A 5* Destination: The Creation of New Transnational Moral Spaces of Remembrance on TripAdvisor." *International Journal of Politics, Culture, and Society* 35, no. 2 (2022): 221–38. https://doi.org/10.1007/s10767-020-09363-7.

Buda, Dorina Maria, Anne-Marie d'Hauteserre, and Lynda Johnston. "Feeling and Tourism Studies." *Annals of Tourism Research* 46 (2014): 102–14. https://doi.org/10.1016/j.annals.2014.03.005.

Butcher, Jim. *The Moralisation of Tourism: Sun, Sand . . . and Saving the World?* London: Routledge, 2002.

Butterfield, Fox. "'Silent March' on Guns Talks Loudly: 40,000 Pairs of Shoes, and All Empty." *New York Times*, September 21, 1994, https://www.nytimes.com/1994/09/21/us/silent-march-on-guns-talks-loudly-40000-pairs-of-shoes-and-all-empty.html.

Byford, Jovan. "When I Say 'The Holocaust,' I Mean 'Jasenovac': Remembrance of the Holocaust in Contemporary Serbia." *East European Jewish Affairs* 37, no. 1 (2007): 51–74. https://doi.org/10.1080/13501670701197946.

Calvan, Ciana Bobby. "9/11 Artifacts Share 'pieces of Truth' in Victims' Stories." *AP News*, September 8, 2021. https://apnews.com/article/lifestyle-travel-new-york-museums-2d1d1f9e9ed4ee3777012cba21dad602.

Campbell, Maeve. "Thousands of Kids' Shoes Appear in London Square as a Form of Protest." *Euro News*, May 19, 2020. https://www.euronews.com/green/2020/05/19/thousands-of-kids-shoes-appear-in-london-square-as-a-form-of-protest.

Carr, Gilly. "The Small Things of Life and Death: An Exploration of Value and Meaning in the Material Culture of Nazi Camps." *International Journal of Historical Archaeology* 22, no. 3 (2018): 531–52. https://doi.org/10.1007/s10761-017-0435-0.

Carrier, James G. *Gifts and Commodities: Exchange and Western Capitalism Since 1700*. Material Cultures: Interdisciplinary Studies in the Material Construction of Social Worlds. London: Routledge, 2012.

Carter, Roy E. "Murray Edelman. Politics as Symbolic Action: Mass Arousal and Quiescence. Pp. 188. Chicago, Ill.: Markham, 1971. (University of Wisconsin, Institute for Research on Poverty.) No Price. Paperbound." *Annals of the American Academy of Political and Social Science* 406, no. 1 (1973): 236–37. https://doi.org /10.1177/000271627340600170.

Causevic, Senija, and Paul Lynch. "Phoenix Tourism: Post-conflict Tourism Role." *Annals of Tourism Research* 38, no. 3 (2011): 780–800. https://doi.org/10.1016/j.annals .2010.12.004.

Cerkez, Aida, and Amel Emric. "Srebrenica Women Tell Tale of Loss Through Objects of Memory." *AP News*, July 9, 2015. https://apnews.com/article/f46c3715e17540 3a964bf1147f1b9daa.

Cerulo, Karen A. "Mining the Intersections of Cognitive Sociology and Neuroscience." In "Brain, Mind and Cultural Sociology," ed. Karen A. Cerulo. Special issue, *Poetics* 38, no. 2 (2010): 115–32. https://doi.org/10.1016/j.poetic.2009.11.005.

Chaklin, Martha. "Purity, Pollution and Place in Traditional Japanese Footwear." In *Shoes: A History from Sandals to Sneakers*, ed. Giorgio Riello and Peter McNeil, 160–82. Oxford: Berg, 2011.

Cheal, Felicity, and Tony Griffin. "Pilgrims and Patriots: Australian Tourist Experiences at Gallipoli." *International Journal of Culture, Tourism and Hospitality Research* 7, no. 3 (2013): 227–41. https://doi.org/10.1108/IJCTHR-05-2012 -0040.

Cohen, Erik H. "Educational Dark Tourism at an *In Populo* Site: The Holocaust Museum in Jerusalem." *Annals of Tourism Research* 38, no. 1 (2011): 193–209. https://doi.org/10.1016/j.annals.2010.08.003.

Cole, Tim. *Selling the Holocaust: From Auschwitz to Schindler; How History Is Bought, Packaged and Sold*. New York: Routledge, 1999.

"The Collection." National September 11 Memorial & Museum. https://www .911memorial.org/visit/museum/collection.

Collins, Randall. "Emotional Energy as the Common Denominator of Rational Action." *Rationality and Society* 5, no. 2 (1993): 203–30. https://doi.org/10.1177 /1043463193005002005.

———. *Explosive Conflict: Time-Dynamics of Violence*. New York: Routledge, 2022.

———. *Interaction Ritual Chains*. Princeton, NJ: Princeton University Press, 2005.

———. "Social Movements and the Focus of Emotional Attention." In *Passionate Politics: Emotions and Social Movements*, ed. Jeff Goodwin, James M. Jasper, and Francesca Polletta, 27–44. Chicago: University of Chicago Press, 2001.

———. *Violence: A Micro-sociological Theory*. Princeton, NJ: Princeton University Press, 2009.

Condé, Anne-Marie. "Capturing the Records of War." *Australian Historical Studies* 36, no. 125 (2005): 134–52. https://doi.org/10.1080/10314610508682915.

Cooke, Simon. "Sebald's Ghosts: Traveling Among the Dead in the Rings of Saturn." *Journeys* 11, no. 1 (2010): 50–68. https://doi.org/10.3167/jys.2010.110103.

Coplan, Amy. "Catching Characters Emotions: Emotional Contagion Responses to Narrative Fiction Film." *Film Studies* 8, no. 1 (2006): 26–38. https://doi.org/10.7227/FS.8.5.

Cordner, Stephen, and Morris Tidball-Binz. "Humanitarian Forensic Action – Its Origins and Future." *Forensic Science International* 279 (2017): 65–71. https://doi.org/10.1016/j.forsciint.2017.08.011.

"Coronavirus: 'We Are at War' – Macron." *BBC News*, March 16, 2020. https://www.bbc.com/news/av/51917380.

Cotter, Jennifer. "New Materialism and the Labor Theory of Value." *Minnesota Review* 2016, no. 87 (2016): 171–81. https://doi.org/10.1215/00265667-3630928.

Cowan, Paula, and Henry Maitles. "'We Saw Inhumanity Close Up.' What Is Gained by School Students from Scotland Visiting Auschwitz?" *Journal of Curriculum Studies* 43, no. 2 (2011): 163–84. https://doi.org/10.1080/00220272.2010.542831.

Creigh-Tyte, Stephen W., and Sara Selwood. "Museums in the U.K.: Some Evidence on Scale and Activities." *Journal of Cultural Economics* 22, no. 2 (1998): 151–65. https://doi.org/10.1023/A:1007562103987.

Cruz, Joe, and Robert Gordon. "Simulation Theory." In *Encyclopedia of Cognitive Science*, ed. L. Nagel. Nature, 2002.

Csikszentmihalyi, Mihaly, and Eugene Halton. *The Meaning of Things: Domestic Symbols and the Self.* Cambridge: Cambridge University Press, 1981.

Dagger, Richard. "Ideological Communities and Conceptual Contests: The Case of Rights." *Journal of Political Ideologies* 4, no. 3 (1999): 397–402. https://doi.org/10.1080/13569319908420805.

Das, Santanu. "Reframing Life/War 'Writing': Objects, Letters and Songs of Indian Soldiers, 1914–1918." *Textual Practice* 29, no. 7 (2015): 1265–87. https://doi.org/10.1080/0950236X.2015.1095446.

Dastur, Françoise. *Death: An Essay on Finitude.* London: Athlone, 1996.

David, Lea. "Human Rights, Micro-solidarity and Moral Action: 'Face-to-Face' Encounters in the Israeli/Palestinian Context." *Thesis Eleven* 154, no. 1 (2019): 66–79. https://doi.org/10.1177/0725513619874928.

———. "Moral Remembrance and New Inequalities." *Global Perspectives* 1, no. 1 (2020): 11782. https://doi.org/10.1525/001c.11782.

———. *The Past Can't Heal Us: The Dangers of Mandating Memory in the Name of Human Rights.* Human Rights in History. Cambridge: Cambridge University Press, 2020.

David, Lea, and Siniša Malešević. "Ideology and Nation-States." In *The Routledge Handbook of Ideology and International Relations*, ed. Jonathan Leader Maynard and Mark L. Haas, 23–39. London: Routledge, 2022.

Davidson, Joyce, and Liz Bondi. "Spatialising Affect; Affecting Space: An Introduction." *Gender, Place & Culture* 11, no. 3 (2004): 373–74. https://doi.org/10.1080/0966369042000258686.

De Battista, Julieta. "Lacanian Concept of Desire in Analytic Clinic of Psychosis." *Frontiers in Psychology* 8 (2017). https://www.frontiersin.org/articles/10.3389/fpsyg.2017.00563.

Deasy, Kristin, and Dzenana Halimovic. "Srebrenica Survivors Feel Pain After Evidence Destroyed." *Radio Free Europe/Radio Liberty*, September 3, 2009. https://www.rferl.org/a/1814205.html.

DeKoven Ezrahi, Sidra. "Conversation in the Cemetery: Dan Pagis and the Prosaics of Memory." In *Holocaust Remembrance: The Shapes of Memory*, ed. Geoffrey Hartman, 121–34. Hoboken, NJ: Wiley, 1994.

DeMello, Margo. *Feet and Footwear: A Cultural Encyclopedia*. Santa Barbara, CA: Greenwood, 2009.

DiMaggio, Paul J., and Walter W. Powell. "The Iron Cage Revisited: Institutional Isomorphism and Collective Rationality in Organizational Fields." *American Sociological Review* 48, no. 2 (1983): 147–60. https://doi.org/10.2307/2095101.

Doleshal, Zachary Austin. *In the Kingdom of Shoes: Bata, Zlín, Globalization, 1894–1945*. Toronto: University of Toronto Press, 2021.

Douglas, Mary. *Purity and Danger: An Analysis of Concepts of Pollution and Taboo*. London: Routledge, 1966.

Dowell, Stuart. "Jewish Girl's Shoe Found at Site of WWII Ghetto Bunker." *First News*, 2022. https://www.thefirstnews.com/article/archeologists-unearth-jewish-girls-shoe-at-site-of-wwii-ghetto-bunker-31117.

Dresler, Emma, and Jochen Fuchs. "Constructing the Moral Geographies of Educational Dark Tourism." *Journal of Marketing Management* 37, nos. 5–6 (2021): 548–68. https://doi.org/10.1080/0267257X.2020.1846596.

Dudley, Sandra H. "Paku Karen Skirt-Cloths (Not) at Home: Forcibly Migrated Burmese Textiles in Refugee Camps and Museums." In *Objects of War: The Material Culture of Conflict and Displacement*, ed. Leora Auslander and Tara Zahra, 277–308. Ithaca, NY: Cornell University Press, 2018.

Duffy, Terence M. "Museums of 'Human Suffering' and the Struggle for Human Rights." *Museum International* 53, no. 1 (2001): 10–16. https://doi.org/10.1111/1468-0033.00292.

Duijzings, Ger. "Commemorating Srebrenica: Histories of Violence and the Politics of Memory in Eastern Bosnia." In *The New Bosnian Mosaic: Identities,*

Memories and Moral Claims in a Post-war Society, ed. Xavier Bougarel, Elissa Helms, and Ger Duijzings, 141–66. Aldershot: Ashgate, 2007.

Durkheim, Emile. *The Elementary Forms of the Religious Life*. Oxford: Oxford University Press, 1912 (2001).

Dziuban, Zuzanna. "Atopic Objects: The Afterlives of Gold Teeth Stolen from Holocaust Dead." *Journal of Material Culture* 25, no. 4 (2020): 408–27. https://doi.org/10.1177/1359183520954462.

———, ed. *Mapping the "Forensic Turn": Engagements with Materialities of Mass Death in Holocaust Studies and Beyond*. Vienna: New Academic, 2017.

Dziuban, Zuzanna, and Ewa Stańczyk. "Introduction: The Surviving Thing: Personal Objects in the Aftermath of Violence." *Journal of Material Culture* 25, no. 4 (2020): 381–90. https://doi.org/10.1177/1359183520954514.

Ebrey, Patricia Buckley. *The Cambridge Illustrated History of China*, 2nd ed. Cambridge: Cambridge University Press, 2010.

Edensor, Tim. "Reconnecting with Darkness: Gloomy Landscapes, Lightless Places." *Social & Cultural Geography* 14, no. 4 (2013): 446–65. https://doi.org/10.1080/14649365.2013.790992.

Eichner, Itamar. "Remains of 1,400 Jews Murdered in Holocaust Discovered in Mass Grave in Belarus." *Ynet News*, October 17, 2021. https://www.ynetnews.com/article/h1hw9athy.

Ekman, P., R. W. Levenson, and W. V. Friesen. "Autonomic Nervous System Activity Distinguishes Among Emotions." *Science* 221, no. 4616 (1983): 1208–10. https://doi.org/10.1126/science.6612338.

Elliott, Michael A. "The Institutionalization of Human Rights and Its Discontents: A World Cultural Perspective." *Cultural Sociology* 8, no. 4 (2014): 407–25. https://doi.org/10.1177/1749975514541099.

Ellsworth, Elizabeth. *Places of Learning: Media, Architecture, Pedagogy*. New York: Routledge, 2005.

Emberley, Julia. "The Ends of Fashion; or Learning to Theorise with Shoes in the Bata Shoe Museum." In *Footnotes: On Shoes*, ed. Shari Benstock and Suzanne Ferriss, 17–40. New Brunswick, NJ: Rutgers University Press, 2001.

England, Paula, and George Farkas. *Households, Employment, and Gender: A Social, Economic, and Demographic View*. New York: Routledge, 2017.

Epps, Philomena. "If the Shoe Fits: The Gendered Connotations of Footwear in Art History." Art UK, 2020. https://artuk.org/discover/stories/if-the-shoe-fits-the-gendered-connotations-of-footwear-in-art-history.

Erll, Astrid. "The Hidden Power of Implicit Collective Memory." In *Memory, Mind & Media*, ed. Andrew Hoskins and Amanda J. Barnier, e14. Cambridge: Cambridge University Press, 2022. https://doi.org/10.1017/mem.2022.7.

Falk, John H., and Lynn D. Dierking. *The Museum Experience.* London: EDS, 2011.
Fariss, Christopher J. "Respect for Human Rights Has Improved Over Time: Modeling the Changing Standard of Accountability." *American Political Science Review* 108, no. 2 (2014): 297–318.
Farmaki, Anna. "Dark Tourism Revisited: A Supply/Demand Conceptualisation." *International Journal of Culture, Tourism and Hospitality Research* 7, no. 3 (2013): 281–92. https://doi.org/10.1108/IJCTHR-05-2012-0030.
Fast, J. D. "After Columbine: How People Mourn Sudden Death." *Social Work* 48, no. 4 (2003): 484–91. https://doi.org/10.1093/sw/48.4.484.
Feigenbaum, Anna. "Moving Protests: The Stories Objects Can Tell." *Designabilities* (blog), November 1, 2018. https://designabilities.wordpress.com/2018/11/01/moving-protests-the-stories-objects-can-tell/.
Fernandez Munos, Ariana, and Derek Congram. "The Evidentiary Value of Cultural Objects from Mass Graves: Methods of Analysis, Interpretation, and Limitations." In *Missing Persons: Multidisciplinary Perspective on the Disappeared*, ed. Derek Congram, 269–87. Toronto: Canadian Scholars', 2016.
Fernández-Álvarez, José-Paulino, David Rubio-Melendi, Antxoka Martínez-Velasco, Jamie K. Pringle, and Hector-David Aguilera. "Discovery of a Mass Grave from the Spanish Civil War Using Ground Penetrating Radar and Forensic Archaeology." *Forensic Science International* 267 (2016): e10–17. https://doi.org/10.1016/j.forsciint.2016.05.040.
Ferrandiz, Francisco. "Exhuming the Defeated: Civil War Mass Graves in 21st-Century Spain." *American Ethnologist* 40, no. 1 (2013): 38–54.
Fondebrinder, Luis. "Uncovering the Evidence: The Forensic Sciences in Human Rights." *New Tactics in Human Rights*, 2004. https://www.newtactics.org/resource/uncovering-evidence-forensic-sciences-human-rights.
"Foot Talk: When a Shoe Is Not a Shoe: Empty Shoe Protests." *Foot Talk* (blog), September 11, 2021. http://foottalk.blogspot.com/2005/06/when-shoe-is-not-shoe.html.
"Footwear Production Worldwide 2021." Statista, 2021. https://www.statista.com/statistics/1044823/global-footwear-production-quantity/.
Foss, Karen A., and Kathy L. Domenici. "Haunting Argentina: Synecdoche in the Protests of the Mothers of the Plaza de Mayo." *Quarterly Journal of Speech* 87, no. 3 (2001): 237–58. https://doi.org/10.1080/00335630109384335.
Fox, N. J., and P. Alldred. "Sociology, Environment and Health: A Materialist Approach." *Public Health* 141 (2016): 287–93. https://doi.org/10.1016/j.puhe.2016.09.015.
Freeden, Michael. "Assembling: From Concepts to Ideologies." In *Ideologies and Political Theory: A Conceptual Approach*, ed. Michael Freeden. Oxford: Oxford University Press, 1998.

———, ed. *Ideologies and Political Theory: A Conceptual Approach*, reprint ed. Oxford: Clarendon, 2008.

Gabriel, Allison, Michael Daniels, James Diefendorff, and Gary Greguras. "Emotional Labor Actors: A Latent Profile Analysis of Emotional Labor Strategies." *Journal of Applied Psychology* 100, no. 3 (2015): 863–79. https://doi.org/10.1037/a0037408.

Gadsby, J. "The Effect of Encouraging Emotional Value in Museum Experiences." Conference paper, 2011.

Gahongayire, Liberata, and Anne Marie Nyiracumi. "Breaking Silence: Documenting Individual Experiences Based on Visitors' Book of Kigali Genocide Memorial Centre, Rwanda." *International Journal of Innovation and Applied Studies* 7, no. 4 (2014): 1444–57.

Gamble, Christopher N., Joshua S. Hanan, and Thomas Nail. "What Is New Materialism?" *Angelaki* 24, no. 6 (2019): 111–34. https://doi.org/10.1080/0969725X.2019.1684704.

Gamson, William A. *Talking Politics*. Cambridge: Cambridge University Press, 1992.

Gasana, Fiona. "Gisozi Memorial Site: Voices of the Past Immortalised." IGIHE, April 25, 2011. https://en.igihe.com/arts-culture/gisozi-memorial-site-voices-of-the-past.

Gassiot Ballbé, Ermengol, and Dawnie Wolfe Steadman. "The Political, Social and Scientific Contexts of Archaeological Investigations of Mass Graves in Spain." *Archaeologies* 4, no. 3 (2008): 429–44. https://doi.org/10.1007/s11759-008-9081-9.

Gibson, Margaret. "Melancholy Objects." *Mortality* 9, no. 4 (2004): 285–99. https://doi.org/10.1080/13576270412331329812.

Gibson, Shawn. "Barrie Police Investigating Theft of Shoes from Spirit Catcher Memorial." *Barrie Today*, June 11, 2021. https://www.barrietoday.com/police-beat/barrie-police-investigating-theft-of-shoes-from-spirit-catcher-memorial-3866178.

Gill, Graeme, and Luis F. Angosto-Ferrandez. "Introduction: Symbolism and Politics." *Politics, Religion & Ideology* 19, no. 4 (2018): 429–33. https://doi.org/10.1080/21567689.2018.1539436.

Godis, Nataliia, and Jan Henrik Nilsson. "Memory Tourism in a Contested Landscape: Exploring Identity Discourses in Lviv, Ukraine." *Current Issues in Tourism* 21, no. 15 (2018): 1690–1709. https://doi.org/10.1080/13683500.2016.1216529.

Goeldner, Charles R., and J. R. Brent Ritchie. *Tourism: Principles, Practices, Philosophies*, 12th ed. Hoboken, NJ: Wiley, 2012.

Goffman, Erving. *Relations in Public: Microstudies of the Public Order*. New Brunswick, NJ: Transaction, 1971.

Goldberg, Amos, and Haim Hazan, eds. *Marking Evil: Holocaust Memory in the Global Age*. Making Sense of History, vol. 21. New York: Berghahn, 2015.

Goldberg, Wendy A., K. Alison Clarke-Stewart, John A. Rice, and Ellen Dellis. "Emotional Energy as an Explanatory Construct for Fathers' Engagement with Their Infants." *Parenting* 2, no. 4 (2002): 379–408. https://doi.org/10.1207/S15327922PAR0204_03.

"Golden Gate Bridge Turns 75." UPI, May 27, 2012. https://www.upi.com/News_Photos/view/upi/12cb2d3f355409a7584f3fc6c6ae55a5/Golden-Gate-Bridge-turns-75/.

Golding, Viv. "Collaborative Museums: Curators, Communities, Collections." In *Museums and Communities: Curators, Collections and Collaboration*, ed. Viv Golding and Wayne Modest, chap. 1. London: Bloomsbury, 2013.

Gomez, Raquel. "Walk a Mile in Some Victim's Shoes to Build a Shared Future." *Shared Future News*, March 16, 2018. https://sharedfuture.news/walk-a-mile-in-some-victims-shoes-to-build-a-shared-future/.

Goodwin, Jeff, James M. Jasper, and Francesca Polletta, eds. *Passionate Politics: Emotions and Social Movements*. Chicago: University of Chicago Press, 2001.

Gosden, Chris. "Making Sense: Archaeology and Aesthetics." *World Archaeology* 33, no. 2 (2001): 163–67.

Gosden, Chris, and Yvonne Marshall. "The Cultural Biography of Objects." *World Archaeology* 31, no. 2 (1999): 169–78.

Grebo, Lamija. "Cipele 'Mrtvare': Otisak Vremena i Svjedočenje o Srebrenici." *Detektor*, 2021. https://detektor.ba/2021/06/22/cipele-mrtvare-otisak-vremena-i-svjedocenje-o-srebrenici/.

Gregory, Adrian. *The Silence of Memory: Armistice Day, 1919–1946*. The Legacy of the Great War, ed. Jay Winter. Oxford: Berg, 1994.

Griffin, Des, and Morris Abraham. "The Effective Management of Museums: Cohesive Leadership and Visitor-Focused Public Programming." *Museum Management and Curatorship* 18, no. 4 (2000): 335–68. https://doi.org/10.1080/09647770000301804.

Grossman, Ron. "Woman Seeks Return of Paintings She Did at Auschwitz." *Washington Post*, October 29, 2006. https://www.washingtonpost.com/archive/politics/2006/10/29/woman-seeks-return-of-paintings-she-did-at-auschwitz/e267a564-a22a-4fa8-8de2-1e3185c6521c/.

"Guatemala: Belongings Provide Answers to Families of the Missing." International Committee of the Red Cross, 2017. https://www.icrc.org/en/document/guatemala-belongings-provide-answers-families-missing.

Guthrie, Amy. "Children's Remains Found in Mexican Mass Graves." *Seattle Times*, September 23, 2018. https://www.seattletimes.com/nation-world/childrens-remains-found-in-mexican-mass-grave/.

Haentjens, Ann M. E. "Ritual Shoes in Early Greek Female Graves." *L'Antiquité Classique* 71 (2002): 171–84.

Haglund, William D. "Archaeology and Forensic Death Investigations." *Historical Archaeology* 35, no. 1 (2001): 26–34.

Hagman, George. "Beyond Decathexis: Toward a New Psychoanalytic Understanding and Treatment of Mourning." In *Meaning Reconstruction and the Experience of Loss*, ed. Robert A. Neimeyer, 13–31. Washington, DC: American Psychological Association, 2001.

Haidari, Niloufar. "From Yasser Arafat to Madonna: How the Palestinian Keffiyeh Became a Global Symbol." *Guardian*, December 11, 2023, https://www.theguardian.com/world/2023/dec/11/keffiyeh-scarf-fashion-history-palestine.

Hallam, Elizabeth, and Jenny Hockey. *Death, Memory, and Material Culture*. Materializing Culture. Oxford: Berg, 2001.

Hartmann, Rudi. "Dark Tourism, Thanatourism, and Dissonance in Heritage Tourism Management: New Directions in Contemporary Tourism Research." *Journal of Heritage Tourism* 9, no. 2 (2014): 166–82. https://doi.org/10.1080/1743873X.2013.807266.

Hass, Kristin Ann. *Carried to the Wall: American Memory and the Vietnam Veterans Memorial*. Berkeley: University of California Press, 1998.

Hassan, Jennifer. "Hundreds of Tiny Shoes: Protest Spotlights Child Death Toll in Ukraine's Mariupol." *Washington Post*, April 10, 2022. https://www.washingtonpost.com/world/2022/04/10/mariupol-child-death-toll-helsinki-protest-ukraine-war/.

Hatfield, Elaine, John T. Cacioppo, and Richard L. Rapson. "Emotional Contagion." *Current Directions in Psychological Science* 2, no. 3 (1993): 96–99.

Henderson, Susan. "Clogs, Boots and Shoes Built to the Sky." In *Identities and Citizenship Education: Controversy, Crisis and Challenges; Program and Abstract Book*, ed. Peter Cunningham, 678–89. 15th Annual CiCe Network Conference, Lisbon. London: London Metropolitan University, Institute for Policy Studies in Education, 2013.

Hershatter, Gail. *Women and China's Revolutions*. Lanham, MD: Rowman & Littlefield, 2018.

Herva, Vesa-Pekka, Eerika Koskinen-Koivisto, Oula Seitsonen, and Suzie Thomas. "'I Have Better Stuff at Home': Treasure Hunting and Private Collecting of World War II Artefacts in Finnish Lapland." *World Archaeology* 48, no. 2 (2016): 267–81. https://doi.org/10.1080/00438243.2016.1184586.

Higgins, Andrew. "Belarus Building Site Yields the Bones of 1,214 Holocaust Victims." *New York Times*, April 27, 2019. https://www.nytimes.com/2019/04/27/world/europe/belarus-holocaust-mass-grave.html.

Hirsch, Marianne, and Leo Spitzer. "What's Wrong with This Picture?" *Journal of Modern Jewish Studies* 5, no. 2 (2006): 229–52. https://doi.org/10.1080/14725880600741615.

Hochschild, Arlie. *The Second Shift: Working Families and the Revolution at Home*, revised ed. New York: Penguin, 2012.

Hochschild, Arlie Russell. "Emotion Work, Feeling Rules, and Social Structure." *American Journal of Sociology* 85, no. 3 (1979): 551–75.

———. *The Managed Heart: Commercialization of Human Feeling*, 3rd ed. Berkeley: University of California Press, 2012.

Hodgkinson, Sarah. "The Concentration Camp as a Site of 'Dark Tourism.'" *Témoigner entre histoire et mémoire* 113 (2013): 22–32. https://doi.org/10.4000/temoigner.272.

Hopgood, Stephen. *The Endtimes of Human Rights*. Ithaca, NY: Cornell University Press, 2015.

Horne, Donald. *The Great Museum: The Representation of History*. London: Pluto, 1984.

Horne, Madison. "9/11 Lost and Found: The Items Left Behind." National September 11 Memorial & Museum, last updated September 7, 2023. https://www.history.com/.amp/news/9-11-artifacts-ground-zero-photos.

Horsthuis, Jorie. "Evidence of Atrocities: Fragments of the Bosnian War." *Politico*, March 20, 2019. https://www.politico.eu/interactive/evidence-of-atrocities-fragments-of-the-bosnian-war/.

Hoskins, Janet. *Biographical Objects: How Things Tell the Stories of People's Lives*. New York: Routledge, 1998.

Hughes, Michael. *The Anarchy of Nazi Memorabilia: From Things of Tyranny to Troubled Treasure*. London: Routledge, 2022.

Hughes, Rachel. "Dutiful Tourism: Encountering the Cambodian Genocide." *Asia Pacific Viewpoint* 49, no. 3 (2008): 318–30. https://doi.org/10.1111/j.1467-8373.2008.00380.x.

Hutchinson, John. "Warfare and the Sacralisation of Nations: The Meanings, Rituals and Politics of National Remembrance." *Millennium: Journal of International Studies* 38, no. 2 (2009): 401–17. https://doi.org/10.1177/0305829809347538.

"ICRC Central Tracing Agency: Half a Century of Restoring Family Links." International Committee of the Red Cross, April 7, 2010. https://www.icrc.org/en/doc/resources/documents/interview/centra-tracing-agency-interview-070410.htm.

Ignatow, Gabriel. "Speaking Together, Thinking Together? Exploring Metaphor and Cognition in a Shipyard Union Dispute." *Sociological Forum* 19, no. 3 (2004): 405–33. https://doi.org/10.1023/B:SOFO.0000042555.15713.4d.

"International Katyn Commission Findings." Transcript. Smolensk, April 30, 1943.

Israfilova, F., and C. Khoo. "Sad and Violent but I Enjoy It: Children's Engagement with Dark Tourism as an Educational Tool." *Tourism and Hospitality Research* 19, no. 4 (2019): 478–87. https://doi.org/10.1177/1467358418782736.

Iturriaga, Nicole. "How Forensic Science Can Aid the Human Rights Movement." Aeon, 2021. https://aeon.co/essays/how-forensic-science-can-aid-the-human-rights-movement.

Ivry, Tsipy, and Elly Teman. "Shouldering Moral Responsibility: The Division of Moral Labor Among Pregnant Women, Rabbis, and Doctors." *American Anthropologist* 121, no. 4 (2019): 857–69. https://doi.org/10.1111/aman.13314.

Jackson, Beverley. *Splendid Slippers: A Thousand Years of an Erotic Tradition*. Berkeley, CA: Ten Speed, 1998.

Jaeger, Stephan. "Visitor Emotions, Experientiality, Holocaust, and Human Rights: TripAdvisor Responses to the Topography of Terror (Berlin) and the Kazerne Dossin (Mechelen)." In *Visitor Experience at Holocaust Memorials and Museums*, ed. Diana I. Popescu, 31–45. London: Routledge, 2023.

"Japanese Youth Demand Action on Global Warming in 'Shoe Protest' Outside Diet." *Mainichi Daily News*, September 26, 2020. https://mainichi.jp/english/articles/20200926/p2a/00m/0na/008000c.

Jarvis, Helen. "Powerful Remains: The Continuing Presence of Victims of the Khmer Rouge Regime in Today's Cambodia." *Human Remains and Violence: An Interdisciplinary Journal* 1, no. 2 (2015): 36–55. https://doi.org/10.7227/HRV.1.2.5.

Jasper, James M. *The Emotions of Protest*. Chicago: University of Chicago Press, 2018.

———. "The Emotions of Protest: Affective and Reactive Emotions in and Around Social Movements." *Sociological Forum* 13, no. 3 (1998): 397–424.

Jasper, James M., and Jane D. Poulsen. "Recruiting Strangers and Friends: Moral Shocks and Social Networks in Animal Rights and Anti-nuclear Protests." *Social Problems* 42, no. 4 (1995): 493–512. https://doi.org/10.2307/3097043.

Johnson, Kim K. P., and Sharron J. Lennon, eds. *Appearance and Power*. New York: Bloomsbury Academic, 1999.

Johnson, Nels. "Palestinian Refugee Ideology: An Enquiry Into Key Metaphors." *Journal of Anthropological Research* 34, no. 4 (1978): 524–39.

Johnson, Peter, and Thomas Barry. "The Economics of Museums: A Research Perspective." *Journal of Cultural Economics* 22, nos. 2–3 (1998): 75–85.

Jones, Ellen Carol. "Empty Shoes." In *Footnotes: On Shoes*, ed. Shari Benstock and Suzzane Ferriss, 197–232. New Brunswick, NJ: Rutgers University Press, 2001.

Jugo, Admir. "Artefacts and Personal Effects from Mass Graves in Bosnia and Herzegovina: Symbols of Persons, Forensic Evidence or Public Relics?" *Cahiers Sirice* 19, no. 2 (2017): 21. https://doi.org/10.3917/lcsi.019.0021.

Jugo, Admir, and Sari Wastell. "Disassembling the Pieces, Reassembling the Social: The Forensic and Political Lives of Secondary Mass Graves in Bosnia and

Herzegovina." In *Human Remains and Identification: Mass Violence, Genocide, and the "Forensic Turn,"* ed. Élisabeth Anstett and Jean-Marc Dreyfus, 142–74. Manchester: Manchester University Press, 2015.

Juhl, Kirsten. *The Contribution by (Forensic) Archaeologists to Human Rights Investigations of Mass Graves*. Stavanger: Arkeologisk museum i Stavanger, 2005.

Kaiser, Susan B., Howard G. Schutz, and Joan L. Chandler. "Cultural Codes and Sex-Role Ideology: A Study of Shoes." *American Journal of Semiotics* 5, no. 1 (1987): 13–33.

Kang, Eun-Jung, Noel Scott, Timothy Lee, and Roy Ballantyne. "Benefits of Visiting a 'Dark Tourism' Site: The Case of the Jeju April 3rd Peace Park, Korea." *Tourism Management* 33 (2012). https://doi.org/10.1016/j.tourman.2011.03.004.

Karčić, Hikmet. "Uncovering the Truth: The Lake Perućac Exhumations in Eastern Bosnia." *Journal of Muslim Minority Affairs* 37, no. 1 (2017): 114–28. https://doi.org/10.1080/13602004.2017.1294374.

Kay, Nikki. "Families in Corona-Norco Unified School District Use Shoes to Protest Potential Vaccine Mandate." *Spectrum News*, November 16, 2021. https://spectrumnews1.com/ca/la-east/education/2021/11/16/families-in-corona-norco-school-district-protest-potential-vaccine-mandate.

Kennedy, Rosanne, and Sulamith Graefenstein. "From the Transnational to the Intimate: Multidirectional Memory, the Holocaust and Colonial Violence in Australia and Beyond." *International Journal of Politics, Culture, and Society* 32, no. 4 (2019): 403–22. https://doi.org/10.1007/s10767-019-09329-4.

Kidron, Carol. "Being There Together: Dark Family Tourism and the Emotive Experience of Co-presence in the Holocaust Past." *Annals of Tourism Research* 41 (2013): 175–94. https://doi.org/10.1016/j.annals.2012.12.009.

King, Alex. *Memorials of the Great War in Britain: The Symbolism and Politics of Remembrance*. The Legacy of the Great War, ed. Jay Winter. Oxford: Berg, 1998.

Klinger, David. *Into the Kill Zone: A Cop's Eye View of Deadly Force*. San Francisco: Wiley, 2013.

Knappett, Carl. "Photographs, Skeuomorphs and Marionettes: Some Thoughts on Mind, Agency and Object." *Journal of Material Culture* 7, no. 1 (2002): 97–117. https://doi.org/10.1177/1359183502007001307.

Knappett, Carl, and Lambros Malafouris. *Material Agency: Towards a Non-anthropocentric Approach*. Berlin: Springer, 2008.

Knecht, Lyndsay. "A Dallas Theater Company Needs Your Shoes to Honor Victims of Gun Violence." Cry Havoc Theater Company, November 8, 2018. https://www.cryhavoctheater.org/important-articles/2018/11/8/a-dallas-theater-company-needs-your-shoes-to-honor-victims-of-gun-violence.

Knudsen, Britta. "Thanatourism: Witnessing Difficult Pasts." *Tourist Studies* 11 (2011): 55–72. https://doi.org/10.1177/1468797611412064.

Ko, Dorothy. *Every Step a Lotus: Shoes for Bound Feet*. Berkeley: University of California Press, 2002.

Komter, Aafke. "Heirlooms, Nikes and Bribes: Towards a Sociology of Things." *Sociology* 35, no. 1 (2001): 59–75.

Korman, Remi. "Bury or Display? The Politics of Exhumation in Post-genocide Rwanda." In *Human Remains and Identification: Mass Violence, Genocide, and the "Forensic Turn,"* ed. Élisabeth Anstett and Jean-Marc Dreyfus, 203–20. Manchester: Manchester University Press, 2015.

Kucia, Marek. "The Europeanization of Holocaust Memory and Eastern Europe." *East European Politics and Societies* 30, no. 1 (2016): 97–119. https://doi.org/10.1177/0888325415599195.

Landman, Todd. "Measuring Human Rights: Principle, Practice, and Policy." *Human Rights Quarterly* 26, no. 4 (2004): 906–31.

Langer, Lawrence L. *Holocaust Testimonies: The Ruins of Memory*. New Haven, CT: Yale University Press, 1993.

Latour, Bruno. *We Have Never Been Modern*. Cambridge, MA: Harvard University Press, 1993.

Latour, Bruno, and Peter Weibel, eds. *Making Things Public: Atmospheres of Democracy*. Cambridge, MA: MIT Press, 2005.

Laver, James. *A Concise History of Costume*. London: Thames & Hudson, 1969.

Lazzeretti, Cecilia. *The Language of Museum Communication: A Diachronic Perspective*. London: Palgrave Macmillan, 2016.

Le, Kelly L. "Cu Chi Tunnels: Vietnamese Transmigrant's Perspective." *Annals of Tourism Research* 46 (2014): 75–88. https://doi.org/10.1016/j.annals.2014.02.007.

Leidner, Robin. "Emotional Labor in Service Work." *Annals of the American Academy of Political and Social Science* 561, no. 1 (1999): 81–95. https://doi.org/10.1177/000271629956100106.

Lennon, J. John, and Malcolm Foley. *Dark Tourism: The Attraction of Death and Disaster*. New York: Cengage, 2001.

Levenson, R. W. "Human Emotions: A Functional View." In *The Nature of Emotion: Fundamental Questions*, ed. P. Ekman and R. J. Davidson, 123–26. New York: Oxford University Press, 1994.

Levy, Daniel, and Natan Sznaider. "Memory Unbound: The Holocaust and the Formation of Cosmopolitan Memory." *European Journal of Social Theory* 5, no. 1 (2002): 87–106. https://doi.org/10.1177/1368431002005001002.

Lewis, Geoffrey. *For Instruction and Recreation: Centenary History of the Museums' Associations*. London: Quiller, 1989.

Lim, Nangyeon. "Cultural Differences in Emotion: Differences in Emotional Arousal Level Between the East and the West." *Integrative Medicine Research* 5, no. 2 (2016): 105–9. https://doi.org/10.1016/j.imr.2016.03.004.

Lindemann, Erich. "Symptomalology and Management of Acute Grief." *American Journal of Psychiatry* 101 (1944): 144–48.

Linden, Harry van der. "From Combat Boots to Civilian Shoes: Reflections on the Chickenhawk Syndrome." *Radical Philosophy Review* 13, no. 2 (2010): 173–80. https://doi.org/10.5840/radphilrev201013219.

Linenthal, Edward. *Preserving Memory: The Struggle to Create America's Holocaust Museum*. New York: Columbia University Press, 2001.

Lioy, Daniel, ed. *International Bible Lesson Commentary 2008–2009: The New Standard in Biblical Exposition Based on the International Sunday School Lessons (ISSL)*. Colorado Springs, CO: David C. Cook, 2008.

Luckins, Tanja. "Collecting Women's Memories: The Australian War Memorial, the Next of Kin and Great War Soldiers' Diaries and Letters as Objects of Memory in the 1920s and 1930s." *Women's History Review* 19, no. 1 (2010): 21–37. https://doi.org/10.1080/09612020903444635.

Luker, Kristin. *Abortion and the Politics of Motherhood*. Berkeley: University of California Press, 1985.

MacGregor, Lisa. "Hundreds of 'Empty Shoes' a Reminder of Those Killed by Drunk Drivers." *Global News*, September 20, 2014. https://globalnews.ca/news/1574436/empty-shoes-in-tomkins-park-represent-those-killed-by-drunk-drivers/.

MacLennan, Ian. "Powerful Memorial at the Spirit Catcher in Barrie for the 215 Children of Former B.C. Residential School." *Barrie 360*, May 31, 2021. https://barrie360.com/powerful-memorial-at-the-spirit-catcher-in-barrie-for-the-215-children-of-former-b-c-residential-school/.

Major, Laura. "Unearthing, Untangling and Re-Articulating Genocide Corpses in Rwanda." *Critical African Studies* 7, no. 2 (2015): 164–81. https://doi.org/10.1080/21681392.2015.1028206.

Malešević, Siniša. "The Act of Killing: Understanding the Emotional Dynamics of Violence on the Battlefield." *Critical Military Studies* 7, no. 3 (2021): 313–34. https://doi.org/10.1080/23337486.2019.1673060.

———. *Grounded Nationalisms: A Sociological Analysis*. Cambridge: Cambridge University Press, 2019.

———. *Identity as Ideology: Understanding Ethnicity and Nationalism*. New York: Palgrave Macmillan, 2006.

———. "Is Nationalism Intrinsically Violent?" *Nationalism and Ethnic Politics* 19, no. 1 (2013): 12–37. https://doi.org/10.1080/13537113.2013.761894.

Malinowski, Bronislaw. *Argonauts of the Western Pacific: An Account of Native Enterprise and Adventure in the Archipelagoes of Melanesian New Guinea; [Robert Mond Expedition to New Guinea, 1914–1918]*. London: Routledge, 1922.

Margalit, Avishai. *The Ethics of Memory*. Cambridge, MA: Harvard University Press, 2004.

Marshall, Tom. "Sea of Empty Shoes Left in Whitehall as Part of Global ME Protest." *Evening Standard*, May 25, 2016. https://www.standard.co.uk/news/london/millionsmissing-sea-of-empty-shoes-left-outside-department-of-health-in-global-me-protest-a3256756.html.

Martens, J. D. "The Life Jacket Graveyard." *Intrepid Times*, August 26, 2019. https://intrepidtimes.com/2019/08/the-life-jacket-graveyard/.

Martini, Annaclaudia, and Dorina Maria Buda. "Dark Tourism and Affect: Framing Places of Death and Disaster." *Current Issues in Tourism* 23, no. 6 (2020): 679–92. https://doi.org/10.1080/13683500.2018.1518972.

Martinovic, Iva. "Serbs Honor Srebrenica Victims with Shoe Memorial." *Radio Free Europe/Radio Liberty*, July 10, 2010. https://www.rferl.org/a/Serbs_Honor_Srebrenica_Victims_With_Shoe_Memorial/2096026.html.

Mauss, Marcel. *The Gift: The Form and Reason for Exchange in Archaic Societies*. Reprint of 1954 English edition. London: Cohen & West.

McPhail, Clark, and Ronald T. Wohlstein. "Individual and Collective Behaviors Within Gatherings, Demonstrations, and Riots." *Annual Review of Sociology* 9 (1983): 579–600.

Mehmedovic, Ahmo. "Keeping the Belongings of Genocide Victims Near Their Graves." *Balkan Diskurs*, February 21, 2022. https://balkandiskurs.com/en/2022/02/21/the-belongings-of-genocide-victims/.

"Memorial of Shoes Honoring Srebrenica Opens in Ankara." *Dünya*, July 9, 2012. https://www.dunya.com/gundem/memorial-of-shoes-honoring-srebrenica-opens-in-ankara-haberi-178948.

Merleau-Ponty, Maurice. *Phenomenology of Perception*. Trans. Donald Landes. London: Routledge, 2013.

Mettraux, Guénaël. "13 Genocide and International Criminal Tribunals." In *International Crimes and the Ad Hoc Tribunals*, ed. Guénaël Mettraux, 193–205. Oxford: Oxford University Press, 2006.

"Mexican Drug Cartels' Victims Tell Their Stories in Hanging Shoes Exhibition." *ABC News*, May 11, 2016. https://www.abc.net.au/news/2016-05-11/shoes-of-mexican-missing-people-hang-in-museum-exhibition/7404944.

Meyer, John W., John Boli, George M. Thomas, and Francisco O. Ramirez. "World Society and the Nation-State." *American Journal of Sociology* 103, no. 1 (1997): 144–81. https://doi.org/10.1086/231174.

Meyer, John W., and Brian Rowan. "Institutionalized Organizations: Formal Structure as Myth and Ceremony." *American Journal of Sociology* 83, no. 2 (1977): 340–63.

Mihara, Chie. "The History and Evolution of Shoes!" *Dolita* (blog), 2022. https://www.dolitashoes.com/blogs/news/the-history-and-evolution-of-shoes-blog.

Miles, William F. S. "Auschwitz: Museum Interpretation and Darker Tourism." *Annals of Tourism Research* 29, no. 4 (2002): 1175–78. https://doi.org/10.1016/S0160-7383(02)00054-3.

Milne, Catherine, and Tracey Otieno. "Understanding Engagement: Science Demonstrations and Emotional Energy." *Science Education* 91, no. 4 (2007): 523–53. https://doi.org/10.1002/sce.20203.

Mitchell, Charlotte. "Mass Grave Containing Bones, Clothes and Shoes of Nazi Massacre Victims Is Uncovered Near Belarus Village Where 1,000 Women, Children and Pensioners Were Slaughtered." *Daily Mail*, April 30, 2021. https://www.dailymail.co.uk/news/article-9530131/Mass-grave-containing-bones-clothes-shoes-Nazi-victims-uncovered-near-Belarus-village.html.

Monegal, Antonio. "Exhibiting Objects of Memory." *Journal of Spanish Cultural Studies* 9, no. 2 (2008): 239–51. https://doi.org/10.1080/14636200802283761.

Moon, Claire. "Extraordinary Deathwork: New Developments in, and the Social Significance of, Forensic Humanitarian Action." In *Forensic Science and Humanitarian Action: Interacting with the Dead and the Living*, ed. Roberto C. Parra, Sara C. Zapico, and Douglas H. Ubelaker, 37–48. Hoboken, NJ: Wiley, 2020.

———. "Human Rights, Human Remains: Forensic Humanitarianism and the Human Rights of the Dead." *International Social Science Journal* 65, nos. 215–216 (2014): 49–63. https://doi.org/10.1111/issj.12071.

Morris, J. Andrew, and Daniel C. Feldman. "The Dimensions, Antecedents, and Consequences of Emotional Labor." *Academy of Management Review* 21, no. 4 (1996): 986–1010. https://doi.org/10.2307/259161.

Moscardo, Gianna. "Exploring Social Representations of Tourism Planning: Issues for Governance." *Journal of Sustainable Tourism* 19, nos. 4–5 (2011): 423–36. https://doi.org/10.1080/09669582.2011.558625.

Moscovici, Serge. *Social Representations: Essays in Social Psychology*. New York: NYU Press, 1984.

Mosse, George L. *Fallen Soldiers: Reshaping the Memory of the World Wars*, reprint ed. New York: Oxford University Press, 1991.

Moyn, Samuel. *The Last Utopia: Human Rights in History*. Cambridge, MA: Belknap, 2012.

Mundorff, Amy Z., Eric J. Bartelink, and Elaine Mar-Cash. "DNA Preservation in Skeletal Elements from the World Trade Center Disaster: Recommendations for Mass Fatality Management." *Journal of Forensic Sciences* 54, no. 4 (2009): 739–45. https://doi.org/10.1111/j.1556-4029.2009.01045.x.

"Myanmar Junta Charges Celebrities with Promoting Protests." *AP News*, April 20, 2021. https://apnews.com/article/myanmar-junta-charge-celebrities-promoting-protests-50fcb59c57f041930eac17b793e3c369.

N1 Sarajevo. "Anniversary of Srebrenica Playground Massacre: 74 Pairs of Shoes for 74 Victims." *N1*, April 12, 2021. https://ba.n1info.com/english/news/anniversary-of-the-srebrenica-playground-massacre-74-shoes-for-74-victims/.

Naguib, Nefissa. "Storytelling: Armenian Family Albums in the Diaspora." *Visual Anthropology* 21, no. 3 (2008): 231–44. https://doi.org/10.1080/08949460801986228.

Nettelfield, Lara J., and Sarah E. Wagner. *Srebrenica in the Aftermath of Genocide*. New York: Cambridge University Press, 2013.

Ngai, Sianne. *Ugly Feelings*. Cambridge, MA: Harvard University Press, 2007.

Nittle, Nadra. "The Empty Shoes at the Capitol Have a Long, Grim History." *Racked*, March 14, 2018. https://www.racked.com/2018/3/14/17121658/empty-shoes-symbol-death-capitol-school-shootings.

Nizri, Osnat Shalev, and Carol A. Kidron. "Taking the Soldier Home: Sustaining the Domestic Presence of Absent Fallen Soldiers in Israel." *Memory Studies* 15, no. 5 (2022): 1232–47. https://doi.org/10.1177/17506980221094511.

Nora, Pierre. "Between Memory and History: Les Lieux de Mémoire." *Representations*, no. 26 (1989): 7–24. https://doi.org/10.2307/2928520.

Nuhanovic, Hasan. "Missing People, Missing Stories in the Aftermath of Genocide and 'Ethnic Cleansing' in Srebrenica and Prijedor." Master's thesis, RMIT University, 2022.

O'Kane, Caitlin. "164 Pairs of Shoes Placed on the Lawn of the Capitol, Representing Nurses Who Died from Coronavirus." *CBS News*, July 22, 2020. https://www.cbsnews.com/news/nurses-shoes-died-coronavirus-capitol-lawn-164-health-care-workers-pandemic/.

O'Keefe, Linda. *Shoes: A Celebration of Pumps, Sandals, Slippers and More*. New York: Workman, 1996.

"Od zataškavanja zločina do ukopavanja leševa u Batajnici." *Danas*, April 8, 2020. https://www.danas.rs/vesti/drustvo/suocavanje/od-zataskavanja-zlocina-do-ukopavanja-leseva-u-batajnici/.

Olsen, Kjell. "Authenticity as a Concept in Tourism Research: The Social Organization of the Experience of Authenticity." *Tourist Studies* 2, no. 2 (2002): 159–82. https://doi.org/10.1177/1468797902761936644.

Orange, Jennifer A., and Jennifer J. Carter. "'It's Time to Pause and Reflect': Museums and Human Rights." *Curator: The Museum Journal* 55, no. 3 (2012): 259–66. https://doi.org/10.1111/j.2151-6952.2012.00150.x.

Ortner, Sherry B. "On Key Symbols." *American Anthropologist* 75, no. 5 (1973): 1338–46.

Oster, Sharon B. "Holocaust Shoes: Metonymy, Matter, Memory." In *The Palgrave Handbook of Holocaust Literature and Culture*, ed. Victoria Aarons and Phyllis Lassner, 761–84. Cham: Springer, 2020.

Owens, Trevor. "Tripadvisor Rates Einstein: Using the Social Web to Unpack the Public Meanings of a Cultural Heritage Site." *International Journal of Web Based Communities* 8, no. 1 (2012): 40–56. https://doi.org/10.1504/IJWBC.2012.044681.

Pastor, Doreen. *Tourism and Memory: Visitor Experiences of the Nazi and GDR Past*. London: Routledge, 2021.

Pearce, Philip L., and Uk-Il Lee. "Developing the Travel Career Approach to Tourist Motivation." *Journal of Travel Research* 43, no. 3 (2005): 226–37. https://doi.org/10.1177/0047287504272020.

Peltier, Elian. "With Marches Banned, Shoes Carry a Message." *New York Times*, November 29, 2015. https://www.nytimes.com/interactive/projects/cp/climate/2015-paris-climate-talks.

"Pink Shoes Protests About Women in Church." *NZ Catholic*, October 28, 2022. https://nzcatholic.org.nz/?p=26121.

Podoshen, Jeffrey S. "Dark Tourism Motivations: Simulation, Emotional Contagion and Topographic Comparison." *Tourism Management* 35 (2013): 263–71. https://doi.org/10.1016/j.tourman.2012.08.002.

Podoshen, Jeffrey S., Vivek Venkatesh, Jason Wallin, Susan A. Andrzejewski, and Zheng Jin. "Dystopian Dark Tourism: An Exploratory Examination." *Tourism Management* 51 (2015): 316–28. https://doi.org/10.1016/j.tourman.2015.05.002.

Pond, Mimi. *Shoes Never Lie*. New York: Berkley, 1985.

Poria, Yaniv, Arie Reichel, and Avital Biran. "Heritage Site Management: Motivations and Expectations." *Annals of Tourism Research* 33, no. 1 (2006): 162–78. https://doi.org/10.1016/j.annals.2005.08.001.

Poturović, Midhat. "Srebrenica Victims' Personal Items Help Keep Memories Alive." *Radio Free Europe/Radio Liberty*, February 7, 2020. https://www.rferl.org/a/srebrenica-massacre-victims-personal-items-help-keep-memories-alive/30416483.html.

Preece, Tanaya, and Garry G. Price. "Motivations of Participants in Dark Tourism: A Case Study of Port Arthur, Tasmania, Australia." In *Taking Tourism to the Limits*, ed. Chris Ryan, Stephen J. Page, and Michelle Aicken, 191–98. Advances in Tourism Research. Oxford: Elsevier, 2005.

Primo, Levi. *Survival in Auschwitz: If This Is a Man*. New York: Simon and Schuster, 1958.

Probert, Christina. *Shoes in Vogue Since 1910*. London: Thames & Hudson, 1981.

"Protest for Ukraine: New Shoes Laid at Memorial of Jewish Victims." *Hungary Today*, March 28, 2022. https://hungarytoday.hu/ukrainian-war-protest-budapest-hungary-embassy-of-ukraine-shoes-on-the-danube-bank-genocide-zelenskyy-orban/.

"Protest with Shoes." Institute for Environmental Policy, August 5, 2020. https://iep-al.org/protest-with-shoes/.

Quatrehomme, Gérald, Unité Police d'Identification de Victimes de Catastrophes, Steve Toupenay, Tania Delabarde, Bernard Padovani, and Véronique Alunni. "Forensic Answers to the 14th of July 2016 Terrorist Attack in Nice." *International Journal of Legal Medicine* 133, no. 1 (2019): 277–87. https://doi.org/10.1007/s00414-018-1833-5.

Radley, Alan. "Artefacts, Memory and a Sense of the Past." In *Collective Remembering*, ed. David Middleton and Derek Edwards, 46–59. London: Sage, 1990.

Radonić, Ljiljana. "Post-Communist Invocation of Europe: Memorial Museums' Narratives and the Europeanization of Memory." *National Identities* 19, no. 2 (2017): 269–88. https://doi.org/10.1080/14608944.2016.1264377.

Radonić, Ljiljana. "Slovak and Croatian Invocation of Europe: The Museum of the Slovak National Uprising and the Jasenovac Memorial Museum." *Nationalities Papers* 42, no. 3 (2014): 489–507. https://doi.org/10.1080/00905992.2013.867935.

Rajner, Mirijam. "From the Shtetl to the Flowers of Auschwitz and Back: The Creation, Reception and Destiny of Zinovii Tolkatchev's Art." In *Images of Rupture Between East and West: The Perception of Auschwitz and Hiroshima in Eastern European Arts and Media*, ed. Urs Heftrich, Robert Jacobs, Bettina Kaibach, and Karoline Thaidigsmann, 155–85. Heidelberg: Universitätsverlag Winter, 2016.

Renfrew, Colin, and Ezra B. W. Zubrow, eds. *The Ancient Mind: Elements of Cognitive Archaeology*. Cambridge: Cambridge University Press, 1994.

Renfro, Evan. "Stitched Together, Torn Apart: The Keffiyeh as Cultural Guide." *International Journal of Cultural Studies* 21, no. 6 (2018): 571–86. https://doi.org/10.1177/1367877917713266.

Renshaw, Layla. *Exhuming Loss: Memory, Materiality and Mass Graves of the Spanish Civil War*. Critical Cultural Heritage Series. Walnut Creek, CA: Left Coast, 2011.

———. "Unrecovered Objects: Narratives of Dispossession, Slow Violence and Survival in the Investigation of Mass Graves from the Spanish Civil War." *Journal of Material Culture* 25, no. 4 (2020): 428–46. https://doi.org/10.1177/1359183520954499.

Reuters. "Paris Climate Protesters Banned but 10,000 Shoes Remain – Video." *Guardian*, November 29, 2015. http://www.theguardian.com/environment/video/2015/nov/29/paris-climate-protesters-banned-but-10000-shoes-remain-video.

Rhode, Deborah L. *The Beauty Bias: The Injustice of Appearance in Life and Law.* New York: Oxford University Press, 2010.

Riding, Alan. "The Fight Over a Suitcase and the Memories It Carries." *New York Times*, September 16, 2006. https://www.nytimes.com/2006/09/16/arts/design/16ridi.html.

Riello, Giorgio, and Peter McNeil, eds. *Shoes: A History from Sandals to Sneakers.* Oxford: Berg, 2011.

Ritzer, George. *The McDonaldization of Society*, 8th ed. Los Angeles: Sage, 1993 (2014).

Robben, Antonius C. G. M., ed. *Death, Mourning, and Burial: A Cross-Cultural Reader.* Malden, MA: Wiley-Blackwell, 2004.

Roepstorff, Andreas. "Things to Think With: Words and Objects as Material Symbols." *Philosophical Transactions of the Royal Society B: Biological Sciences* 363, no. 1499 (2008): 2049–54. https://doi.org/10.1098/rstb.2008.0015.

Rojas, Carmen de, and Carmen Camarero. "Visitors' Experience, Mood and Satisfaction in a Heritage Context: Evidence from an Interpretation Center." *Tourism Management* 29, no. 3 (2008): 525–37. https://doi.org/10.1016/j.tourman.2007.06.004.

Rojek, Chris. "Indexing, Dragging and the Social Construction of Tourist Sights." In *Touring Cultures: Transformation of Travel and History*, ed. Chris Rojek and John Urri, 52–74. New York: Routledge, 1997.

Rosengarten, Ruth. *Second Chance: My Life in Things.* Open Book, 2022.

Rossi, William A. *Sex Life of the Foot and Shoe.* Malabar, FL: Krieger, 1993.

Rothberg, Michael. *The Implicated Subject: Beyond Victims and Perpetrators.* Stanford, CA: Stanford University Press, 2019.

Rothman, Rozann. "Political Symbolism." In *The Handbook of Political Behavior*, vol. 2, ed. Samuel L. Long, 285–340. Boston: Springer, 1981.

Rousseau, Nicky. "Identification, Politics, Disciplines: Missing Persons and Colonial Skeletons in South Africa." In *Human Remains and Identification: Mass Violence, Genocide, and the "Forensic Turn,"* ed. Élisabeth Anstett and Jean-Marc Dreyfus, 175–202. Manchester: Manchester University Press, 2015.

Rubin, Jonah S. "Transitional Justice Against the State: Lessons from Spanish Civil Society-Led Forensic Exhumations." *International Journal of Transitional Justice* 8, no. 1 (2014): 99–120. https://doi.org/10.1093/ijtj/ijt033.

Ruiz, Rebecca. "Why 'Handmaid's Tale' Costumes Are the Most Powerful Meme of the Resistance Yet." *Mashable*, May 28, 2017. https://mashable.com/article/handmaids-tale-protests-costumes.

Russell, Benjamin. "Coventry Climate Change Protest Features 168 Pairs of Shoes." *BBC News*, August 2, 2020. https://www.bbc.com/news/uk-england-coventry-warwickshire-53628335.

Rousso, Henry. "History of Memory, Politics of the Past: What For?" In *Conflicted Memories: Europeanizing Contemporary Histories*, ed. Konrad Jarausch and Thomas Lindenberger, 23–36. Oxford: Berghahn, 2007.

Salmons, Paul. "A Blanket, a Letter, a Shoe: Searching for Meaning in Traces of the Holocaust." *Reform Judaism* (blog), May 1, 2019. https://reformjudaism.org/blog/blanket-letter-shoe-searching-meaning-traces-holocaust.

Sant Cassia, Paul. *Bodies of Evidence: Burial, Memory and the Recovery of Missing Persons in Cyprus*. New Directions in Anthropology, vol. 20. New York: Berghahn, 2007.

Santora, Marc, and Anna Lukinova. "On a Corpse's Wrist, an Emblem of Ukrainian Fortitude." *New York Times*, September 23, 2022. https://www.nytimes.com/2022/09/23/world/europe/ukraine-war-graves-bracelet.html.

Sassen, Robyn. "'Dark Choreography' of the Johannesburg Holocaust and Genocide Centre." *Performance Research* 25, no. 2 (2020): 87–94. https://doi.org/10.1080/13528165.2020.1752581.

Sather-Wagstaff, Joy. *Heritage That Hurts: Tourists in the Memoryscapes of September 11*. Walnut Creek, CA: Routledge, 2011.

Saunders, Nicholas J., and Paul Cornish, eds. *Contested Objects: Material Memories of the Great War*. London: Routledge, 2013.

Schlereth, Thomas J. "Collecting Ideas and Artifacts: Common Problems of History Museums and History Texts." *Roundtable Reports* (1978): 1–12.

Schneider, David M. *American Kinship: A Cultural Account*, 2nd ed. Chicago: University of Chicago Press, 1980.

Schuppli, Susan. *Material Witness: Media, Forensics, Evidence*. Cambridge, MA: MIT Press, 2020.

Sciscente, Mikayla. "The 9/11 Memorial Museum Is Home to the Shoes of Survivors." National September 11 Memorial & Museum. https://www.911memorial.org/connect/blog/911-memorial-museum-home-shoes-survivors#:~:text=To%20walk%20a%20mile%20in,three%20varied%20tales%20of%20survival.

Seaton, A. V. "Guided by the Dark: From Thanatopsis to Thanatourism." *International Journal of Heritage Studies* 2, no. 4 (1996): 234–44. https://doi.org/10.1080/13527259608722178.

Seaton, A. V., and J. J. Lennon. "Thanatourism in the Early 21st Century: Moral Panics, Ulterior Motives and Alterior Desires." *New Horizons in Tourism: Strange Experiences and Stranger Practices* (2004): 63–82. https://doi.org/10.1079/9780851998633.0063.

Senior, John. "The Rise of Museums." Open Learn, July 4, 2010. https://www.open.edu/openlearn/history-the-arts/history/the-rise-museums.

"Settlement Reached Over Auschwitz Suitcase." Auschwitz-Birkenau State Museum, June 4, 2009. http://auschwitz.org/en/museum/news/settlement-reached-over-auschwitz-suitcase,568.html.

Shaery-Yazdi, Roschanack. "Erasing Traces with DNA Tests: Syrian Military Security and Mass Grave Politics in Post-2005 Lebanon." *Anthropological Quarterly* 94, no. 1 (2021): 65–93.

Shanks, Michael. "Symmetrical Archaeology." *World Archaeology* 39, no. 4 (2007): 589–96. https://doi.org/10.1080/00438240701679676.

Sharp, Morgan. "Students Gather Shoes for Pickering Wetlands Protest." *Canada's National Observer*, February 25, 2021. https://www.nationalobserver.com/2021/02/25/news/students-gather-shoes-pickering-wetlands-protest.

Sharpley, Richard. "Chapter 1. Shedding Light on Dark Tourism: An Introduction." In *The Darker Side of Travel: The Theory and Practice of Dark Tourism*, ed. Richard Sharpley and Philip R. Stone, 3–22. Bristol: Channel View, 2009.

Sharpley, Richard, and Philip R. Stone. "Chapter 6. (Re)presenting the Macabre: Interpretation, Kitschification and Authenticity." In *The Darker Side of Travel: The Theory and Practice of Dark Tourism*, ed. Richard Sharpley and Philip R. Stone, 109–28. Bristol: Channel View, 2009. https://doi.org/10.21832/9781845411169-007.

Shendar, Yehudit. "Private Tolkatchev at the Gates of Hell." Yad Vashem Museum. https://www.yadvashem.org/yv/en/exhibitions/tolkatchev/about-exhibition.asp.

"'Shoes of the Dead' – Exhibition in Dresden Devoted to the Victims of the Holocaust." Majdanek State Museum, February 3, 2014. https://www.majdanek.eu/en/news/shoes_of_the_dead_____exhibition_in_dresden_devoted_to_the_victims_of_the/471.

"The 'Shoes' Protest Was About Something Not Happening in Bend. Is It a Frontload to a Bigger Fight?" *Source Weekly*, December 8, 2021. https://www.bendsource.com/bend/the-shoes-protest-was-about-something-not-happening-in-bend-is-it-a-frontload-to-a-bigger-fight/Content?oid=15872972.

"Shoes Replace Protesters as Swiss Climate Activists Obey Virus Curbs." *Reuters*, April 24, 2020. https://www.reuters.com/article/us-health-coronavirus-swiss-climatechang-idUSKCN226206.

Shughart, William F. "An Analytical History of Terrorism, 1945–2000." *Public Choice* 128 (2006): 7–39.

Sikkink, Kathryn. *Evidence for Hope: Making Human Rights Work in the 21st Century*. Human Rights and Crimes Against Humanity 28. Princeton, NJ: Princeton University Press, 2017.

"Silent Shoe Protest at Lack of Funding for ME." *ITV News*, September 27, 2016. https://www.itv.com/news/westcountry/2016-09-27/silent-shoe-protest-at-lack-of-funding-for-me.

Silver Ochayon, Sheryl. "The Shoes on the Danube Promenade—Commemoration of the Tragedy." Yad Vashem, 2014. https://www.yadvashem.org/articles/general/shoes-on-the-danube-promenade.html.

Simic, Olivera. "Memorial Culture in the Former Yugoslavia: Mothers of Srebrenica and the Destruction of Artefacts by the ICTY." In *The Arts of Transitional Justice: Culture, Activism, and Memory After Atrocity*. Springer Series in Transitional Justice, vol. 6, ed. Peter D. Rush and Olivera Simić, 155–72. New York: Springer, 2014.

Simmel, Georg. *The Philosophy of Money*, 2nd ed. Ed. David Frisby. New York: Routledge, 1990.

Sitch, Bryan. "Radical Objects: A Refugee's Life Jacket at Manchester Museum." History Workshop, December 7, 2017. https://www.historyworkshop.org.uk/radical-objects-a-refugees-life-jacket-at-manchester-museum/.

Skrozza, Tamara. "Tragovi prikrivene smrti." *Vreme*, July 9, 2003. https://www.vreme.com/vreme/tragovi-prikrivene-smrti/.

Smith, Michael R., Jennifer L. Rasmussen, Maura J. Mills, Andrew J. Wefald, and Ronald G. Downey. "Stress and Performance: Do Service Orientation and Emotional Energy Moderate the Relationship?" *Journal of Occupational Health Psychology* 17, no. 1 (2012): 116–28. https://doi.org/10.1037/a0026064.

Soar, Katy, and Paul-François Tremlett. "Protest Objects: Bricolage, Performance and Counter-archaeology." *World Archaeology* 49, no. 3 (2017): 423–34. https://doi.org/10.1080/00438243.2017.1350600.

Sodaro, Amy. *Exhibiting Atrocity: Memorial Museums and the Politics of Past Violence*. New Brunswick, NJ: Rutgers University Press, 2018.

Soeum, Yim. "Tuol Sleng Launches Moving New Exhibition of Victims' Clothes." *Khmer Times*, December 27, 2021. https://www.khmertimeskh.com/50995959/tuol-sleng-launches-moving-new-exhibition-of-victims-clothes/.

Soksreinith, Ten. "Cambodia's Genocide Museum Conserves Clothing of Khmer Rouge Victims." *VOA*, February 9, 2018. https://www.voanews.com/a/cambodia-genocide-museum-begins-conserving-clothing-of-khmer-rouge-victims/4245122.html.

Šošić, Lovorka. "Say It with Your Shoes: Croatians Protest for Better Jobs." *Liberties*, May 17, 2016. https://www.liberties.eu/en/stories/say-it-with-your-shoes/8435.

Spenser, Clare. "The Rise of Genocide Memorials." *BBC News*, June 11, 2012. https://www.bbc.com/news/magazine-16642344.

Staerklé, Christian, and Alain Clémence. "Why People Are Committed to Human Rights and Still Tolerate Their Violation: A Contextual Analysis of the Principle–Application Gap." *Social Justice Research* 17, no. 4 (2004): 389–406. https://doi.org/10.1007/s11211-004-2058-y.

Starl, Klaus, Veronika Apostolovski, Isabella Meier, Markus Möstl, Maddalena Vivona, and Alexandra Kulmer. *Human Rights Indicators in the Context of the European Union*. Brussels: European Commission, 2014. https://repository.gchumanrights.org/server/api/core/bitstreams/8c067be2-0646-4a59-a476-3987938393d3/content.

Steele, Valerie. *Fetish: Fashion, Sex and Power*. New York: Oxford University Press, 1997.

Stein, Rebecca L. "Retour sur la dépossession Israël, la *Nakba*, les Choses." *Ethnologie française* 45, no. 2 (2015): 309–20. https://doi.org/10.3917/ethn.152.0309.

Steinberg, Ronnie, and Deb Figart. "Emotional Demands at Work: A Job Content Analysis." *Annals of the American Academy of Political and Social Science* 561 (1999): 177–91. https://doi.org/10.1177/000271629956100012.

Sterchele, Davide. "The Limits of Inter-religious Dialogue and the Form of Football Rituals: The Case of Bosnia-Herzegovina." *Social Compass* 54, no. 2 (2007): 211–24. https://doi.org/10.1177/0037768607077032.

Stone, Philip. "Dark Tourism Scholarship: A Critical Review." *International Journal of Culture, Tourism and Hospitality Research* 7, no. 3 (2013): 307–18. https://doi.org/10.1108/IJCTHR-06-2013-0039.

———. "A Dark Tourism Spectrum: Towards a Typology of Death and Macabre Related Tourist Sites, Attractions and Exhibitions." *Tourism: An International Interdisciplinary Journal* 54, no. 2 (2006): 145–60.

Subotić, Jelena. "Remembrance, Public Narratives, and Obstacles to Justice in the Western Balkans." *Studies in Social Justice* 7 (2013): 265–83. https://doi.org/10.26522/ssj.v7i2.1047.

Sudoyo, Herawati, Putut T. Widodo, Helena Suryadi, Yuliana S. Lie, Dodi Safari, Agung Widjajanto, D. Aji Kadarmo, Soegeng Hidayat, and Sangkot Marzuki. "DNA Analysis in Perpetrator Identification of Terrorism-Related Disaster: Suicide Bombing of the Australian Embassy in Jakarta 2004." *Forensic Science International: Genetics* 2, no. 3 (2008): 231–37. https://doi.org/10.1016/j.fsigen.2007.12.007.

Sugarman, Roslyn. "Shoes: A Matter of Life or Death." Sydney Jewish Museum, November 21, 2019. https://sydneyjewishmuseum.com.au/news/shoes-a-matter-of-life-or-death/.

Sumler, Alan. "A Catalogue of Shoes: Puns in Herodas 'Mime' 7." *Classical World* 103, no. 4 (2010): 465–75.

Swidler, Ann. "Culture in Action: Symbols and Strategies." *American Sociological Review* 51, no. 2 (1986): 273–86. https://doi.org/10.2307/2095521.

Sydney Jewish Museum. "One of the First Permanent Human Rights Exhibitions to Open in a Museum in Australia" (press release), February 15, 2018. https://sydneyjewishmuseum.com.au/wp-content/uploads/2018/01/Final-MEDIA-RELEASE-Sydney-Jewish-Museums-new-Holcoaust-and-Human-Righ...-2.pdf.

Sznaider, Natan. "Compassion, Cruelty, and Human Rights." In *World Suffering and Quality of Life*, ed. Ronald E. Anderson, 55–64. Dordrecht: Springer, 2015.

———. "The Sociology of Compassion: A Study in the Sociology of Morals." *Cultural Values* 2, no. 1 (1998): 117–39. https://doi.org/10.1080/14797589809359290.

Tace, Hedrick. "Are You a Pura Latina? Or, Menudo Every Day: Tacones and Symbolic Ethnicity." In *Footnotes: On Shoes*, ed. Shari Benstock and Suzanne Ferriss, 135–56. New Brunswick, NJ: Rutgers University Press, 2001.

"Thieves Steal Holocaust Victims' Shoes at Polish Museum." *BBC News*, November 25, 2014. https://www.bbc.com/news/world-europe-30202861.

Thomas, Julia Adeney. "The Evidence of Sight." *History and Theory* 48, no. 4 (2009): 151–68.

Thomas, Suzie, Oula Seitsonen, and Vesa-Pekka Herva. "Nazi Memorabilia, Dark Heritage and Treasure Hunting as 'Alternative' Tourism: Understanding the Fascination with the Material Remains of World War II in Northern Finland." *Journal of Field Archaeology* 41, no. 3 (2016): 331–43. https://doi.org/10.1080/00934690.2016.1168769.

Thrift, Nigel. "Intensities of Feeling: Towards a Spatial Politics of Affect." *Geografiska Annaler: Series B, Human Geography* 86, no. 1 (2004): 57–78. https://doi.org/10.1111/j.0435-3684.2004.00154.x.

———. *Non-representational Theory: Space, Politics, Affect*. London: Routledge, 2008.

Tlili, Anwar. "Encountering the Creative Museum: Museographic Creativeness and the Bricolage of Time Materials." *Educational Philosophy and Theory* 48, no. 5 (2016): 443–58.

Todorov, Tzvetan. *Theories of the Symbol*, trans. Catherine Porter. Ithaca, NY: Cornell University Press, 1984.

Tracqui, Antoine, Celine Deguette, Tania Delabarde, Yann Delannoy, Isabelle Plu, Isabelle Sec, Lilia Hamza, Marc Taccoen, and Bertrand Ludes. "An Overview of Forensic Operations Performed Following the Terrorist Attacks on November 13, 2015, in Paris." In "Forensic Multidisciplinary Involvement After Terrorist Attacks." Special issue, *Forensic Sciences Research* 5, no. 3 (2020): 202–7.

"TripAdvisor Sorry for Auschwitz Review Error." *BBC News*, May 7, 2021. https://www.bbc.com/news/technology-57023794.

Tsai, William, and Anna S. Lau. "Cultural Differences in Emotion Regulation During Self-Reflection on Negative Personal Experiences." *Cognition & Emotion* 27, no. 3 (2013): 416–29. https://doi.org/10.1080/02699931.2012.715080.

Turim, Maureen. "High Angles of Shoes: Cinema, Gender and Footwear." In *Footnotes: On Shoes*, ed. Shari Benstock and Suzanne Ferriss, 58–92. New Brunswick, NJ: Rutgers University Press, 2001.

Turkle, Sherry, ed. *Evocative Objects: Things We Think With*. Cambridge, MA: MIT Press, 2011.

Turley, Darach, and Stephanie O'Donohoe. "The Sadness of Lives and the Comfort of Things: Goods as Evocative Objects in Bereavement." *Journal of Marketing Management* 28, nos. 11–12 (2012): 1331–53. https://doi.org/10.1080/0267257X.2012.691528.

Turner, Jonathan H. *Human Emotions: A Sociological Theory*. London: Routledge, 2007.

Turner, Victor. *The Forest of Symbols: Aspects of Ndembu Ritual*. Ithaca, NY: Cornell University Press, 1970.

"TV Liberty: Dilema Koja Tišti Porodice Ubijenih u Genocidu: Ukopati Nekoliko Kostiju Ili Čekati?" *Radio Free Europe*, 2023. https://www.slobodnaevropa.org/a/tv-liberty-srebrenica-mostar-ratni-zlocin-proslost/32544218.html.

"Uoči 27. Obljetnice Tragedije u Srebrenici Otvorena Izložba Fotografija Mrtvare." Ministarstvo kulture i medija, Republika Hrvatska, July 6, 2022. https://min-kulture.gov.hr/vijesti-8/uoci-27-obljetnice-tragedije-u-srebrenici-otvorena-izlozba-fotografija-mrtvare/22450.

Vallone, Jordan. "Parents Leave Shoes to Protest Covid-19 Mandates in Schools." *LI Herald*, November 24, 2021. https://www.liherald.com/stories/parents-leave-shoes-to-protest-covid-19-mandates-in-schools,136481.

Varga, Somogy, and Charles Guignon. "Authenticity." In *The Stanford Encyclopedia of Philosophy*, ed. Edward N. Zalta. Stanford, CA: Metaphysics Research Lab, Stanford University, 2020. https://plato.stanford.edu/archives/spr2020/entries/authenticity/.

Vehkasalo, Veera. "Lifejacket Graveyard." *Crisis & Environment*, October 15, 2019. https://crisisandenvironment.com/lifejacket-graveyard/.

Verdery, Katherine. *The Political Lives of Dead Bodies: Reburial and Postsocialist Change*. New York: Columbia University Press, 2000.

Wagner, Sarah. *To Know Where He Lies: DNA Technology and the Search for Srebrenica's Missing*. Berkeley: University of California Press, 2008.

Wagner, Sarah, and Rifat Kesetovic. "Absent Bodies, Absent Knowledge: The Forensic Work of Identifying Srebrenica's Missing and the Social Experiences

of Families." In *Missing Persons: Multidisciplinary Perspective on the Disappeared*, ed. Derek Congram, 42–73. Toronto: Canadian Scholars', 2016.

Wainwright, Oliver. "9/11 Memorial Museum: An Emotional Underworld Beneath Ground Zero." *Guardian*, May 14, 2014. https://www.theguardian.com/artanddesign/2014/may/14/9-11-memorial-museum-new-york.

Walden, Victoria Grace, ed. *The Memorial Museum in the Digital Age*. Sussex: Reframe, 2022.

Waligórska, Magdalena, and Ina Sorkina. "The Second Life of Jewish Belongings– Jewish Personal Objects and Their Afterlives in the Polish and Belarusian Post-Holocaust Shtetls." *Holocaust Studies* 29, no. 3 (2023): 341–62. https://doi.org/10.1080/17504902.2022.2047292.

Wallenberg, Louise. "Men in Boots: On Spectacular Masculinity and Desublimation." In *Shoe Reels: The History and Philosophy of Footwear in Film*, ed. Elizabeth Ezra and Catherine Wheatley, 148–65. Edinburgh: Edinburgh University Press, 2020.

Weaver, David, Chuanzhong Tang, Fangfang Shi, Ming-Feng Huang, Kevin Burns, and Ang Sheng. "Dark Tourism, Emotions, and Postexperience Visitor Effects in a Sensitive Geopolitical Context: A Chinese Case Study." *Journal of Travel Research* 57, no. 6 (2018): 824–38. https://doi.org/10.1177/0047287517720119.

Weeks, Jerome. "7,000 Shoes and Counting: Dallas Teen Actors Build Public Set for New Play on Gun Violence." *KERA News*, July 6, 2018. https://www.keranews.org/arts-culture/2018-07-06/7-000-shoes-and-counting-dallas-teen-actors-build-public-set-for-new-play-on-gun-violence.

Weizman, Eyal. "Chapter Fifty-Two from Forensic Architecture: Notes from Fields and Forums (2012)." In *Posthumanism in Art and Science: A Reader*, ed. Giovanni Aloi and Susan McHugh, 308–10. New York: Columbia University Press, 2021.

West, Janice. "The Shoe in Art, the Shoe as Art." In *Footnotes: On Shoes*, ed. Shari Benstock and Suzzane Ferriss, 41–57. New Brunswick, NJ: Rutgers State University, 2001.

Wharton, Amy. "The Sociology of Emotional Labor." *Annual Review of Sociology* 35 (2009): 147–65. https://doi.org/10.1146/annurev-soc-070308-115944.

Whiteley, Aliya. "The Symbolism of Shoes in the Movies." *Den of Geek*, April 30, 2013. https://www.denofgeek.com/movies/the-symbolism-of-shoes-in-the-movies/.

Wikan, Unni. "Bereavement and Loss in Two Muslim Communities: Egypt and Bali Compared." *Social Science & Medicine* 27, no. 5 (1988): 451–60. https://doi.org/10.1016/0277-9536(88)90368-1.

Williams, Paul. *Memorial Museums: The Global Rush to Commemorate Atrocities*. Oxford: Berg, 2007.

Wing Yan, Vivian Ting. "Living Objects: A Theory of Museological Objecthood." In *The Thing About Museums: Objects and Experience, Representation and Contestation*, ed. Sandra Dudley, Amy Jane Barnes, Jennifer Binnie, Julia Petrov, and Jennifer Walklate, 171–81. London: Routledge, 2011.

Winnicott, Donald W. *The Maturational Processes and the Facilitating Environment: Studies in the Theory of Emotional Development*. London: Routledge, 2018.

Winter, Jay. *Sites of Memory, Sites of Mourning: The Great War in European Cultural History*. Canto Classics. Cambridge: Cambridge University Press, 1995.

Wispé, Lauren. *The Psychology of Sympathy*. New York: Plenum, 1991.

Witmore, Christopher. "Symmetrical Archaeology." In *Encyclopedia of Global Archaeology*, ed. Claire Smith, 1–15. Cham: Springer, 2019. https://doi.org/10.1007/978-3-319-51726-1_2708-1.

Witmore, Christopher L. "Symmetrical Archaeology: Excerpts of a Manifesto." *World Archaeology* 39, no. 4 (2007): 546–62. https://doi.org/10.1080/00438240701679411.

Wobovnik, Claudia. "These Shoes Aren't Made for Walking: Rethinking High-Heeled Shoes as Cultural Artifacts." *Visual Culture & Gender* 8 (2013): 82–92.

Woods, Thomas A. "Getting Beyond the Criticism of History Museums: A Model for Interpretation." *Public Historian* 12, no. 3 (1990): 77–90. https://doi.org/10.2307/3378200.

Worden, J. William. *Grief Counseling and Grief Therapy: A Handbook for the Mental Health Practitioner*, 5th ed. New York: Springer, 2018.

Wordie, Jason. "Why Homes in Asia Maintain a Strict Shoes-Off Rule." *South China Morning Post*, December 13, 2019. https://www.scmp.com/magazines/post-magazine/short-reads/article/3041781/why-homes-asia-maintain-strict-shoes-rule-often.

Yankholmes, Aaron, and Bob McKercher. "Understanding Visitors to Slavery Heritage Sites in Ghana." *Tourism Management* 51 (2015): 22–32. https://doi.org/10.1016/j.tourman.2015.04.003.

Yankovska, Ganna, and Kevin Hannam. "Dark and Toxic Tourism in the Chernobyl Exclusion Zone." *Current Issues in Tourism* 17 (2013): 929–39. https://doi.org/10.1080/13683500.2013.820260.

Yazedjian, Laura, and Rifat Kešetović. "The Application of Traditional Anthropological Methods in a DNA-Led Identification Process." In *Recovery, Analysis, and Identification of Commingled Human Remains*, ed. Bradley J. Adams and John E. Byrd, 271–84. Totowa, NJ: Humana, 2008.

Yoshida, Kaori, Huong T. Bui, and Timothy J. Lee. "Does Tourism Illuminate the Darkness of Hiroshima and Nagasaki?" In "Special Issue on Marketing and Branding of Conflict-Ridden Destinations." Special issue. *Journal of Destination*

Marketing & Management 5, no. 4 (2016): 333–40. https://doi.org/10.1016/j.jdmm
.2016.06.003.

Young, James Edward. *The Texture of Memory: Holocaust Memorials and Meaning.* New Haven, CT: Yale University Press, 1994.

Young, Linda. "Magic Objects/Modern Objects: Heroes' House Museums." In *The Thing About Museums: Objects and Experience, Representation and Contestation*, ed. Sandra Dudley, Amy Jane Barnes, Jennifer Binnie, Julia Petrov, and Jennifer Walklate, 143–58. London: Routledge, 2011.

"Yugoslavia: Families of Kosovo Missing Can Consult New Book of Belongings." International Committee of the Red Cross, February 8, 2001. https://www.icrc.org/en/doc/resources/documents/news-release/2009-and-earlier/57jquv.htm.

Zamperini, Paola. "A Dream of Butterflies? Shoes in Chinese Culture." In *Shoes: A History from Sandals to Sneakers*, ed. Giorgio Riello and Peter McNeil, 196–206. Oxford: Berg, 2011.

Zelizer, Barbie. *Remembering to Forget: Holocaust Memory Through the Camera's Eye.* Chicago: University of Chicago Press, 1998.

Zembylas, Michalinos. "'Pedagogy of Discomfort' and Its Ethical Implications: The Tensions of Ethical Violence in Social Justice Education." *Ethics and Education* 10, no. 2 (2015): 163–74. https://doi.org/10.1080/17449642.2015.1039274.

Zils, Michael, and Marco Schulze, eds. *Museums of the World*, 9th ed. Munich: K. G. Saur, 2002.

Zimmerer, Jürgen. "Climate Change, Environmental Violence and Genocide." *International Journal of Human Rights* 18, no. 3 (2014): 265–80. https://doi.org/10.1080/13642987.2014.914701.

Zombory, Máté. "The Birth of the Memory of Communism: Memorial Museums in Europe." *Nationalities Papers* 45, no. 6 (2017): 1028–46. https://doi.org/10.1080/00905992.2017.1339680.

INDEX

affect, 146, 246, 268–73, 291–92
agency, 5, 11–19, 28–36, 41–49, 97, 149, 186, 200–233
Appadurai, Arjun, 26, 34–36
Argentina, 14, 65, 73–79
Argentine Forensic Anthropology Team, 106, 241, 254, 283–88, 295
artifacts, 33, 42, 71–74, 83–105, 114, 122, 132–36, 173–75, 183, 248
Auschwitz-Birkenau State Museum, 36, 77, 83, 92, 118–19, 140–57, 171–76, 26–296
authenticity, 54–55, 98, 122–45, 173–74, 200, 265–66

Beijing, 197
Belgrade, 89; protest, 197, 205–6
biographical journey, 200
Bosnia, 65–67, 79; mass graves in, 92–103, 126, 158, 163, 205–6, 227; protests in, 243–74, 295
broken watch, 4, 13, 45, 47, 48, 110, 121

Cambodia, 100, 255, 258, 264, 306, 318; Khmer Rouge and, 81, 92–95, 122

Canada, 73, 78, 317; protests, 208, 212, 218, 226, 280–87
China, 66, 79, 163–64, 275–76
circuit, 11, 19, 27, 28, 220, 227; victims' shoes, 255–72
circuit theory, 3–5, 10, 45–49, 64
circulation, 21, 35, 36, 42–49, 173–80, 200, 218, 225, 233–36
climate, 103, 165, 193; protests, 204, 216–18, 233–35
Collins, Randall, 11, 28–31, 48, 54–55, 128, 228, 240–42, 247, 263–65, 271–72, 279, 288, 297; emotional charge, 12, 29, 50–56, 182; emotional energy, 5, 9–31, 39–58, 110–20, 121, 130–52, 177–87, 194, 200–202, 214–28, 264; interaction ritual theory, 11, 29–31, 54, 128, 147
Colombia, 79, 81
commodities, 2, 34–36, 159
concentration camps, 2, 5, 41, 96, 171–73, 225, 288
COVID-19, 10, 79, 199; protests, 209, 214, 217, 233
Cyprus, 100

dark tourism, 6, 12, 19, 228, 263; memorial museums 122, 133–59, 187–95; visitors, 51–54
desire objects, ideology, 222–37; private homes, 109–31; political action, 192–221; rediscovery, 82–108; shoes, 158–59, 176–79, 186–89; theoretical model, 2–59, 64, 67–70; value of, 132–53
desires, 2–3, 10, 15, 22–26, 37, 82, 94, 128; moral orders, 186, 222–27, 233
DNA, 48, 67, 95–101, 251–52, 257, 294–95
duty to remember, 61, 70, 75–76

emotional contagion, 54, 148
emotional labor, 12–13, 19, 46, 51–58, 135, 138, 146–50, 220, 228
emotional mining, 20, 179, 180, 181, 182, 185, 192, 227
crypto emotions, 185
evidence, 8–10, 20, 41, 67–69, 78–91, 116, 121, 171–75, 226, 233; court, 25, 27, 32, 54; forensic, 95–97, 100, 104

facing the past, 70, 76
forensics, 6, 15, 64–65, 91, 100, 106–8, 223–24

genocide, 17, 34, 37, 41, 64–80, 84, 118, 119, 122–26, 148–58, 188, 190, 205, 294; commemorations, 218, 229, 245–55, 264, 270
Greece, 72, 177, 193
grief, 11–12, 25–26, 38, 42, 68–69, 111–12, 142, 149

Ground Zero, 94, 116, 124, 140–42, 227, 269
Guatemala, 65, 95, 99–100, 258

Hochschild, Arlie Russell, 12, 51–53, 150, 228, 241, 247, 273
Holocaust, 12, 38, 62–66, 117, 123–24, 140, 143, 151, 203, 207, 212; museum, 41, 76–84, 169–91
Hong Kong, 79, 197, 216
humanitarianism, 64
human rights, 9–22, 27–28, 45, 51, 59, 92, 104, 107, 108, 122–30, 158–237, 264, 289; abuses, 39, 60–66, 70, 75–85, 106, 134, 139–42, 214, 231–33
human–object relations, 11, 3, 7, 8, 11, 17, 32, 45, 58, 109, 133, 178, 218, 222, 236

ideological worldviews, 3–4, 16, 19, 21, 130–31, 213, 218, 225–30
ideology, 4–5, 7, 16, 59, 195–233
implicated subject, 139
Iraq, 93, 103, 208
Italy, 160–61, 177, 212

Kosovo, 1–2, 89, 102, 259

Majdanek, 169–75, 184
Malešević, Siniša, 9–11, 128; nationalism, 215, 230, 248, 265, 271
mass graves, 2, 9, 36, 40, 67, 80–105, 125, 177
material culture, 9–10, 17, 32–35, 95, 111, 196
material turn, 32
melancholy, 111, 261–64

memorabilia, 2, 31, 38, 223
memorial museums, 6, 9, 12, 15, 16, 20, 133–38, 151, 182, 191–95, 220, 224–26, 232; history of, 75–83
memorialization, 9, 106, 123, 130, 172, 194, 207, 224, 228, 231; human rights memorialization agenda, 60–83
memory, 2, 17–18, 21–22, 26, 32, 36–37, 40–48, 60–70, 82–83, 110, 129, 138, 173, 184, 191; of the Holocaust, 38, 117–19, 141–42, 208–9; tacit, 234–36
Merleau-Ponty, Maurice, 185–186
Mexico, 79, 93, 100, 103, 197, 213, 226
moral claims, 10, 14, 25–27, 200–202, 219
moral communities, 6, 201–15, 234
moral labor, 12–21, 46, 50–64, 134, 138, 150–52, 177–200, 220, 225–28
moral orders, 2–17, 27–28, 45, 84–85, 129, 199, 209–15, 224–25, 233–36
moral remembrance, 9, 61–65, 76–83, 106–7, 130, 207

national museums, 62, 72–74
nationalism, 19–22, 27, 59–62, 84, 128–30, 204–34
nation-states, 60, 63, 67, 72–75, 229–34

Palestinians, 14, 207
personal items, 2–17, 25, 36–48, 67–83, 91–112, 122–28, 222–23
piles of shoes, 169, 172–175, 179
Podrinje Identification Project, 96–99
political action, 3, 5, 6, 10, 13–17, 21, 25–27, 41, 45, 47, 58, 134; case studies 158–92; ideology 194–234

popular culture, 165
prop, 225
protest, 14, 21, 196–218, 285–92
public spaces, 12, 20, 47, 63, 125–37, 151, 196, 200–208, 225, 233

rediscovery, 17–20, 58–59, 90–91, 105–6, 151
remembrance 19, 61–62, 76–82, 114, 139, 175, 225, 235–36
Republika Srpska, 102–3, 206, 258–59, 295
Rwanda, 65–80, 95, 124, 140, 145–49, 175, 188, 250, 257–59

September 11, 47, 56, 80, 93–94, 123–25, 208, 248, 252, 256
siege of Sarajevo, 57
sites of atrocities, 3–4, 9, 18, 38–40, 84
Spain, 65, 100, 161, 250, 258
Srebrenica, 25, 47, 81, 93, 96–105, 114–15, 124–129, 132, 157–58, 205–6
symbol, 14, 21, 57, 167, 179, 197–99, 218

terrorist attacks, 2, 40, 56, 93, 103, 203, 216
theoretical model, 19, 46
Tolkatchev, Zinovii, 171–72, 277
transitional justice, 6, 60, 63–64, 81–82, 224, 232
Tripadvisor, 8–9, 144, 182, 187–88, 240
Tuol Sleng, 80, 122, 175, 279

Ukraine, 140, 163, 177; protest, 188, 195, 210

victims, 5, 14–17, 21, 26–27, 36, 49, 56–69, 70, 74–79, 85; museums, 145, 149, 150, 153, 157, 169–83; in political action, 187–88, 192–94, 200–207, 210–15, 218, 220, 224, 232–34; testimonials, 91–107, 115, 118–19, 123–24

victims' shoes, 5, 14, 16, 17, 21, 49; in protest 192–94, 200–220, 232, 234; history of 153, 169–187

war, 1–2, 17, 34–41, 63–75, 92, 116, 166, 170–71, 193, 203–10, 233

witness, 2, 31, 41, 44, 97, 123, 125, 170, 202

Printed in the USA
CPSIA information can be obtained
at www.ICGtesting.com
JSHW021719231024
72255JS00001B/4